DRAWING IDEAS OF THE MASTERS

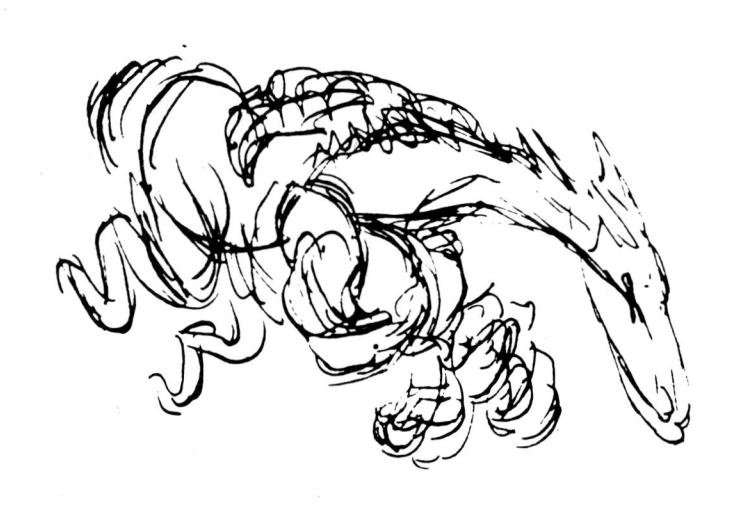

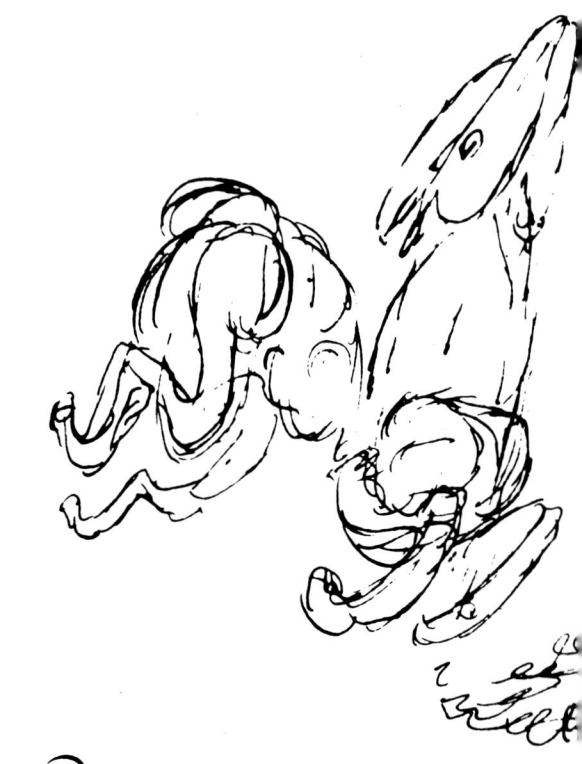

1412 85 a Galorierande Pforde

AUTHOR'S NOTE

I should like to thank all those who have helped in and contributed to the production of this book, particularly Mark Ritchie and Jean-Claude Peissel for their expertise and experience, Marie Leahy for efficient and tactful editing, Freddie Quartley for her sensitive design, Ann Gissing for typing an illegible manuscript, Elaine Scott for library facilities, and Margery Malins for continuous help and advice.

EM

Phaidon Press Limited, Littlegate House, St Ebbe's Street, Oxford

First published 1981 ©1981 by Phaidon Press Limited All rights reserved No part of this publication may be reproduced, stored in a retrieval system, or transmitted in any form or by any means, electronic, mechanical, photocopying, recording or otherwise, without the prior permission of the publishers.

British Library Cataloguing in Publication Data Malins, Frederick

Drawing ideas of the masters.

1. Drawing - Instruction

I. Title

741.2 NC730

ISBN 0-7148-2123-3

Composition by Filmtype Services Limited, Scarborough, England Printed in the United States of America

Contents

Introduction	-
Drawing Terms and Techniques	I
List of Illustrations	Ι∠
Portraits	18
The Figure	40
Figure Composition	60
Landscape	78
The Built Environment	96
Animals	I I 2
Further Reading	126
Index	I 2 7
Acknowledgements	т 2 8

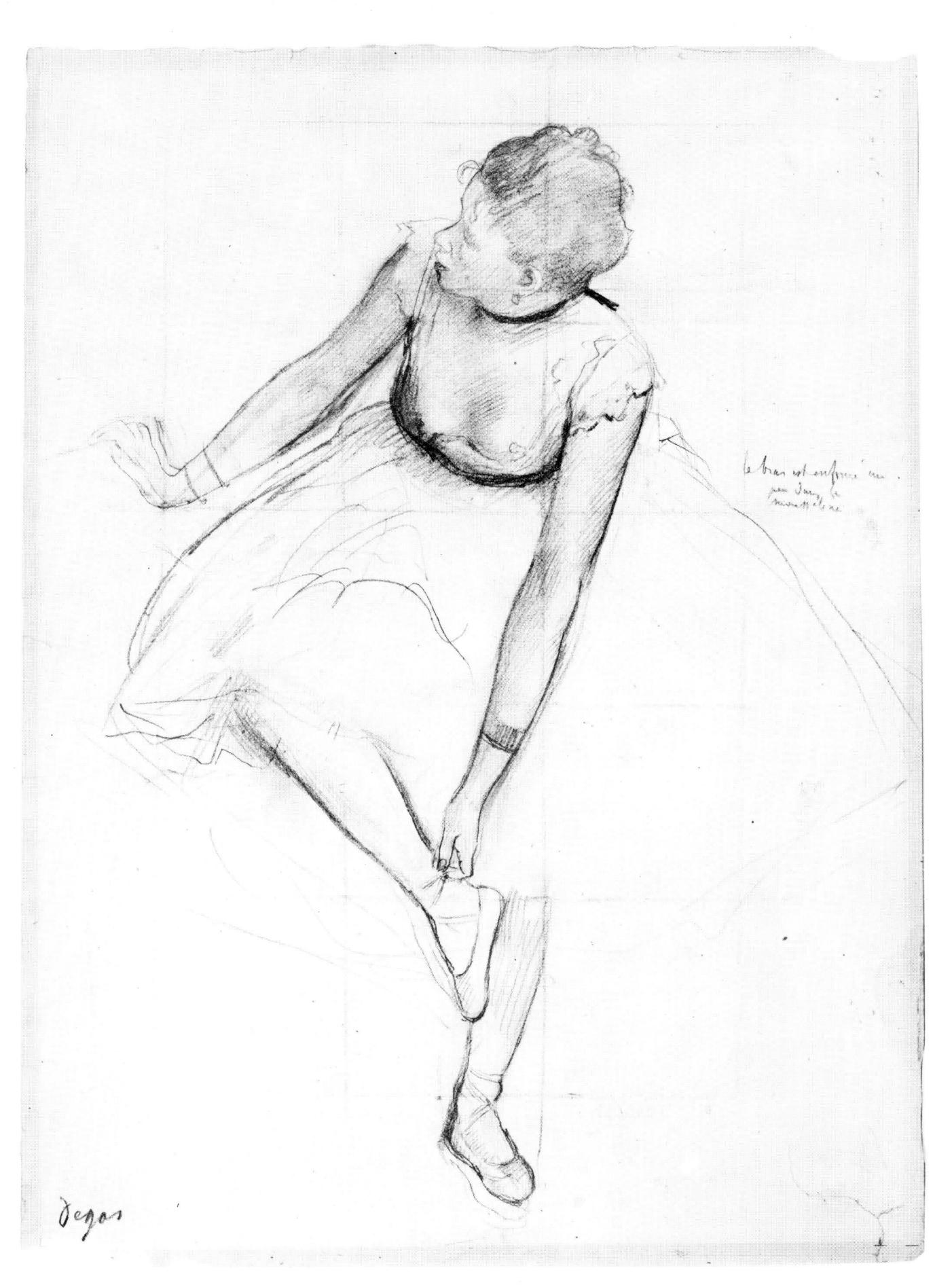

Edgar Degas

Dancer Adjusting Slipper

This book is intended to help the reader deepen his appreciation of drawing by studying a selection of works from the point of view of the artist. Although books, slides, films, and lectures are obviously helpful to the student, an appreciation of art is best achieved by simply looking at works of art; reproductions can therefore play a particularly useful part in a study of the visual arts. This is especially true in the case of drawings, since they tend to rely less on colour than other media, are often reproduced in their original size, and, like the books in which they appear, are intended to be studied at close quarters. Furthermore, in looking at drawings we have the advantage of experiencing a direct link with the artist. The marks made by hand responding to eye, however recently or however long ago, have the power to communicate to us directly, without intermediary, whereas in painting the marks have been translated into colour, and in sculpture the concept is clothed in three dimensions.

If we study the history of drawing we notice immediately the great variety of media used by artists, and the immense variation in the ways the same media have been handled by different artists. Indeed, to understand more about the material aspect of what is essentially a practical process there is no better way than to actually make marks, if not drawings, with the various means at one's disposal; discovering their possibilities and limitations, and attempting to copy some of the drawings in this book using the same medium as that originally used by the artist, would be a most rewarding and useful experience.

There are three important preliminary decisions that the artist must make before beginning a drawing: firstly, which medium to use – Wet? Dry? A combination of both? Is the drawing to be in colour or monochrome? What surface is it to be drawn on? Paper? Card? White or coloured? The choice will be

based on the artist's personal preference and experience. Secondly, he must consider the scale of the drawing and the amount of detail involved as this may limit the range of media at his disposal; for example, if a small sketch is to be made on the back of an envelope (as Sickert used to do on occasion) the medium of charcoal or chalk would be totally unsuitable. Thirdly, the artist must bear in mind the purpose of his drawing: it may, for example, be intended to give a client a preview of how a finished drawing may look, or, more commonly, it may be a preparation for work to be carried out in some other medium - a plan or an elevation for a building, or a sketch for a painting or piece of sculpture. The preparatory drawing may be quite small compared to the final work (a fresco or a tapestry, for example). In this case it is common practice for the drawing to be 'squared up' as a means of enlargement when transferring to wall or canvas, and sometimes one can still see this grid of squares superimposed on the drawing (see, for example, Stanley Spencer's Elsie Chopping Wood, Ill. 67).

Where drawings are only a preparatory stage the artist will have the final work in mind when he makes his choice of medium; a drawing for a subsequent painting will perhaps not only show the shadows or light and shade by means of 'tone', but will also indicate the tone values of the colours (as in the preparatory studies of Seurat, for example); in this case the artist will choose to execute the drawing in a tonal medium such as chalk or conté crayon. If the artist wishes to emphasize the linear aspects – whether seen or imagined - of his subject, for example perspective and the relationship between lines (as in the work of Mondrian), or if movement expressed in linear terms (as in Van Gogh's Cypresses, Ill. 96) is his chief concern, then he will choose a medium appropriate for this purpose – reed pen and ink, perhaps. If however,

he wishes to create effects by means of tonal qualities, for example the drama of light and shade (as in a sketch by Rembrandt), or the atmospheric quality of distant mountains (as in a study by Claude), he will be inclined to choose wash and brush, or charcoal, media which lend themselves to broad tonal effects, rather than spend time laboriously hatching dark areas of tone by using pen and ink.

What is drawing?

Let us begin our investigation of drawing by defining our terms. There are as many definitions of the word 'drawing' as there are books on drawing, and numerous interpretations of the different definitions. The Oxford Universal Dictionary defines drawing as 'delineation by pen, pencil or crayon', making no mention of brush, silverpoint, pastel or anything else capable of making a mark, and implying by the use of the word 'delineation' that drawing is always a matter of lines rather than areas. The Encyclopedia of World Art informs us that 'the word drawing covers in general all those representations in which an image is obtained by marking whether simply or elaborately upon a surface which constitutes the background'. The second definition, which refers to 'representation' opens up the more useful line of enquiry. What is a representation? The Shorter Oxford Dictionary devotes forty lines of close print (some 360 words) to an explanation of representation, of which 'the action or fact of exhibiting in some visual image or form' seems to have some relevance to drawing, but the definition 'an image, likeness or reproduction in some manner, of a thing' takes us rather nearer to understanding the meaning of drawing.

To what extent is a drawing a 'likeness', image or representation of something? Would one drawing be better than another because it looked more like the thing it represented? Of course it depends what one means by 'looking like', and what one understands by a 'likeness'. If by a likeness one means a photographic reproduction, imagining therefore that the better the drawing the more it will resemble a photograph, one would be mistaken. No artist in history has ever produced a drawing which anyone would mistake for a photograph, nor a drawing which anyone would mistake for reality. Drawing is clearly neither copying nor mechanical reproduction, and we should not attempt to assess the qualities of a drawing by referring it to some vaguely remembered faded photograph, some dimly recalled set of visual clichés. Within the context of this work, therefore, the word 'drawing' will refer to a creative activity involving skill, feeling, observation, and intelligence, resulting in a graphic representation of a visual experience seen or imagined. The word 'graphic' in this connection implies the use of a medium in which colour is of secondary importance to line and form. By representation is meant the creation (on paper or other suitable surface) of a set of relationships analogous to those of point, line, shape, or tone which the artist has discovered by a visual analysis of his subject.

While bearing in mind that drawing is essentially a practical activity we must appreciate that it is also a means of interpretation and expression, and it is important that we understand clearly what the artist is trying to do (for example, when drawing from his observation), and, equally, what he is not trying to do. What is he trying to 'see' as he gazes at the scene before him? Obviously we need to understand what is meant by 'see' and to be able to differentiate between the 'seeing' involved in drawing, and the seeing that enables us to move about in our everyday life. (Matisse, when asked if he saw a tomato differently if about to paint it or eat it, explained that if he was going to eat it he simply saw it in the same way as everybody else.) When we understand what the artist is trying to 'see' we will be in a better position to appreciate the extent to which he has conveyed his vision to us.

It is of fundamental importance to understand first and foremost that the artist is not setting out to draw things (unlike the amateur, who devotes each page of his sketch-book to one 'thing': for example, 'A Dog' or 'A Shoe'); rather, he attempts to express those visual relationships between points, lines, spaces, and tones which he selects from the chaotic mass of visual information that confronts him in every situation.

The kind of seeing necessary to make a visual analysis is difficult, since it is impeded by various factors, and is only achieved by intensive training and self-discipline, coupled with an innate talent. The ability to 'see' required for drawing is very different from the everyday 'seeing' which enables us to recognize our surroundings, things, or people. In our everyday seeing we are presented with an infinite variety of impressions: images of bewildering complexity and constantly changing pattern flicker on our retina, and most of the time, fortunately, we are practically unaware of them, sifting and selecting a few relevant facts. We recognize a bus as one we want to catch, we do not notice how it grows in size as it comes towards us; figures at one end of a room do not strike us as being smaller than those near to us.

Most of drawing consists of discovering the dif-

ference between what we know and what we see. In other words, drawings reveal the difference between the appearance of everyday experiences and our preconceived idea of these visual experiences preconceived ideas which are based on the schematic images we have in our mind's eye, and which have a tendency to superimpose themselves whenever we try to re-evaluate our visual sensations. Hence it is difficult for the beginner to draw a cube with the top (or bottom) on the eye-level so that it presents a straight line, since the top (or bottom) is known to be there. Similarly, a child may draw a cup with the top roughly circular but with a flat base since he knows that without this it could not stand up.

This same tendency to confuse what we know and what we see poses difficulties for beginners when they come to deal with foreshortening: trying to draw a foreshortened arm (which may appear half the length of the other arm) when both arms are known to be of the same length, results in a subconscious attempt to resolve the 'short' arm to its known 'normal' length, and it is thus drawn longer than its appearance warrants. Similarly, there is an innate tendency when dealing with movement in a pose - a twist or a bend - to try to minimize it and restore the figure to the static position 'seen' in the mind's eye.

There are still other factors apart from preknowledge, previous experience, and preconceived ideas interfering with our ability to see; for instance our view of the world may be affected by mood, by our degree of personal involvement or interest. Another important factor intimately related to the idea of preconception is the ability to name what is seen; this results in a schematic image being conjured up by that name, thereby effectively interfering with the purely visual sensation. It is well known, for example, that if a group of students is asked to make a sketch of a rather ambiguous diagram, shown to them for a brief period and described as 'an anchor' (see Fig. 1) then the results will have more of the characteristics of an anchor than those to whom the same diagram is presented as 'a pickaxe'. Similarly, in drawing the figure there is the same innate tendency to think in

are described. The clearly defined line which separates 'head' from 'neck' in the average beginner's drawing is the result of thinking of (and seeing) the head and neck as separate concepts described by separate words - whereas what is in fact seen is a head-neck complex. In the same way, the black lines round lips, or the individual hairs of eyebrows, are all easily verbally identifiable parts of the head which are pounced on and generally drawn with delight by the amateur, pleased to recognize familiar landmarks. Unfortunately, it is this recognition of objects by name rather than by appearance which gives to the drawings of heads by beginners that peculiar and unlikely 'Identikit' character they so often possess. The final factor which we need to consider in our

terms of the names by which various parts of the body

investigation of the nature of drawing is the rôle of the artist's 'understanding' in the complex process of 'seeing'. As Constable said, '... we see nothing truly until we understand it . . . 'Seeing' a chessboard or a simple symmetrical object from the point of view of drawing it will be considerably simplified if we understand that the alternate black and white squares are square and alternate, or, in the case of the object, that both sides are equal. Imagine trying to draw either of the following shapes without understanding their basic construction:

If we understand that a tree may be used as shade or umbrella, that it has grown, moving continuously, though imperceptibly, this will enable us more easily to see the tree as an organic structure. In drawing the figure the artist will realize and convey his realization that the surface form is related to the basic framework of the body, that certain muscles are flexed, others

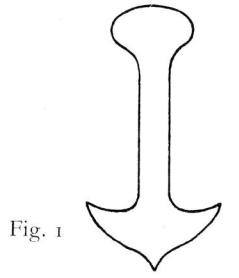

relaxed, that clothing is related to forms beneath and that the drapery is affected by gravity, tension or compression. All these and many other ideas are understood and revealed by the intelligent draughtsman whose skill lies in analysing the relationships of lines, forms, and shapes, simplifying complex forms to their basic geometry, organizing multiple tones into three selected values, and conveying graphically and with economy the visual discoveries that this book is about.

In order to facilitate study of the drawings chosen for this book they have been grouped by subject (rather than by technique, or in chronological order), since it is useful in learning to develop appreciation to be able to compare and contrast one work with another, a process made more valid when there are common factors: for example, artists drawing the nude must all deal with the subtlety of form and problems of proportion, and the anatomy of the human body. The choice of artists and subjects is a very personal one, and is based on the author's experience of teaching art appreciation for many years in schools of art and in university extra-mural departments, and on his experience as a practising artist. It is hoped that the ideas in the text will not only encourage the reader to look afresh at the work of the Great Masters, but also suggest new approaches and techniques he can explore in his own drawings. Those who are less familiar with the terms used in drawing may wish to study the glossary before going any further; the more experienced reader will probably prefer to turn straight to the text.

Drawing Terms and Techniques

Aerial perspective: a term particularly applicable to landscape drawing; refers to a technique of creating the illusion of distance by using lighter tones to represent distant areas, with progressively diminishing contrast of tonal intervals from foreground, through middle distance to background.

Aquarelle: a drawing (or painting) in transparent watercolour. Aquatint: an etching technique, used to produce control of tonal areas in prints. The name is derived from the resemblance of prints using the method, to drawings using watercolour washes. This technique is rarely used alone but in association with etching and/or dry point. Goya, Sandby, and Picasso all made wide use of aquatint. The traditional method of producing an aquatint is to cover a copper or zinc plate with a fine dust of powdered resin. The plate is carefully warmed in order to fuse these specks onto the plate, thereby covering it with a fine granular surface. When the plate is put into a bath of acid, this mordant will gradually eat around each speck of the acid-resisting resin dust, thereby creating a finely pitted surface which, if printed, would create an allover even tone. To control the depth and distribution of tonal areas, an acid-resisting varnish is applied with a brush to stop out the lightest areas after the first biting. Subsequent stopping-out and deeper re-biting can produce a wide range of tones, from the faintest to rich velvety darks. There are variations of this process, e.g. sugar lift.

Bistre: see CONTÉ

Blender: a type of brush in which the hair fans out like a shaving-brush, instead of coming to a point; used to blend two or adjacent tones of wet colour imperceptibly into each other by stippling.

Body colour: opaque watercolour (see GOUACHE).

Brush: for drawing purposes, the sable brush is the most suitable and most commonly used. It is made from the hairs of the red sable, using the natural tips of the hairs to form the pointed end of the brush. A good quality brush is resilient, sympathetic, and keeps its pointed shape. Until the end of the nineteenth century and the introduction of the so-called lead pencil, such a brush was called a 'pencil'. The pointed shape is most common, but flat sables are also used. Second quality brushes are mixtures of sable and ox-hair. Badger-hair and dark squirrel, known as camel-hair, are sometimes used, although the camel-hair is soft and floppy; large camel-hair, known as a mop, is sometimes used for blending.

Calligraphic: refers to drawings executed in a free, flowing manner, whether in pen or brush, suggesting the cursive

quality of fine handwriting; particularly applicable to drawings by Matisse and Picasso.

Camera obscura: the name means literally 'dark chamber' and the device consists of a box (or box-like room) with a small aperture in which a double convex lens is fitted. Light comes through this onto a sheet of ground glass or translucent paper onto which the main lines of the drawing are traced.

Capriccio: a composition that contains bizarre, fantastic or grotesque subjects; also an extravagantly conceived architectural scene or *veduta* in which the architectural elements are accurately depicted but anomalously combined; a *veduta* with purely imaginary elements is called a *veduta ideata*. Canaletto and Robert were eighteenth-century *vedutisti*.

Carbon pencil/Charcoal pencil: a very useful and popular form of black pencil available in different degrees of hardness from soft, through medium to hard; can be used to produce broad areas of tone as well as more detailed linear drawing.

Cartridge: a kind of heavy drawing paper.

Chalk: see CONTÉ CRAYON

Charcoal: a black crayon, usually made from charred willow or vine twigs, available in various degrees of hardness and thickness. Charcoal has been used by artists from earliest times. It is a medium capable of great variety from extremely subtle to rich black and velvety. It is very suitable for rapid work and for comparatively large-scale work. Although easily smudged off, it tends to leave a trace of the first impression, so is useful to the draughtsman who wishes to carry out revisions and corrections while still being able to see what is being corrected (a process which may be observed in some drawings by Degas). The ability to smudge is used (particularly in nineteenth-century drawings) to create continuous transitions of tone by using a stump or finger. The finished drawing is generally sprayed with fixative.

Chiaroscuro: literally 'light/dark': a term applied to drawing (and painting) to describe accentuated light and dark effects — the latter usually accentuated to the point where shadowed parts of the form are lost against the dark tone of the background. Rembrandt in particular excelled in this technique.

Chinese ink: see INK

Coloured pencils: so-called coloured pencils, consisting of unnamed pigments and mixed with clay binder, are sold in an astonishing variety of colours; none have played a significant rôle in the history of drawing and they are not recommended as a medium.

Conté crayon: French brand name of crayons which are made

in the form of square-sectioned sticks or as pencils. Chalk based, they contain no grease and are available in several colours. The most popular is sanguine – a kind of brick red; they are also available in sepia (reddish brown), bistre (greenish brown), white and black, in three grades of hardness (soft, medium, and hard).

Contour: the outline or periphery of a figure (or object); the line that bounds or delimits a form or an area.

Contrapposto: a pose in which the figure stands with most of the weight on one leg, and with the vertical axis of the body in an S-curve; a pose much admired by Italian artists of the Renaissance (e.g. Botticelli) and neoclassical artists (e.g. Ingres) since.

Crayon: any drawing material in stick form; a stick of chalk or material with chalk base such as conté crayon. The term is also applied to charcoal, grease crayons and lithographic crayons, and is used to describe wax crayons used by children.

Cross-hatching: see HATCHING

Cross-section: often abbreviated to 'section' in drawings in which the form appears to have been cut through and the face of the cut is visible; more usually refers to an indication of the changing surfaces of a form by means of lines or dotted lines (Henry Moore frequently makes use of this technique in his drawings).

Dragged: describes the technique of brushing comparatively dry paint over a surface so that the colour adheres to the raised parts, leaving even slightly lower parts untouched.

Engraving: the process of incising a design or drawing onto a hard surface usually of metal or wood, with a sharp tool called a graver, creating an intaglio printing surface. Prints are produced in etching by inking the plate and wiping off the surface, leaving the ink only in the engraved lines – the deeper the incised line, the darker it will print. The technique developed at the same time in Italy, Germany, and the Netherlands, influencing artists throughout Europe (e.g. Dürer, Botticelli).

Etching: the process whereby a design or drawing is eaten into a metal plate, usually copper or zinc, by a mordant - often nitric acid; a chemical process in contrast to the physical process of engraving. The drawing is made with a needle, through a thin coat of an acid-resisting ground, in order to expose the metal to the acid. The plate, back and sides protected, is immersed in acid for a short period, then the lines which are to be faintest are protected with stop-out varnish. The deeper the line is etched, the darker it will print. The plate is returned to the acid bath to deepen the lines not stopped out. The process of stopping out and re-biting is repeated until the required depth of tone in the darkest areas has been achieved. Ink is dabbed into these lines, and the surface of the plate wiped (almost) clean, leaving the ink in the lines only. The inked plate is printed onto damped paper by an etching process. The etched line differs from the engraved line in that the engraved line tends to be crisper, sharper, and more mechanical in feeling.

Figura serpentinata: exaggerated elongation of the figure into a long drawn-out S-curve.

Foreshortening: the diminishing of certain dimensions of an object or figure in order to show it in a correct spatial relationship. A figure with arm stretched towards the observer, or falling through space (see Michelangelo, Rubens) must be foreshortened.

Golden section: a canon of proportion marked out in the first century BC by Vitruvius to establish architectural standards, and used since in painting and sculpture as well as in architecture. The proportions considered to be ideal are those in which the shorter is to the greater, as the greater is to the whole: approximately 5 units to 8 units.

Gouache: opaque watercolours, usually sold in tubes, containing the same ingredients as transparent watercolours but with the addition of an opaque white.

Graphite: an allotrope of carbon used in pencils. It was not until the eighteenth century that its true composition was understood: previously called 'plumbago' or 'black lead'. This name persisted and today graphite pencils are frequently designated as 'lead pencils'.

Ground: the texture (rough or smooth) or particularly the colour of the surface (sometimes called the support) on which a drawing or painting is made.

Ground plan: positions occupied by forms on a plane drawing (i.e. when seen from directly above).

Hatching: drawing closely parallel lines on a surface to produce a dark tone and thereby simulate the appearance of shadows. Cross-hatching is similar to hatching but uses intersecting parallel lines.

Highlight: the reflection of the light source (often the sky) from the surface of an object.

Ink: drawing ink, usually called Indian ink, is used in both pen drawing and wash drawing. It consists of carbon, usually lamp black, finely dispersed in an aqueous binder with a wetting agent. It is water-resistant, and when dry may be gone over with wash or watercolour. Chinese ink is similar to Indian ink but it is dried and moulded into sticks which the artist uses by rubbing the end on an ink-stone with the addition of water.

Lead pencil: see PENCIL

Linear perspective: a method by which objects are made to appear to recede in space by being drawn progressively smaller and by the parallel lines which are receding from the spectator being drawn as meeting in a point (the vanishing point) on the horizon or eye-level. In practice the rules of so-called legitimate construction are not rigidly adhered to, otherwise a somewhat mechanical effect would result (see Saenredam, Canaletto).

Ochre: earth colours which owe their hue to the presence of iron hydroxide. They are obtainable in a range of hues. If yellow ochres (light, medium, or gold) are heated they turn red and give rise to a whole range of burnt red ochres and earth colours, all reliable in all techniques. These natural burnt ochres, or red earths, are frequently found in volcanic areas as a by-product of past eruptions. Ochre colours are known by various names, including yellow ochre, raw umber, burnt sienna, burnt umber; (terre-verte or green earth is similar in nature to ochre).

Pastel: a soft, easily breakable coloured crayon containing just enough gum to hold the pigment together. The softer the

pastel, the more it is preferred. Pastels are called paintings rather than drawings because the colours are applied in masses rather than lines. Pastels are very fragile and the colours lie on the surface of the paper as a kind of coloured dust, but under glass they are very permanent. Spraying with fixative is best avoided since it will bring up reds, ruin tonal relationships, and destroy the characteristic soft quality of the medium.

Pen: originally most pen drawings were done with pens made from stalks of reeds or quills; mass-production of steel nibs in the nineteenth century largely supplanted reeds and quills (but see Van Gogh).

Pencil: until the introduction of the so-called lead pencil at the turn of the nineteenth-century, a pencil meant a small, pointed watercolour brush. The 'lead' pencil, although very commonly used today for drawing purposes by students, is a difficult medium to handle and has rarely been used by artists in the past, although Ingres and Spencer have found it eminently suitable for their precise styles. See also carbon/ charcoal pencil.

Perspective: see AERIAL PERSPECTIVE and LINEAR PERSPECTIVE Pigment: the basic colouring agent in paint. Those pigments, so-called earth colours, found occurring in nature, have long been esteemed for their permanence and compatibility with other pigments. Pigments which are available as a dry powder may be mixed with gum and water to produce watercolour, or with drying oil to produce oil colour, or egg can be added to produce tempera colour.

Plane: a flat surface. Forms may be described in terms of planes. Profile: an outline; especially refers to the face seen from the side.

Profile perdu: a profile that is largely turned away, showing chiefly the contour of the cheek and jaw - a device which enables us to imagine the features for ourselves.

Sanguine: see CONTÉ CRAYON

Schema: a diagram used as a guide to obtain 'correct' proportion. Geometric schema are sometimes used as a means of drawing the human figure, using an ovoid for the head and spheres and cubes, for example, for other proportions. Drawings from memory must make use of schema, but schema based on years of study and first-hand observation are better than those based on second-hand models. (Although William Blake's schema were fundamentally poor, his personal vision overcame this limitation.)

Sepia: a drawing ink, fairly permanent. Most popular from 1780 to 1880, when bistre tended to be used. Sepia is a warm, reddish brown colour, whereas bistre tends towards a cooler greenish brown.

Silver-point: drawings in silver-point are made on paper specially coated with white pigment, using a silver rod as a kind of stylus. This produces a greyish line which becomes gradually darker as the silver tarnishes. Any soft metal such as copper or lead could be used (though they would not darken like silver), and the paper could be coated with white bodycolour which would give much the same effect as the silverpoint. Used extensively for drawings during the Renaissance.

Square up: a method of enlarging a drawing. Numbered squares are superimposed on the drawing (directly or on a tracing paper overlay); a similarly numbered grid of larger squares is drawn on the canvas (or other new surface). By noting the positions of lines intersecting the squares on the drawings and plotting these intersections on corresponding squares on the canvas, the drawing may be enlarged to any required size.

Stippling: tapping the colour or the support with the point or tip of the brush or pen as a means of producing an effect of

Stop out varnish: an acid resistant varnish used in etching or aquatint to protect those parts of the metal plate which the artist considers to have been bitten sufficiently deeply.

Stump: a light roll of paper pointed at both ends and used to smudge charcoal or chalk drawings to achieve very smooth tonal graduations.

Sugar lift: a variation of the aquatint technique whereby a sugar solution (with the addition of Indian ink to make the lines visible) is used to draw on the plate. Varnish is applied all over and when this is dry the plate is immersed in warm water. which lifts the stop-out varnish from the sugar drawn lines as they dissolve.

Tempera: refers to a technique of painting in which the pigment is mixed with an emulsion of oily and watery constituents. Eggs, being a natural source of such an emulsion, have traditionally been used, but synthetic emulsions, with vegetable gums or animal glues as the emulsifying agents, have also proved successful.

Three crayons: the technique of using black, white, and red conté crayon to indicate colour as well as form. A surprisingly wide range of colours may be suggested by the use of these three alone. Especially useful in figure work (see Veronese).

Tone: a term describing the effect of shadow used to suggest the three-dimensional quality of form; adding 'tone' to a drawing means creating the effect of light and shade.

Tone value: all colours have a tone value, according to whether they are light or dark. Tone value is that quality which distinguishes a light colour from a dark colour.

Topographic landscape: a landscape in which the actual features are depicted as accurately as possible.

Vanishing point: in linear perspective, a point at infinite distance on the horizon line at which lines parallel to each other appear to converge.

Veduta ideata: a scene, apparently realistic, but in fact composed of imaginary elements (see Piranesi; see also CA-

Wash: a brush drawing done on paper using different dilutions of ink or monochrome watercolour. Wash drawings which include the use of pen to define or detail selected areas are, in Britain, called pen-and-wash drawings. It is a difficult technique since a marriage of the two elements is not easily achieved.

Watercolour: pigment mixed with water and gum arabic – the gum causes the pigment to adhere firmly to the paper (or other support). Glycerine (or a similar agent) is used to delay drying and increase transparency - the essential characteristic of this medium. Watercolour is generally used on a white support so that the untouched white background can be used as light parts of the drawing.

List of Illustrations

PORTRAITS

I. Pablo Picasso

Head of a Young Man (1923) Conté crayon The Brooklyn Museum, Carll De Silver Fund

2. Andrea del Verrocchio

Head of a Woman with Elaborate Coiffure (c. 1475) Black chalk with white heightening British Museum, London

3. Amedeo Modigliani

Portrait of Mateo Alegria (1915) Brush and ink wash The Rose and Henry Pearlman Foundation, New York

4. Paul Klee

Portrait of a Girl Smiling (1910) Pen and ink and wash Paul Klee Foundation, Museum of Fine Arts, Berne

5. Juan Gris

Portrait of Max Jacob (1919) Pencil Collection, The Museum of Modern Art, New York. Gift of James Thrall Soby

6. Henri Matisse

The Plumed Hat (1919) Pencil Courtesy of the Detroit Institute of Arts

7. Paul Cézanne

Self-portrait (c. 1880) Pencil Museum of Fine Arts, Budapest

8. Jacques Villon

Self-portrait (1942) Pen and ink Galerie Louis Carré et Cie, Paris

9. Jacques Villon

My Portrait (1934) Pen and Indian ink on tracing paper Galerie Louis Carré et Cie, Paris

10. Oskar Kokoschka

The Artist's Mother Relaxing in an Armchair Black chalk Albertina, Vienna

11a. Gian Lorenzo Bernini

Self-portrait (c. 1620) Red chalk with touches of white body colour British Museum, London

11b. Gian Lorenzo Bernini

Self-portrait as an Old Man Black chalk with some yellow body colour British Museum, London

12. Leonardo da Vinci

Self-portrait Red chalk Royal Library, Turin

13. Albrecht Dürer

Head of an Old Man (1521) Brush and black ink, heightened with white on dark violet-tinted paper Staatliche Museen Preussischer Kulturbesitz, Kupferstichkabinett

14. Hans Holbein

An English Woman Black and red chalk and yellow watercolour British Museum, London

15. Raphael (Raffaello Sanzio)

Female Saint, half-length (c. 1504) Black chalk on stylus sketch British Museum, London

16. Rembrandt van Rijn

Seated Old Man (B–9408) Red crayon National Gallery of Art, Washington. Rosenwald Collection

17. Edgar Degas

Study for Portrait of Diego Martelli Black and white chalk Courtesy of the Fogg Art Museum, Harvard University. Bequest – Meta and Paul J. Sachs

18. Pablo Picasso

Man with Pipe (1912) Charcoal Courtesy of Dr and Mrs Israel Rosen, Baltimore, Maryland

19. Louis Marcoussis

Portrait of Edouard Gazanion (c. 1912) Watercolour, Indian ink, and gouache Private Collection

20. Peter Paul Rubens

Portrait of Isabella Brandt (c. 1622) Black, red, and white chalk and pen and ink British Museum

21. Jean Antoine Watteau

Portrait of Isabella Brant Red, black, and white chalk Reproduced by permission of the Syndics of the Fitzwilliam Museum, Cambridge

22. Vincent Van Gogh

Peasant of the Camargue Graphite and brown ink Courtesy of the Fogg Art Museum, Harvard University. Bequest – Grenville L. Winthrop

23. Egon Schiele

Self-portrait (1912) Watercolour and pencil Private Collection, Courtesy Galerie St Etienne, New York

24. Veronese (Paolo Caliari)

Head of a Negro Red, black, and white chalk Musée du Louvre, Paris

25. Jean Antoine Watteau

Head of a Negro inclined to right Red and black chalk, touched with pink-coloured pastel British Museum, London

THE FIGURE

26. Alberto Giacometti

Nude Black chalk Private Collection

27. Henry Moore

Standing Nude (1928) Charcoal, and brush and ink Private Collection

28. André Dunoyer de Segonzac

Young Girl by a Red Umbrella (c. 1930) Watercolour The Brooklyn Museum, Henry L. Batterman Fund, New York

29. Egon Schiele

Wally with Red Blouse (c. 1913) Pencil, watercolour, and tempera Courtesy Serge Sabarsky Gallery, New York

30. Henry Moore

Reclining Nude (1931) Brush and sepia wash Victoria and Albert Museum, London. Crown copyright

31. Michelangelo Buonarroti

Study for the Creation of Adam (c. 1511) Red chalk British Museum, London

32. Aristide Maillol

Reclining Nude Red conté crayon with traces of charcoal Courtesy of The Art Institute of Chicago

33. Pierre Auguste Renoir

Nude Woman Seated (c. 1885–90) Red chalk heightened with white British Museum, London

34. Jean Auguste Ingres

Nude Study Pencil and wash Musée Ingres, Montauban

35. Botticelli (Alessandro di Mariano Filipepi)

Abundance (c. 1480) Pen and brown ink and brown wash, heightened with white, over black chalk British Museum, London

36. Gian Lorenzo Bernini

Study for a Fountain Black chalk and brown wash British Museum, London

37. Leonardo da Vinci

Leda and the Swan Black chalk, pen, bistre, and wash Devonshire Collection Chatsworth. Reproduced by Permission of the Trustees of the Chatsworth Settlement

38. Peter Paul Rubens

Study of a Figure for the Descent of the Damned Black and white chalk Victoria and Albert Museum, London. Crown copyright.

39. Michelangelo Buonarroti

Study for a Flying Angel (c. 1536?) Hard black chalk British Museum, London

40. Rembrandt van Rijn

A Girl Sleeping (c. 1660-9) Brush and sepia wash British Museum, London

41. Henri de Toulouse-Lautrec

Woman Asleep Red chalk over transparent paper Museum Boymans-van Beuningen, Rotterdam

42. Rembrandt van Rijn

Study of a Female Nude Reclining on a Couch Pen and wash Courtesy of The Art Institute of Chicago

43. Jean Antoine Watteau

Study for 'La Toilette' Red and black chalk British Museum, London

44. Jean Antoine Watteau

A Woman Performing her Toilet Black and red chalk British Museum, London

45. Edgar Degas

Dancer Adjusting Slipper (also frontispiece) Pencil and charcoal, heightened with white chalk The Metropolitan Museum of Art, New York. Bequest of Mrs H. O. Havemeyer, 1929. The H. O. Havemeyer Collection

46. Pablo Picasso

Female Nude with Raised Arms Pen and Indian ink Private Collection

47. Marcel Gromaire

Seated Nude Pen and ink Private Collection

48. Gentile Bellini

A Turkish Woman (c. 1480) Fine pen and Indian ink British Museum, London

49. Paul Gauguin

Woman of Brittany Crayon, charcoal, and pastel Courtesy of The Art Institute of Chicago

50. Guercino (Giovanni Francesco Barbieri)

Seated Nude with Arms Upraised Pen, brown ink and wash British Museum, London

51. Amedeo Modigliani

Caryatid (c. 1914–16) Oil on canvas Musée National d'Art Moderne, Paris

52. Rembrandt van Rijn

Nude Study of Young Man Standing Pen and bistre wash Albertina, Vienna

53. Georges Seurat

Standing Female Model (c. 1887) Conté crayon Private Collection

54. Henri Matisse

Nude (1936) Chinese ink Private Collection

55. Henri Matisse

Nude with Fern (1948) Brush and Indian ink Musée National d'Art Moderne, Paris

FIGURE COMPOSITION

56. François Boucher

Three Nymphs Black and white chalk on blue laid paper By Permission of The Fine Arts Museum of San Francisco

57. Paul Cézanne

Four Bathers Pencil and black chalk Museum Boymans-van Beuningen, Rotterdam

58. Raphael (Raffaello Sanzio)

Composition-study for the Borghese Entombment (1507) Pen and brown ink with traces of black chalk British Museum, London

59. Hieronymus Bosch

Entombment Grey wash over black chalk British Museum, London

60. Pablo Picasso

Two Figures, Hands Clasped (1921) Pencil Private Collection

61. Paul Delvaux

The Siesta (1947) Wash, pen and ink Collection, The Museum of Modern Art, New York. The Kay Sage Tanguy Bequest

62. Raphael (Raffaello Sanzio)

The Virgin and Child: Study for the Madonna di Foligno (c. 1511–12) Black chalk on greenish-grey paper British Museum, London

63. Michelangelo Buonarroti

The Virgin and Child with the Infant St John (c. 1533) Black chalk British Museum, London

64. Dante Gabriel Rossetti

Hamlet and Ophelia Pen and ink over pencil British Museum, London

65. Henri Fuseli

Hamlet and Ophelia (1775–6) Pen and brown ink with washes of grey and pink British Museum, London

66. William Blake

The Blasphemer (c. 1800) Watercolour and pen. The Tate Gallery, London

67. Stanley Spencer

Chopping Wood in the Coal Cellar, Elsie (1944-5) Pencil Mr and Mrs Thomas Gibson

68. Rembrandt van Rijn

Group of Three Women before a House Pen and bistre wash Rijksmuseum,

69. Henri de Toulouse-Lautrec

At the Opera Oil, blue crayon, and charcoal on manila Musée Toulouse-Lautrec, Albi

70. Thomas Gainsborough

Second Study for the Duke and Duchess of Cumberland Black chalk and stump and white chalk British Museum, London

71. Georges Seurat

Study for La Grande-Jatte (c. 1885) Black chalk British Museum, London

72a. Thomas Gainsborough

Diana and Actaeon: Study (c. 1784-5) Black and white chalks and grey and grey-black washes Private Collection

72b. Thomas Gainsborough

Diana and Actaeon: Study (c. 1784–5) Indian ink wash heightened with white Henry E. Huntingdon Library and Art Gallery, San Marino

72c. Thomas Gainsborough

Diana and Actaeon: Study Black chalk and wash heightened with white Reproduced by kind permission of the Trustees of the Cecil Higgins Art Gallery, Bedford

73. Thomas Gainsborough

Diana and Actaeon (c. 1784-5) Oil on canvas Reproduced by gracious permission of Her Majesty The Queen

74. Albrecht Dürer

The Nailing to the Cross (c. 1504) Pen and brown ink Private Collection

75. Albrecht Dürer

The Nailing to the Cross (1504) Pen and black ink with grey wash, heightened with white, on green prepared paper Albertina, Vienna

76. Rembrandt van Rijn

Two Women Teaching a Child to Walk (c. 1637) Red chalk on rough greyish paper British Museum, London

77. Henry Moore

Two Women Bathing a Child (1948) Pencil, pen and ink, crayon, and watercolour Private Collection

78. Vittore Carpaccio (?)

The Adoration of the Magi Pen and bistre over black chalk Courtesy of the Fogg Art Museum, Harvard University. Bequest – Charles A. Loeser.

79. Nicolas Poussin

The Adoration of the Magi Pen and ink wash Musée Condé, Chantilly

80. Jean Auguste Ingres

Sir John Hay and his Sister, Mary (1816) Pencil British Museum, London

81. Pablo Picasso

Diaghilev and Selinburg (1919) Pencil Private Collection

LANDSCAPE

82. Vincent Van Gogh

The Road from Tarascon (1888) Pen and ink The Solomon R. Guggenheim Museum, New York

83. Samuel Palmer

Landscape Pen and brown ink Private Collection

84. Wolfgang Huber

Mountainous Landscape with a Fortified City (1541) Pen and ink with watercolour British Museum, London

85. Roelandt Savery

Alpine Landscape Black and red chalk, with pale blue wash British Museum, London

86. John Constable

Tillington Church (1834) Watercolour over pencil, with some black ink British Museum, London

87. Thomas Gainsborough

Cart on a Woodland Road (c. 1760-5) Watercolour British Museum, London

88. Claude Lorrain

Clearing in a Wood near Rome (c. 1645) Pen and brown ink, brown wash and grey bodycolour over red chalk British Museum, London

89. Adam Elsheimer

River Landscape (c. 1605-10) Bodycolour British Museum, London

90. Jean Honoré Fragonard

Landscape with a Bridge through Trees Pen and ink and watercolour British Museum, London

91. Raoul Dufy

Olive Trees by the Golfe Juan Watercolour The Tate Gallery, London

92. Peter Paul Rubens

Trees Reflected in Water at Sunset (c. 1635-40) Black, red and white chalk British Museum, London

93. Camille Pissarro

An Orchard (1890) Watercolour British Museum, London

94. Paul Cézanne

Pistachio Tree at Château Noir Watercolour and pencil Courtesy of The Art Institute of Chicago

95. Piet Mondrian

Apple Tree (1912) Charcoal on grey paper Private Collection

96. Vincent Van Gogh

Grove of Cypresses (1889) Pen and ink over pencil Courtesy of The Art Institute of Chicago

97. Leonardo da Vinci

A Delnge (c. 1515) Black chalk and ink Reproduced by gracious permission of Her Majesty The Queen

98. Anthony Van Dyck

A Meadow bordered by Trees Watercolour and bodycolour, on blue-grey paper British Museum, London

99. J. M. W. Turner

Benson or Bensington, near Wallingford (1806-7) Watercolour British Museum, London

100. Vincent Van Gogh

La Crau from Montmajour Reed and fine pen with brown ink on black chalk British Museum, London

101. Pieter Bruegel

Alpine Landscape Pen and brown ink Musée du Louvre, Paris

102. Claude Lorrain

The Tiber above Rome: Evening Effect (c. 1640) Brown wash British Museum, London

103. Georges Seurat

Landscape Study for La Grande-Jatte (c. 1885) Black conté crayon British Museum, London

104. J. M. W. Turner

Venice, S. Giorgio from the Dogana (1819) Watercolour British Museum, London

105. John Sell Cotman

Greta Bridge (1805) Watercolour British Museum, London

106. Alexander Cozens

A Rocky Landscape (c. 1786) Indian ink and brown wash British Museum, London

107. John Robert Cozens

Interlaken: the Peaks of the Jungfrau Group in the Distance (c. 1776) Watercolour British Museum, London

THE BUILT ENVIRONMENT

108. Paul Klee

From an Old Town (1924) Pencil Collection Angela Rosengart, Lucerne

109. Antonio Canaletto

Piazza di S. Basso Pen and ink over red chalk Staatliche Museen Preussischer Kulturbesitz, Kupferstichkabinett

110. J. M. W. Turner

The Burning of the Houses of Parliament (1834) Watercolour British Museum, London

111. James Abbott McNeill Whistler

Street Scene, with a Tar Engine Watercolour over black lead British Museum, London

112. John Constable

The Ruins of Cowdray Castle, Interior (1824) Watercolour over pencil British Museum, London

113. Thomas Girtin

Great Hall, Conway Castle (c. 1799) Watercolour British Museum, London

114. Jean Honoré Fragonard

Genoa, Staircase of the Palazzo Balbi (c. 1760) Black chalk British Museum, London

115. Giovanni Battista Piranesi

Monumental Staircase leading to a Vaulted Hall (c. 1755) Pen and ink, with brown wash, over red chalk British Museum, London

116. Hubert Robert

Rome, the Villa Ludovisi (1764) Pen and brown ink, with brown wash on watercolour British Museum, London

117. Claude Lorrain

Landscape with Mercury and Argus (1660) Pen and brown ink British Museum, London

118. John Constable

Stonehenge (before 1835) Watercolour over black chalk British Museum.

119. J. M. W. Turner

Paestum in a Storm (after c. 1830) Watercolour over black lead British Museum, London

120. Victor Marie Hugo

Castle above a Lake Brush drawing in brown wash British Museum,

121. John Sell Cotman

Bristol, St Mary Redcliffe (1801) Watercolour strengthened with gum British Museum, London

122. John Sell Cotman

A Sarcophagus in a Pleasure-ground Watercolour British Museum,

123. Richard Parkes Bonington

Paris, The Institut seen from the Quais (1827) Watercolour and bodycolour British Museum, London

124. Vittore Carpaccio

Fortified Harbour with Shipping (c. 1495) Pen and brown ink over red chalk British Museum, London

125. Jan van Scorel

Alpine Landscape with a Bridge Pen and brown ink British Museum, London

126. Paul Cézanne

Provençal Landscape with Trees and Houses Pencil Kunstmuseum Basel, Kupferstichkabinett

127. Piet Mondrian

Church at Domburg (1914) Indian ink Collection Haags Gemeentemuseum, The Hague

128. Jacob van Ruysdael

View in Alkmaar with the Groote Kerk Grey wash over black chalk British Museum, London

129. Pieter Jansz Saenredam

Interior of the So-called Chapel Church at Alkmaar (1661) Pen and pale brown ink and washes of grey and watercolour. British Museum, London

ANIMALS

130. Two Bison, back to back

(early Magdalenian period) Lascaux, Dordogne

131. Pablo Picasso

Minotaur Attacking an Amazon (1933) Etching Bibliothèque Nationale,

132. Honoré Daumier

Don Quixote and Sancho Panza Charcoal washed with Indian ink The Metropolitan Museum of Art, New York. Rogers Fund, 1927

133. Pablo Picasso

The Picador (1951) Brush and ink Private Collection

134. Paul Cézanne

The Tired Horse Pencil Kunstmuseum Basel, Kupferstichkabinett

135. Pieter Bruegel the Elder

The Team of Horses (c. 1564) Pen and brown ink over black chalk Albertina, Vienna

136. Leonardo da Vinci

Studies of Horsemen (c. 1503) Pen and brown ink British Museum, London

137. Paul Klee

Galloping Horses (1912) (title page) Ink on paper The Norton Simon Museum of Art at Pasadena. The Blue Four Galka Scheyer Collection

138. Albrecht Dürer

Death on Horseback (1505) Charcoal British Museum, London

139. Eugène Delacroix

Tiger Attacking a Wild Horse Wash Musée du Louvre, Paris

140. Theodore Géricault

Charging Officer of the Carabineers Black pencil, watercolour, and gouache Musée du Louvre, Paris

141. Henri de Toulouse-Lautrec

Equestrienne (1899) Crayon The Museum of Art, Rhode Island School of Design. Gift of Mrs Murray S. Danforth

142. Peter Paul Rubens

Lioness (c. 1615) Black and yellow chalk, with white body colour British Museum, London

143. Rembrandt van Rijn

Four Studies of Lions (c. 1648?) Pen and brown ink with brown wash British Museum, London

144. Theodore Géricault

Studies of a Wild Striped Cat Graphite Courtesy of the Fogg Art Museum, Harvard University. Bequest - Grenville L. Winthrop

145. Eugène Delacroix

Three Studies of Cats Pencil Musée du Louvre, Paris

146. Francis Barlow

Fight between an Elephant and Rhinoceros (1684) Pen and bistre and grey wash Courtauld Institute Galleries, London

147. Rembrandt van Rijn

Elephant (c. 1637) Black chalk British Museum, London

148. Henri de Toulouse-Lautrec

Bouboule, Madame Palmyre's Bulldog Pen and ink and brush, heightened with white Musée Toulouse-Lautrec, Albi

149. Albrecht Dürer

Greyhound (c. 1500) Brush and black ink Reproduced by gracious permission of Her Majesty The Queen

150. François Boucher

Study of a Rooster Black, red, and white chalk Nationalmuseum, Stockholm

151. Jean Honoré Fragonard

Bull in a Stable Brown wash Private Collection

152. Hendrick Goltzius

Camel Black and red chalk British Museum, London

153. Jean Antoine Watteau

Five Studies of a Dromedary Red and black chalk Private Collection

Portraits

'Of what consequence is it to the Arts what a Portrait Painter does?' WILLIAM BLAKE

All drawings of heads are not portraits: a portrait deals with the features of the individual (the perceptual), whereas a head is concerned with the general (the conceptual). A portrait artist may choose to see the individual's head and features in terms of three-dimensional geometry, but a head conceived and constructed using the basic building blocks of the cone, cube, cylinder, and sphere is not a portrait - although many great draughtsmen, including Raphael, Verrocchio, Leonardo, and Picasso, have constructed some very convincing heads in this way. Similarly, portraits may be seen in terms of lines, and heads may be constructed from linear elements (see Klee). Or, again, a portrait may be seen in terms of an African mask (see Ill. 3), though the mask itself is not the portrait, but an invention based on an idea. Neither approach to creating a work of art is more worthy than the other, they are simply different.

All portraits represent a compromise between the personality and demands of the sitter and those of the artist. Artists have generally attempted to show the sitter in a favourable light rather than reflect the less attractive aspects such as the pompous and the pretentious, or the merely pretty or prosaic. There is, though, a danger that excessive vanity on the part of the sitter (or the patron) may result in the weak artist, determined to please, sliding into gross flattery – this is particularly noticeable in drawings of children. There is also the alternative danger, namely that failing to flatter the vain sitter may result in the loss of the commission (or even the destruction of the painting, as in the case of Graham Sutherland's portrait of Sir Winston Churchill).

A certain degree of flattery being acceptable, artist and sitter normally agree that a 'likeness' should be the end result. A likeness, of course, is very simple to achieve: newspaper cartoons and caricatures are sufficiently 'like' to be recognizable, but neither would be likely to please the sitter or satisfy the portrait artist. Furthermore, there are innumerable 'likenesses' of any one of us, as a Polyfoto will demonstrate. Different artists will show us different likenesses of the same sitter. If we compare Rubens' drawing of his first wife with Watteau's version of Rubens' drawing, we can see that a drawing is a portrait not only of the sitter but also of the artist – and when the artist is also the sitter we may find 40-odd different self-portraits, as in the case of Van Gogh. All these portraits may well be like him at different times, in different circumstances.

Of course, there are other problems associated with portraiture as well as those of pleasing the sitter. In the same way that a landscape artist is confronted by the changing moods of Nature, so the human face is capable of expressing varied and subtle emotions, and it is for the portrait artist to choose that emphasis which he feels will convey something of the character of the sitter.

Portraiture has always taxed the skills of even the greatest draughtsmen, and the challenge it continues to offer was aptly summed up by Hogarth: 'By perpetual attention to this branch only, one should imagine they would attain a certain stroke — quite the reverse — for though the whole business lies in an oval of four inches long, which they have before them, they are obliged to repeat and alter the eyes, mouth and nose, three or four times, before they can make it what they think right.'

1. Pablo Picasso Head of a Young Man

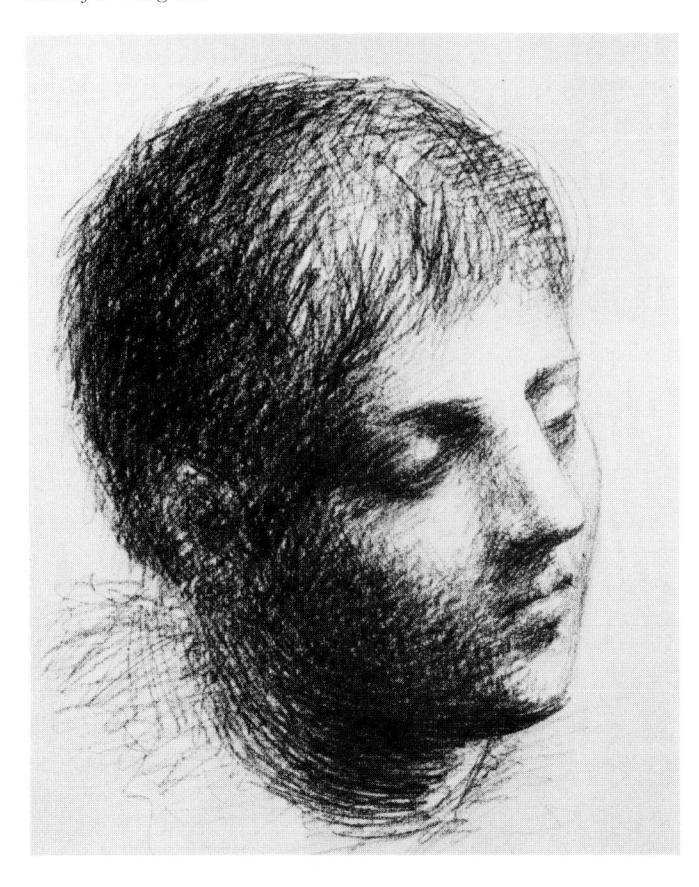

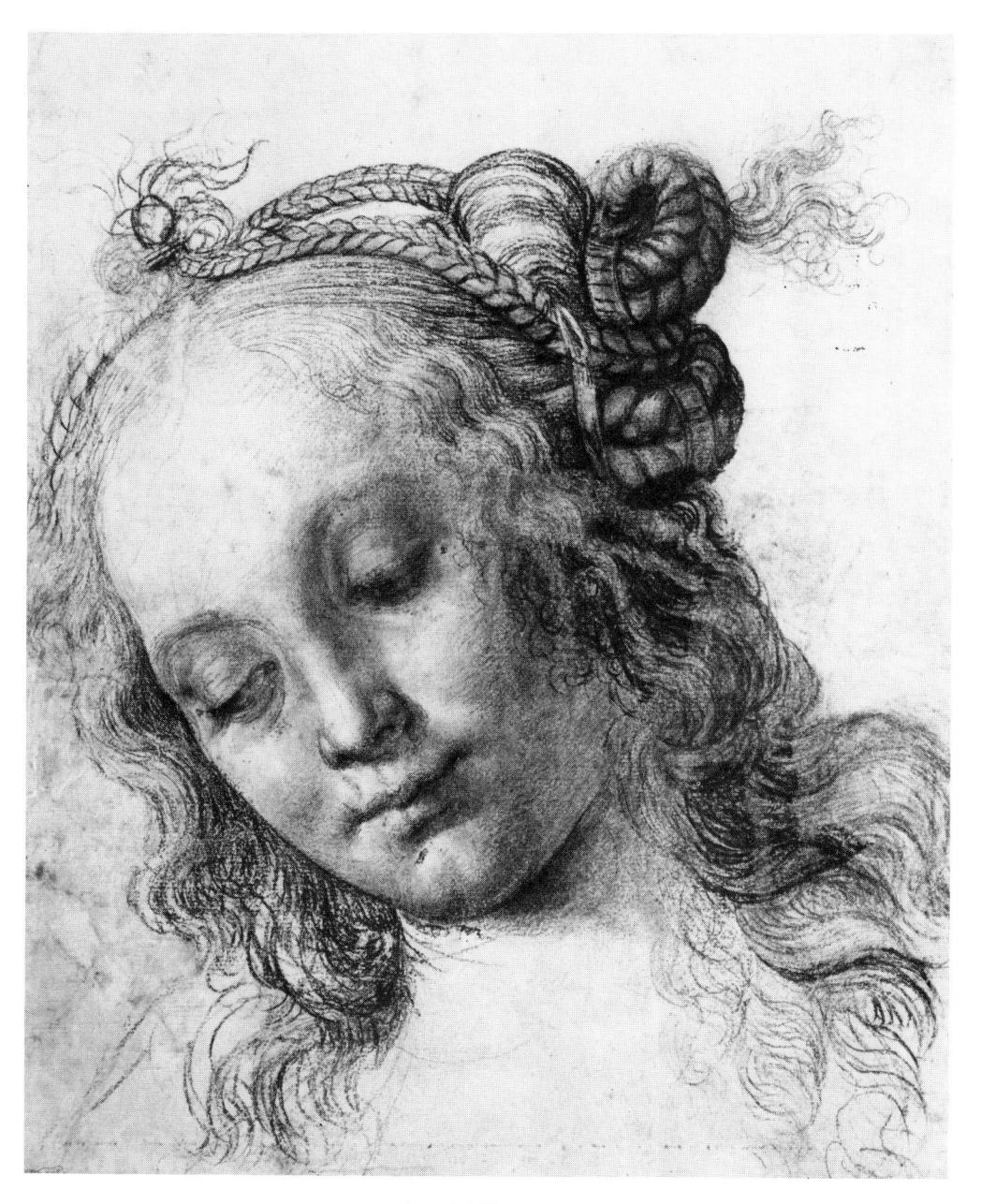

This drawing by Picasso is entitled Head of a Young Man and, like many of his drawings, it is an invention freely based on classical models. This is not a portrait of an individual, rather it is a head constructed from geometric forms, an idea rather than a piece of observation. The head is first conceived as an ovoid form and the directional strokes of the crayon are used to hatch the form into existence, assuming a source of light on the right. (This technique of close hatching is somewhat similar to that used by Veronese (see Ill. 24), but whereas Picasso uses it to create form and lighting, Veronese uses it also to suggest colour by means of tone value.) Eye sockets are hollowed into the basic ovoid and the eyes themselves constructed from spherical forms covered with overlapping lids, due consideration being given to the perspective problems involved in assessing the relative curvatures. The nose is treated as a projecting, wedge-like continuation of the forehead. Smaller spherical additions become nostrils, bottom lip, and chin; the neck is a simple cylindrical support for the head. Unfortunately, this process is not as easy to put into practice as it sounds!

2. Andrea del Verrocchio Head of a Woman with Elaborate Coiffure

Andrea del Verrocchio creates an elaborately braided hairstyle which helps to disguise the ovoid form of the head; the centre parting serves to establish the start of the major axis which runs down the centre of the nose, and over the lips and cleft of the chin. The minor axes, establishing the relationship in perspective between the eyes, nostrils, and the line of the lips, are carefully considered, and take into account the curvature of the surface. As in the drawing by Picasso, these main forms are lit from a single source (in this case on the left), and tone is applied to create shadows and reflected lights. Subtle modelling of the surfaces of the main forms allows the artist to convey individuality and expression.

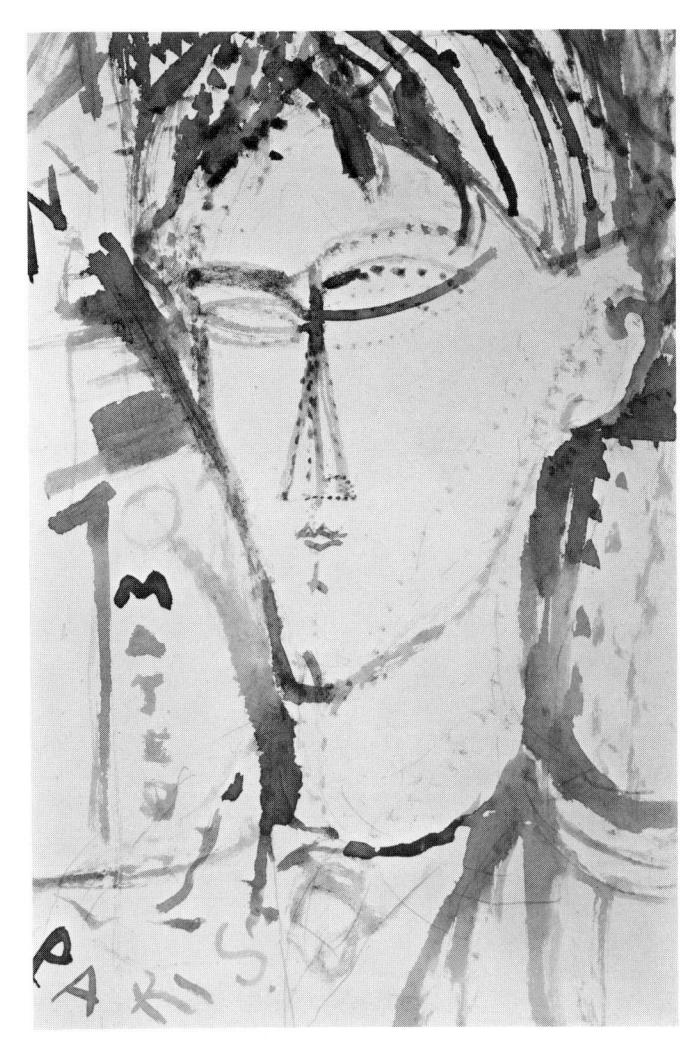

3. Amedeo Modigliani Portrait of Mateo Alegria

Modigliani's drawing, like Klee's, is very much concerned with lines of very varied character - some sweeping, some thick and heavy, some faint and broken. The dotted lines are equally varied, some apparently drawn with the other end of the brush. Like Klee's, this is a drawing of linear relationships, but unlike the former, these lines represent curves, angles, and directions derived from the sitter and his background. The left-hand side of the face sweeps off into the space beyond, the left side of the neck follows suit, and these upward thrusts are paralleled by the sweeping movement of the neck/shoulder line on the right, resulting in a powerful feeling of organic growth, which again reminds us of Klee's drawing. However, Modigliani's first love was sculpture: the dotted lines in this drawing are very reminiscent of the marks made by the sculptor's punch as he begins to define the form. Modigliani had seen examples of the exciting threedimensional masks of African origin and his drawing strongly reflects this influence. And yet this is a portrait of Mateo Alegria and doubtless a 'likeness', but this 'likeness' is couched in terms of an African mask, with spaces cut out for the eyes. It is rather as if the sitter's appearance is described to us in another language – the language of the Congo, as spoken by an Italian with a pronounced Parisian accent!

4. Paul KleePortrait of a Girl Smiling

All Paul Klee's work was related to his research into the various rôles played by those fundamental elements of art – point, line, tone, and colour. This drawing explores a particular aspect of line, that is, its capacity to create a sense of movement. The quality of line which Klee employs here is both fluent and fluid, and he makes full use of the controlled and contrived accident. By using wet paper to work on he allows the line to spread and grow and take on a life of its own. At this stage Klee steps in, directing and controlling. He emphasizes the eyes, and, by watering down the wash he softens the corners of the mouth to convey the idea of smiling.

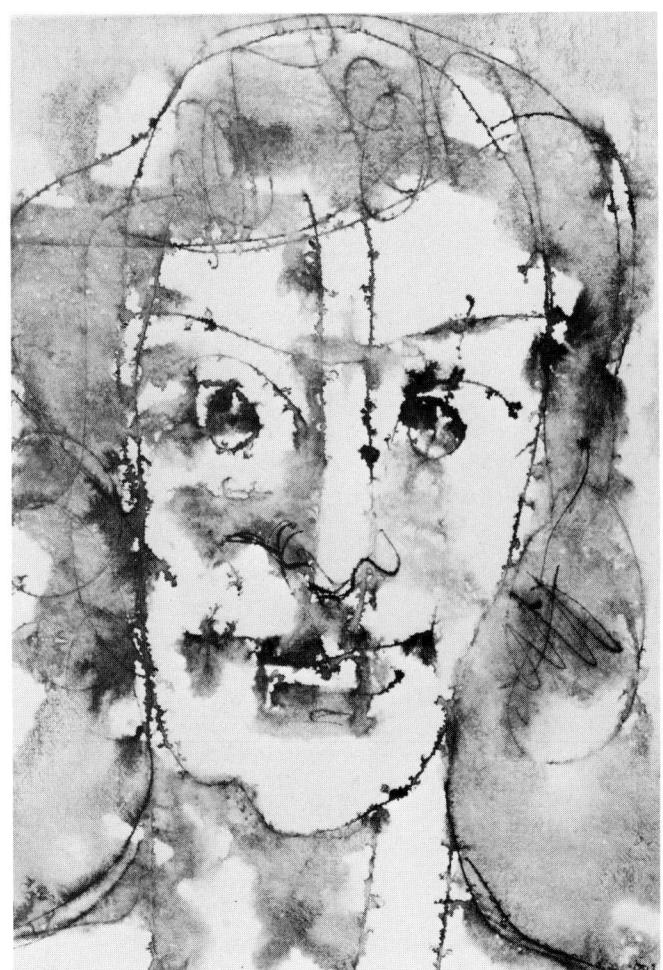

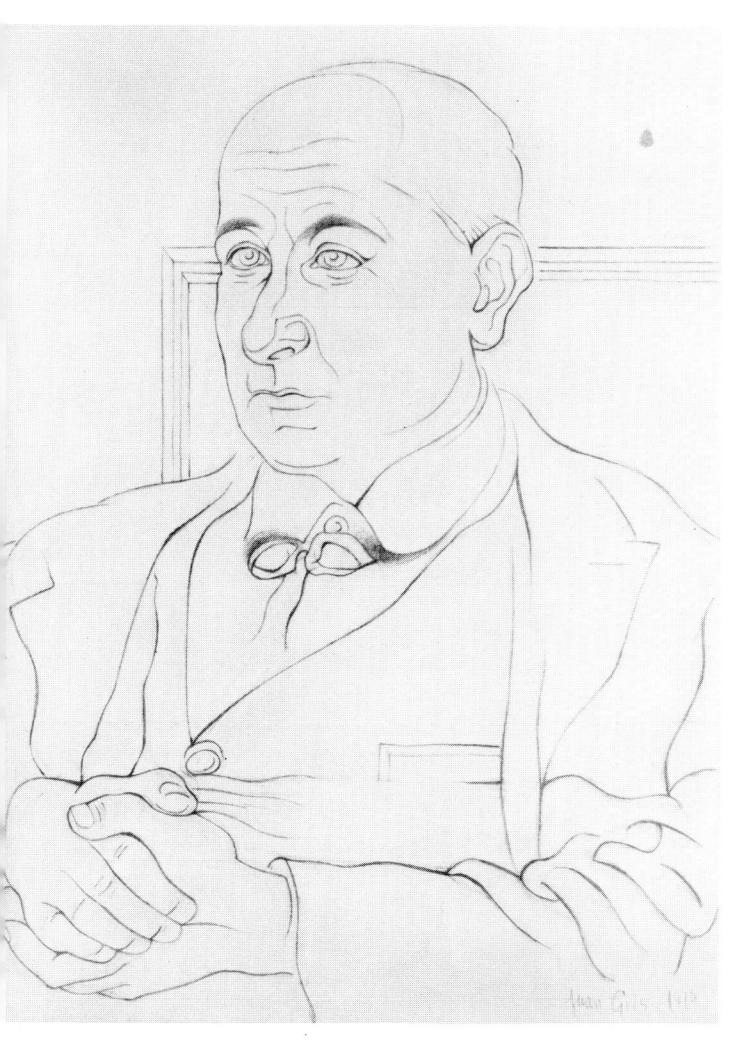

5. Juan Gris
Portrait of Max Jacob

These two drawings were both carried out in the same year: 1919. Gris represents the classical Cubist tradition and Matisse that of the Fauves (a group of artists primarily interested in strong colour and a decorative approach to painting). Gris uses lines to express the structure of the head and is not concerned with the fleeting effects of lighting; the change of plane on the nose, and the thickness of the ear and the collar are indicated by linear means. In the background we see the vertical/horizontal structural suggestion, treated in fainter lines than the head, reminding us of Cézanne's preoccupation with reinforcing the idea of the picture plane by emphasizing the verticals and horizontals (see also Picasso, Ill. 18). The drawing is basically intellectual in approach, and is concerned with the idea of balance without resort to symmetry - the asymmetrical relationship between the eyes and eyebrows is balanced by the two sides of the bow-tie, and echoed in the different treatment of lapels; the clasped hands, themselves balancing but not repeating each other, are in turn balanced by their opposite number, the folds of the sleeve on the other side.

6. Henri Matisse The Plumed Hat

The Matisse drawing is likewise expressed in terms of line, but though the means may be similar, the purpose is quite different. In this case the emotional content, at once sensuous and decorative, is stressed: all the lines are rhythmically curved and the soft, swinging curves express a mood of pleasant relaxation. 'I have always considered drawing *not* as an exercise of particular dexterity but above all a means of expressing intimate feelings and moods – a means simplified to give greater simplicity to expression which shall speak without heaviness directly to the mind of the spectator.' The drawing illustrates exactly Matisse's own words.

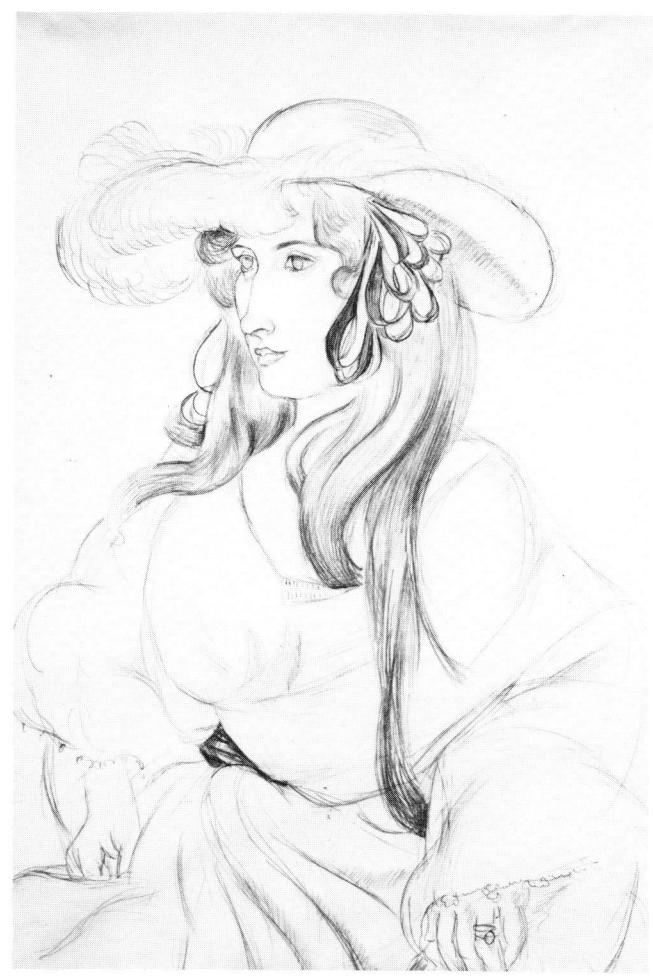

7. Paul Cézanne Self-portrait

Cézanne would have been hard pressed to make a living as a portrait painter since he worked with painfully slow deliberation, considering carefully each stroke and mark (after over a hundred sittings for a portrait, he is reported to have declared himself not displeased with the shirtfront!). Perhaps because of his painstaking approach, he may have found sitters (apart from his servants) difficult to find; this would also explain why he used himself as a model so frequently.

Dissatisfied with the superficial approach (that is, an approach concerned with surface appearances) of the Impressionists, Cézanne tried to re-introduce the 'solid and durable', seeing his subject – whether a head, landscape or still-life - in terms of its underlying form, and ignoring the trivialities of accidental lighting effects, or variations of surface texture. In order to achieve the solid and durable, the form, he used the effects of light and shade to indicate a few significant changes of plane in his subject, but not simply to record or describe lighting conditions at a particular time. This preoccupation with form, expressed by an accentuation of the planes, has given Cézanne's drawing a squared-up character: notice the chiselled quality of the forehead and the interpretation of eyelids as straight lines. This faceted treatment of form (which Cézanne conveniently translated into his paintings using the square stroke of the hog-hair brush) was one of the aspects of his work which was developed by the Cubists.

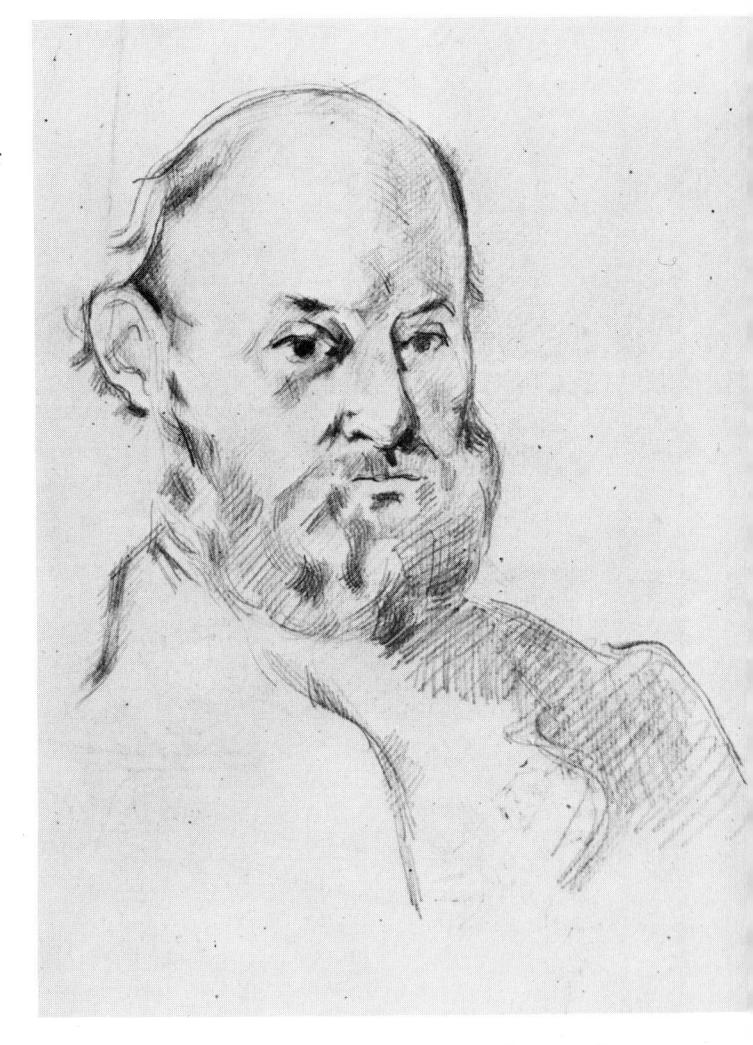

Villon's work, although coming many years later, springs directly from the Cubist vision, but re-introduces at the same time the sense of light as part of the scene – almost a kind of 'Impressionist Cubism'. This inherent contradiction in terms occasionally means that Villon's paintings can perhaps be called exercises in style, since the rôle of colour is difficult to reconcile with the two opposite polarities of Impressionism and Cubism; his drawings, though, are quite clear in their intention. In his self-portrait he sensitively defines the edges of planes by straight lines; the planes are then hatched by straight lines not only to indicate their direction, the angle at which they are lying relative to each other, but also to suggest the effect of light and shade.

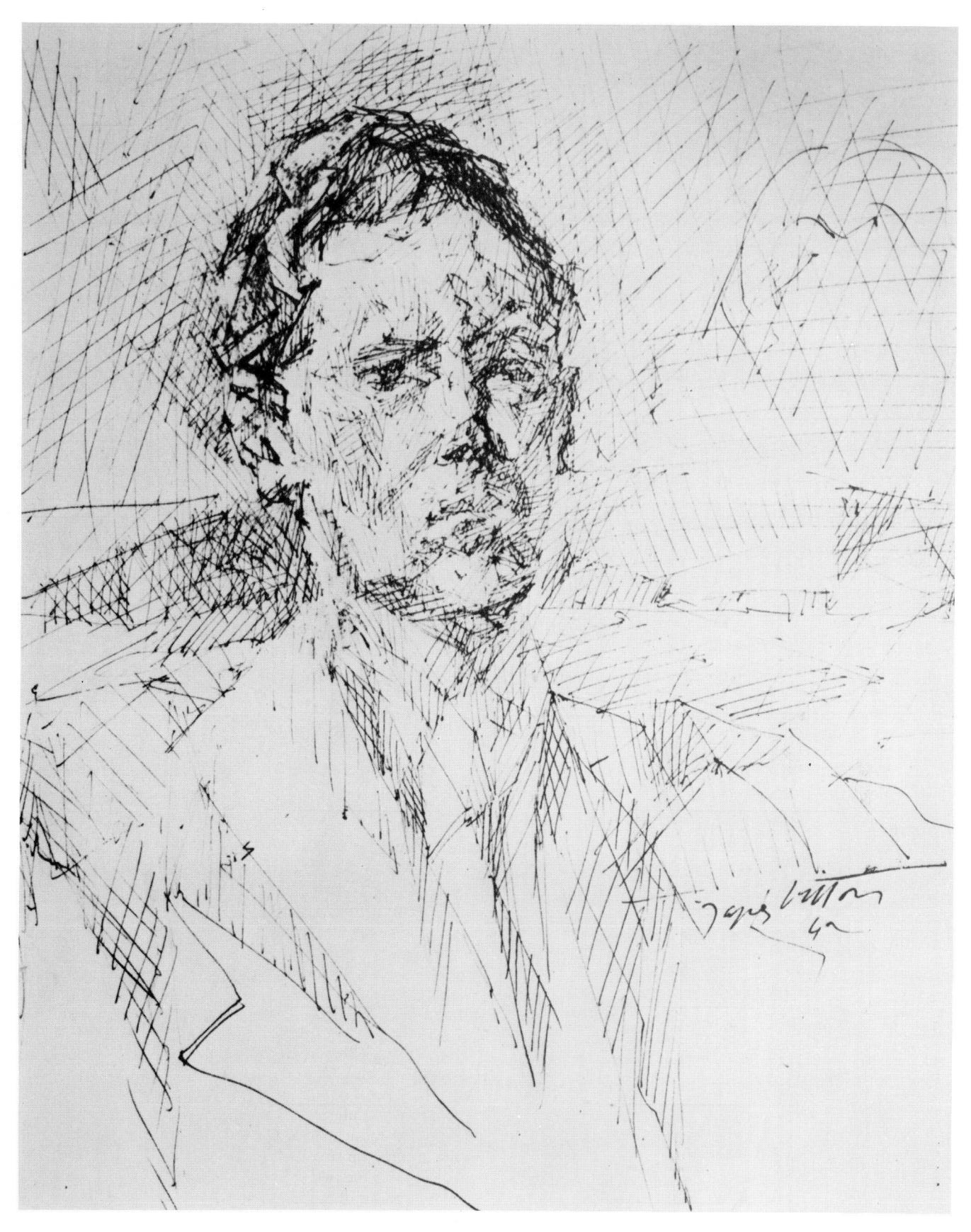

8. Jacques Villon Self-portrait

9. Jacques Villon My Portrait

Portraits, though usually showing the face, are of course not restricted to the head alone. In his three-quarter length self-portrait of 1934 Jacques Villon shows clearly his preoccupation with the representation of form by means of planes, which he expresses solely by lines; every form is rigorously squared up and presented in terms of straight lines. Here, Villon also exploits one of the fundamental qualities of line as a means of graphic expression, namely its ability to convey economically and directly the idea of transparency. Lines are used to create overlapping planes, through which we can see other lines. This idea of using transparent planes to express form (a method originally used by Braque and Picasso during their Analytical Cubist period) is exploited further by Villon's use of transparent paper. By tracing one image of the head on top of another and slightly shifting the paper in the process, he suggests that the head is seen from several viewpoints at once, each slightly overlapping the next.

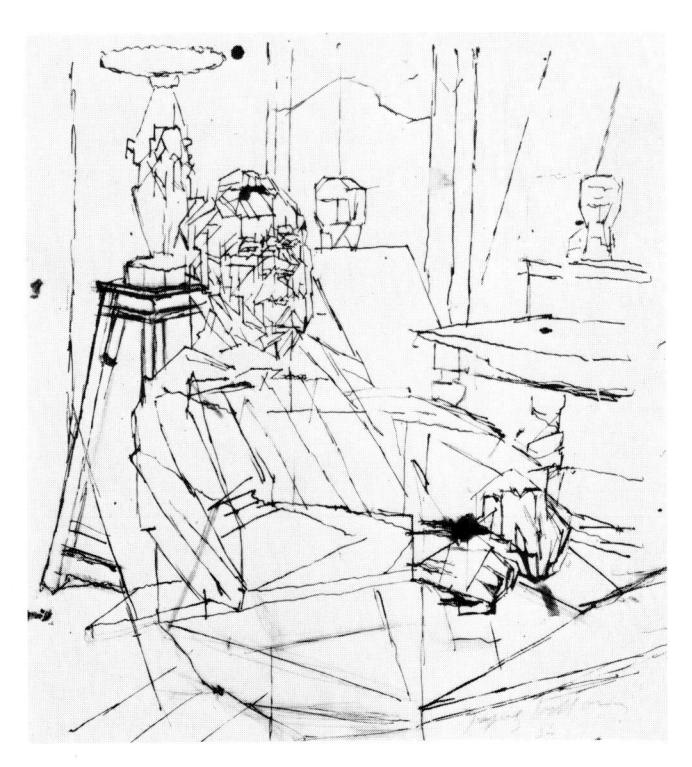

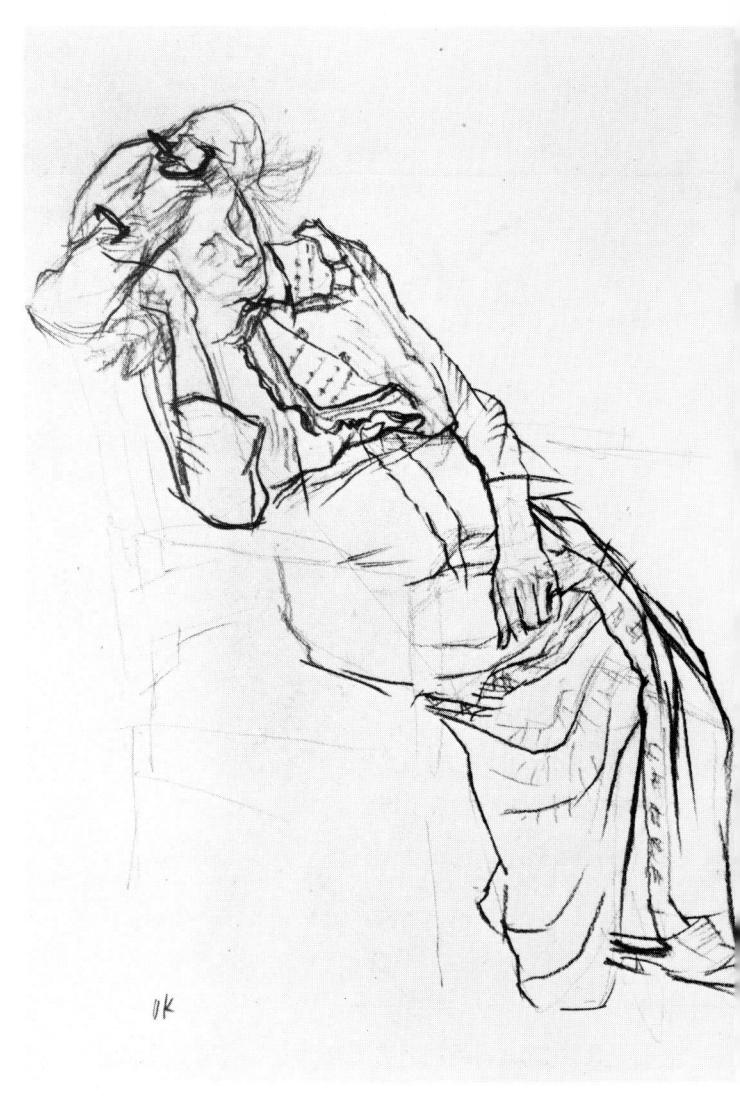

10. Oskar Kokoschka

The Artist's Mother Relaxing in an Armchair

In Kokoschka's portrait of his mother relaxing in an armchair the chair is hardly indicated at all, though it is perfectly implied by the posture and perspective of the figure. Like Villon, Kokoschka uses line alone, without the effect of light and shade, to describe the full-length figure. The line travels sensitively over the surface, creating a mood of acceptance and resignation. Kokoschka's line, with its minute changes of direction, is based on very careful observation; on the whole, though, straight lines predominate, giving the drawing a somewhat edgy quality. There are many very faint lines which are difficult to see in reproduction, but which are very important ingredients; the closed eyes, the internal structure of hands and wrists, and the short lines of hatching on sleeves are included not to indicate direction of light, but to indicate direction of form.

One of the chief qualities this drawing possesses, and one which is responsible for its sense of authority, is the consistency of its perspective; this is expressed through the use of lines which run across the major axes of the figure (in particular across the eyes, mouth, bodice, and skirt).

Bernini could be called the personification of the High Baroque period. He brought together architecture (he was the papal architect), sculpture, and painting into one creative unity, using light as a unifying and dramatic force. These two self-portraits are very similar in intention and execution, although separated in time by some sixty years. In each case Bernini has chosen a left-facing three-quarter front view (since it is easier for a right-handed person to draw this position without the hand smudging work already done), with light coming from the left side of the drawing. It is particularly interesting to compare these two self-portraits, the one by the young, highly talented 22-year-old and the other by the experienced old man. Time has brought changes in the appearance of the face: the hair has receded, the eyes have become sunken in their sockets, the lines and folds of flesh are signs of age. But in spite of this, there are more similarities than differences. For example, the skull, more in evidence as the flesh shrinks, remains the same bony structure which Bernini had been concerned primarily to reveal in his earlier drawing; also, both studies are concerned primarily with form. To express this Bernini uses chalk techniques which enable him to model with ease from very light to rich dark. He makes particular use of reflected light (a device he handled with equal skill as an architect), so that the strongest tone is always along the edge where the form changes plane.

One experiences a rather curious sensation when looking at the old man (who is apparently observing us, but of course in reality was observing himself): we seem to see the young Bernini gazing out from behind this face. It may be a rather fanciful suggestion, but perhaps Bernini's quizzical expression, a combination of compassion, tolerance, and slight amusement, indicates that he too has recognized his youth.

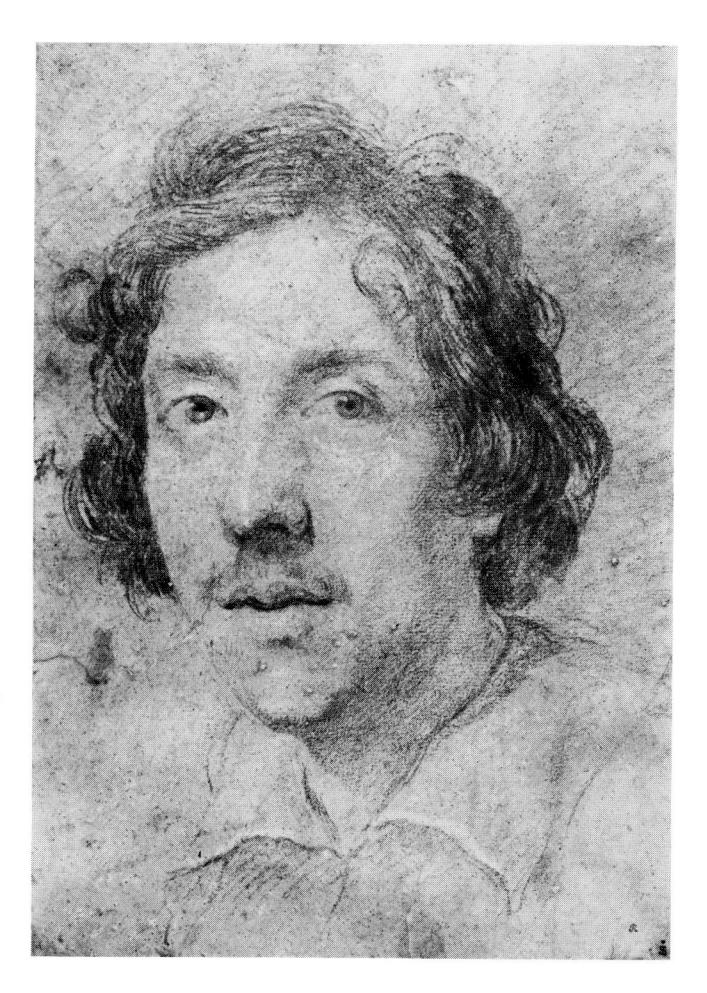

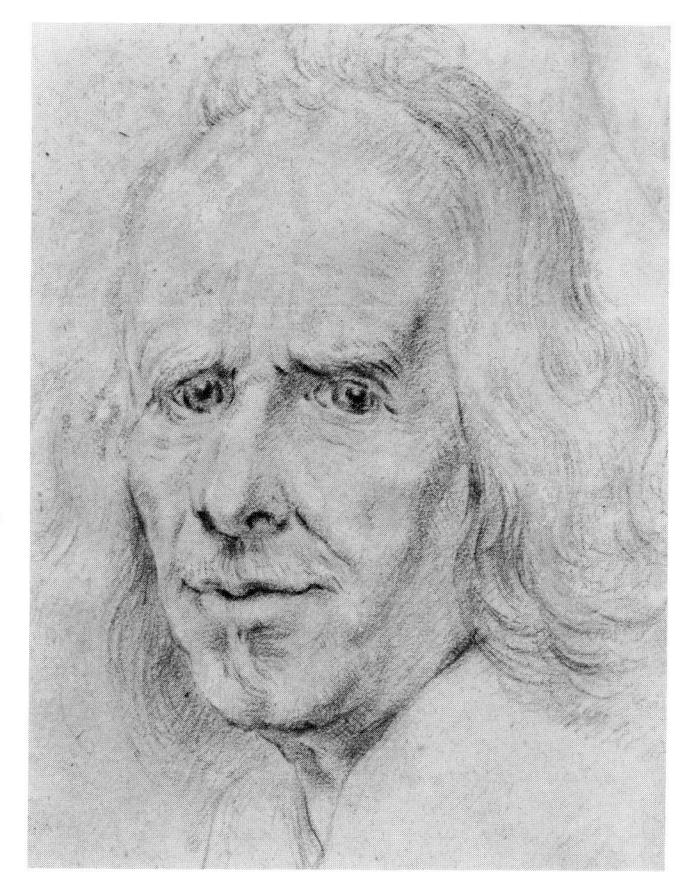

There have been all kinds of opinion and conjecture as to the appearance of Leonardo. Learned authorities have suggested that his likeness may be found in various sketches, but it is generally agreed that this is a self-portrait of the artist as an old man; some authorities have suggested that the drawing may be a free copy of Michelangelo's Moses, and indeed it has an Old Testament authority and dignity. That the drawing is by Leonardo is not in dispute, nor that it is a powerful and penetrating psychological study.

Leonardo made many careful studies of the anatomy of the human figure, including the head, dissecting and crosssectioning the cranium in his search for knowledge. In this drawing he concentrates on the features, the outer limits of the drawing and the edges of the skull being barely indicated; the roundness of the forehead is conveyed by the way that the deep furrows overlap as they travel round and over the contour, helping us almost to see 'round the corner'. The hair, eyebrows, and beard are rippling movements, becoming imperceptibly fainter as their distance from us increases. Leonardo tended to seek analogies in Nature and universal principles of organic growth, and here he relates the parallel movements of hair to his other studies of flowing water and the swirling movement of growing grasses. The unforgettable expression - particularly in the deep-set, penetrating eyes and in the downswept brows which parallel the down-turned corners of the mouth - powerfully brings to mind Leonardo's disillusionment and frustration in dealing with the vastness of the problems of art and life - a frustration we find expressed in one of his notebooks: 'Tell me if anything was ever done ... was anything ever done ... tell me if ...

This drawing of a character described by Dürer as 'a hale and hearty 93-year-old' is one of a number of similar preparatory drawings which the artist used for his painting of St Jerome in Meditation (now in the National Gallery, Lisbon). Dürer uses the very dark purple paper as middle tone and gives equal importance to the handling of dark and light passages, not merely picking out the highlights in white. This structurally solid drawing is largely a study in textural qualities. The dragged, dry, light passage on the cap conveys the surface feel of the material; the headband, we can tell, has a different texture. The bony skull gleams in the light under the deeply furrowed forehead; the rheumy eyes - their expression so different from Leonardo's hawk-like, hypnotic stare - invite our compassion, perhaps even our pity. The coarse texture of the greasy nose contrasts with the delicate fineness of the wispy beard, itself differing from the hair, drawn in black pen line, which escapes from under the cap; the different kinds of hair are skilfully expressed by different kinds of line.

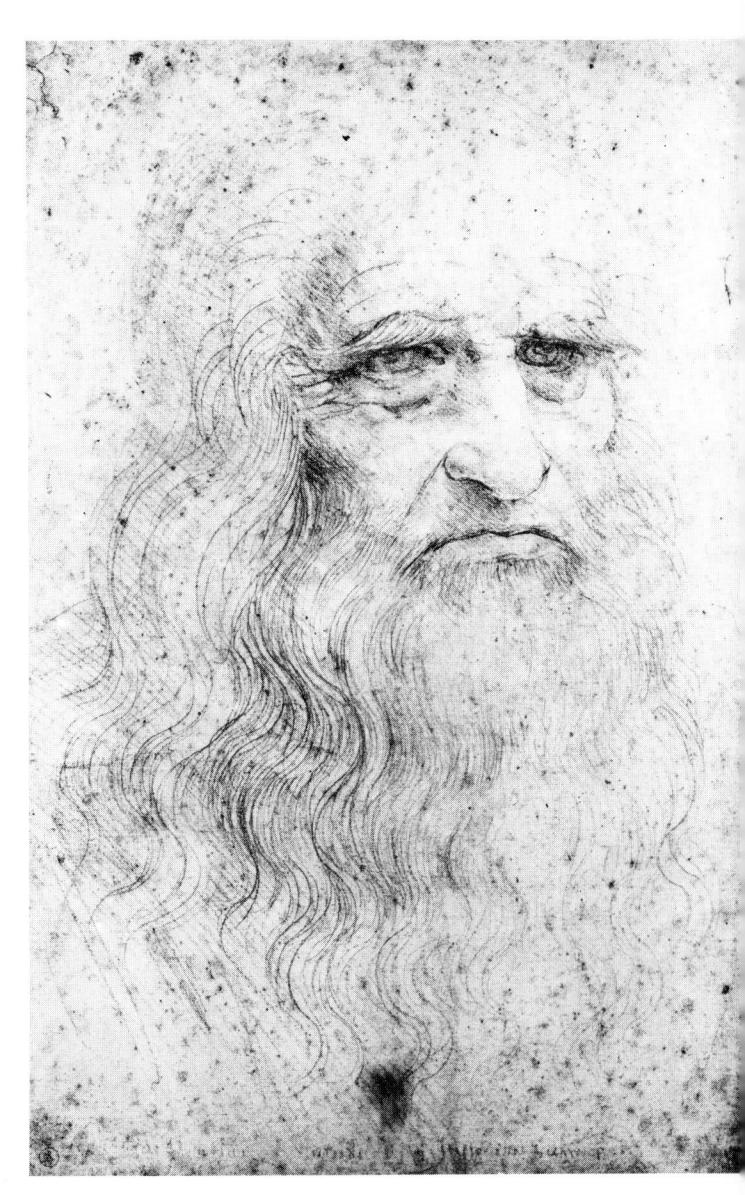

12. Leonardo da Vinci Self-portrait

13. Albrecht Dürer Head of an Old Man

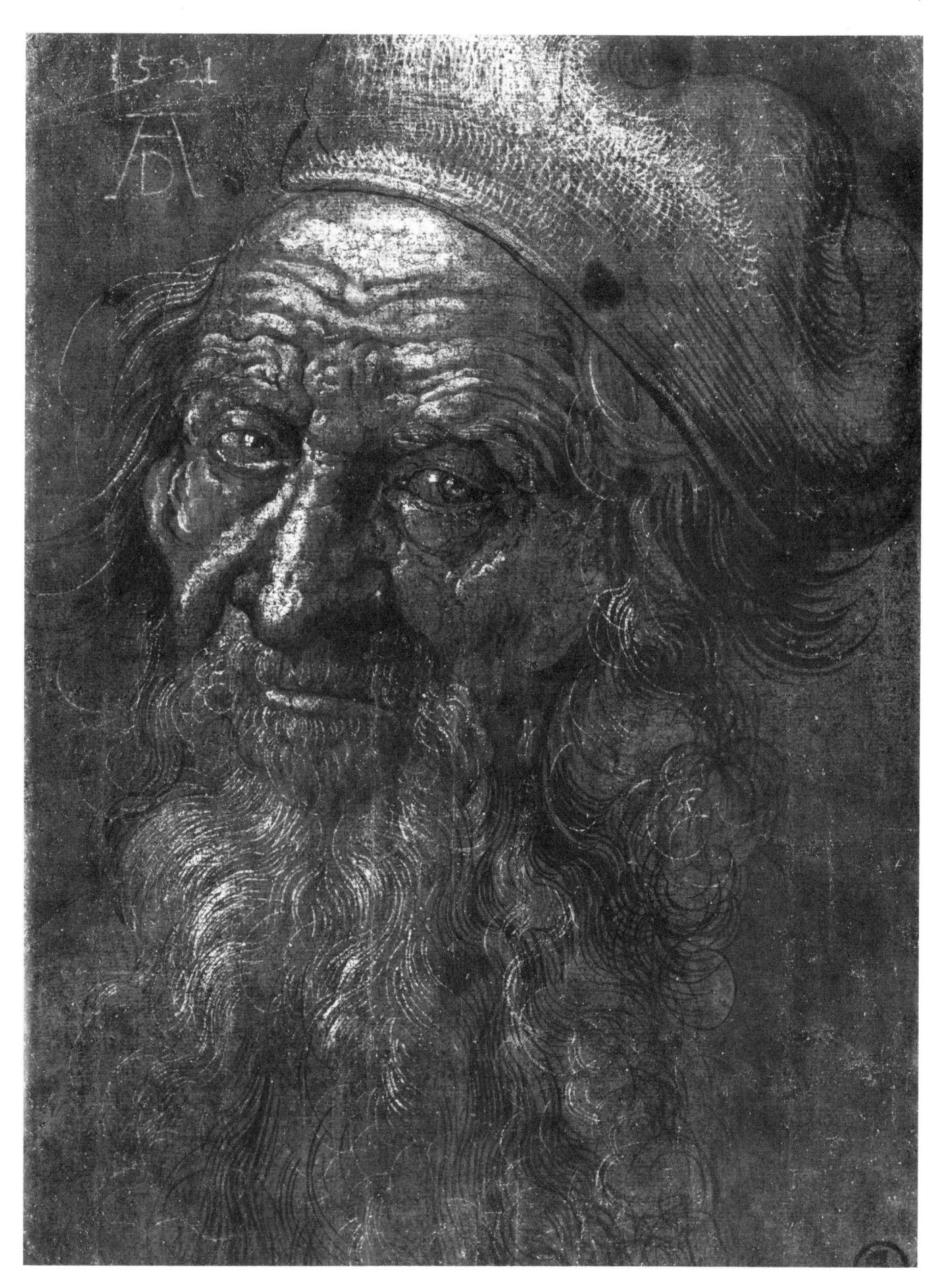

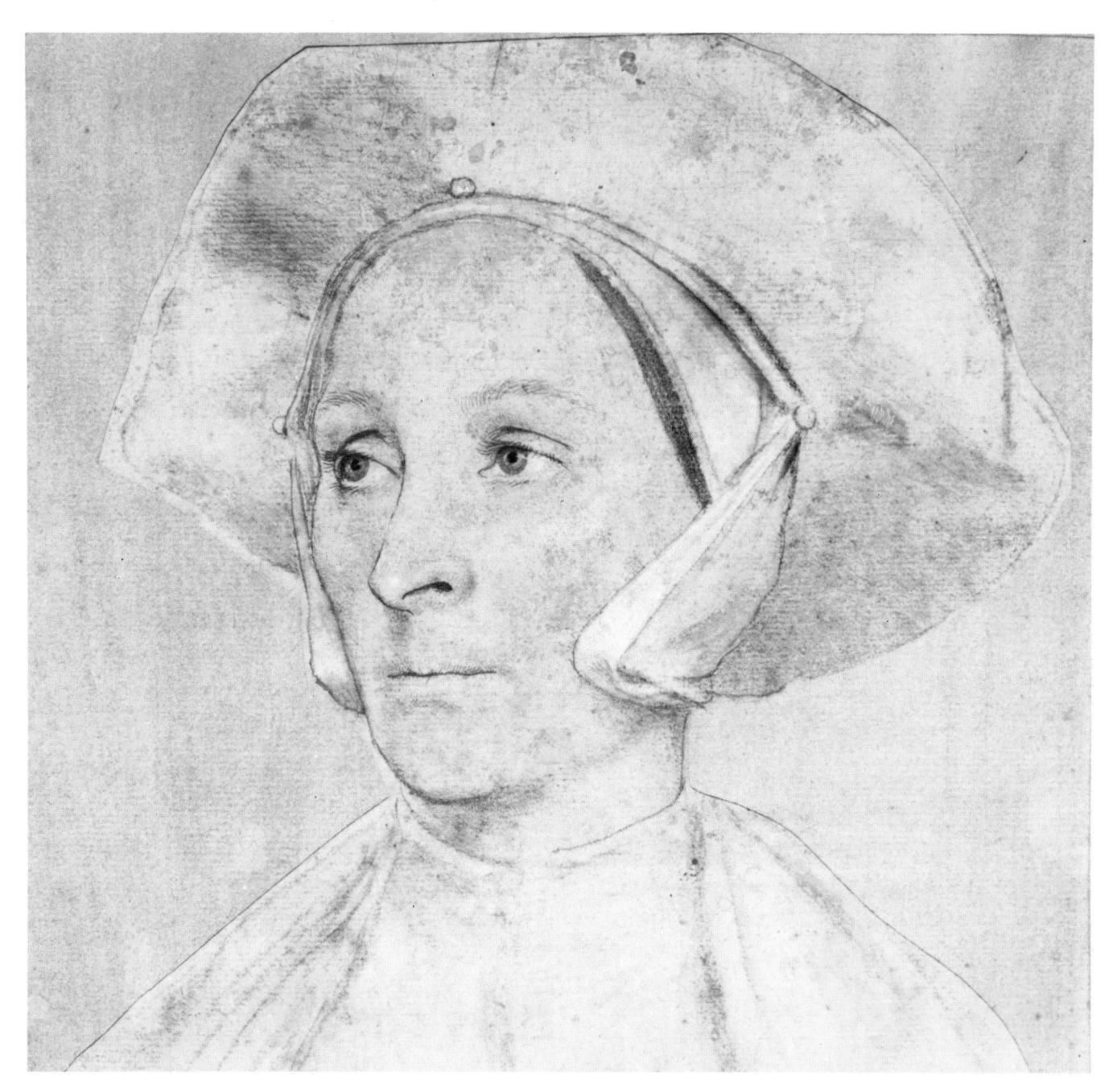

14. Hans Holbein An English Woman

Hans Holbein the Younger was a contemporary of Raphael and was much influenced by the Renaissance painters of Italy. He became Court Painter to Henry VIII in 1538 and drew and painted all the noteworthy characters at Court, picking out the distinctive features of each face with authority and assurance. In this portrait of an English lady in hat and coif the relationship between the eyes, seen from this particular viewpoint, is very cleverly realized, while the sensitive drawing of the mouth, with its very slightly accentuated colour, is a triumph of true observation. Tone and colour are kept to a minimum and are used simply to reinforce line.

15. Raphael Female Saint, half-length

'The essence of Raphael's genius is to be found in his drawings – he combined rhythmic grace with a subtle but convincing indication of form and movement.' This drawing by the 21-year-old Raphael precisely illustrates Claude Marks' observation; it represents classical draughtsmanship at its best and is an example of the kind of drawing that Ingres so admired. Using a minimum of tone, and relying on subtle variations of line to create curved sections of the form, Raphael achieves a convincing sense of softly rounded volume. The use of tone is so subtle that it is impossible to decide where it begins or ends, and the use of line to express the transparency of the head-dress is a clever foil to its use in expressing form in the rest of the drawing.

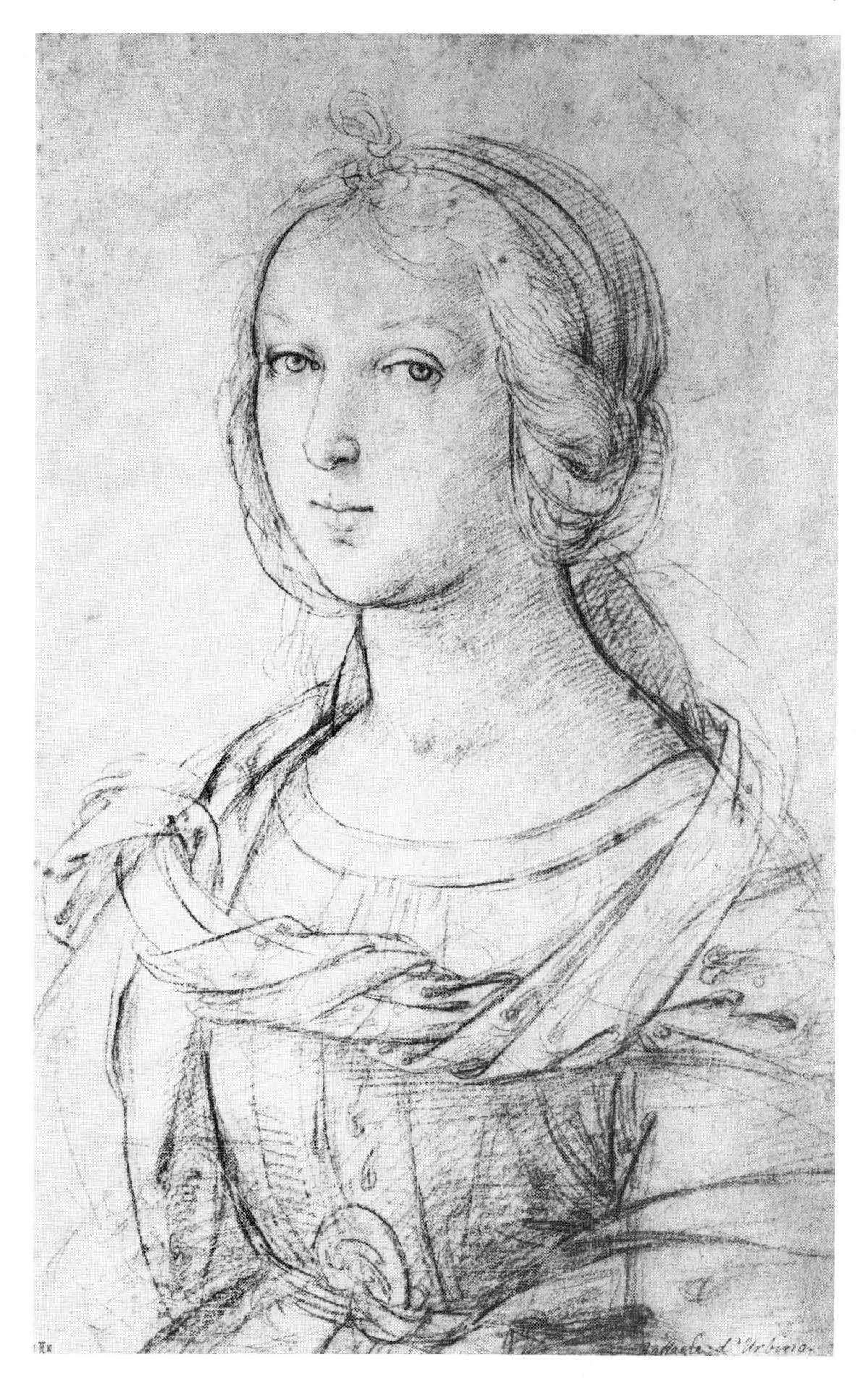

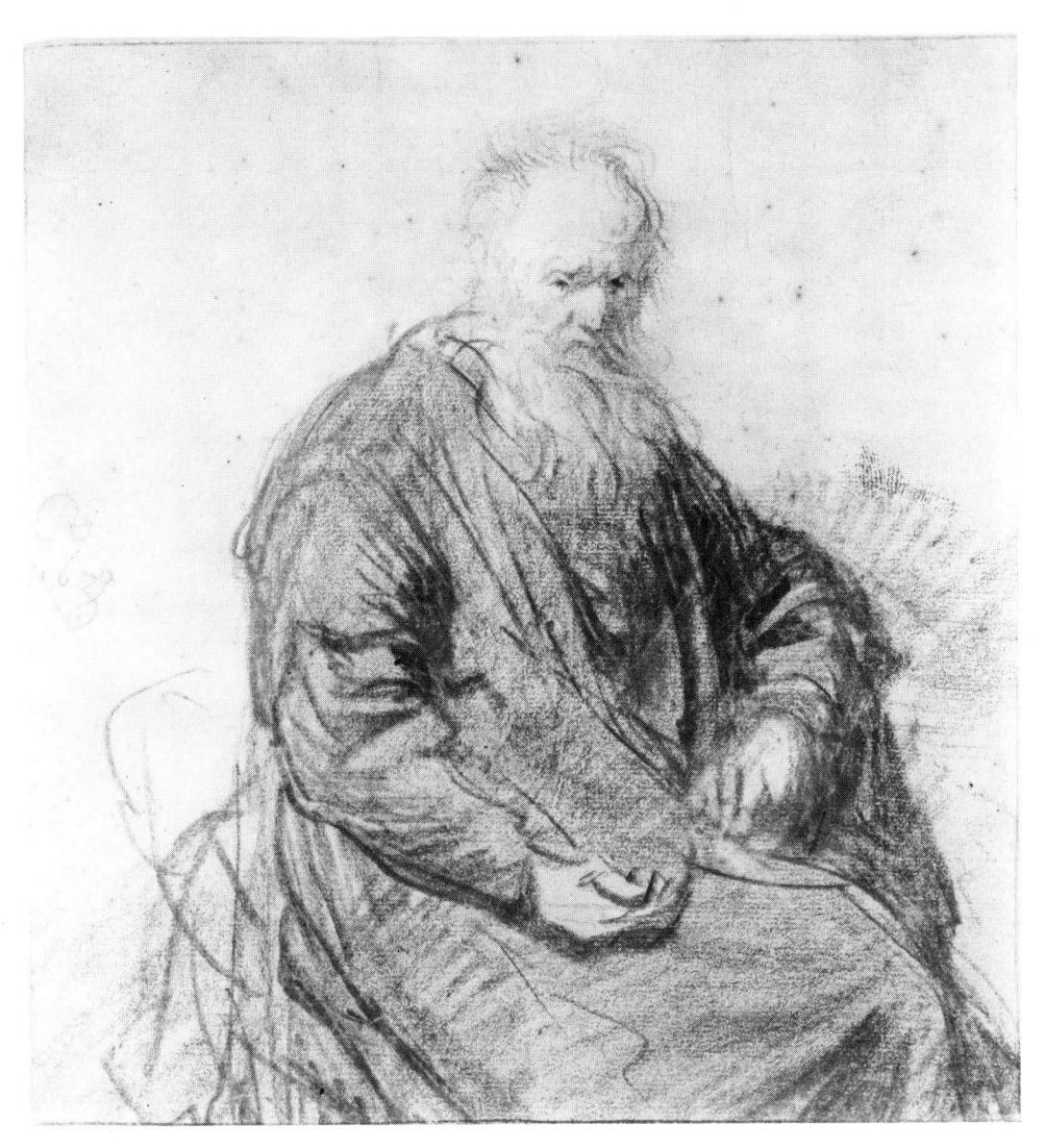

16. Rembrandt Seated Old Man

Although he drew landscapes and animals with equal facility, Rembrandt was essentially interested in the human figure, and is unsurpassed in his penetrating portraits of the old with their profound psychological insight. All his drawings are characterized by his ability to express so much with apparently so little effort and by such simple means. In this drawing Rembrandt calls on the full resources of the crayon from the merest hint to the strongest statement, to convey not only the shape but also the bulk of the body under the clothes. With only a few strokes he expresses the distance across the front of the figure, between the near arm and the further one, using convincing foreshortening to create this space. Rembrandt's unique ability to produce a feeling of light, atmosphere, and space are revealed in this work, and the sense of a single consistent viewpoint is a characteristic of the drawings of both Rembrandt and Degas.

17. Edgar Degas Study for Portrait of Diego Martelli

In this study for the portrait of Diego Martelli the artist's eyelevel is above the head of the sitter and the feeling of looking down is consistently maintained (consistent in as much that the legs are clearly further from us than the head). The angle of the implied line joining the twin curves at the bottom of the dark jacket contributes to this sense of looking down by sloping steeply upwards towards the eye-level. As in all Degas' drawings the outlines are simple in the extreme and detail is implied rather than drawn. In this sketch the three-dimensional form of the arm is expressed through the drawing of the fingers and by a few marks on the sleeves.

The use of what one may call the 'informative' silhouette as a means of describing form reminds us of the importance of the impact of the Japanese print on artists of the nineteenth century, particularly on the Impressionists. Manet used the silhouette of the jacket in his portrait of Émile Zola in much the same way as Degas in this drawing. Silhouettes are 'informative' in that they can express form by indicating cross-sections or by suggesting or implying perspective by means of parallels.

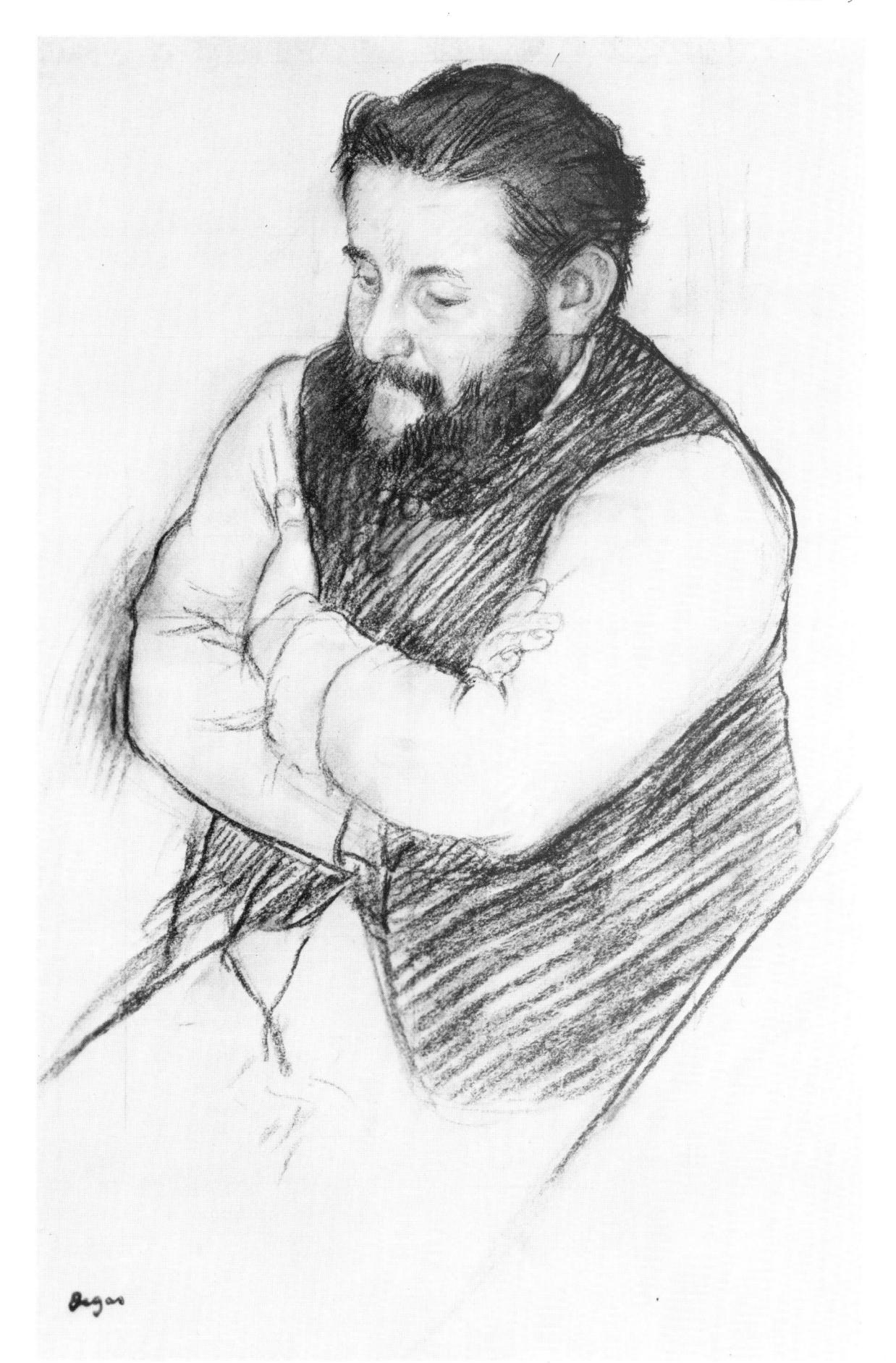

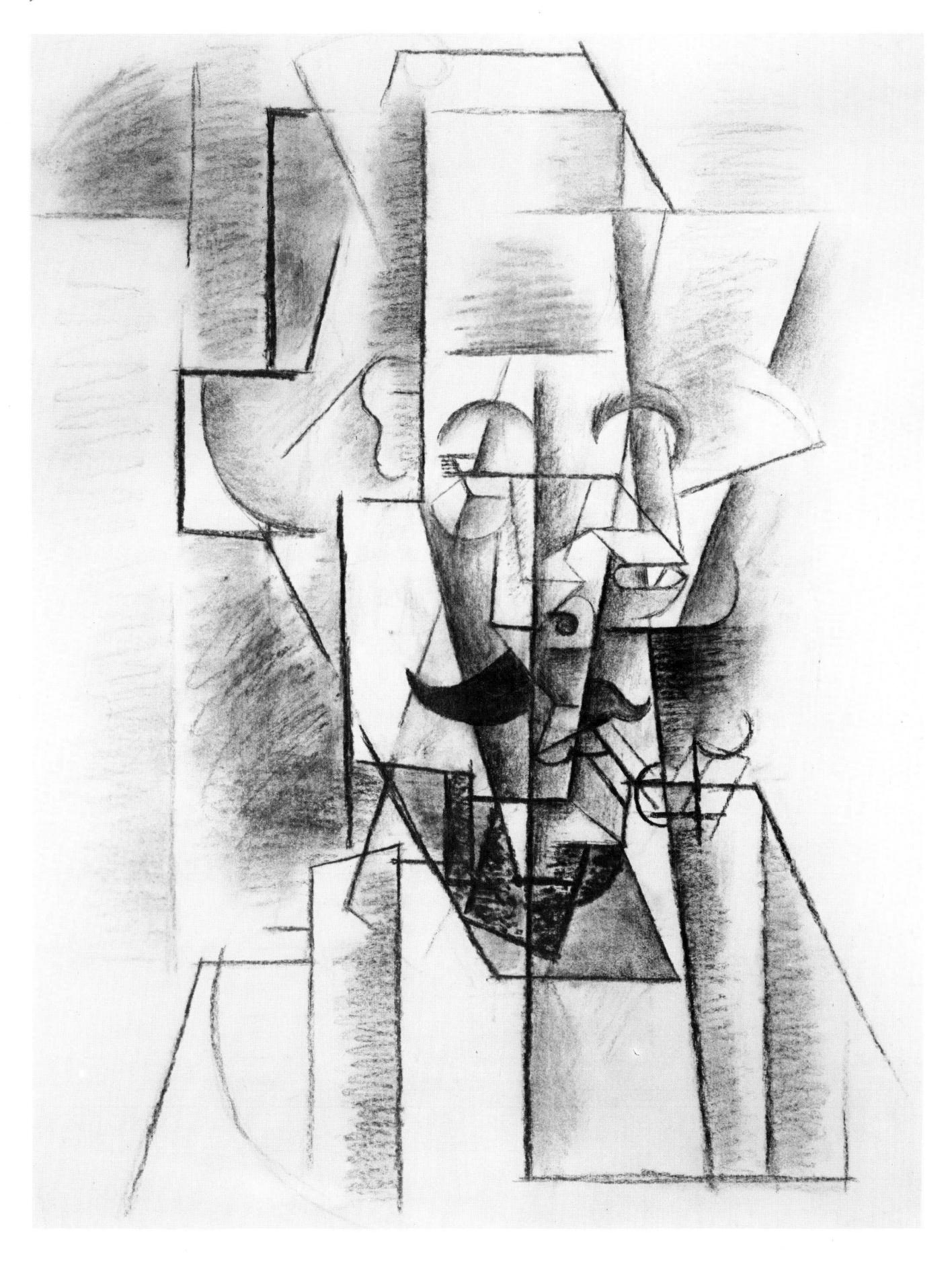

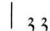

18. Pablo Picasso Man with Pipe

These two drawings, both produced c. 1912, bear witness to many of the principles of Analytical Cubism. Marcoussis, Polish born, was drawn into the Cubist movement while working in Paris. There, under the leadership of Picasso and Braque, artists had begun to look at nature, landscapes, stilllifes, and portraits in terms of planes; but as we see here, these planes were not necessarily confined to the 'subject' itself: they adopted an independent existence, sliding off the 'subject' onto the background. Although initially these planes are defined purely by their linear edges, with correspondingly little sense of depth, the addition of tone, graduating away from these edges, creates a sense of relief. Marcoussis' gradations are of a broader texture than Picasso's, but the principle remains the same. The planes may be read as in front of, or behind, others, but all the time, however deliberately ambiguous their spatial relationship, they still remain resolutely parallel to the picture plane. Although diagonal straight lines are an important element in the linear structure of these drawings, there is a strong emphasis on a vertical and horizontal framework, which keeps the shifting planes parallel to the surface. These ideas were first used by Cézanne, as was the idea of a multiple viewpoint - the combined side-view/front-view, for example, that we find in both these drawings.

19. Louis Marcoussis Portrait of Edouard Gazanion

OVERLEAF: 20. Peter Paul Rubens Portrait of Isabella Brant 21. Jean Antoine Watteau Portrait of Isabella Brant

This drawing of his first wife is one of Rubens' finest portraits. Carried out in the trois crayons technique, it illustrates brilliantly the range and variety which this medium can offer - a variety that other artists have also found useful (see Watteau's Head of a Negro, Ill. 25). The technique is based on the knowledge that black and white combined produce cool greys for translucent half-tones, while the addition of red produces a range of warm, vibrant grevs. Using this technique, Rubens has achieved a complete mastery of both form and surface texture: we can feel the areas where the bone is near the surface, stretching the skin tightly. The forehead is in itself a masterpiece of surface modelling: the hair is treated with springing curves and the whole head expresses exuberance, vitality, and joie de vivre.

Of Flemish extraction, Jean Antoine Watteau studied with interest the works of the Great Masters, and found particular inspiration in the drawings of Rubens. If, as some would claim, a portrait is a portrait of the artist as well as of the sitter, it follows that Watteau's copy of Rubens, translated into red chalk (his favourite medium), should reveal some aspect of Watteau superimposed upon Rubens - who in turn was revealing his feelings for his wife as well as reproducing her appearance. This is in fact the case. Watteau was a person of melancholy temperament, a consumptive who (like Raphael, Van Gogh, and Toulouse-Lautrec) died at the early age of 37. In his drawing the exuberant, vital Isabella of the Rubens portrait is replaced by a more fragile character: the frankly inviting, direct, sexually appraising gaze becomes, in Watteau's version, a much more ambiguous look; the gaze is directed at a point in the distance, and is more a fond remembering of times past, with sadness just below the surface. Watteau's drawing stresses his spontaneity and emphasizes the decorative aspect of the sitter, thereby reflecting the grace and elegance of the French Rococo. He introduces a rippling necklace to echo the lacy edge of the bodice and lowers the neckline to a fashionable décolleté.

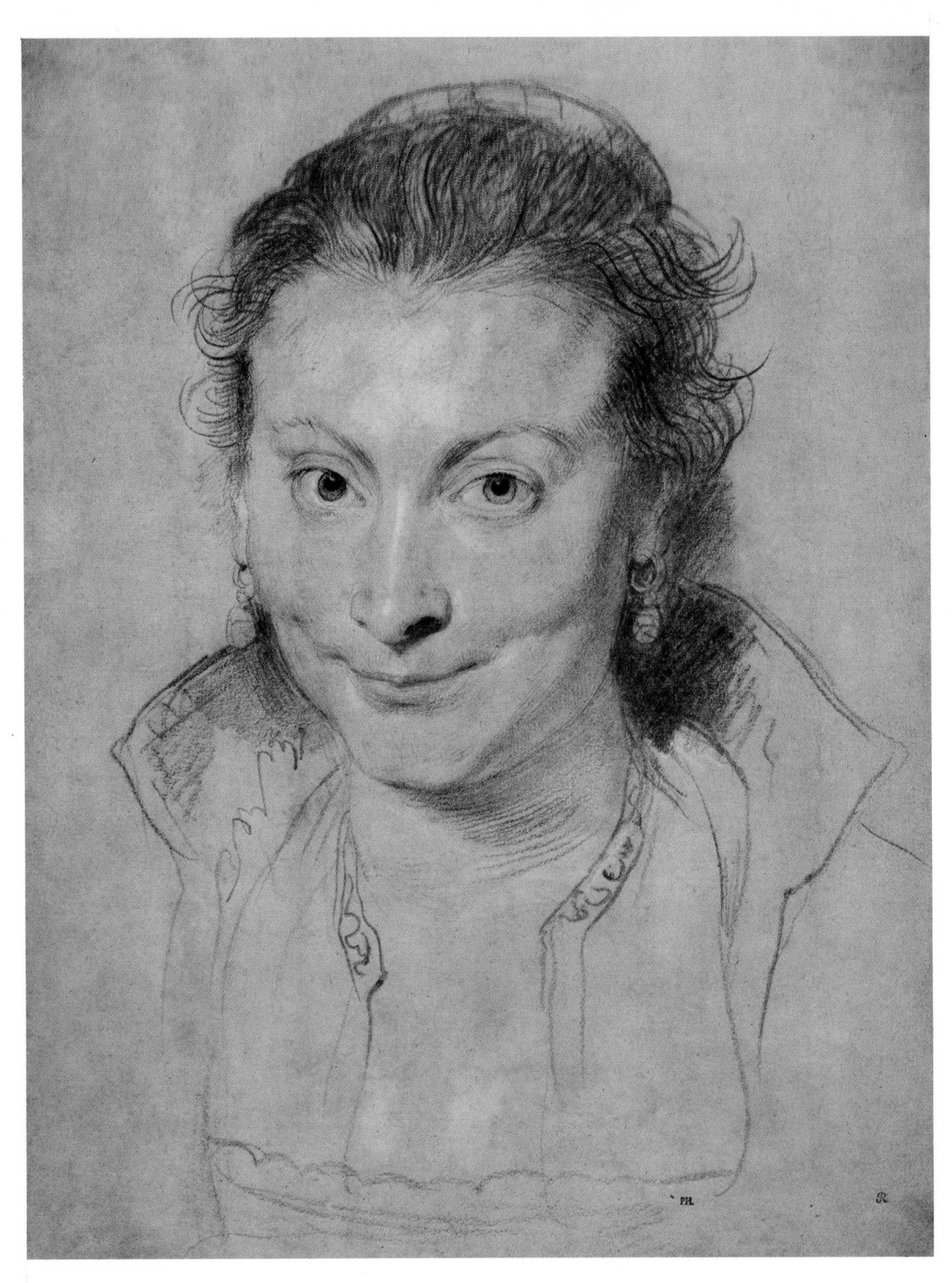

20. Peter Paul Rubens Portrait of Isabella Brant
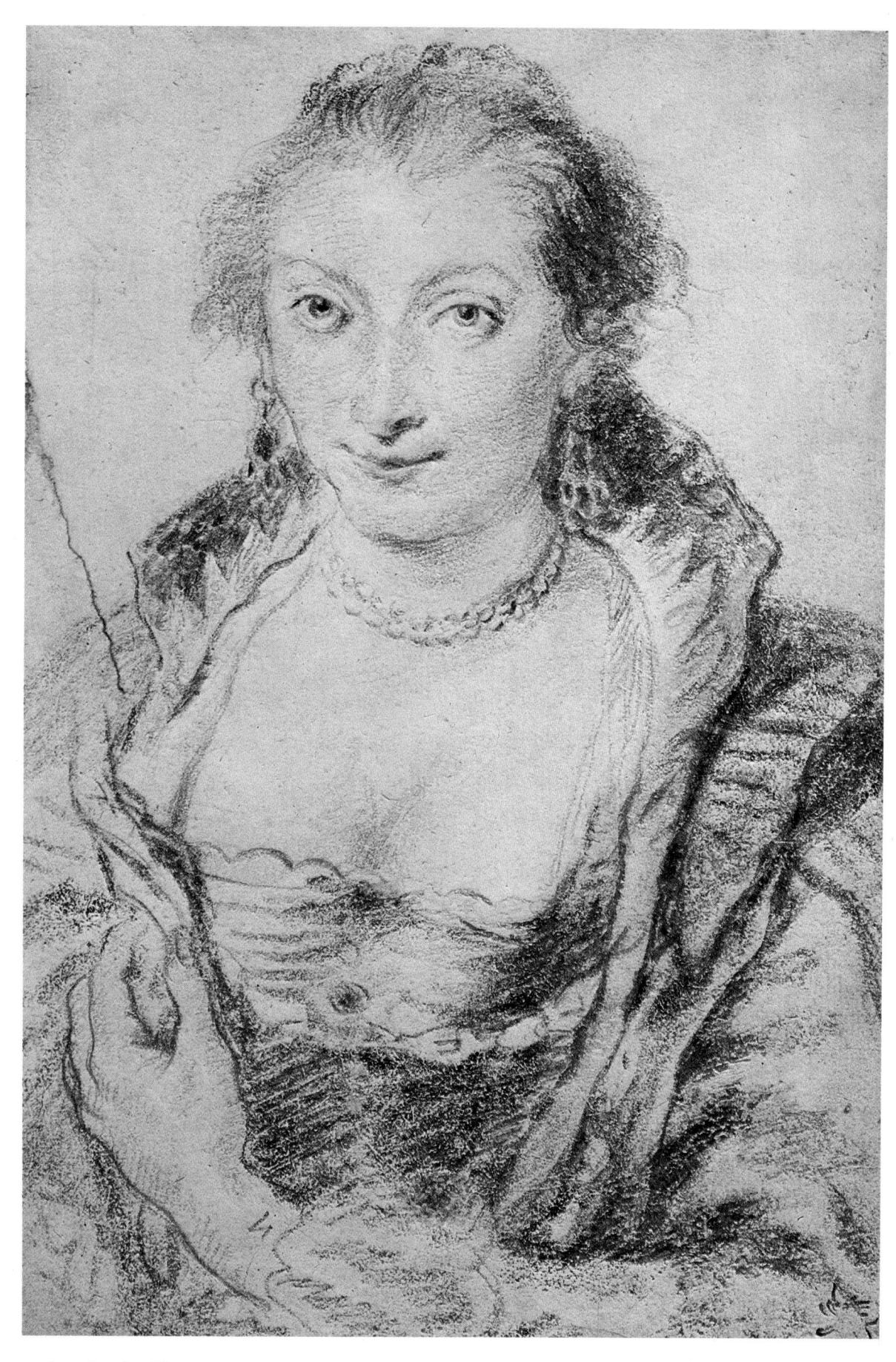

21. Jean Antoine Watteau Portrait of Isabella Brant

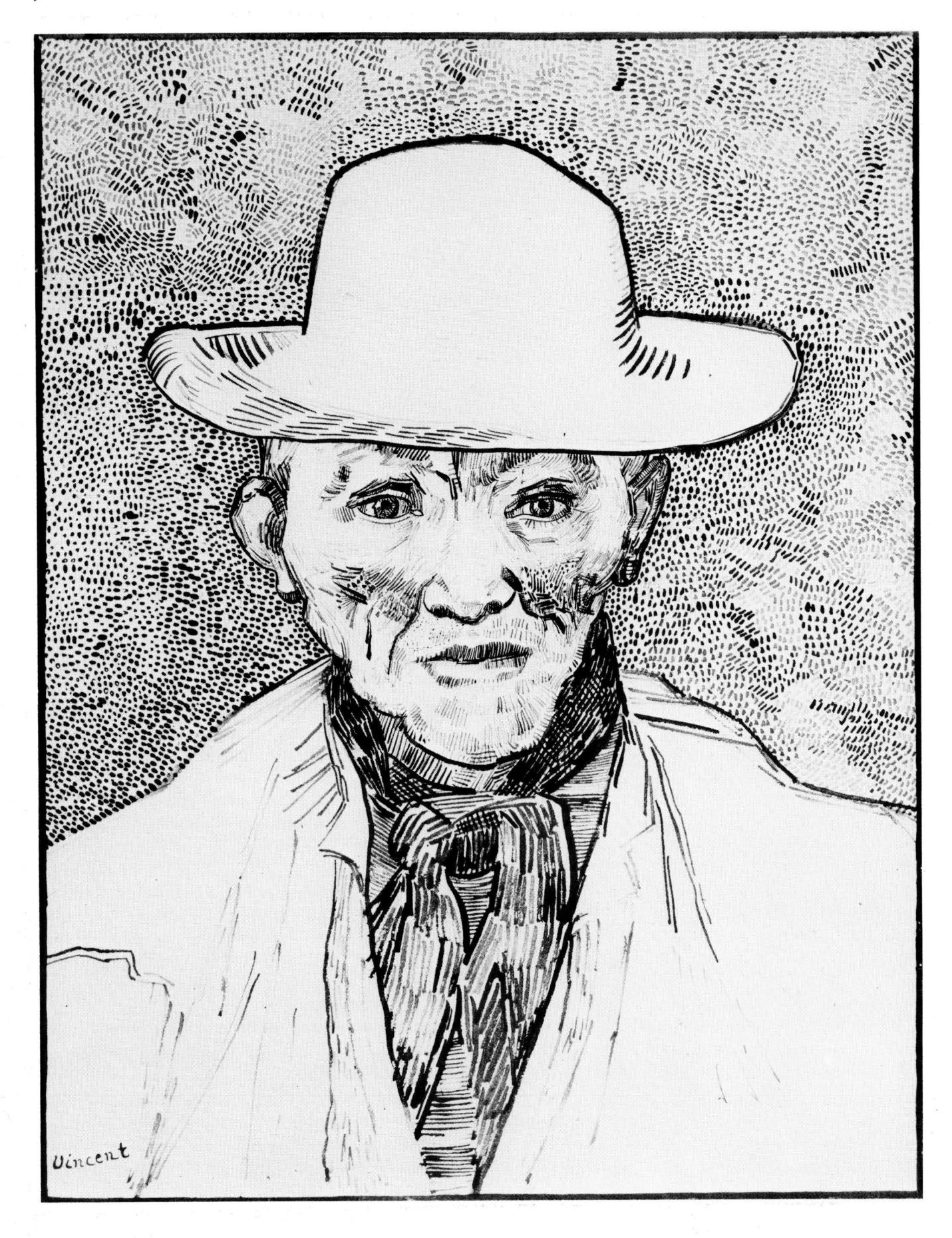

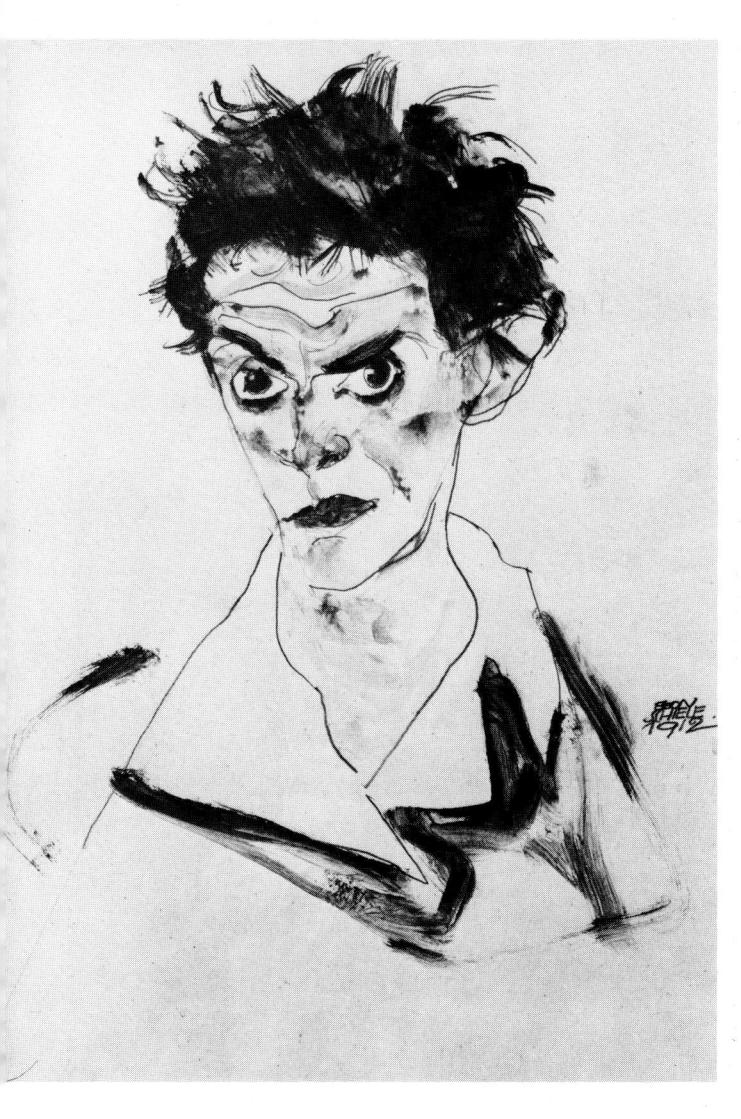

OPPOSITE: **22. Vincent Van Gogh**Peasant of the Camargue

A portrait may be as much a portrait of the artist as of the sitter, and this is particularly true in the case of Vincent Van Gogh. The face of the peasant in this sketch expresses an intensity of feeling which is Van Gogh's own, and the twisting, swirling disturbances of the background are a reflection of Van Gogh's own inner turmoil. Indeed, looking at any work by this artist one is always struck by the sheer physical activity and psychic energy which has gone into its creation. Van Gogh uses the brush or, as here, the reed pen, as a weapon – though for creation rather than destruction. Whether he stabs, slashes, flicks or merely punctuates, his movements are always forceful as he strives to communicate the immediacy and intensity of his personal vision. In this drawing he conveys all the glare and heat of the South, yet without having recourse to shadows.

23. Egon Schiele Self-portrait

To be an Expressionist, to attempt to express one's heightened feelings and emotions about the world rather than simply observe and record objectively, seems an almost certain recipe for disaster. To live at an intensity over and above a certain pitch seems to exhaust the life force prematurely. In his self-portrait Egon Schiele seems to recognize his own twisted personality and face up to it. The way in which he uses the watercolour and crayon is almost deliberately graceless. Expressionist artists seem determined not to seduce us by charm of colour or handling, but make a fetish of impressing on us the harsh realities of life by deliberately adopting a harshness of colour and an ugly, twisted line characterized by abrupt and awkward changes of direction. In this haunted self-portrait Schiele reveals himself, like all Expressionists, the prey of neurotic fears and anxieties, and all those tortured feelings which are the motivation of the Expressionist artist.

OVERLEAF:

24. Veronese

Head of a Negro

25. Jean Antoine Watteau

Head of a Negro

These two drawings of young negroes are concerned with expressing not only form, likeness, and facial expression, but also the warm colour of the skin, and to do this both artists have chosen the same means. Watteau's favourite medium was in fact sanguine (he very rarely used a pen for drawing even when copying pen drawings of others: he translated them into sanguine); for this head, though, he has chosen, like Veronese, the medium known as aux trois crayons, and by working on grey paper has been virtually able to create the sensation of full colour. The head and features are drawn in red, and the shadows strengthened with black; white is used very sparingly to add a glisten to the lips or to highlight the nose. Watteau uses comparatively little red on the turban, only a few marks, using only the black chalk for shadows; as a result the turban appears white, and contrasts with the dark tone and warm colour of the flesh. Veronese, confronted by the same problem, used the same medium but a different ground. Red, black, and white can, in different combinations, produce various colours, and Veronese, like Watteau, exploits these possibilities. By combining strokes of red and black he produces a brown effect; for local colour of lips and cheek he rubs in some red. The solid form of the head is developed by a curved network of chalk lines which describe the shape by following the contours. This profile is an excellent study in perspective. It shows clearly that the outlines of a face are not as if cut out of paper, but are skilfully drawn so that some lines appear near (such as the nose lines) and some further away (for example those over the forehead). In short, the linear boundaries move back and forth in space. Of course this applies to all drawing, but in this particular instance Veronese has made it very clear to us.

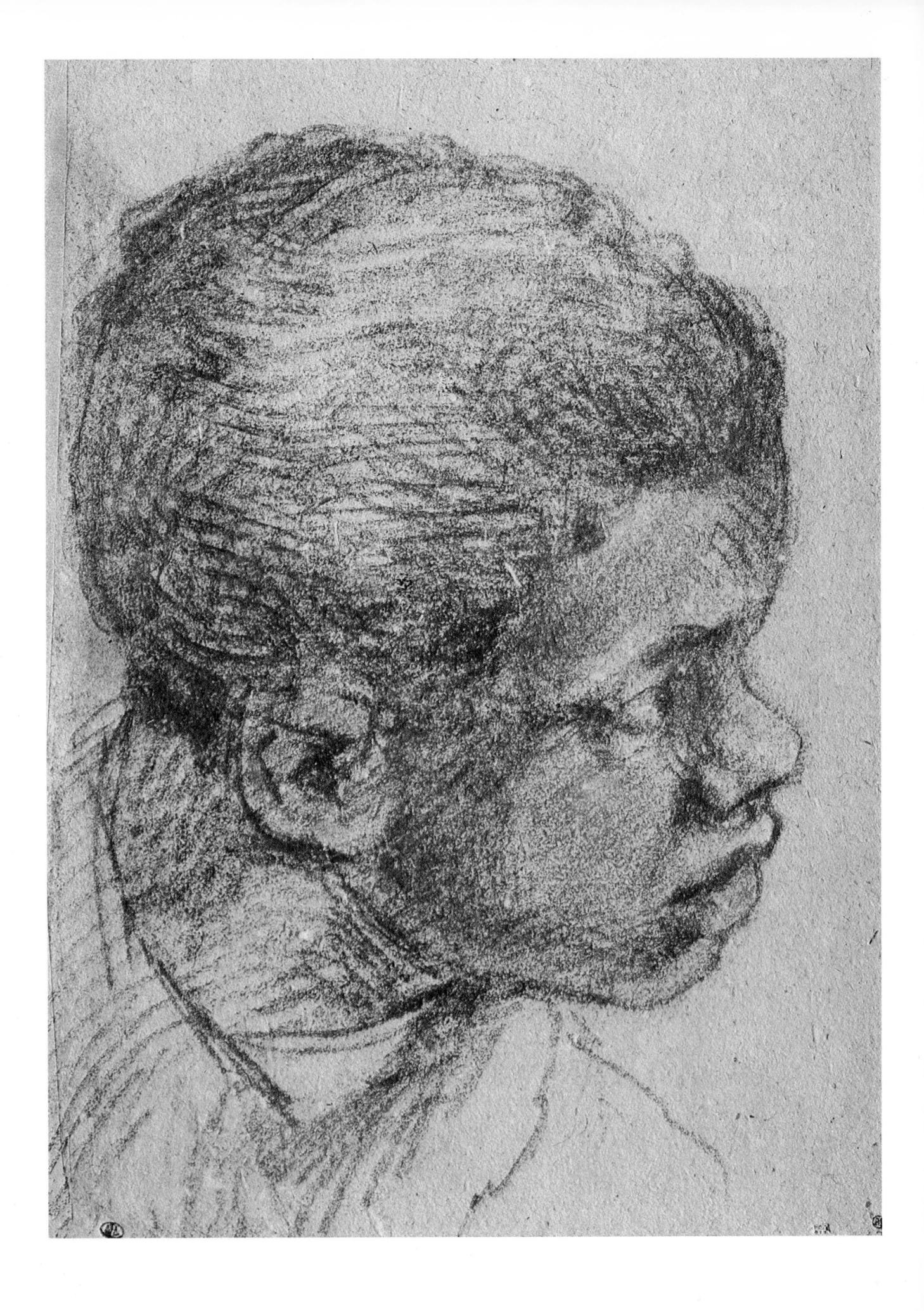

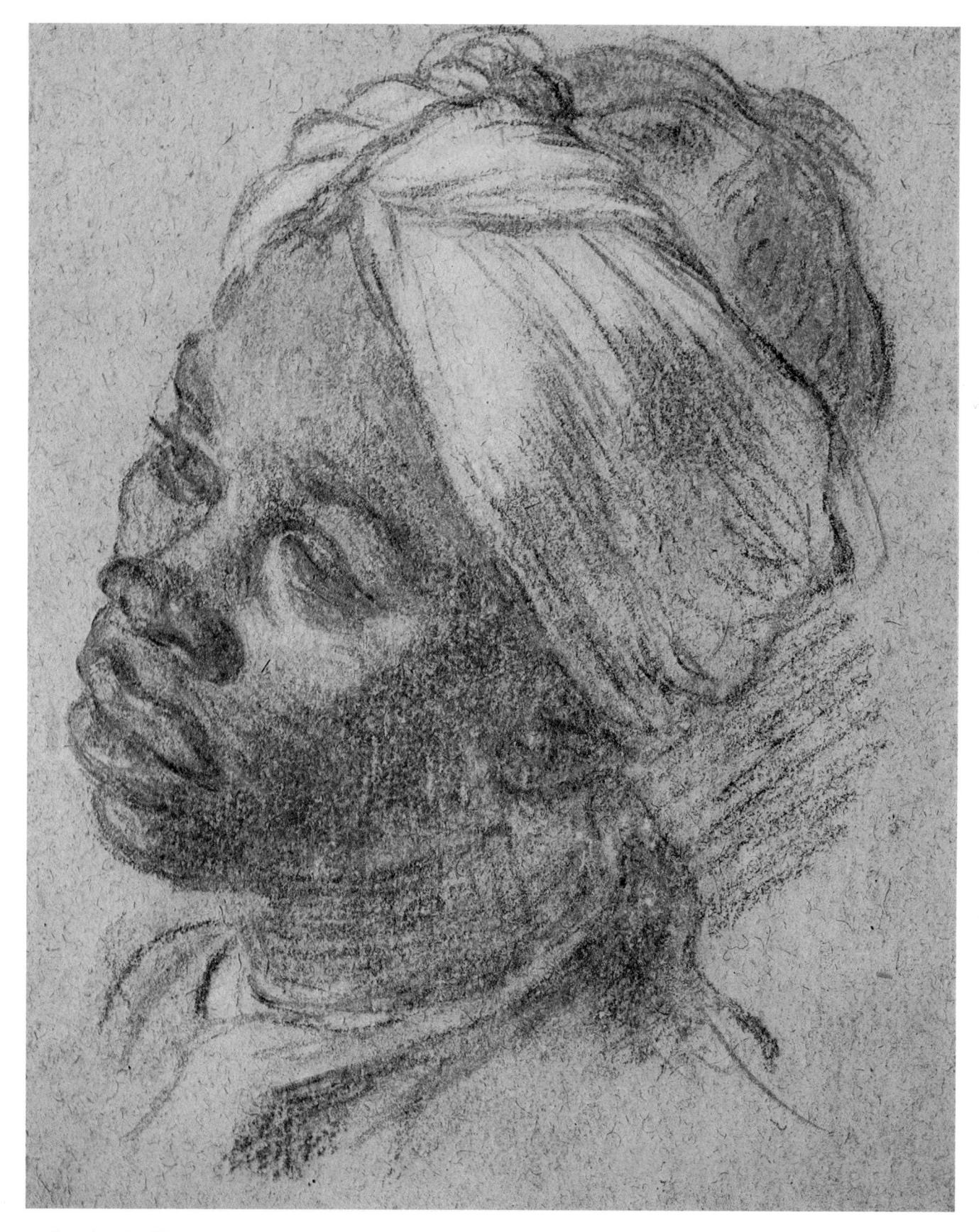

25. Jean Antoine Watteau Head of a Negro

LEFT: **24. Veronese**Head of a Negro

The Figure

Fig. 2

Figure drawing is a subject which has challenged and fascinated generations of artists of all countries. Every age has interpreted it in a different way: in prehistoric times the female nude was a symbol of fertility, while the Egyptians produced a schematic formula which served them well for thousands of years. The Greeks wished to create in their representations of the figure (as in their architecture) a system of perfect proportions, and Renaissance artists (Leonardo da Vinci for example), basing their ideas on the Roman architect and theoretician Vitruvius, attempted to relate the nude to the perfection of geometric form; Michelangelo saw in the male nude the ideal subject,

representing God's handiwork.

The changing attitudes to the female nude over the years are reflected in the works of medieval artists, whose nudes were characterized by small breasts and prominent stomachs, very different from the elongated, fashionplate studies of the sixteenth-century Mannerists, and the hefty beauties of the Baroque period, with their accentuated curves of breasts, bellies, and bottoms. The swinging curves of the female figure (particularly the back view) were ideal subjects to convey that exuberance and delight in movement so characteristic of the Baroque. A more explicit eroticism - though thinly disguised as Greek mythology - is found in the drawings of French artists of the eighteenth century, but the presence of the nude figure in a work without the pretext of fable or some kind of acceptable setting is very rare before the nineteenth century. More individual and personal styles began to appear in the twentieth century and the popularization of the camera in the 1890s introduced a whole new repertoire of poses for the figure. 'Hitherto,' Degas wrote, 'the nude has been represented in poses which presuppose an audience.' Now the 'view through the keyhole' suggested an entirely fresh approach.

The particular difficulties associated with drawing the figure are largely due to its variety, complexity and subtlety of form, and the latent sense of movement. A true realization of the pose is essential, and this involves, besides a sense of the space occupied by the figure, an understanding of, and feeling for, the relationships between the axial directions, the disposition of the weight, and a sensing of those parts which are in tension and those which are in compression. The term 'axial directions' refers to the concept of a line drawn from the top of the head downwards through the middle of the body; this line is known as the major axis. Those lines linking opposite

26. Alberto Giacometti *Nude*

Both these drawings are of standing nudes, front view; both are by sculptors of the twentieth century. They are, however, very different both in intention and in method. Giacometti was primarily a sculptor who modelled his figures, creating them from clay. With swift, continuous movements, using a metal armature to support a continuous building process, he clothes the skeletal framework with clay, producing tall, thread-like figures, as expressive as exclamation marks! This drawing shows a very similar process in two dimensions. Thread-like lines shuttling urgently over the surface weave a fine network, creating the form and pose of the figure; they describe the opposition between the lines of the hips and shoulders, and establish the relationship of the figure to the linear structure of chairs and tables, creating a kind of spatial environment in which the forms exist.

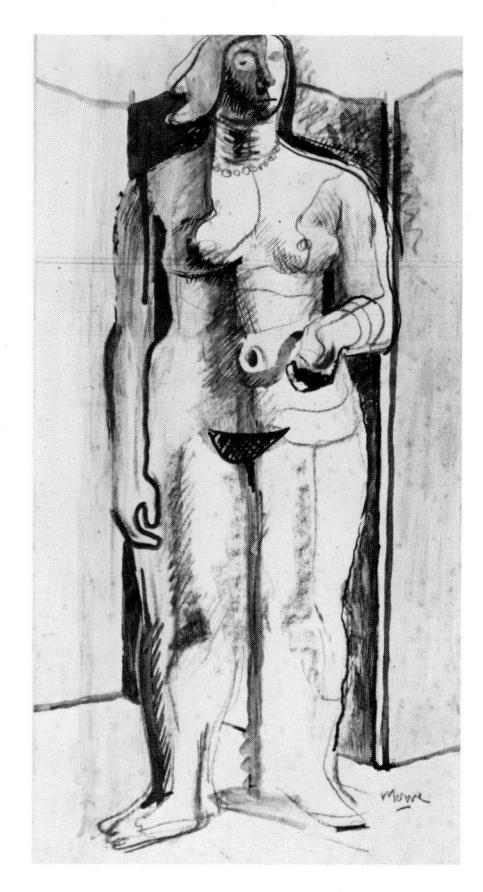

27. Henry Moore Standing Nude

Henry Moore, unlike Giacometti, is predominantly a carver, and whereas Giacometti's drawing seems to relate to the wiry armature of the modeller, this drawing relates to the basic rectangular block, the starting-point of the carver. Running down from the left-hand side of the neck, over the breast and stomach, is a major vertical section which is partially responsible for the four-square quality of this figure - a quality reinforced by the position of the feet which are planted firmly at right angles to each other; the stance is stressed by the parallel with the rectangular, block-like form in the background. This form suggests both the figure within the stone block and a niche for a monumental sculpture. Moore uses tone, not to suggest direction of lighting (areas are lit in an arbitrary way), but simply to convey the idea of form. Similarly, lines are used to show sections of these forms wherever he felt it necessary.

points are known as the minor axes. In Fig. 2 we see the movement of the central (major) axis compared to the vertical, and some of the compensating movements of the minor axes as the left leg of the model supports the weight. The diagram also indicates the general axial thrust of the supporting leg. In a figure standing rigidly upright the minor axes would be at right angles to the major axis but such a pose is virtually impossible to hold since the weight must be constantly adjusted in order to maintain the stance; even the most static pose suggests the possibility of movement.

Before the artist begins drawing the figure he must decide which aspect he is trying to express and which medium will be the most suitable. Michelangelo concentrated on the anatomical form; Boucher and Renoir tried to express roundness and softness by using a medium which enabled them to achieve smooth transitions of tone; Picasso and Matisse often used line as their sole means of expressing the flow and latent energy of a pose. But whatever an artist wishes to express, he can always find an equivalent in the human figure; it is capable of endless variety and endless interpretation.

28. André Segonzac Young Girl by a Red Umbrella

Segonzac is probably better known for his drawings and etchings than for his paintings. All his drawings, whether of boxers, women, animals or landscapes (generally winter scenes with a strongly linear content), have a spontaneity and a sense of *joie de vivre* in the way the possibilities of the different media are exploited. In this large drawing the pencil is used sometimes solely as line and sometimes as a reinforcing or modifying tone on the wash. The function of the wash also varies: sometimes it is used simply to suggest

local colour (as in the red of the umbrella or the checked pattern of the hat), sometimes to produce shadow tone on the form. Everything seems to have been done without any apparent effort, and the whole apparently casually designed. But from the repetition of the curves of the umbrella, paralleling the contours of the model, to the placing of the signature and message, emphasized by the parallel rippling brush marks, everything has been carefully and elegantly placed.

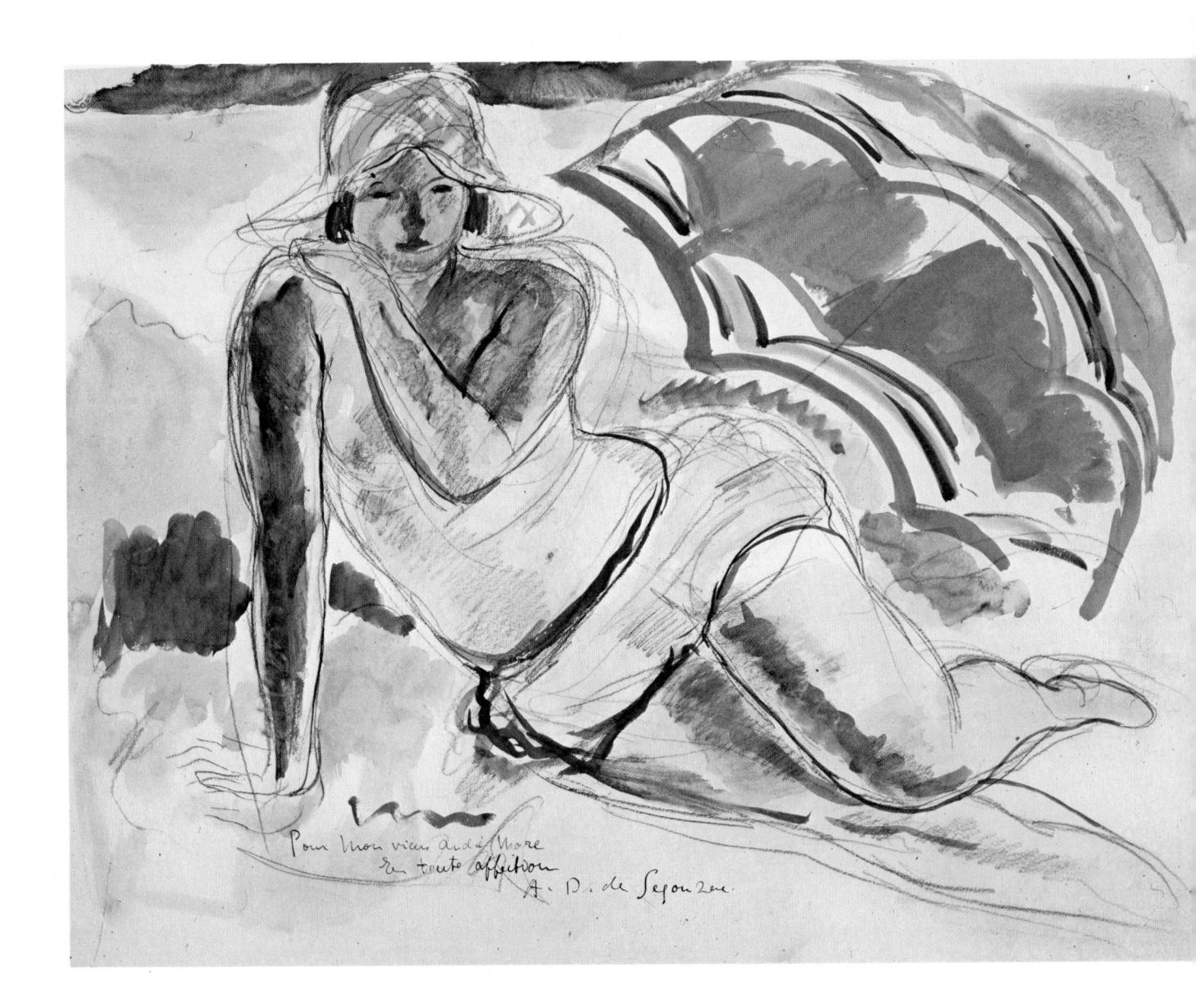

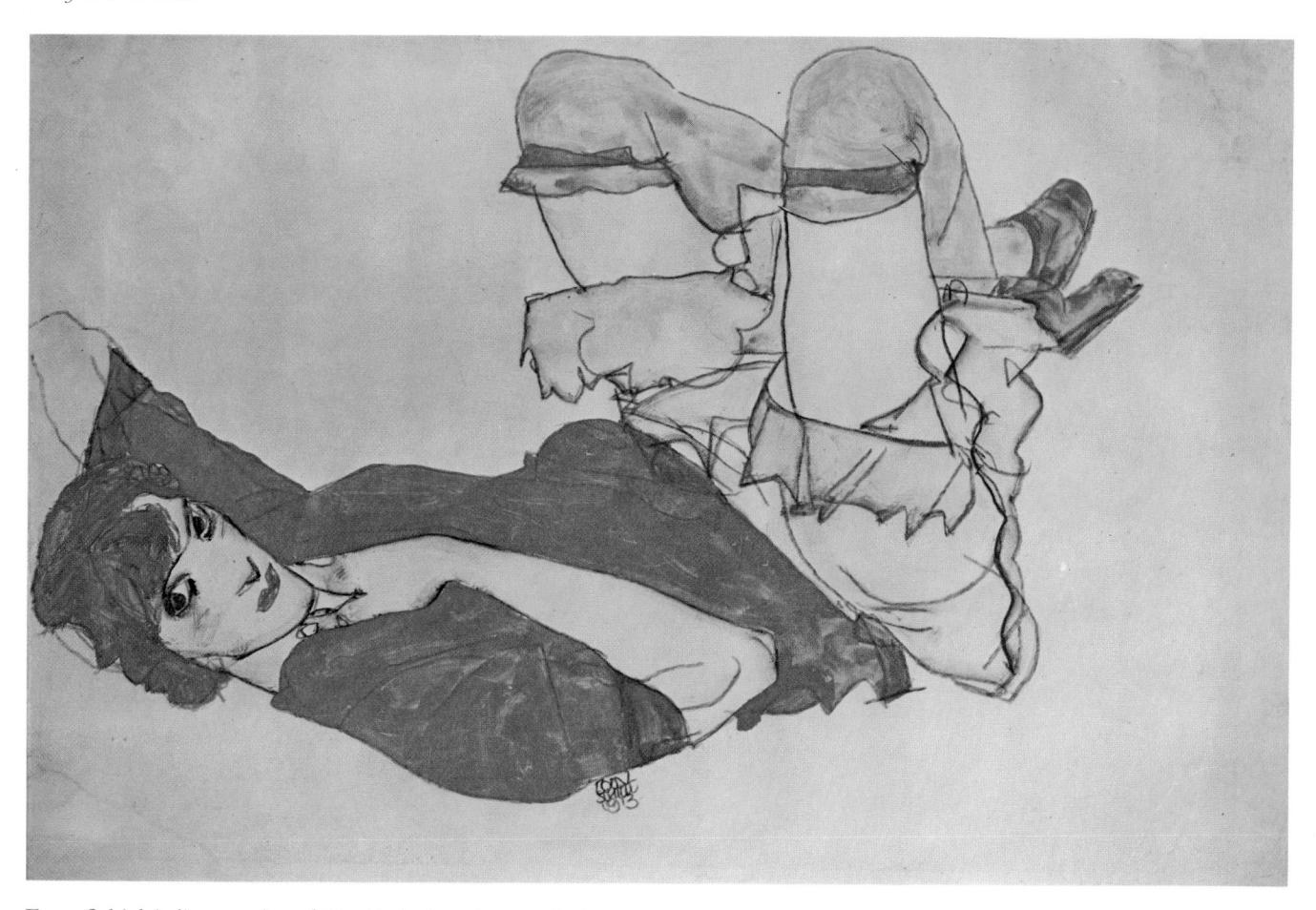

Egon Schiele's line, stark and Gothic in its wiry angularity (compare Bosch's Entombment, Ill. 59), and aggressive in its insistence on facing up to facts, has none of the elegance and charm of Segonzac. During his brief career (he died aged 28) in Vienna, where Sigmund Freud was also trying to make people aware of the truth beneath the surface, he used line as his main means of exploring the human psyche. Like other Expressionists he took a pessimistic view, tending to see man or woman as the victim of Life. His drawings of the female figure were much more naked than nude, and the conservative Viennese found them too explicitly erotic. This drawing, with its flat, stark, discordant colours (red battling for supremacy with ginger), the abrupt angularity of pose and line (the turned-back legs of the drawers are as aggressive as a circular saw), and the insistence of the uncompromising gaze, is a typical example of Schiele's superb sense of draughtsmanship.

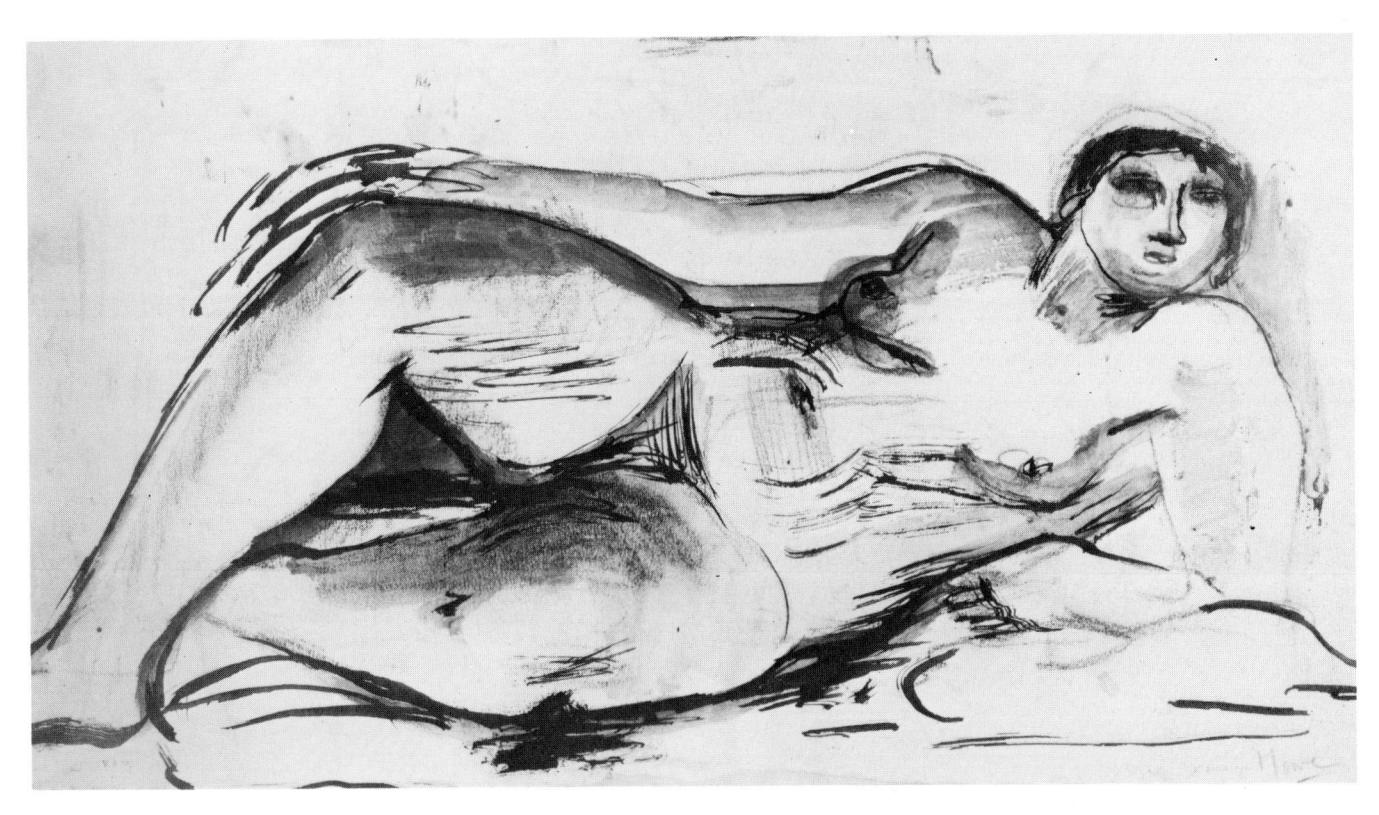

30. Henry Moore Reclining Nude

The theme of the reclining female figure has run through Henry Moore's work as a dominant motif, recurring in different forms throughout his career. Influenced by ancient Mexican sculpture (such as the reclining figure of the rain god Chichén-Itzá), Moore's drawing of the female nude seems to be larger than life and imbued with a kind of primordial significance. The repeating motif of the parallel straight lines emphasizes the relationship of the massive forms to the horizon, glimpsed as a low straight line between the thighs. By using this idea of a low horizon line the artist conveys a sense of monumentality and permanence, while powerfully

suggesting an interchangeable relationship between the hills and valleys of a landscape and the sweeping forms and prominences of the female figure, stirring within us ancestral memories of the Earth Mother Goddess.

Moore uses the brush to produce both line and tonal areas in the form of a simple wash with only slight variation of strength. This tone, like the brief indication of interior modelling in line, is used to show the squareness or roundness of forms, but not to simulate the effect of light and shade.

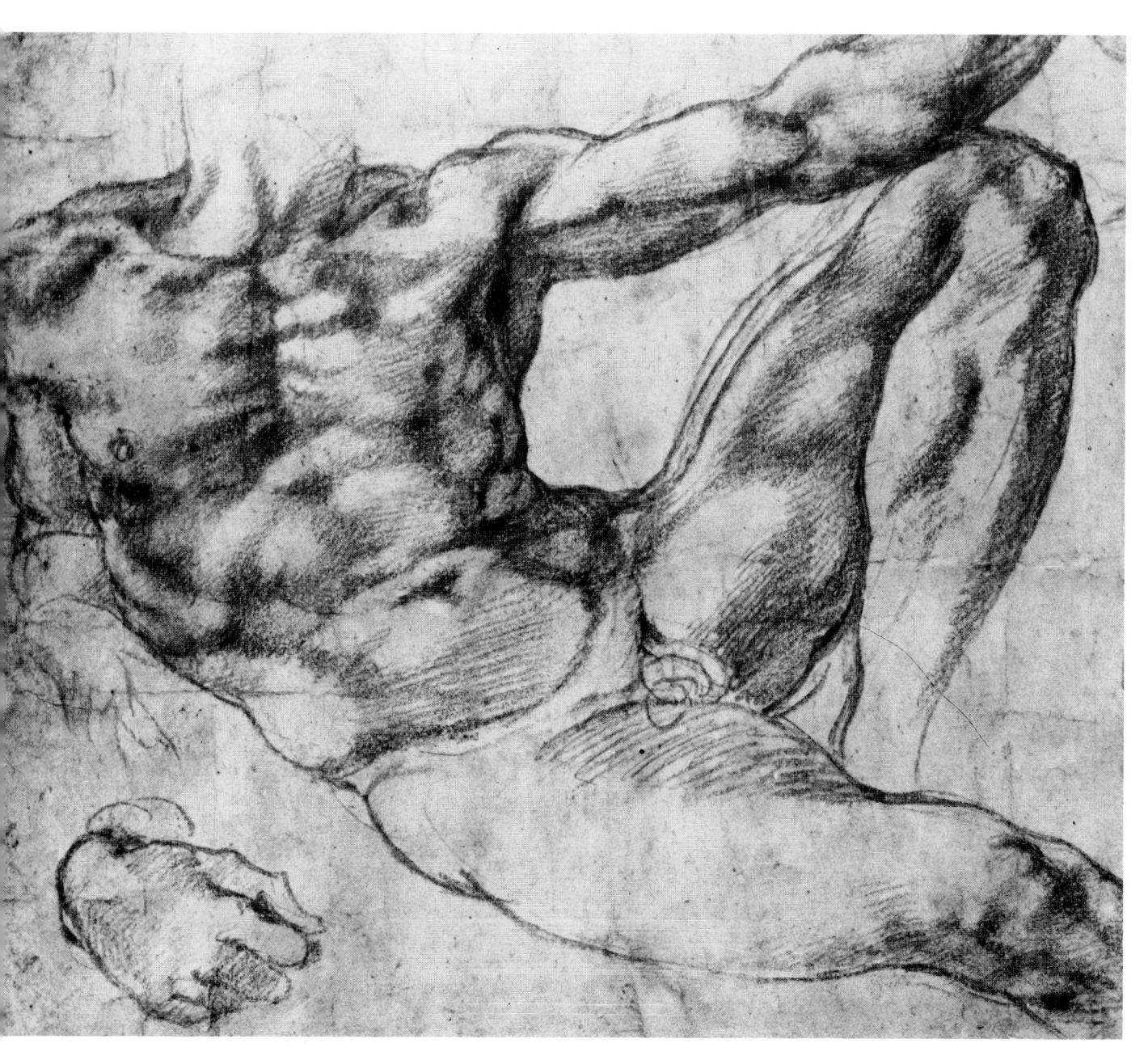

31. Michelangelo Study for the Creation of Adam

From the reclining female nude to the reclining male. Adam waits to be called to life. A study in anatomical form by one of the greatest sculptors of all time, whose knowledge of anatomy was as extensive as Leonardo's. Michelangelo employs the maximum range of tonal variation obtainable from his chosen medium, using the strongest tones on those parts where the form is fullest - that is, where there is a definite change of plane rather than on modelling up the

surfaces of these planes. We can see this method clearly on the nearest edge of the biceps; similarly, the musculature of the torso is stressed along the lines of the main changes of plane, rather than on individual muscles, in the interest of creating form - an interest one would expect from a sculptor. As in the work of all classical draughtsmen, the line is uncompromising and clearly defined.

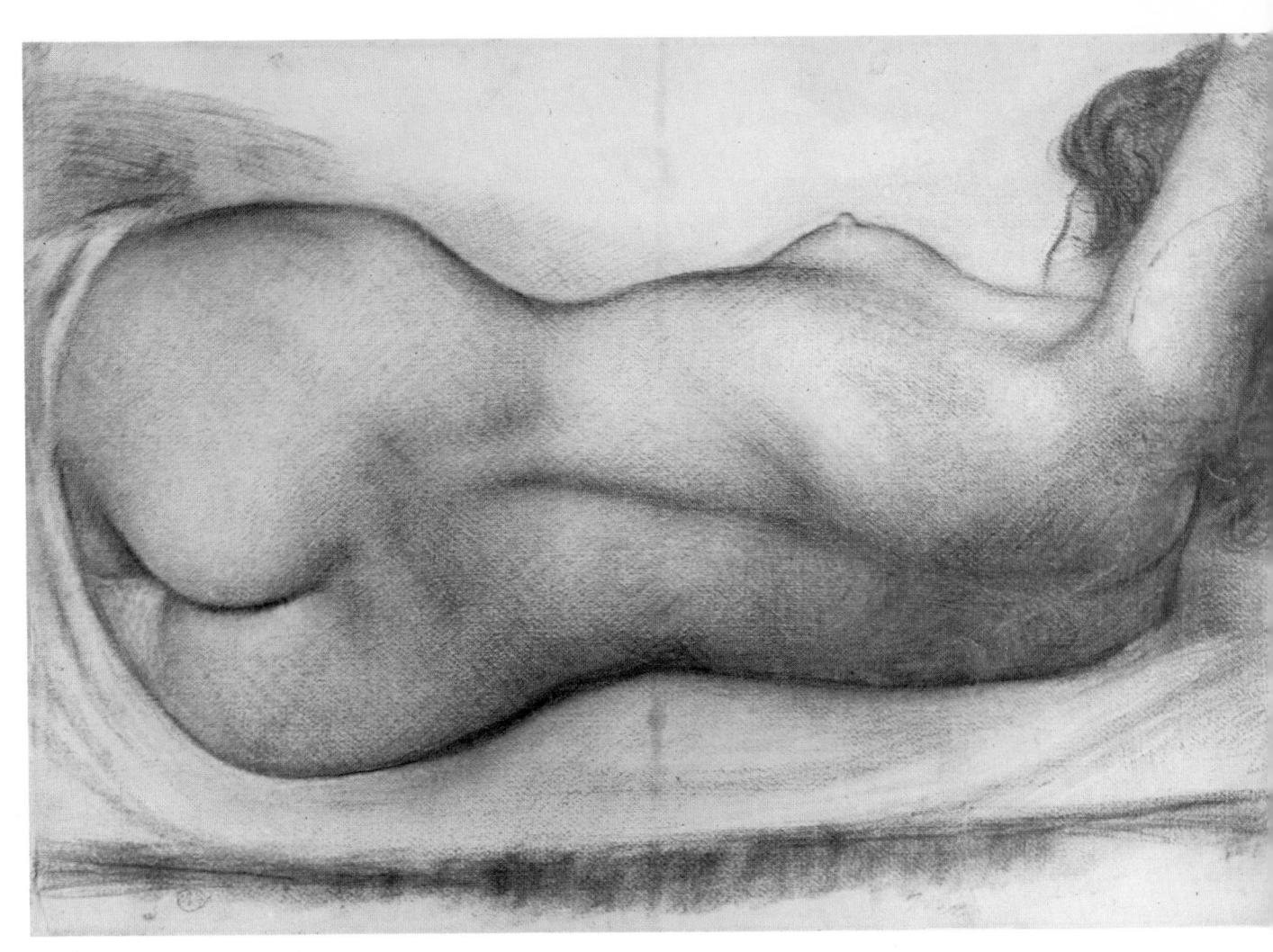

32. Aristide Maillol Reclining Nude

The sculptor Maillol began his career as a painter and tapestry designer, acknowledging freely the influence of Gauguin and Renoir whose pagan devotion to the nude is clearly reflected in his work. Maillol rarely sculpted direct from the model; he preferred to work from large drawings such as this, made from life. 'For my taste' he once wrote, 'there should be as little movement as possible in sculpture . . . the more motionless Egyptian statues are, the more they seem about to move.' This drawing expresses precisely a kind of potential movement, a latent activity, more of a sensuous stretching and flexing than a rearrangement of limbs. This sense of arrested movement is conveyed by the subtle twist of the torso. The heavy contour lines of the form roll slowly backwards and forwards in space; the contour of the breast disappears, as it is overtaken by the slowly rising line of the ribcage, which continually, subtly fades and strengthens. The drawing has a definite warmth and sensuality despite the fact that it is virtually an abstract study of form; it is free from details such as hands, feet, or facial features, which often destroy an overall concept of form.

33. Pierre Auguste Renoir Nude Woman Seated

This drawing probably dates from 1885 - 90 when Renoir, having visited Italy in the winter of 1881 - 2, had 'rediscovered' the classical Ingres (see Ill. 34) through his study of the works of Raphael. As a result Renoir rejected the Impressionists' total preoccupation with light to the exclusion of form, and acknowledged the prime importance of draughtsmanship. Thereafter his drawings took on a monumental sculptural quality which shows his admiration of the surcharged immobility of Maillol's rigidly controlled figures. Like Maillol, Renoir uses strong, firm, simple contours. All the interior forms are modelled within these controlled lines. The detail is subordinate to the whole, fingers being drawn as hand, and facial features largely lost. In this drawing the use of red chalk heightened with white gives the flesh a rosy colour, in keeping with the obvious delight with which Renoir has expressed the firm expanse of buttocks, rounded breast, and thigh. The rotation of the shoulder mass, as the model leans over to the foot, compared with the angle of the hips, is particularly masterly.

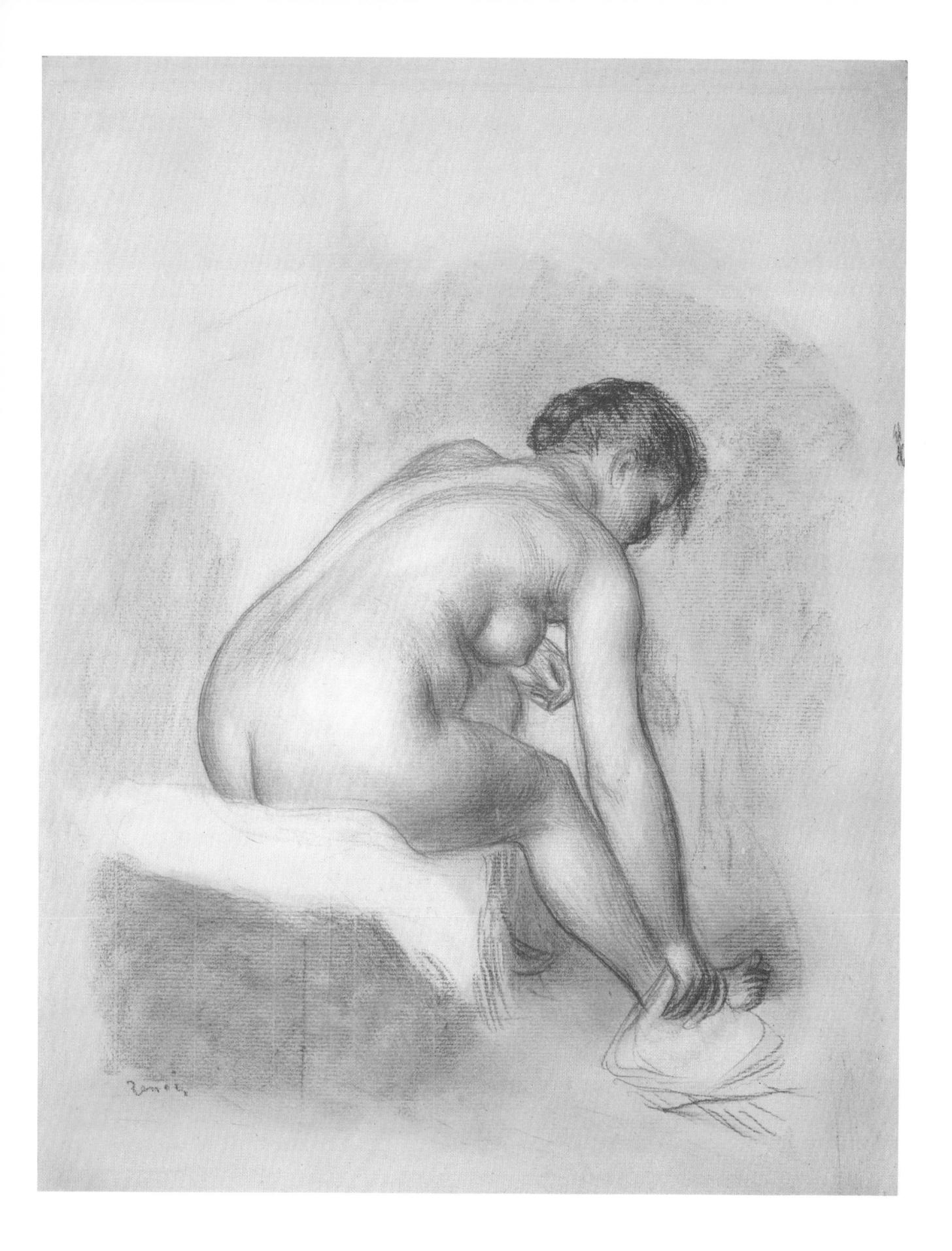

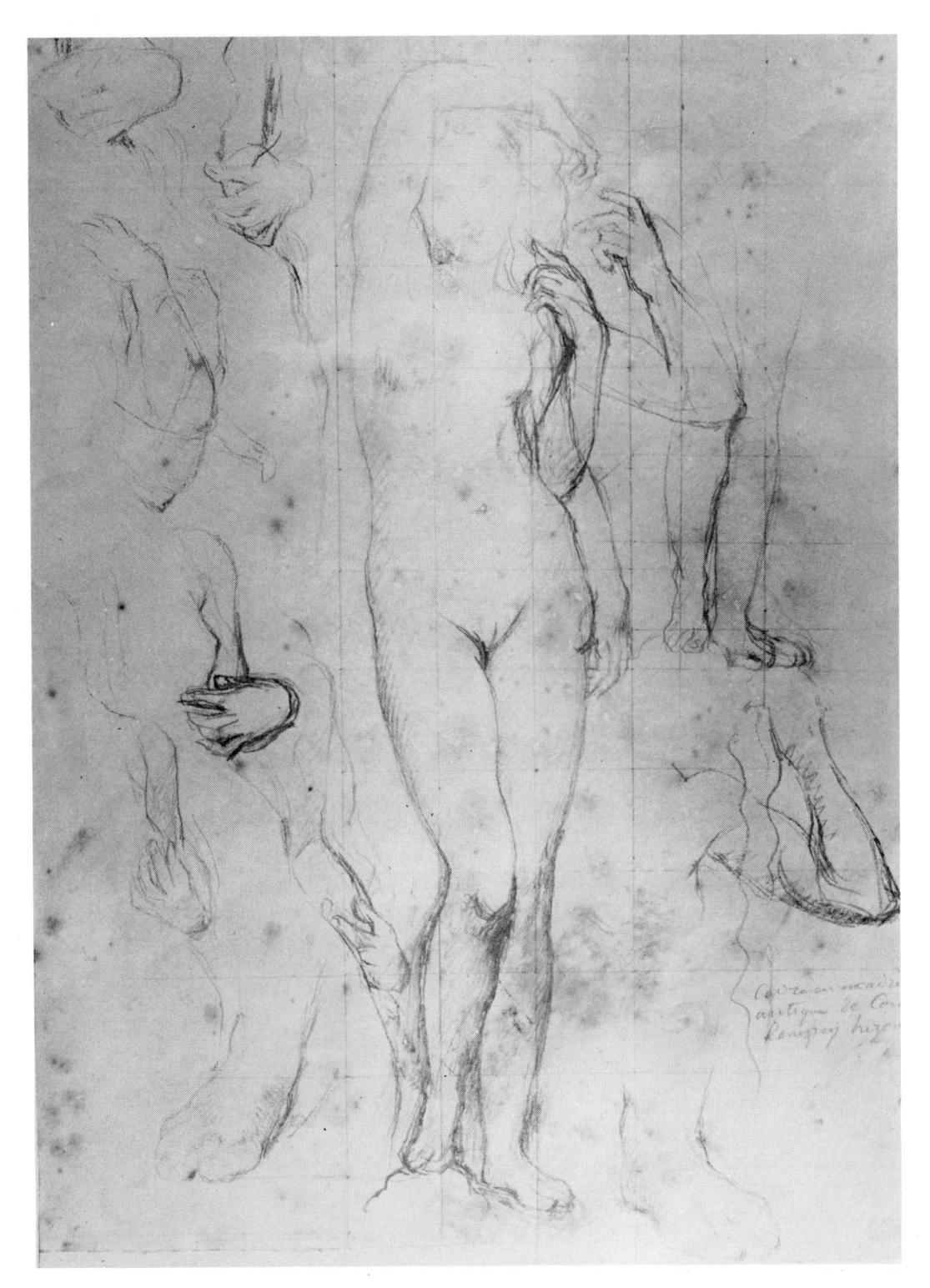

34. Jean Auguste Ingres
Nude Study

Ingres drawing of a female nude is also a preparatory study, and he has squared it up ready for transfer to the canvas. Ingres' use of pencil reminds us of the medieval silver-point, but he has been able to achieve much more flexibility and variety with the new medium (see glossary). In 1806 Ingres left France for Italy, intending to stay a few years but in fact remaining for eighteen. Although he proclaimed an undying admiration for Raphael, behind the cool neoclassical façade there is a feeling of romantic sensuality. This fluid pose, with

the subtly swaying movement of the central axis of the figure, accentuates the quality of grace in a way much more associated with the Italian Mannerists (for example Bronzino) than with Raphael. Ingres insisted on the importance of line and drawing, saying 'draughtsmanship is the probity of Art – line is drawing . . . It is everything.' But Ingres' line is not everything in this drawing. The line is complemented, subtly modelled, and varied by the addition of tone, which changes in weight as it moves from one side of the line to the other.

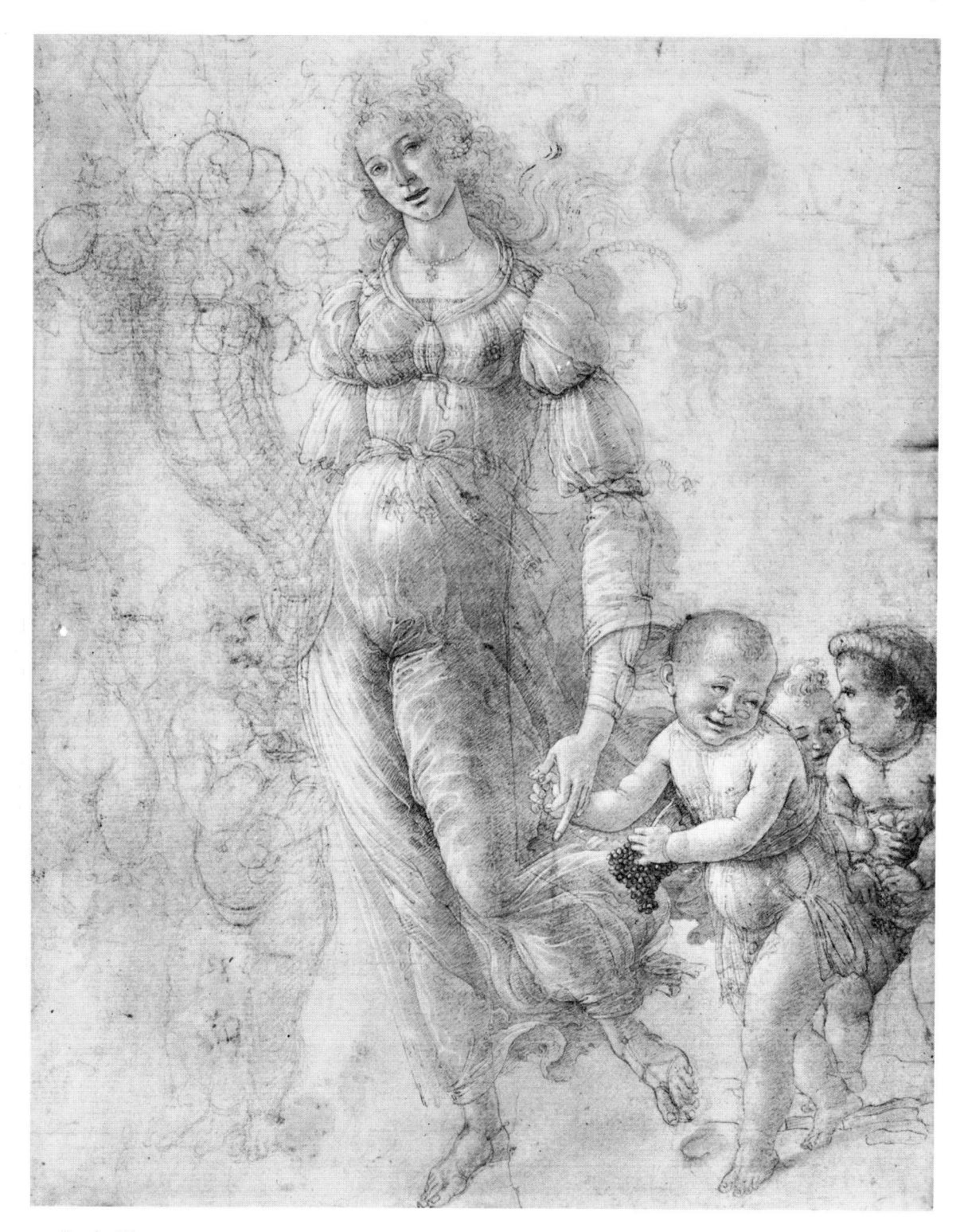

35. Botticelli Abundance

The paintings of Sandro Botticelli are imbued with a sense of nostalgia and dreaminess. In this beautiful drawing, a preparatory study for one of his works, we can see how he achieves both a sense of movement and a subtle transparency. Botticelli chose to work on a middle-tone ground with pen, chalk, and wash, heightening the drawing with white – the ideal combination of media to express delicacy and to bring out the transparency of the drapery. This feeling of delicacy

in turn enhances the sense of movement, which is underlined by the floating ribbons and windswept hair, and by the feet, which are hardly in contact with the ground. Botticelli's use of line is soft and caressing, and the central axis of the principal figure describes a softly swinging curve, which is echoed in the curve of the cornucopia (a thinly veiled allusion to the idea of fertility suggested by the figure).

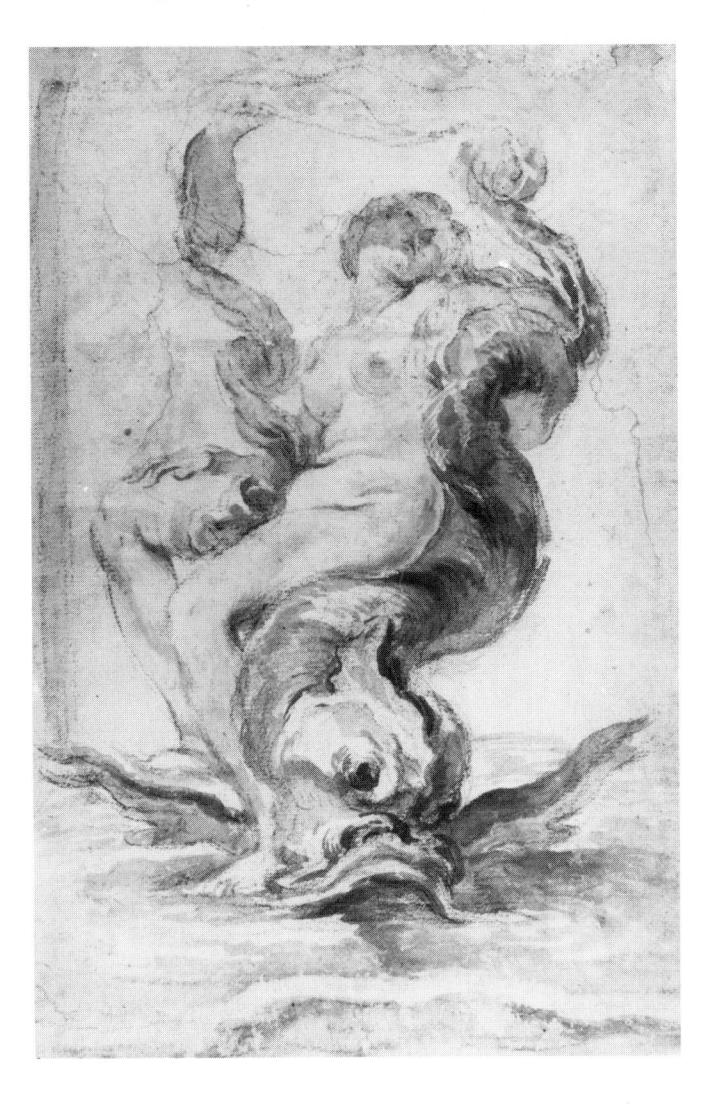

36. BerniniStudy for a Fountain

One of the qualities of High Baroque sculpture is that it appears to deny the nature of the sculptural medium itself the heaviness and solidity of marble, stone, and bronze are transformed; even the human body can become ethereal, simply an expression of movement. Flowing movement was also one of the chief characteristics of the art of the Baroque period, and Bernini's choice of fluid wash and chalk enabled him to create forms which flow easily into each other and into the surrounding space. The fountain, representing as it does the interpenetration of form and surrounding space, became a popular subject for Baroque artists. This drawing, for all its spiral movement into space, is perfectly balanced about the central axis, since, as a sculptor, Bernini was very aware of the importance of the centre of gravity. As in many Baroque works, the drapery begins to take on a life of its own: the turns and twists of the figures, the flying drapery and fins all extend into the surrounding space, making it play an active part in the sculpture.

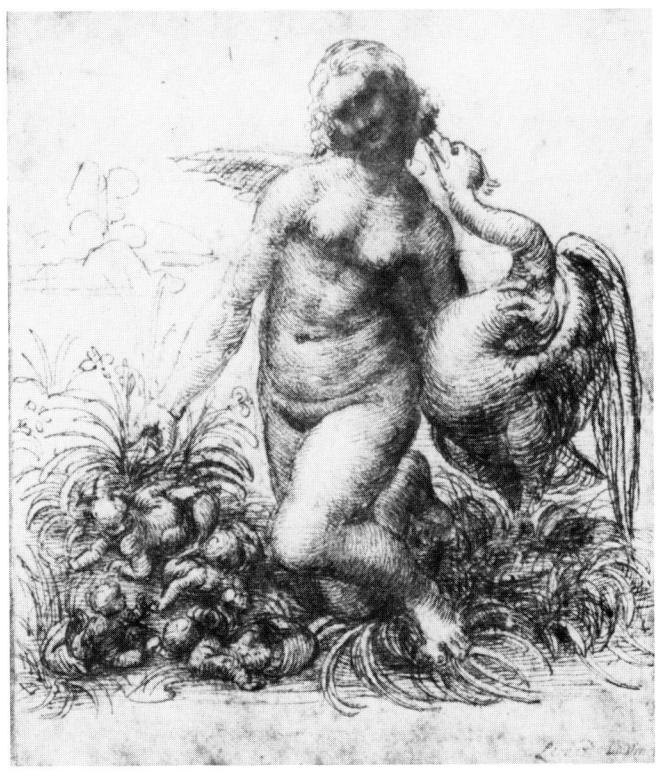

37. Leonardo da Vinci *Leda and the Swan*

Leonardo da Vinci has always been regarded as one of the world's greatest draughtsmen. Although he was not particularly interested in Classical mythology, he was fascinated by movement and by organic growth (see Ill. 97), and made detailed studies of the human embryo which are scientific in approach, as well as this piece of poetic allegory, where babies are seen hatching from eggs. (This is one of several similar preparatory sketches Leonardo made for a painting (now lost) of the story of Leda and the swan.) Leonardo uses the freedom of chalk and wash to soften the edges of the forms (a technique known as sfumato) so as to allow them to merge imperceptibly into each other and into the background. Leonardo was left-handed, and the rounded forms are fully modelled by the use of a close hatching made up of curved lines travelling from right to left - Leda's pose is as sinuous in movement as the neck of the swan.

38. Peter Paul Rubens Study of a Figure for the Descent of the Damned

One of the chief characteristics of the Baroque period was the emphasis on movement (see Ill. 36). Rubens' study of a figure in space (thought to be either Mercury or a damned soul) expresses powerfully the feeling of falling movement. Various successive views are apparently superimposed on each other, creating a sense of an unco-ordinated confusion of arms and legs as the body twists, turns, and swoops in its headlong descent. The use of swirling drapery to crystallize the sensation of movement was another device developed during the Baroque period, and here it is used to reinforce the feeling of rotation.

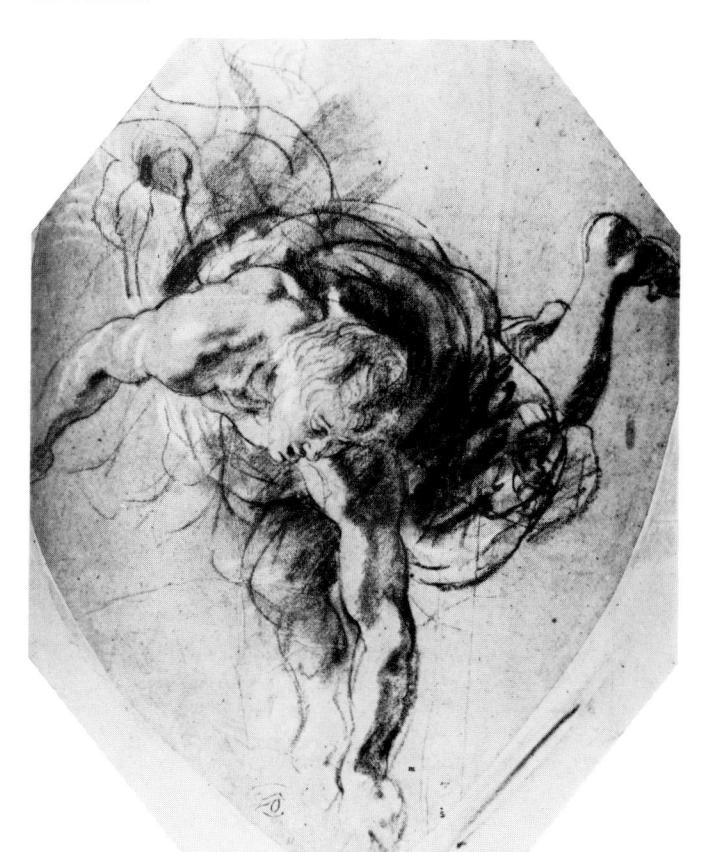

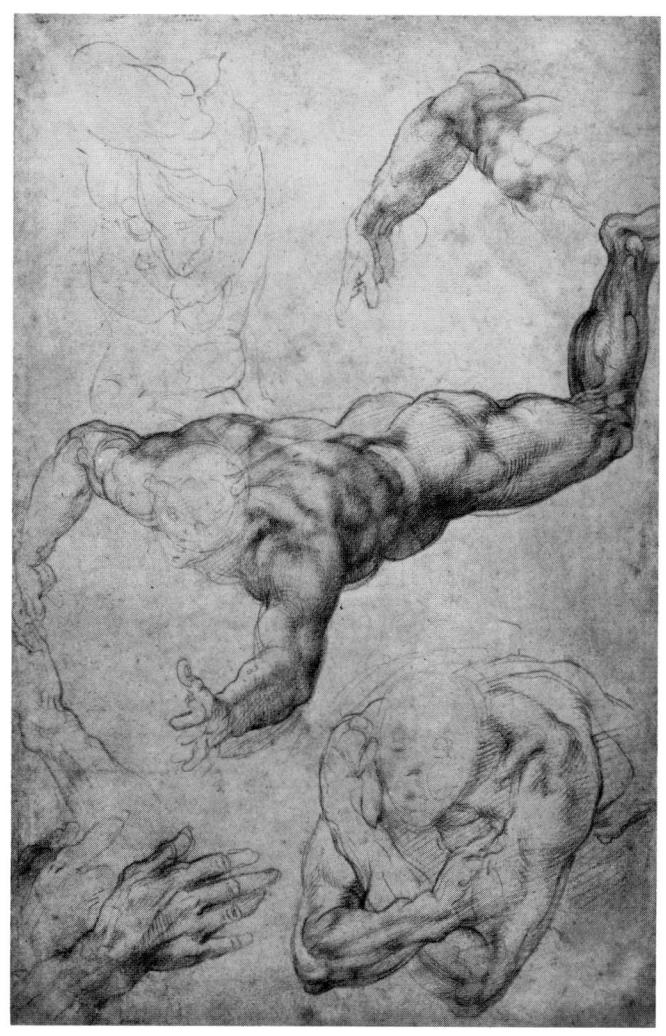

39. Michelangelo Study for a Flying Angel

Michelangelo's drawing of a man falling through space (perhaps a Fallen Angel) is a typically meticulous study of the anatomy of the male nude, a subject of primary interest to this great sculptor. But there is little sense of falling or of weightlessness. The foreshortening and the pose generally seem to have been arrived at by observing a static figure lying on an inclined plane: the knee and the outstretched forearm would be in contact with this surface. The figure is in fact more a study of rigid perspective than of movement, and each form is paralleled by its counterpart, appropriately reduced in size to suggest distance.

40. Rembrandt A Girl Sleeping

In making this sketch, Rembrandt was concerned with summarizing the mood and feeling of the figure. The study is therefore not only pure calligraphy, it is also a piece of careful observation. In order to capture the essentials Rembrandt worked at speed from left to right, with a fully loaded brush. As the brush moves over the rough surface it becomes starved of wash, so that a broken texture is introduced, creating, almost accidentally, lighter tones of wash. Atmospheric depth and form is contained in each brush stroke, and the weight of tone is allowed to vary from the dense black of the foreground to the lighter tones of hand and head.

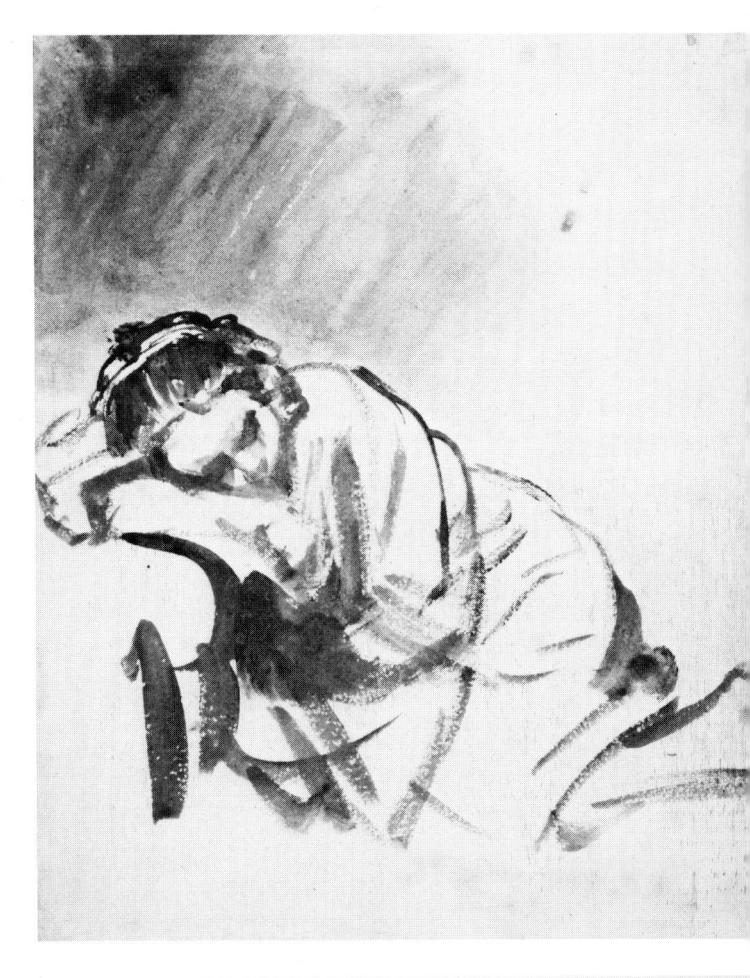

41. Henri de Toulouse-Lautrec Woman Asleep

During his short life Toulouse-Lautrec produced some intensely personal work. He was essentially a draughtsman, using line – even his paintings are virtually coloured lines – as his main means of expression. His early works show an interest in animals, particularly horses, but his studies in Paris and the influence of Impressionist ideas led him to seek models from the seedier areas of life. His drawings of the *habitués* of the bars and brothels of Paris are set down with a certain detachment, though not without an ironic humour and sometimes an element of caricature. In this spontaneous sketch he has reduced the subject to its essential linear rhythms. All his drawings are concerned with movement, even when the subject is static, and the fluid lines of this sleeping figure ripple over the surface, joining hair to pillow and body to bed.

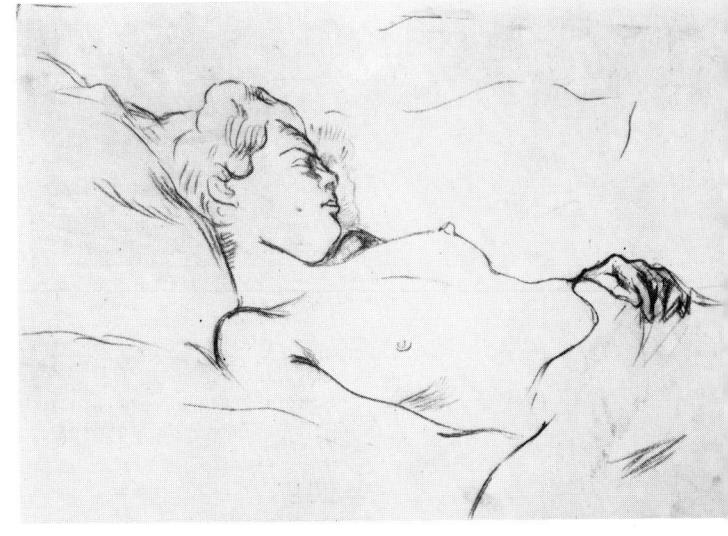

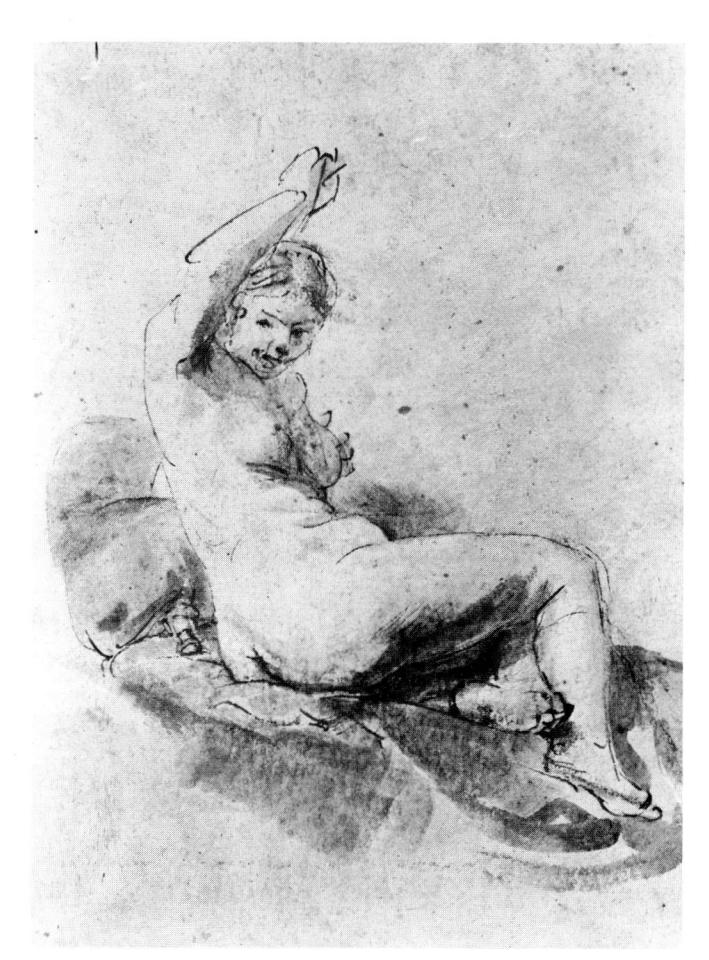

42. Rembrandt Study of a Female Nude Reclining on a Couch

Rembrandt's technique seems to be an almost hit-or-miss affair - except that he never misses! In this pen and wash drawing the pen is used to define and punctuate the vigorous brush strokes. The ink is sometimes dragged to produce a broken texture (compare Ill. 40) and sometimes thinned to produce a delicate wash, giving the effect of a figure bathed in light. Light was as important to Rembrandt as to the Impressionists, but whereas for them it was the subject, the raison d'être, of a work, to Rembrandt it represented a means of enhancing drama, emotional mood or religious content. The soft reflected lights used on the far side of the face and on the curves of the bottom contrast with the sudden sweeps of shadow on the thighs allowing Rembrandt to capture the spontaneity of the pose - the twist of the body as the model turns to show her breasts.

43. Jean Antoine Watteau Study for 'La Toilette'

Amongst Watteau's preparatory studies there are very few sketches of related groups; he preferred to draw individuals and would combine a selection of suitable subjects when he wished to produce a composition. His chosen medium was generally red chalk, the sensuous, delicate sanguine, which suited his temperament. He never used pen and ink, and rarely heightened his drawings with white, relying on the whiteness of the paper for light passages. This drawing is carried out on a pale bluish-grey paper, in red and black chalk. The red, sometimes greyed with black, is used only on the figure, and the result is a delicately coloured effect of warm flesh, with cool half-tones, set against the silvery tones of the drapery; positive strokes emphasize the nostrils, lips, and nipples, and combine with the soft surface modelling, where the chalk is lightly rubbed. The minor axes of the head (the lines through the eyes and the mouth) and the lines of the nipples, breasts, stomach, and thigh suggest a revealing movement, like the unfolding of a fan.

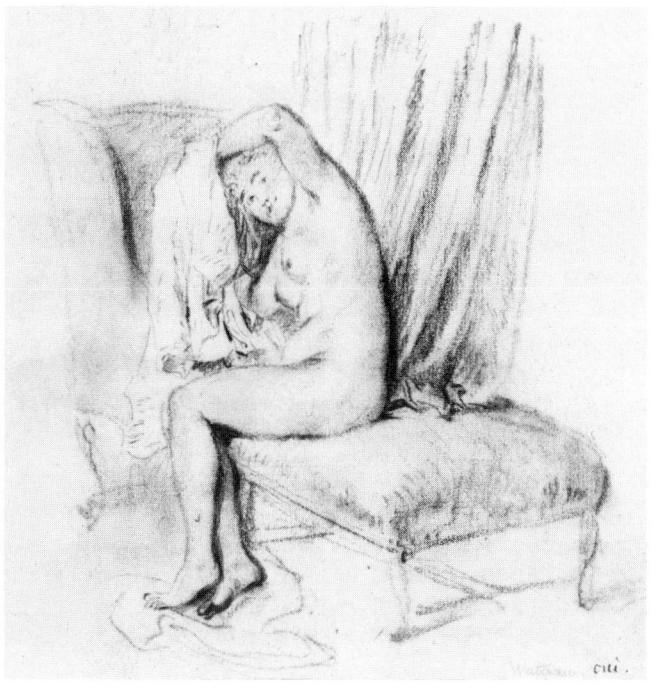

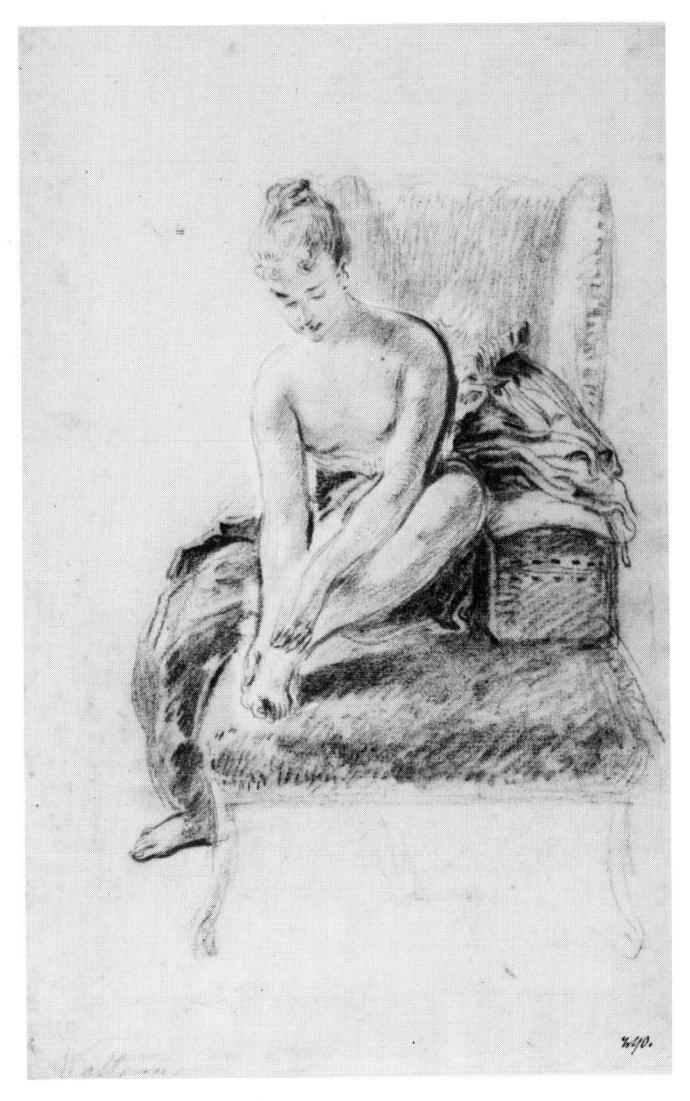

44. Jean Antoine Watteau A Woman Performing her Toilet

Here, as in his study for *La Toilette* (Ill. 43), we see the charm and elegance of Watteau's drawing of the female form. The red chalk again tints the rosy flesh and the black chalk supplies the cool half-tones. Reflected lights and softly graduated shadows subtly round the limbs and create an ambiance of space, soft lighting, and mirrors.

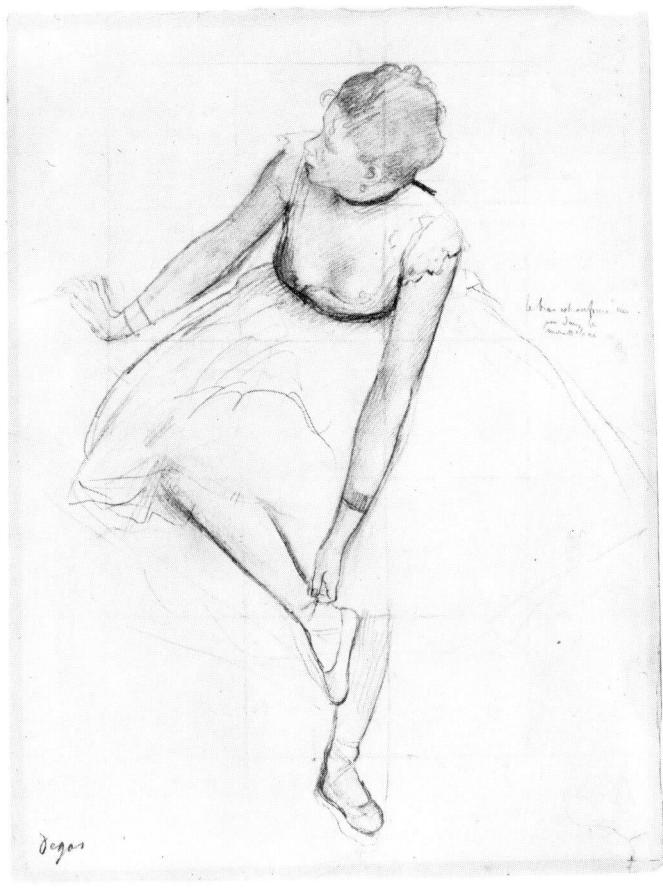

45. Edgar DegasDancer Adjusting Slipper

Edgar Degas also made many drawings of women at their toilet, washing their hair, and drying their bodies after the bath. His swift, almost casual sketches suggest a candid glimpse through a keyhole. Ballet dancers and racehorses were among his favourite subjects (perhaps because both are highly trained, leggy, and professional in their movements). Degas was an excellent draughtsman as we can see from this sketch, carried out in pencil and charcoal and squared up for enlargement and subsequent use in a painting. Typically, Degas has chosen a pose which emphasizes the dancer's angularity and reinforces his expression of a casual, unguarded moment. The viewpoint is, however, absolutely consistent, from the profile drawing of the head to the foot on which the body rests (and which, incidentally, describes the whole of the floor plane). The contours of the drawing are simple but firm (compare Renoir, Ill. 33). To achieve this simplicity, Degas revised and refined the contours without obliterating the original statement, so that he could estimate the degree to which alterations were required. Only very slight tone changes are needed, for example, in the arm adjusting the slipper to indicate a change of axis. The lines indicating the skirt are few, but by skilful direction and placing, the form is clearly expressed.

In 1906, at Gosol in Spain, Picasso discovered the crude Iberian sculpture which was to have a profound effect on his work. The famous Demoiselles d' Avignon, painted the following year, contains elements of both Iberian and Negro sculpture. and is generally accepted as representing the birth of Cubism. The figure in this drawing is treated in a similar way to the Demoiselles and repeats the pose adopted by one of the models. All the contour lines of this symmetrical shape are expressed in terms of convex curves, and every curve is balanced by its opposite; the V-shape between the breasts is similarly balanced by a smaller, inverted V at the base of the stomach. The only lines which do not partake of the curving rhythms are the hatching strokes. These are applied with a kind of crude vigour which is in keeping with the rest of the drawing, but they suggest the strokes of the sculptor's chisel rather than the pen strokes of the draughtsman.

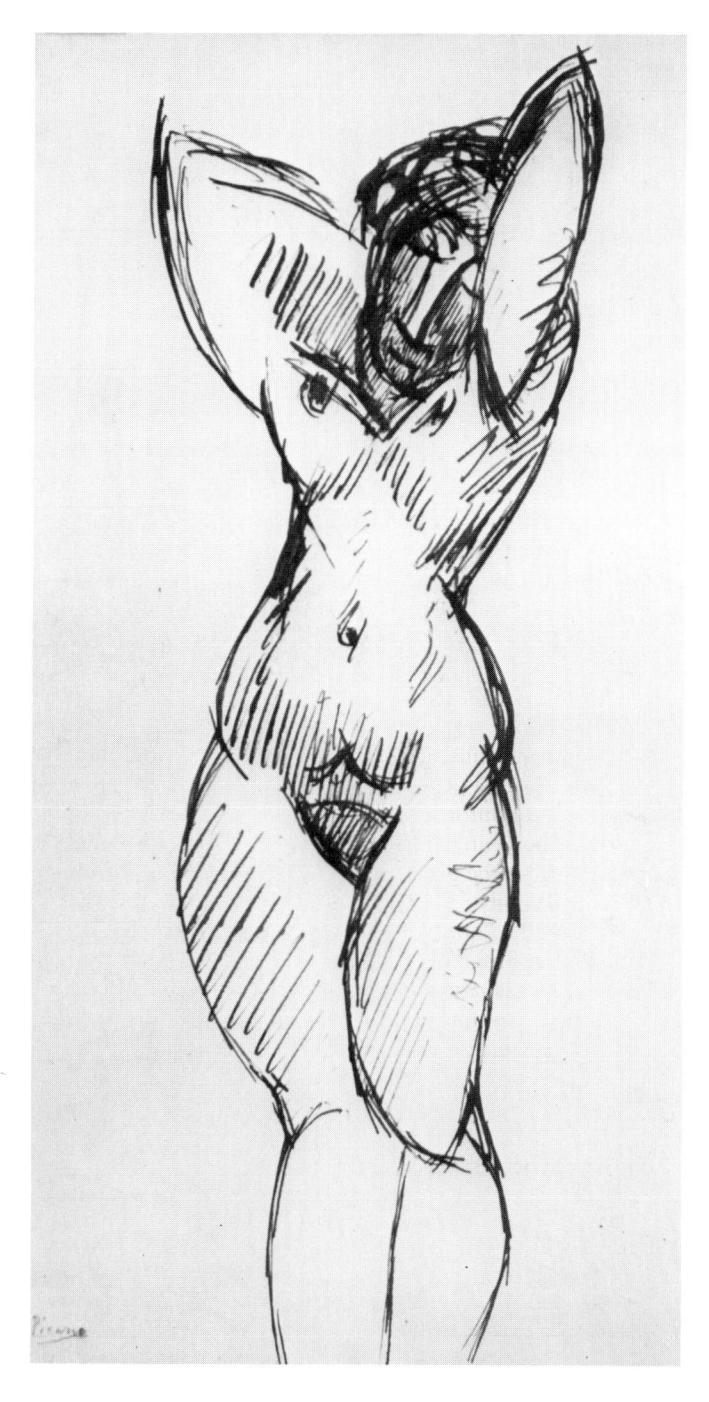

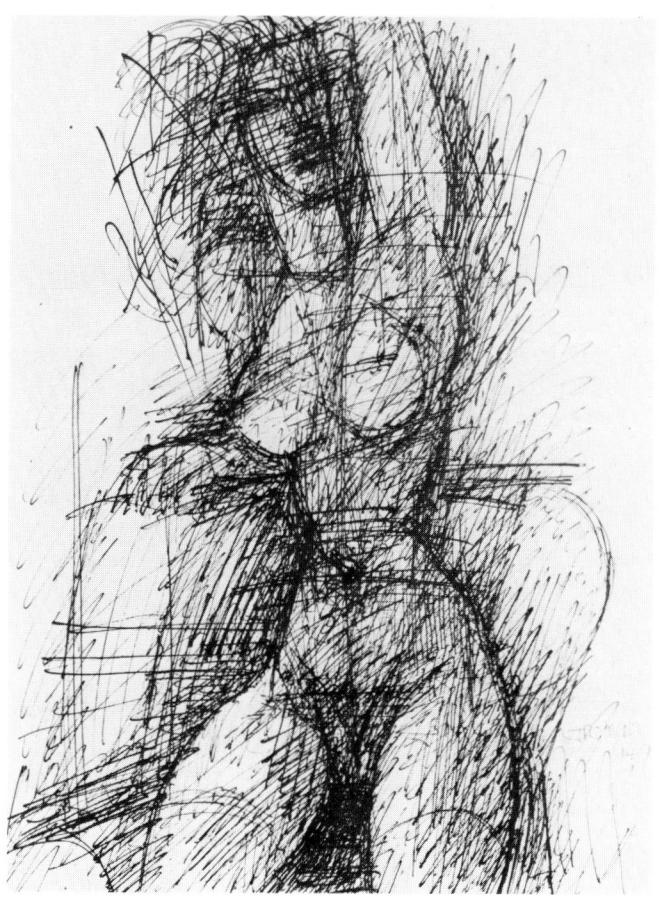

47. Marcel Gromaire Seated Nude

This similarly stretching figure by Marcel Gromaire is drawn in pen and ink, using strong straight lines as well as curves. Gromaire once wrote that 'Art is either a game or a pastime or else it is an activity, an expression for which there is no substitute.' This drawing emphasizes the physical aspect of the activity, the pen reiterating the major axis, through the uplifted arm, between the breasts and through the navel to the pubic symphysis. The change of angle of the minor axes (for example the angle of the breasts compared with the angle of the hips) is also relentlessly hammered. This expressive violence is carried through into the background, so that figure and ground are joined.

46. Pablo Picasso Female Nude with Raised Arms

48. Gentile Bellini

A Turkish Woman

Two studies of seated figures – one by Bellini, one by Gauguin - drawn in different media, but with a consistent viewpoint. (Gauguin's model is, of course, seen from higher up than Bellini's.) Both figures are based on the idea of a four-square block; we can visualize this more clearly if we imagine the area occupied by these seated models on a ground plan. In both cases there is a subtle 'squaring up' of the lines used, in order to accentuate the idea of perspective and thereby convey the idea of forms occupying space. In Bellini's drawing of the Turk's wife this can be seen in the arms, hand, and drapery - some of the lines appearing almost ruled, and in Gauguin's sketch the Breton woman's cap/forehead is a straight line, running in one axial direction; almost at right angles to this is the line of the front edge of the cap, repeated by the twin edges of the ribbons falling behind the shoulders. Perspective is, of course, much more easily established when one can set up a relationship between two (or more) identical forms or shapes, so that parallel lines may be drawn (or imagined) connecting opposite points. The Turkish woman's knees are such parallel forms, as are the arms akimbo. Apart from in the head and head-dress, the perspective basis of Gauguin's study can be sensed in the rectilinear framework of the planes of the apron and even in the squared end of the sleeve, which indicates where the hand is firmly placed on the implied ground plane.

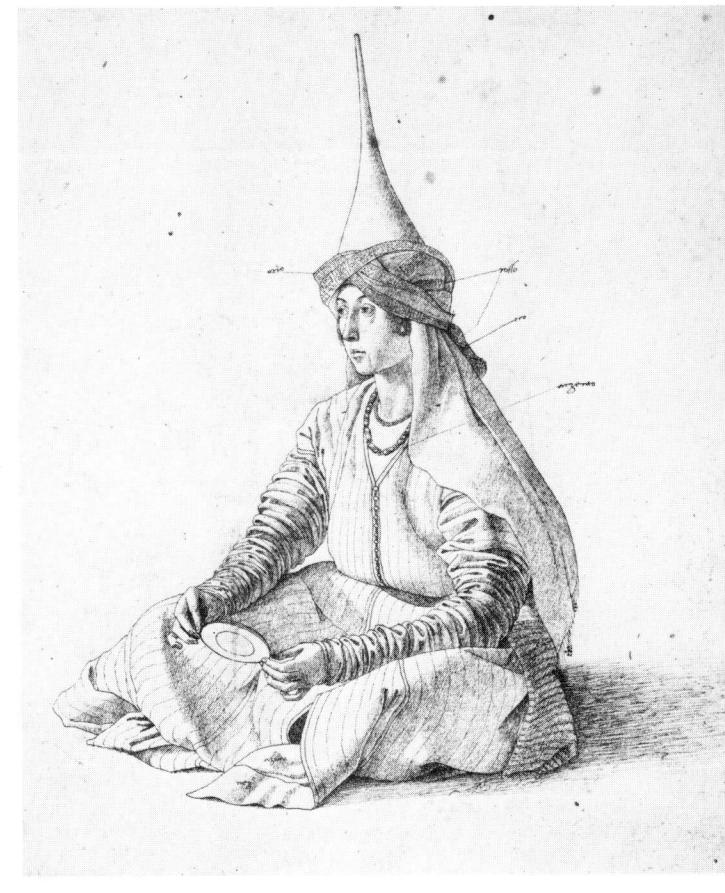

49. Paul Gauguin Woman of Brittany

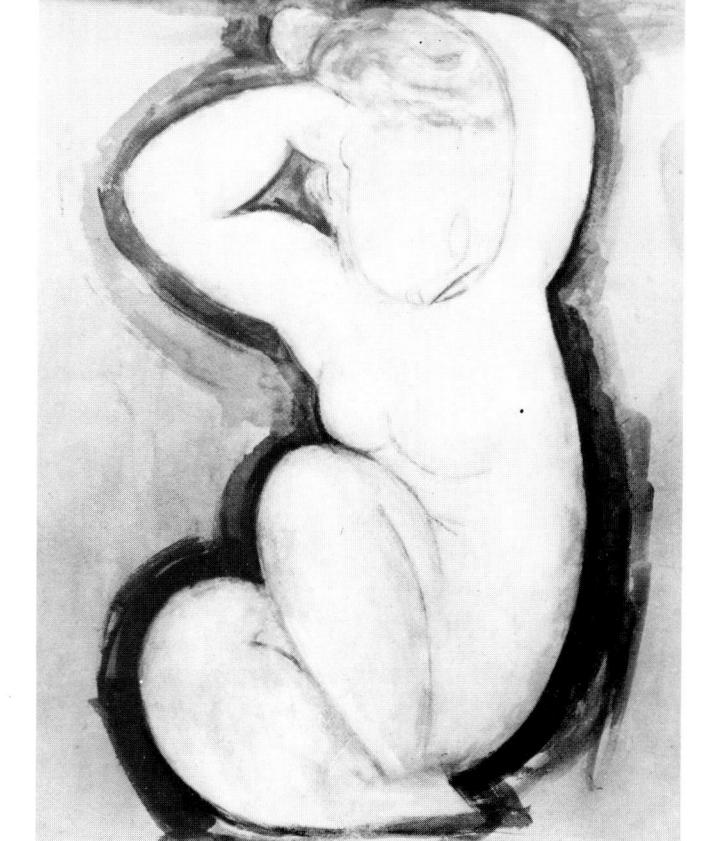

50. Guercino Seated Nude with Arms Upraised

The ink line, varying from barely perceptible to emphatic, enriched by a wash with a similarly wide range of expression, is typical of Guercino's brilliantly inventive draughtsmanship. This is not a pen drawing, nor is it a wash drawing; it is a pen-and-wash drawing resembling a duet, or, more appropriately, a pas de deux, where each partner complements the performance of the other; the result -a sense of unity.

51. Amedeo Modigliani Caryatid

In his early works Modigliani was influenced by the drawings of Steinlen and Toulouse-Lautrec, but the Cézanne exhibition of 1907 and the meeting with the sculptor Brancusi in 1909 reaffirmed his interest in plastic form. The series of drawings of caryatids which Modigliani executed in 1914-15 represents a transition between painting and sculpture. The compact shape of this drawing - the right elbow in line with the back, the left in line with the knee - calls to mind the basis of the structure, the simple cylindrical column. The influence of the sculpture of Brancusi is strongly felt in the lines of the head, which is designed to fit exactly into the enclosing arm; the features do not interrupt the simple contour. The heavy black outline/shadow serves two purposes: it throws the figure into relief and it emphasizes the unity of contour configuration. Pastel is applied to the figure to round and highlight the forms.

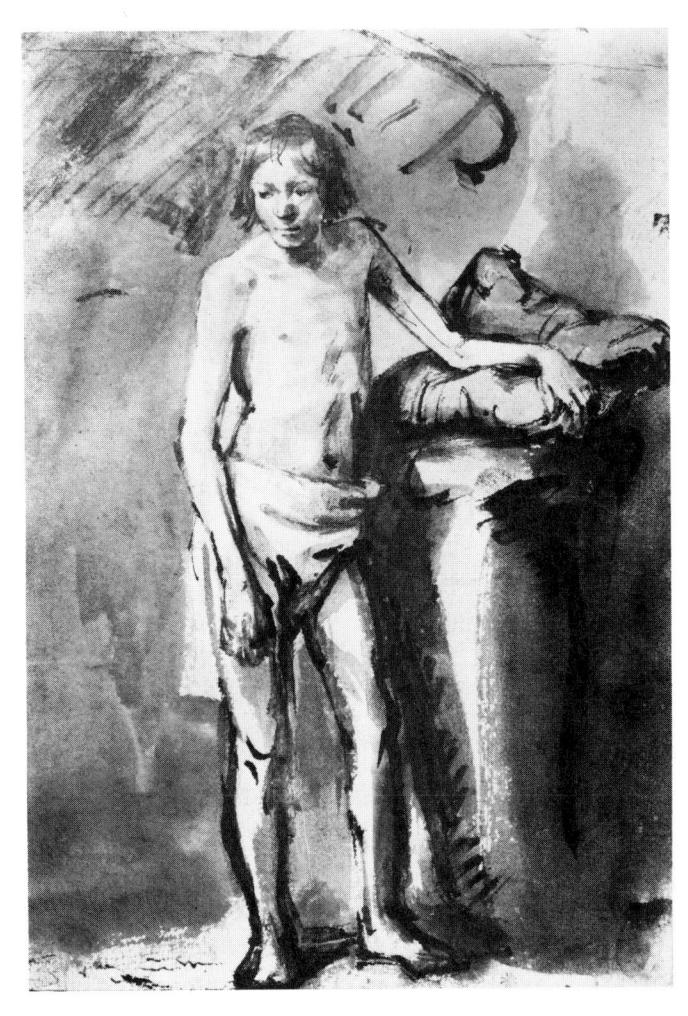

52. RembrandtNude Study of Young Man Standing

In Rembrandt's three-quarter view of the standing figure, carried out in bistre wash with additional pen-work, the weight is taken on the model's right leg, thrusting up the pelvis on that side, so that the shoulders compensate by tilting towards us. The sense of balanced pose and the sheer naturalness of the stance, with the model's right foot well under the body to support the weight (a position always underestimated by amateur draughtsmen, see Fig. 2), all add up to a subtle sense of movement. Rembrandt's hand and wash work in perfect co-ordination, and, as we often find in his drawings, the form is bathed in light, an effect created by the skilful contrast with dark shadow. Shadow is also used to convey space and depth.

53. Georges Seurat Standing Female Model

Seurat's technique of black conté crayon on white paper (see Ill. 71) uses the weave of the paper to break up the solid black and produce a sparkle of light in shadow areas. The formality of this pose - the model looking straight ahead with the weight equally distributed on both feet, placed together produces a static set of relationships, based on the axes of the figure. The central axis becomes a vertical line and the minor axes of the breasts and hands are at right angles to it. These directions are parallel to the edge of the paper and to the right-angled feature in the background. The vertical/ horizontal structures thus set up represent Seurat's reaction to the informality of the Impressionist composition and pose (while he looks over his shoulder to Cézanne, who had also wished to restore order and structure to Impressionism). As is usual in Seurat's drawing, there are no edges defined by lines; tones merge and edges are dissolved into background.

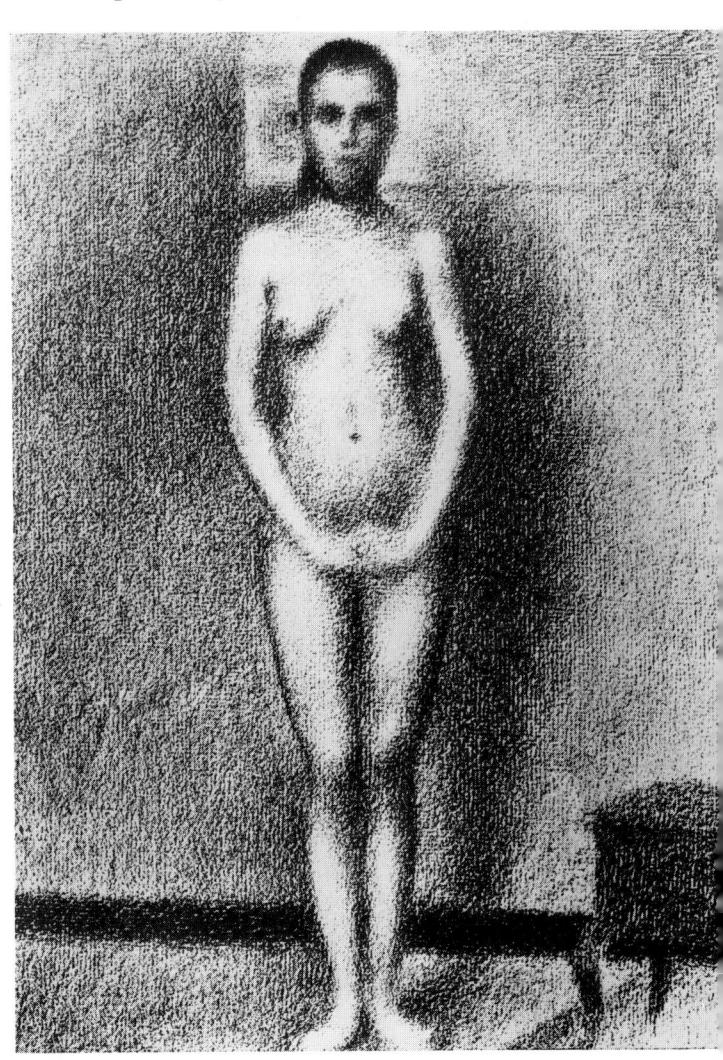

54. Henri Matisse

Nude

Here we have two different figure studies by the same artist, Henri Matisse, one of the founders of twentieth-century art. In 1908 Matisse wrote his Notes d'un Peintre, and, in looking at these drawings, we can largely let the artist speak for himself. He tells us that he dreamt of creating 'an art of balance, purity and serenity, devoid of troubling or depressing subject-matter', and he summed up his aim as 'simplification, organization, expression'. This simplification to pure line, totally excluding tone, is deceptive in its apparent ease, since the more that is omitted, the more significant becomes that which is retained. The effect of spontaneity was in fact the result of a deliberate and painstaking subtraction, a process of gradual reduction which Matisse achieved by tracing the significant lines of his drawing, simplifying them, and repeating the process until he was satisfied.

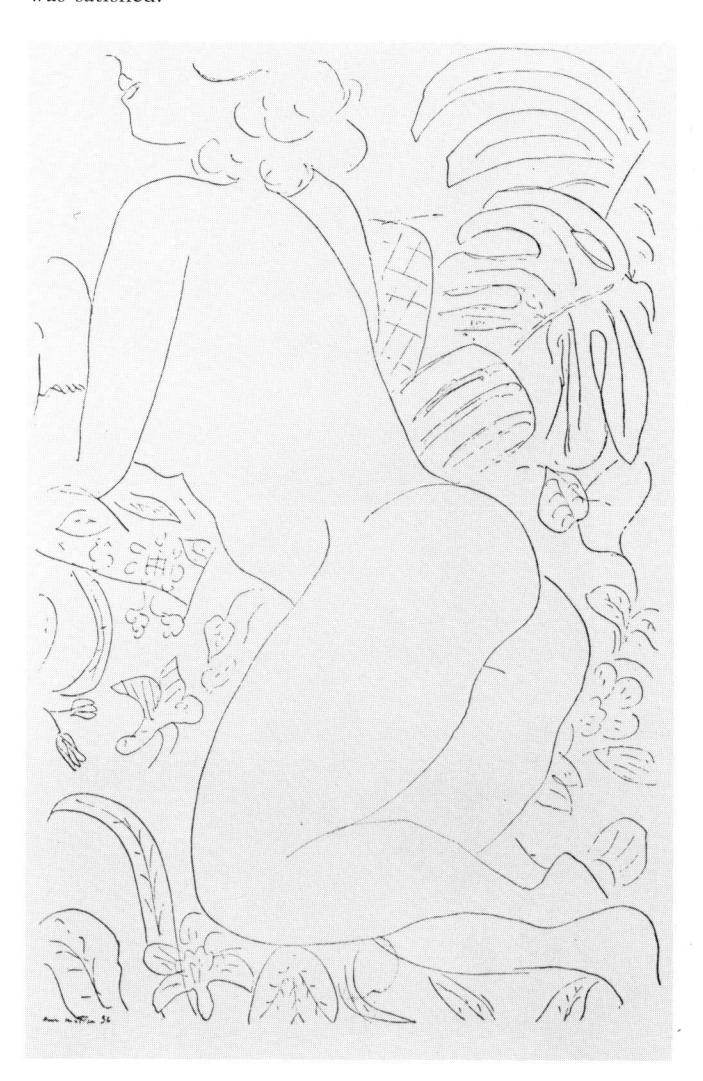

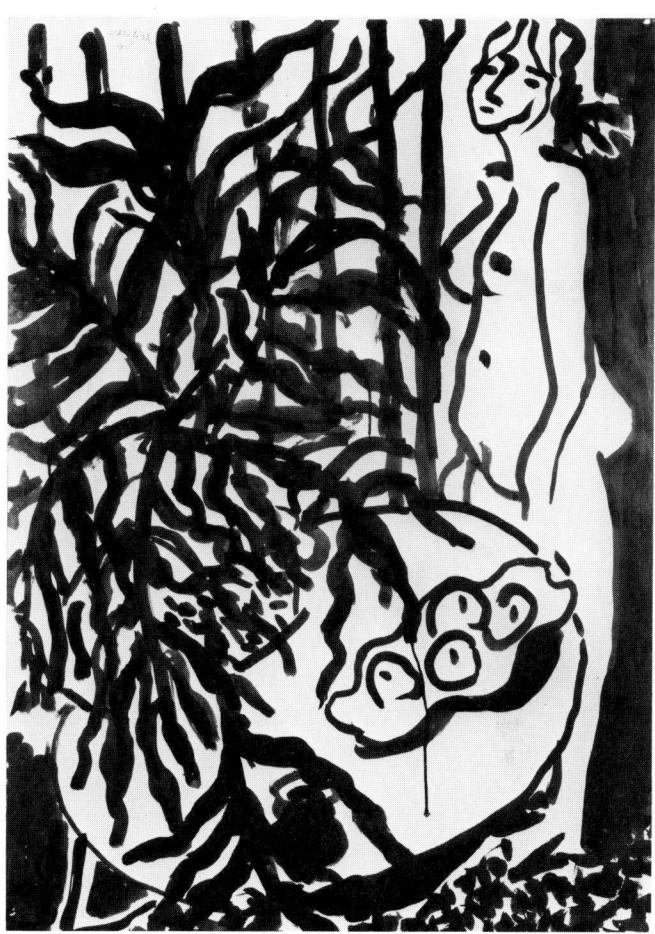

55. Henri Matisse Nude with Fern

As early as 1911 Matisse was interested in the flat patterns and decorative arabesques of Islamic art, with their brilliant floral backgrounds, and he experimented with them in his own work. In this composition it is difficult to say which is background and which is foreground since positive and negative spaces are carefully balanced and closely integrated: 'the whole arrangement of my picture is expressive'. Rarely do we see black and white used to create such a dazzling pattern of movement and colour. It is interesting to note that Matisse, a master of colour, confined himself in all his drawings to black and white: 'a colourist makes his presence known in even a simple charcoal drawing'.

Figure Composition

Composition is the process of arranging and organizing pictorial elements within a space or area in order to produce a conceptual unity. By pictorial elements are meant the point, line, tone, and colour. In figure composition these elements are simply part of or inherent in the figure(s), so that the lines of a figure may express a powerful linear thrust in a certain direction.

In designing a figure composition it is useful to have some idea of the placing of the figures on a ground plan, imagining the space required by the figures as if they were on a chess-board, and visualizing possible alternative positions. (Seurat was clearly able to do this.) Repeating units, such as heads or hands, are useful in producing a sense of rhythm or pattern. William Blake was well aware of this and often made use of it.

Linear thrusts or forces are created by lines (or implied lines, such as the direction of a gaze) moving in a certain direction. These lines are used to link together the different forms and guide the eye along predetermined visual pathways. Whereas the linear forces are designed to produce a sense of balance within the picture space, the tonal areas of light and dark of the figures or their background are largely responsible for a sense of pattern. Composition, then, is the art of juggling with all these elements (and colour) at once, and arriving at a feeling of unity as a result.

The art of composition seems to have been virtually ignored by Paleolithic artists and they rarely included any representation of human figures in their work. Egyptian artists, however, developed a system of figure composition which, in spite of its rigorous limitations, proved sufficiently versatile for all their needs. Figures were allowed to overlap each other, thereby creating a certain spatial quality, but change of scale was related to social standing or degree of importance rather than distance, and since the feet of the figures were always firmly placed on the same horizontal ground line, the illusion of distance was effectively contradicted. Greek artists, judging from mosaics and ceramics, were accomplished in the art of composition, and were able to adapt their figures to fit the required shape, even when this was the circular bowl of a drinking cup. Roman artists, inheriting the Greek experience, had a basic understanding of perspective, and succeeded in arranging their figures in depth. Medieval artists concerned themselves with expressing emotional and spiritual intensity and so found the finite spatial

relationships of life on earth largely irrelevant. It was only during the Italian Renaissance that figure composition really came into its own. Divisions of a space by its internal geometry (see Fig. 3) and the use of the golden section system of proportions were the guiding principles, providing linear division, direction, and proportions for the disposition of the figures. Furthermore, with the development and increased understanding of perspective, artists were able to arrange their figures not only in depth - nearer or further away - but also on different levels. The aim of the designer of the classical Renaissance composition was to produce a balance of shapes, forms, and forces contained within the available picture space, with, wherever possible, the direction of forces and the disposition of the figures parallel to the picture plane. (These principles were revived and adopted by Poussin as well as by Cézanne.)

If the general effect of Renaissance composition, balanced and essentially static, could be symbolized by a triangle, its base firmly parallel to the front edges of the picture, then the Baroque composition may be represented by the figure eight, lying on its side, and in perspective, describing a sense of interweaving movement in depth (see Fig. 4). The compositional attitudes of the eighteenthcentury Rococo artists favoured a smaller, rippling movement rather than the large sweeping waves of the Baroque artists of the previous century, but in the nineteenth century the invention of the camera produced a revolution in compositional ideas. The 'close-up', where one had to look over the top of, or beyond, a foreground feature in order to see the ostensible subject, was a device borrowed from the photographer, as was the whole idea of the casually contrived 'snapshot' composition, and the cutting-off of the edges of figures by the picture frame (see Ill. 69). But in this century it seems that some artists, for example Picasso, Matisse, and Mondrian, have preferred to return to the classical idea of a balanced system of relationships contained and confined within the picture area.

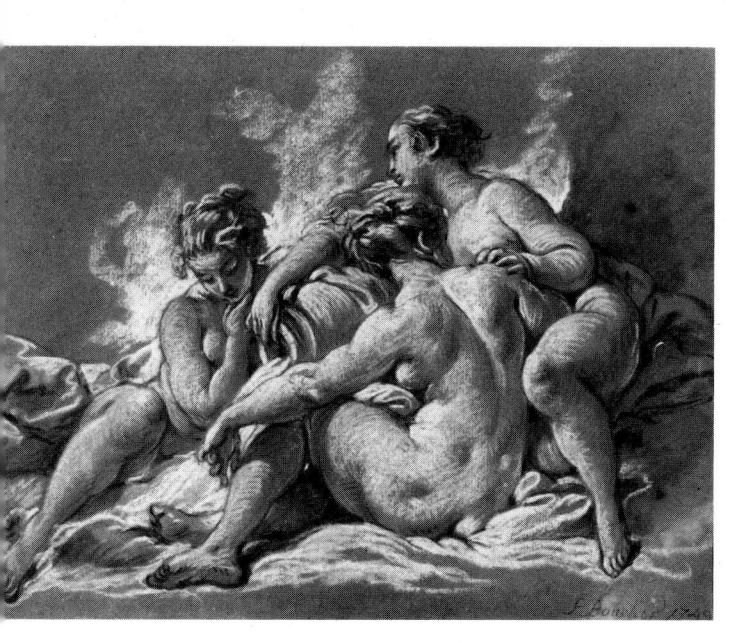

56. François Boucher Three Nymphs

Boucher's three nubile young women seem to be the same one seen from different angles, but always from a position which shows the dimples and folds of flesh to their best advantage. This tightly knit composition of intertwining arms and thighs, where all the forms (including the vessel) are fully rounded, is typical of the eighteenth-century French Rococo a period which Boucher represents so well. Boucher is essentially a decorator, and his young women (like his drawings) are nothing if not decorative. His light chalk travels caressingly over the rounded forms, all of which are expressed in terms of curves: curved lines incessantly overlap, or are overlapped, by the next. Although this may sound slightly mannered, Boucher does it with charm and elegance, and with an eroticism which is an integral part of his vision.

Boucher often uses different-coloured chalks on a middletone paper to achieve the maximum effect of modelling; the sideways use of the chalk, chosen to create broad effects in the background, is unusual, since it is a method generally shunned by artists on account of its associations with the slick or superficial approach. Boucher used it quite frequently, though, and seems to be able to get away with it quite cheerfully!

57. Paul Cézanne Four Bathers

Cézanne's is a totally different viewpoint from that of Boucher, as we see in this apparently rather halting drawing. Cézanne once expressed a wish to be able to 'do Poussin again, from Nature', and made numerous studies for his compositions, including groups of female figures; these were not, however, always drawn from life. Following the methods of Poussin (see Ill. 79), Cézanne arranged his figures in accordance with the basic geometry of his chosen rectangle. This means that the diagonals of the rectangle (and parallel diagonals) play an important part in the disposition of major directional movements. The diagonal line of the seated figure in the foreground, continued along the line of the outstretched arm of the standing figure, is an example of such a movement. This drawing is a formal design, based on classical principles. The figures are placed parallel to the picture plane and all is carefully arranged to create a sense of order and balance. How different from Cézanne's Impressionist contemporaries who were concerned above all with light. Here, although the light apparently comes from the left, the patches of tone appear to be quite arbitrary; in fact, they are all expressed as rectangular patches, suggesting abrupt changes of plane rather than any particular lighting effect. In short, this is a drawing of planes rather than women; everything is conceived in terms of structure.

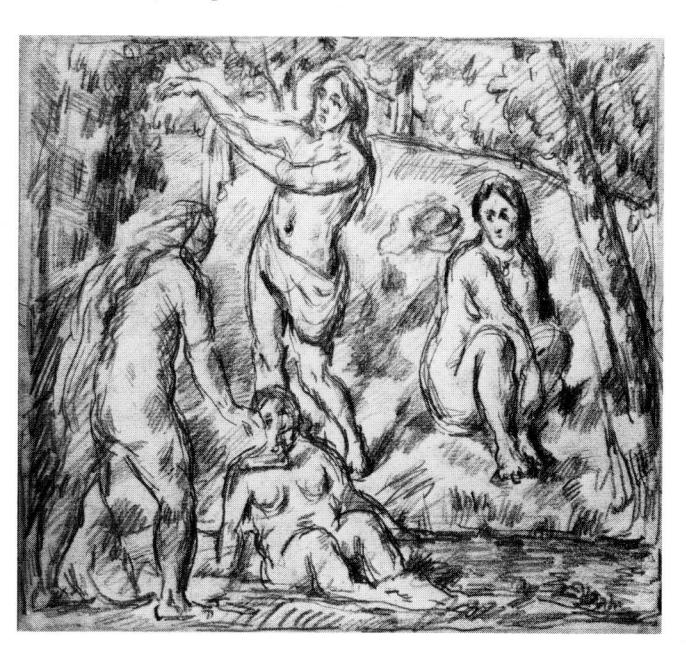

Here we see studies of the Entombment by two master draughtsmen whose careers overlapped. The difference in approach is the difference between the logical and intellectual background of the Renaissance world, where everything is securely based on classical models which have stood the test of time, and that of the medieval world, where the imagination and an acute awareness of the next world is more important than the everyday reality of this one. Raphael sums up the classical art of the High Renaissance, solving all

compositional problems with complete assurance. The graceful, rhythmical lines, or implied lines (such as that enclosing all the heads above the body of Christ) are contained within the picture area; whichever linear path we follow we find it leads to another, which in turn leads us with gentle inevitability back to our starting-point. Above all, the lines are carefully balanced: the curves of the figure on the left, balanced by the figure on the right, are only the abutments for the complex balance of linear thrusts between.

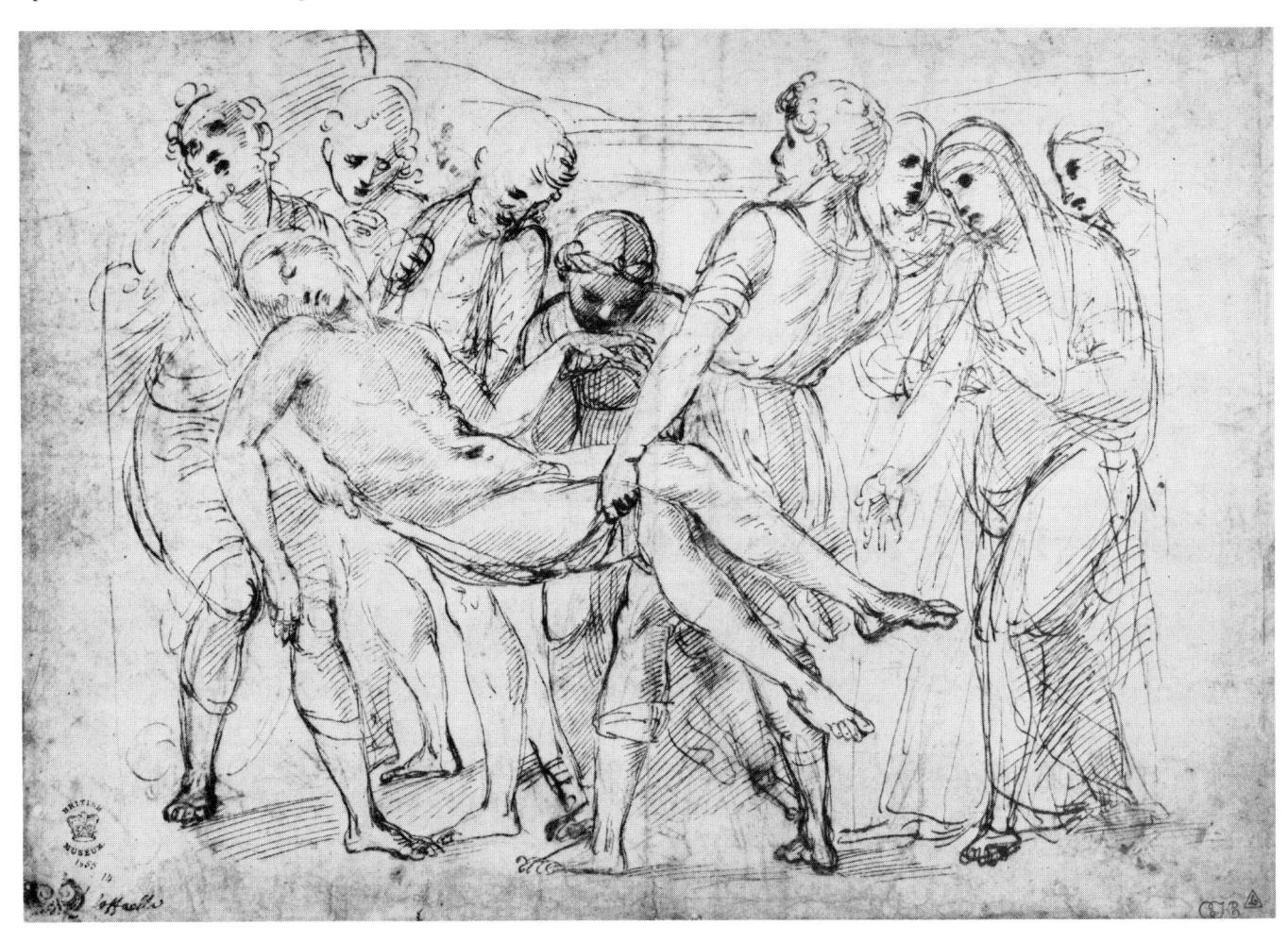

58. Raphael
Composition-Study for the Borghese Entombment

59. Hieronymus Bosch Entombment

Bosch's version of the subject is very different in character. There is nothing here of Raphael's graceful urbanity. Everything is angular, nervous, and uncomfortable. The Crown of Thorns is upheld to show the aggressive spikes, like barbed wire; the sharply pointed beards and pointed hats, and the abrupt angularity of the drapery, all suggest pain and suffering. There is an edgy quality about the drawing (due to the narrowness of tonal areas) which is in keeping with the edginess of the participants, who look guiltily over their shoulders as they are caught in the act of trying, in a kind of furtive haste, to hide the body.

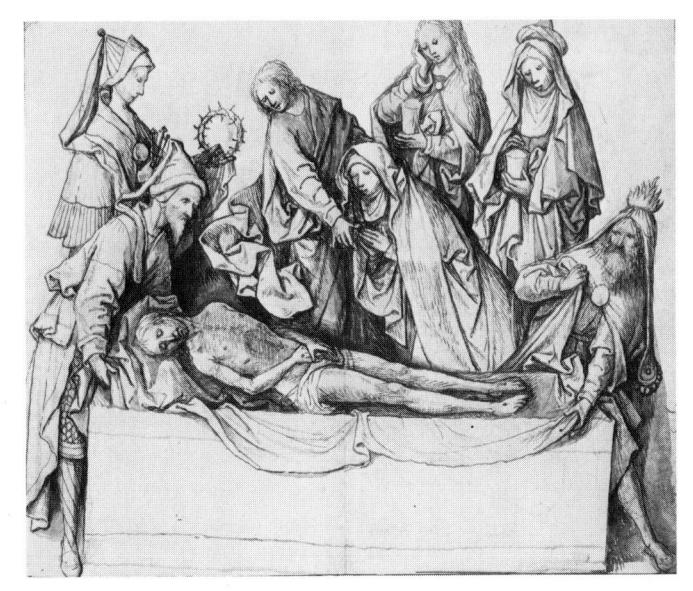

60. Pablo Picasso
Two Figures, Hands Clasped

Composition involving only two figures poses its own special problems, since it is difficult to create a feeling of grouping, balance or compositional unity; the two individuals must be linked together in some way if a satisfactory visual relationship is to be achieved. Picasso solves the problem of balance by using a kind of 'repeat' motif: the two figures echo each other as they adopt almost the same pose in reverse. The accentuated intertwined hands are similarly reversed and create a powerful linking device. The figures in this closely constructed composition are modelled with soft pencil on a coarse paper and are drawn in a kind of monumental sculptural idiom, a method to which Picasso frequently returned throughout his career; the result is a very compact unity.

61. Paul Delvaux The Siesta

Delvaux's composition has a similarly compact feeling. Here we have three figures, one reclining diagonally across the picture space, leaving two very awkward triangular shapes to fill. Delvaux solves the bottom right-hand corner by a particularly inventive pose; the figure in the background is related to the principal figure by a parallel movement. The central figure reclines elegantly in a hammock, whose netting construction is reminiscent of the scales of a fish; in fact the

whole shape is very fish-like, suggesting a fleeting analogy with a mermaid. As is usual in all Delvaux's work the perspective is very exaggerated, the lines converging too sharply for comfort and conveying that sense of another reality which was sought by the Surrealists. Although the sun (or moon) is in the sky, there are no shadows in this dream world. What little tone there is, moves only from one side of the line to the other to give a sense of plasticity.

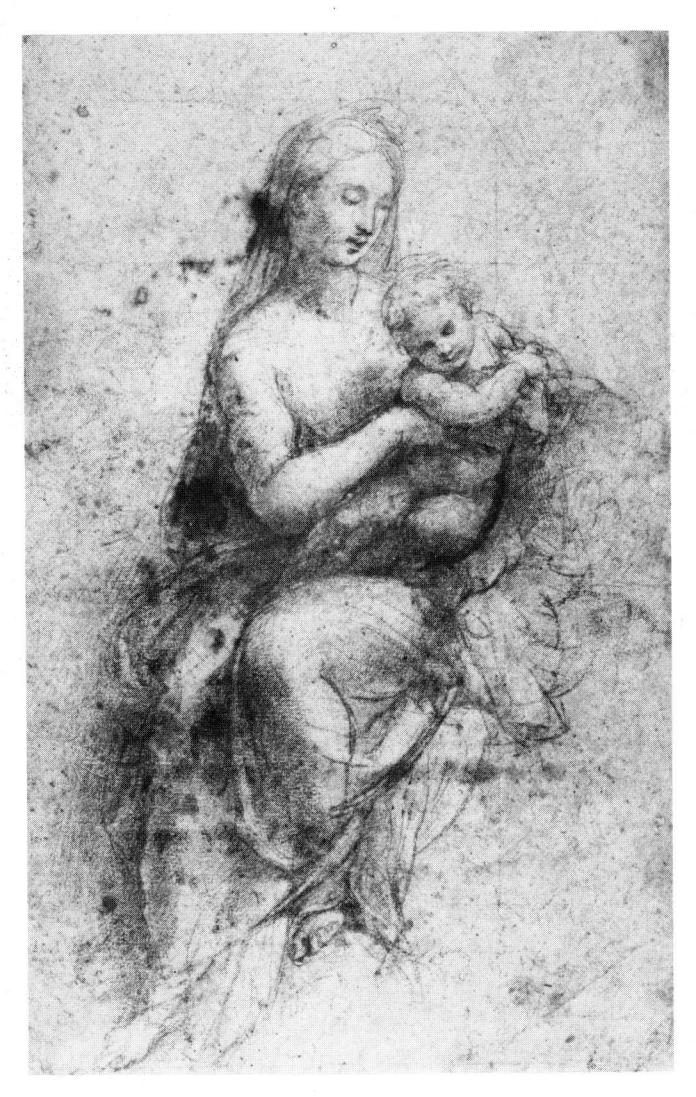

62. RaphaelThe Virgin and Child: Study for the Madonna di Foligno

There are countless examples of the archetypal theme of mother and child, and many artists of the Renaissance found it a rewarding and challenging subject. Although two figures of the same size can present certain compositional difficulties (see Ills. 61 and 62), in the case of the mother and child relationship, the child can be treated as virtually part of the mother, thus making a compact pyramidal group. In this typically balanced composition by Raphael the main axial direction of the Child's body is the exact counterpart of the Madonna's arm. Raphael models his forms so that we can feel them as existing in the logical space created to contain them. For a good example of this quality, look at the definite distance between the Madonna's head and that of the Child. This is an example of the best in classical draughtsmanship:

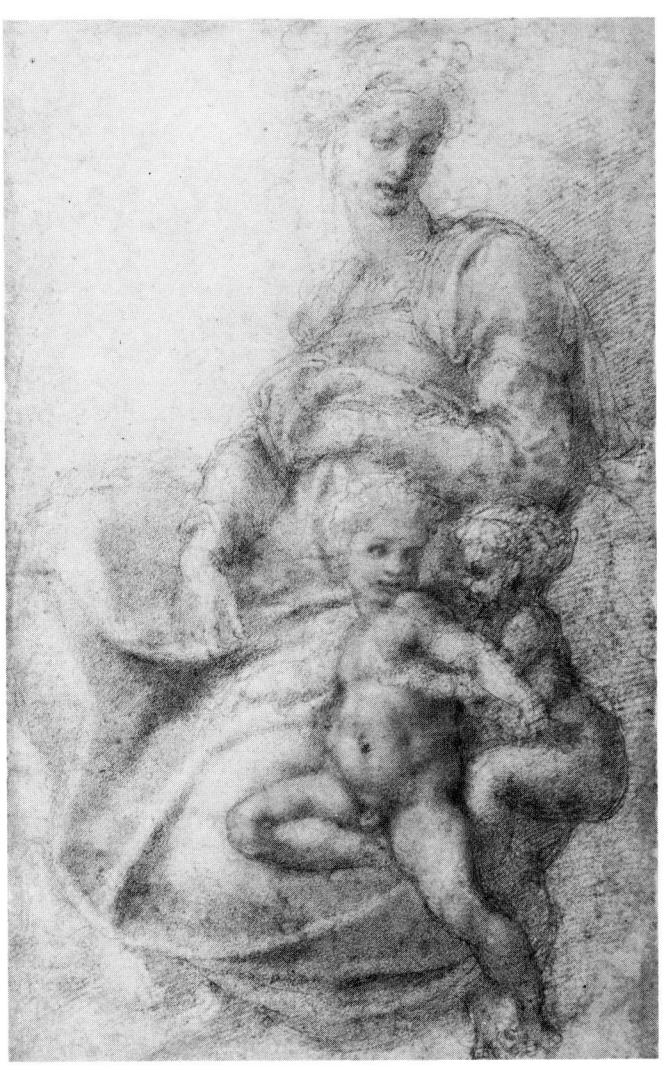

63. MichelangeloThe Virgin and Child with the Infant St John

form, drapery, anatomy of the figure, and foreshortening are all treated with an ease and assurance based on knowledge and understanding.

The triangular grouping is almost a trademark of Renaissance artists. Michelangelo, whose first love was sculpture, welds the Infant Christ and St John firmly to the Madonna. All the forms are fully modelled to suggest the utmost plasticity. The swirling drapery forms a kind of protective cocoon enveloping the children; their heads are placed to coincide with the protective arm of the Mother Figure. Integration of individual forms into an overall unity can hardly get any closer than in this sculptural group. So little would have to be carved away from the original pyramidal block!

64. Dante Gabriel Rossetti

Hamlet and Ophelia

Although these two versions of Hamlet and Ophelia are so different, the underlying mood is curiously similar. It has been said that one of the basic flaws of the approach of the Pre-Raphaelites was that their inspiration was literary rather than visual, and that they were preoccupied with elaborate moral allegories and images which were essentially non-pictorial. (However, Delacroix was equally inspired by literary sources without apparent detriment to his art!) This composition by Rossetti (a poet, who consequently may have tended to think in verbal images rather than in pictorial terms) is essentially claustrophobic, overwrought, and overcrowded. Not only is it overcrowded with detail, but there is little room for the figures as the spatial relationships are so ambiguous. Rossetti seems to have had difficulties with perspective; Hamlet's arm, as he plucks the rose, flourishing in the hot-house atmosphere, appears to be more a short arm than a foreshortened arm.

Everything is elaborately detailed. Surfaces are carved, embroidered or patterned. Throughout the drawing a rich interweaving pattern of lines reminds one of Celtic ornament and medieval illumination. In fact, the drawing may be read in the same way as a page from a manuscript, our eye exploring the intertwining linear rhythms.

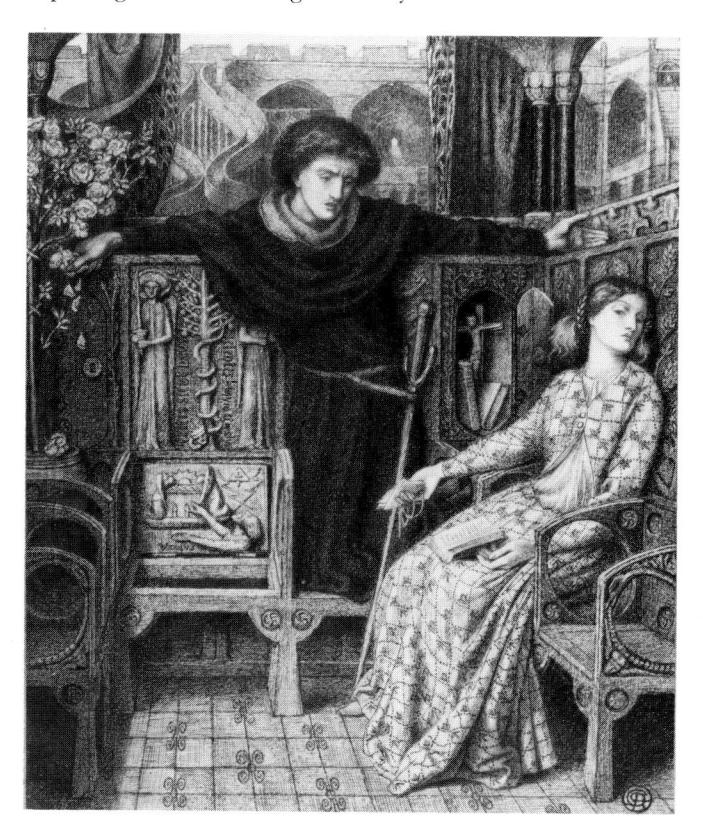

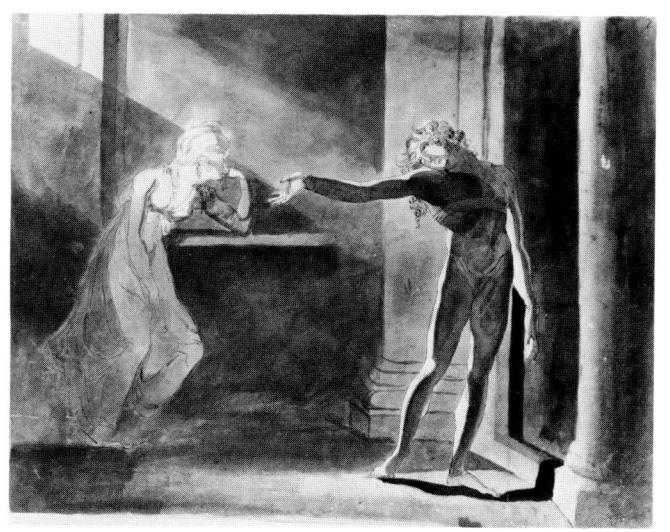

65. Henry Fuseli Hamlet and Ophelia

Fuseli's version of the subject is very different. Instead of the overcrowded hot-house atmosphere of Rossetti's setting we have a completely bare, chillingly cold mise en scène, and a complete absence of detail or decoration. But there is a certain similarity of mood in both these romantic works. Fuseli's heroines, like Rossetti's, tend to drift about in trailing garments. Ophelia is shown in a state of acute ennui, bordering on collapse. (Romantic artists and poets have always tended to associate romantic love with sickness and lingering death.) Hamlet's gesture is just as languid as that of Ophelia in Rossetti's drawing. But in spite of all this dreamy posturing the drawing still makes a strong impact on us, largely because of its use of dramatic tonal contrast and the powerful spotlight, which creates strong shadows and illuminates the stark architectural setting, emphasizing the scene to the point where drama becomes melodrama.

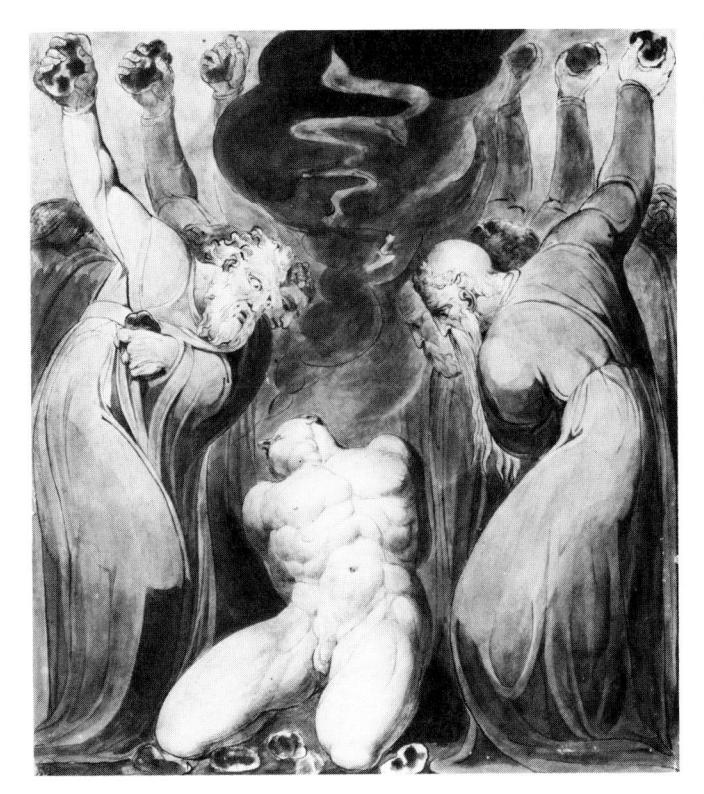

66. William Blake The Blasphemer

'What does "precision of pencil" mean? If it does not mean outline it means nothing.' The view of William Blake, poet, artist, and visionary, is reflected equally in the work of Stanley Spencer. Both artists were visionaries, seeing eternity in a flower, and taking for granted Christ on earth as an everyday experience. Blake, like Spencer, drew with clear outlines, probably partly because of his training as an engraver, but also in order to give the utmost clarity to his visionary experiences, which for him were more real than those perceived by the mere mortal eye. Blake's drawings can sometimes be monotonous, being based on sixteenth-century engravings after Raphael and Michelangelo; also, as we see here, his idea of musculature is schematic rather than observed; however, the sheer power of his conviction transforms the visual clichés, enabling us to share his experiences – experiences which, although expressed in terms of second-hand neoclassical formulae, are conveyed with a medieval sincerity and force. This composition, like many of Blake's, is essentially symmetrical. The tight handling and firm sculptural modelling derive from the compositions of Raphael and Poussin (the tradition of figure composition was not yet firmly established in Britain). The twisting rhythms of the central figure are balanced on each side by the powerful rhythms of the Old Testament figures, collective symbols of ancient authority rather than individuals. The repeating motif of the massive upraised arms suggests the repetitive movement of many, rather than just the few actually depicted.

67. Stanley Spencer Chopping Wood in the Coal Cellar, Elsie

In Stanley Spencer's Elsie Chopping Wood the pencil line is almost mechanically precise: every line is perfectly balanced (just like the archetypal figure perched on the egg box!). The modelling is slight and controlled, neat, precise, and methodical; it has nothing to do with the direction of light, but is simply an adjunct to the line. Spencer manages to give a sense of visionary significance to the mundane scene: the changing viewpoint (sometimes looking down, sometimes up), the curious, almost hallucinatory, clarity of detail, the ambiguity of space and place, the odd relationship between the three figures, and Elsie's preoccupation with something else, give this composition of taut curves a strangely otherworldly quality.

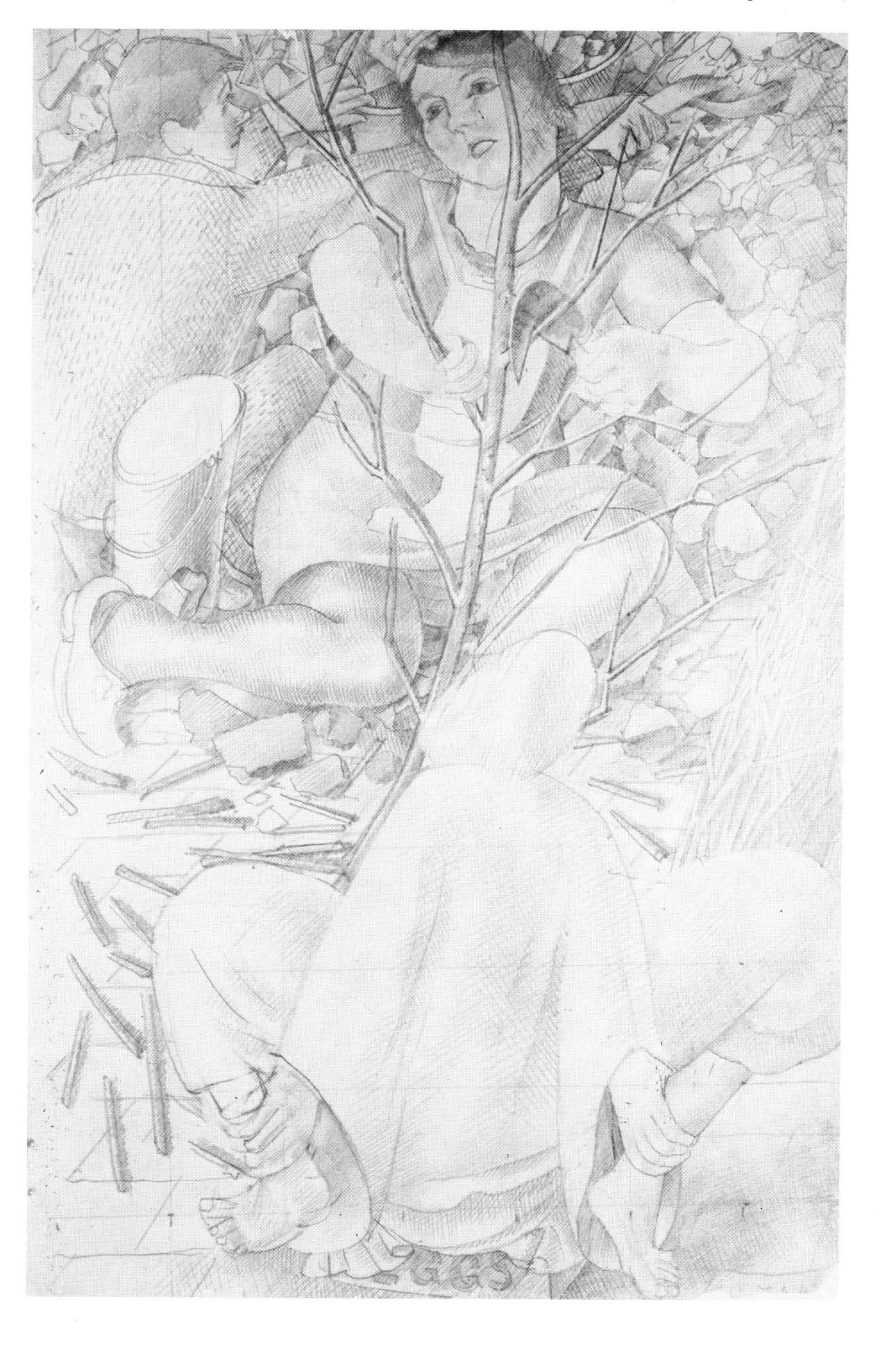

68. Rembrandt

Group of Three Women before a House

Rembrandt has built up this composition by using overlapping forms to create a movement in depth. The foreground figure is seen in three-quarter back view, the next is rotated to a near profile; the suggestion of a chair - a mere two or three lines - bridges the gap to the third figure, who is turned almost completely. Finally, the vertical edge of the 'counter' leads us to the standing figure who gently arrests the upward spiral and, by the downward direction of her gaze, returns us to the starting-point. This is an astonishing tour de force: so much space and form (notice the planes of the old lady's lap, and the form of the second woman's head underlying the head-dress), conveyed by so few lines – but how varied those lines are! Some are as broad and powerful as Van Gogh's, others are delicate and gentle, but always they link up with each other, almost as if this was a piece of calligraphy in which the pen never left the page. The result is complete unity; the individuals become a group linked by a psychological awareness of each other's presence.

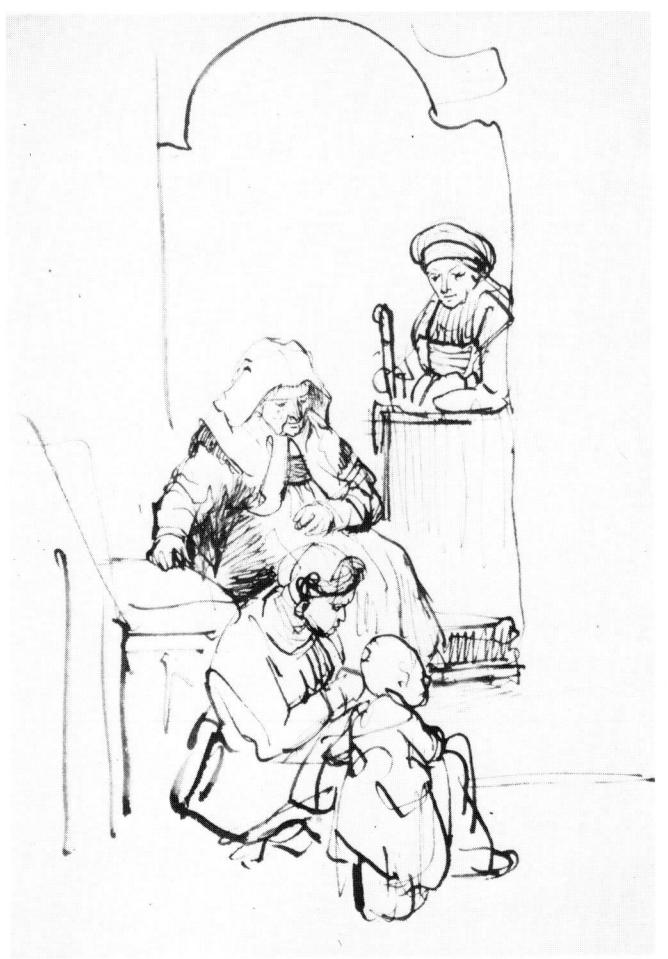

69. Henri de Toulouse-Lautrec At the Opera

Toulouse-Lautrec, like Rembrandt, has 'built up' this composition, superimposing one form on another, and using linear links to take our eye along well-defined visual pathways. Coincidental lines are used to create a continuity of surface movement: the bearded gentleman's stomach sweeps upwards to curve into the body of the singer, and the tailcoat of the conductor shares the line of the music stand. But this is also a composition in depth: from the dense solid black of the magnificent plumes of the hat in the foreground, we find a gradual diminution of tonal strength as we move back in space. Although Toulouse-Lautrec's composition has much in common with Rembrandt's, there is another factor which is in evidence: the influence of the camera. The foreground opera-goers are seen in 'close-up' and we must look over them to see the principal characters. This apparently casual arrangement of figures cut off by the frame is in fact very carefully contrived, and is often found in Toulouse-Lautrec's sketches and paintings.

70. Thomas Gainsborough

Second Study for the Duke and Duchess of Cumberland

A masterly compositional sketch by Gainsborough of the Duke and his wife strolling in the grounds of Cumberland Lodge, while the Duchess's sister sketches in the background. This is a particularly subtly balanced composition, with beautifully controlled variations in tone; in fact it is a drawing more of tonal variation than of three figures accompanied by a small dog in a park-like setting. By using stump to rub in and modify the tone, Gainsborough has produced a sense of outdoor light and shade through which the figures move. His judgement of tonal differentiation between the Duchess's hair and the background or the Duke's cravat, collar, and jacket, are examples of his perfect sense of tonal interval. Gainsborough has scrubbed in some white chalk between the Duchess's head and that of her sister as a tonal link, which completes the circular movement from the Duchess's trailing skirt and through the seated figure of her sister. In the finished painting this white patch becomes an ornamental garden urn in the background. If one half closes one's eyes and looks at this drawing only as differences in tone, one can see that it is a balance of light and dark subtly arranged in an oval, and in fact the finished canvas was painted in that format. The handling - a light, almost nonchalant scribble produces a feathery quality which reminds us of Watteau and the French Rococo, the inspiration for this kind of decorative work, which emphasized good manners and good breeding, and created a mood suggesting a leisured pace of leisured living.

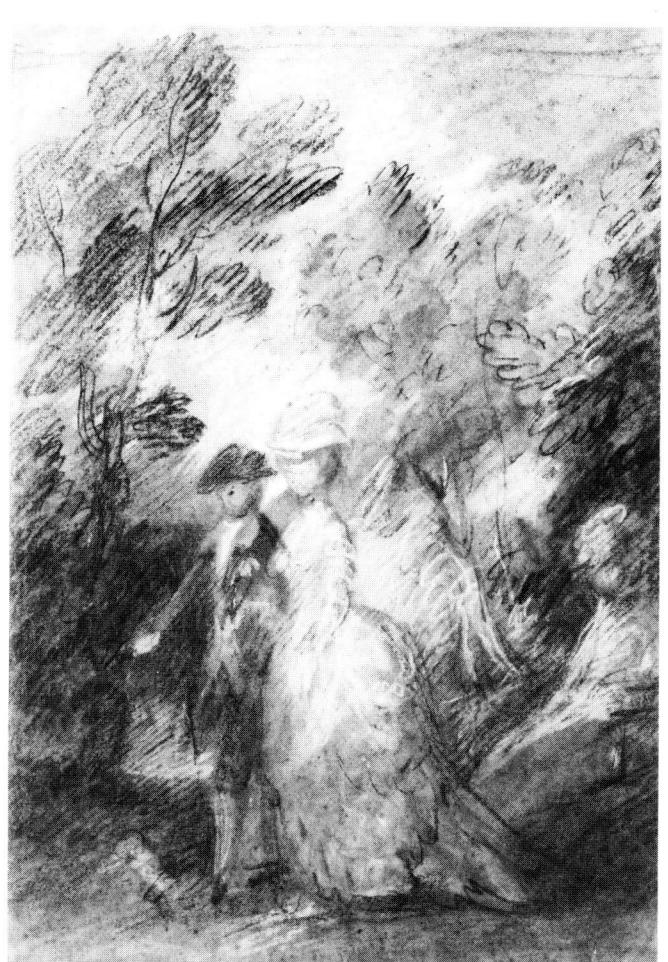

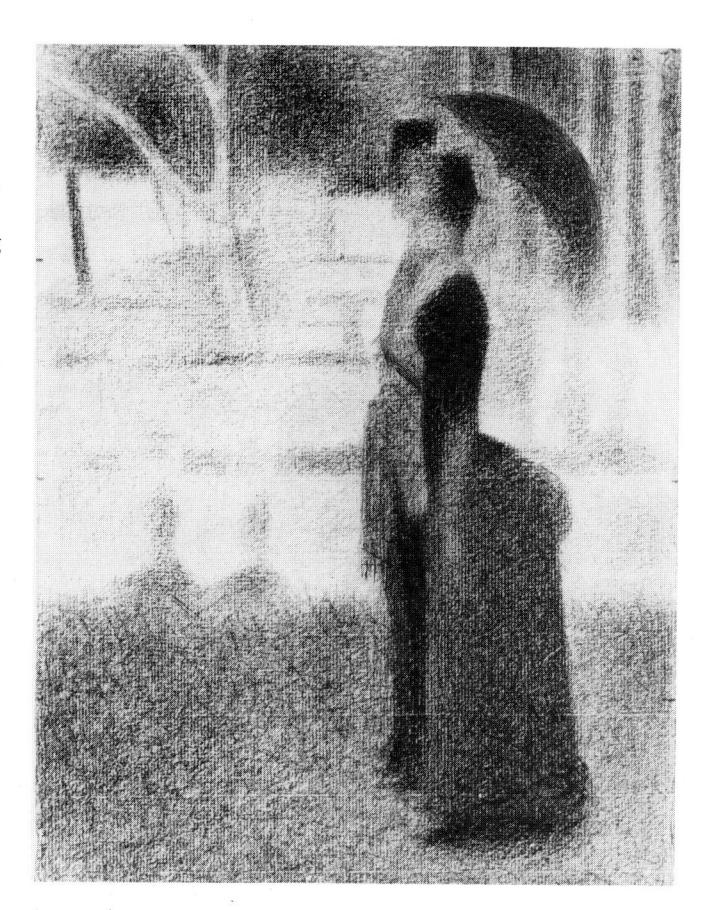

71. Georges Seurat Study for La Grande-Jatte

Another pair of elegant figures, equally fashionably dressed and strolling in a park-like setting, form the figure study for Seurat's painting, Sunday Afternoon on the Île de la Grande-Jatte. The curiously stiff and formal pose of this couple is repeated in the various little groups in the final painting, giving it a strange, hieratic quality. In Seurat's preparatory drawing, line (in the sense that Ingres used it, see Ill. 34) plays virtually no part. Everything is described by tone, using black conté crayon on white paper, and making use of the rough texture of the paper to break up the blacks and introduce an element of light even into the darkest shadows. Paul Signac, who continued the exploration of colour-theory after the death of Seurat, wrote: 'These are the most beautiful painter's drawings that ever existed. Thanks to Seurat's perfected mastery of values, one can say that his "black and whites" are more luminous, and even more full of colour than many a painting in oils.' Seurat's ability to express colour through tone in his drawings was equalled only by Van Gogh's ability to express light through line.

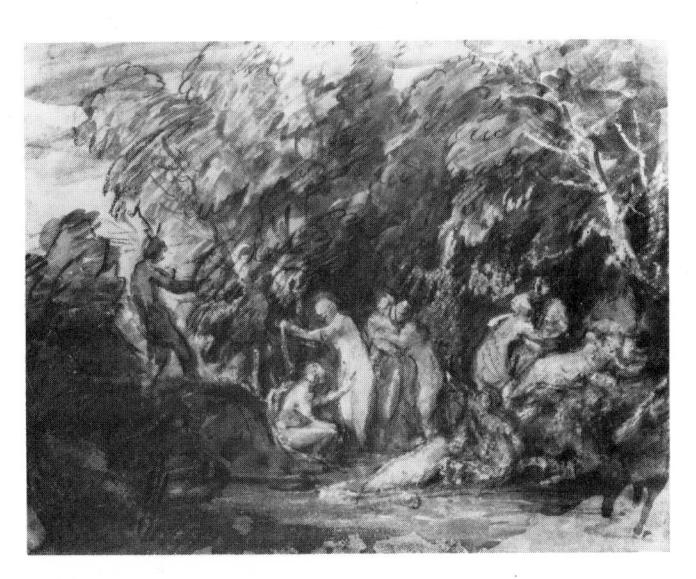

72 a, b, c Thomas Gainsborough Diana and Actaeon: preliminary sketches

Gainsborough painted only one picture based on a theme from Classical mythology, and this is also one of the very few cases where he made more than one preliminary drawing for a painting. The story relates how Actaeon, hunting in a sacred valley, accidentally discovered Diana bathing with her attendant nymphs; whereupon she threw a handful of water in his eyes and turned him into a stag, in which form the unfortunate huntsman was torn to pieces by his own hounds.

Basically, the main problem for the artist is that there are two main characters in the story, and a kind of chorus; one of the principal characters has to be separate, the other has to be part of a group. The problem, then, is how to reconcile this separation with the principles of compositional unity. The three preliminary sketches approach the subject in the same way: the semicircular pool sets the scene, and Actaeon enters abruptly from the left. In each sketch Gainsborough has kept his options open by choosing a mixed medium - chalk on wash and/or wash over chalk – and by working without too precise definition he has been able to keep the composition mobile and flowing.

The first version (72a) concentrates on the idea of the confusion caused by the intrusion of Actaeon, and this is expressed by treating the figures as small, separated groups, arranged along lines which recoil from Actaeon. There is a general thrust from the left towards the right-hand side. Diana's raised arm in shadow creates a rather tenuous link with the intruder. The twisted lines of trees and foliage contribute to the feeling of confusion and agitation.

In the second version (72b) Diana is moved to the left, reducing the gap between Goddess and intruder. The gap is further bridged by a much more decisive gesture. This time there are fewer figures, and the nymphs are arranged in a semicircle with Diana as centre. Actaeon's forward movement links him in a definite relationship to Diana, while the nymphs become merely spectators. Tonally, this composition is much more orderly and organized. Actaeon is emphasized and singled out by being silhouetted against the light, while the silvery bodies of the Goddess and her retinue are enclosed in the curved shadow of the foliage.

In the third preparatory sketch (72c) we have Actaeon silhouetted much as before, but the general mood of the composition (Gainsborough was a master of the evocation of moods) is much less agitated than before - partly because the figures are grouped more compactly. This is the version substantially used in the 'finished' painting.

In fact, the painting never was finished, in the sense of being brought to that fine degree of surface texture which is generally associated with the idea of 'finish'. The final work (73) brings Diana and Actaeon even closer together; there is no need for the forceful throw to bridge this gap, and Diana's gesture is much more graceful than before. She is now the centre of a small, close-knit group, which is linked by the waterfall and by the movement of the figures to a subsidiary reclining group on the right. Actaeon, instead of being separated by silhouetted tone, now sinks into the shadow and becomes part of the background, no longer seen as a serious threat to this group of bathers – nor as a disruptive influence to the unity of Gainsborough's composition.
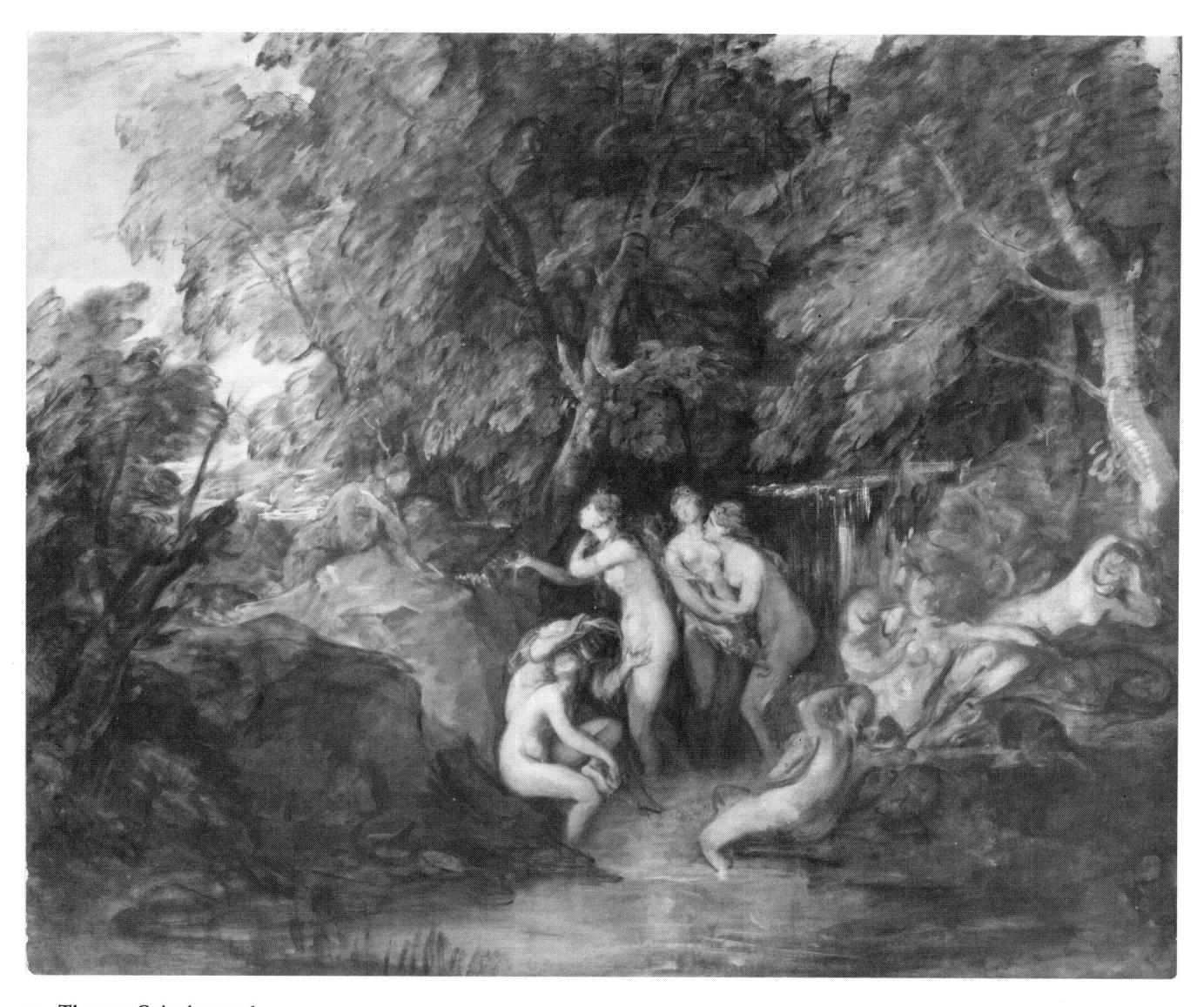

73. Thomas Gainsborough *Diana and Actaeon*

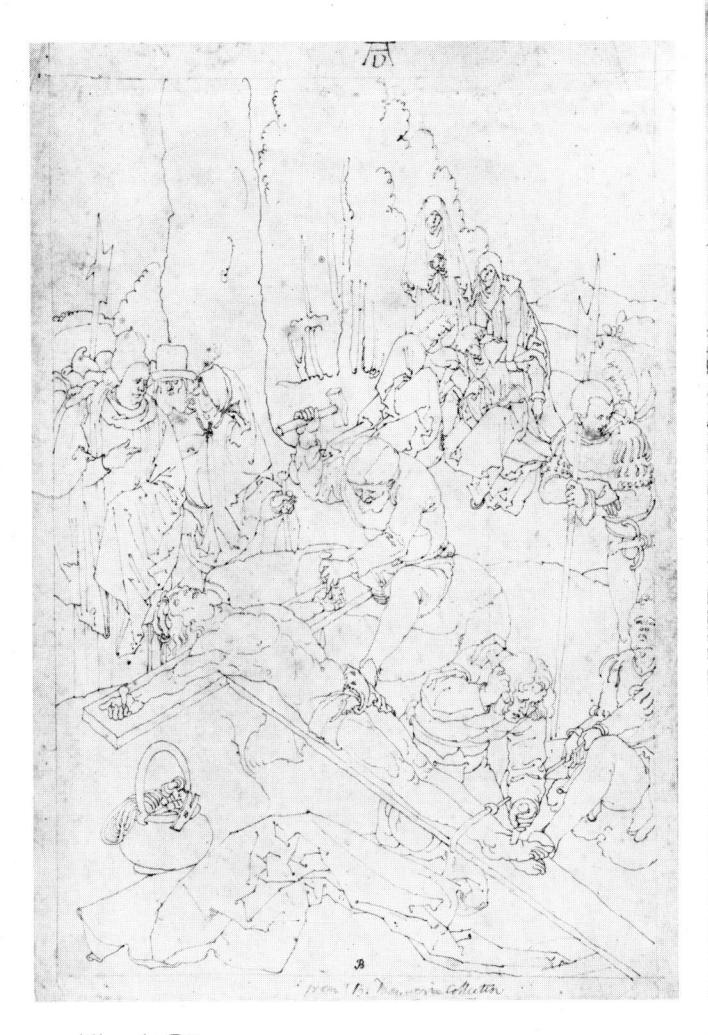

74. Albrecht Dürer The Nailing to the Cross

These two studies by Dürer of Christ being nailed to the Cross, one in line only, the other in tone, belong to a series of twelve drawings of the Passion (one of which has been lost). The linear construction of the composition, clearly defined in the first study, consists of a diagonal leading in from the bottom right-hand corner which is directed back into the picture by the top line of the Cross. This initial diagonal leadin leaves the problem of how to deal with a triangular space on the bottom left. Dürer uses this space for the tools of the trade of the workers who ply their grisly craft with all the objective professionalism they would devote to any other job of work. The carpenter's mate, bracing his foot against the Cross to get a better pull on the rope, creates a linear movement parallel to the top of the Cross (and to the poised hammer) which helps to create a sense of space through the use of parallels shown as converging in perspective.

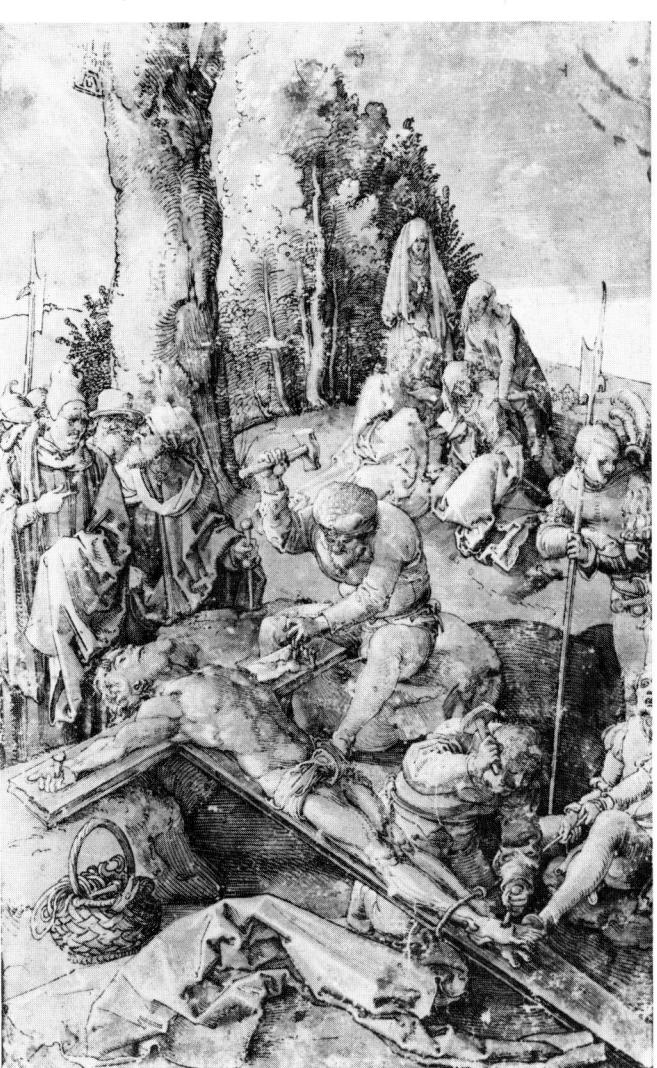

75. Albrecht Dürer The Nailing to the Cross

In Dürer's second study the sense of depth and space is made much more tangible by the addition of tone. We now see that the Cross is supported on two convenient boulders; the foreground drapery becomes almost part of the landscape, and the drapery line follows through to the shadow of the boulder, beginning a sweeping movement which continues behind the trees to the distant hill. The addition of tone also makes clear the main divisions of the landscape into foreground and middle distance, corresponding to the main and secondary figure groupings, and the relationship between groups of figures and groups of trees is now revealed. Finally, the tone is responsible for the sense of surface modelling on the forms: the tree trunk becomes rounded with surface indentations, the anatomical details of Christ's body are thrown into relief, and the textural differences become apparent (on the basket, for example).

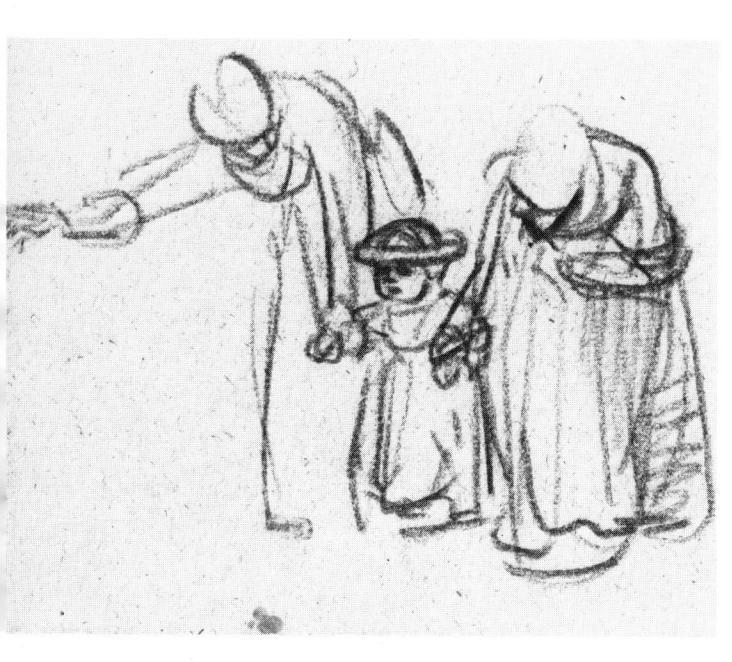

76. Rembrandt Two Women Teaching a Child to Walk

This arrangement of three figures is one of the most expressive drawings in this anthology. The figures move diagonally across the page as our eye is led to the outstretched arm pointing to the ultimate goal - a goal which is all the more difficult for us as well as for the child to reach as we do not normally 'read' from right to left. The ground plane is not drawn at all, but is clearly implied by the perspective of the figures.

By applying less pressure Rembrandt has allowed the texture of the paper to 'grin through' the chalk, breaking up the heaviness of the line where comparatively less emphasis is needed. Particularly well conveyed (with Rembrandt's usual economy of means) are the turned heads of the assisting women, their bodies foreshortened as they bend forward, looking towards their joint responsibility. Also, as we so often find in Rembrandt's compositions, there is a feeling of the characters' psychological involvement and awarenes of each other's presence.

Whereas Rembrandt's drawings are those of the painter/ etcher, Henry Moore's are those of the sculptor. This drawing is concerned primarily with form. The tone is applied solely with the intention of trying to express this idea, and there is no attempt to use the direction or quality of the lighting to convey mood, drama, or even the time of day. This is a purely formal invention, a set of three-dimensional forms created to balance each other, so that when one cylindrical arm grasps the child, the balance is restored by the arm opposite which grasps the bath. To Henry Moore space is just as important as form, and his close network of lines explores the spaces between as carefully as the forms themselves. It is irrelevant that the jug, bath and table do not bear any semblance to actual objects; what matters is the feeling of monumental form and the space in which that form exists. This feeling is powerfully conveyed by Moore's use of mixed media to express the cross-section of a particular form at a given point.

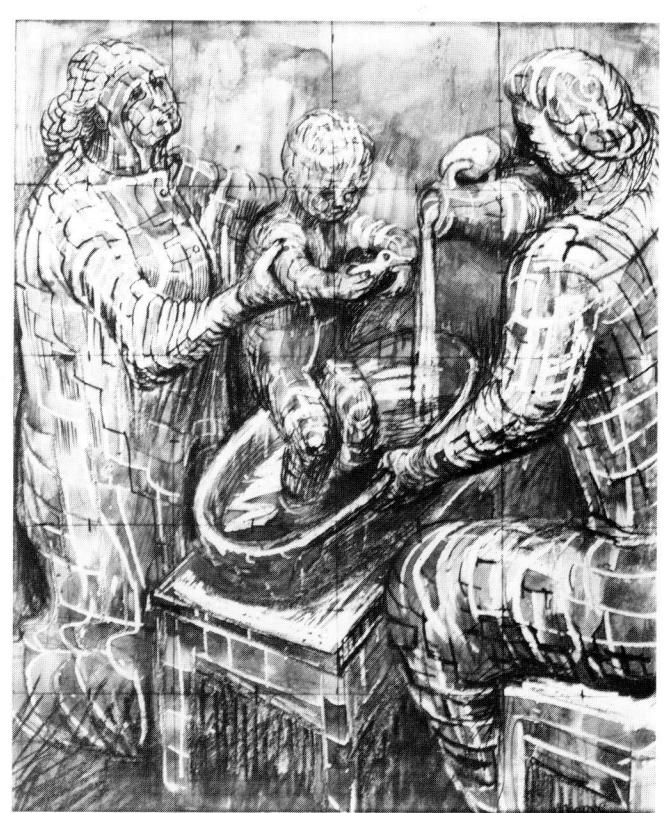

78. Vittore Carpaccio (?) The Adoration of the Magi

This pen and wash drawing attributed to Carpaccio is another good example of a classical composition, and is similar to Poussin's study in many respects. The main group of figures is placed on a raised dais, a kind of shallow stage, which is parallel to the picture plane. As in Poussin's version, the figures are arranged in a triangle (compare Ills. 62 and 63), with the Madonna and Child on one side balanced by the three Magi on the other; these three are themselves arranged in an ascending sequence forming a triangular group, and there are other triangular arrangements within the composition. (These arrangements are related to grid lines which are based on the division of the rectangle as shown on page 60.) The setting is very simple, giving the impression of

being moveable stage scenery; it consists of some Roman ruins and a 'stable', roughly adapted from a grandiose fragment of some quite unlikely architecture, which serves as a dark mass against which to set the figures. Carpaccio uses short broken lines to reinforce and punctuate the wash, which supplies the tone, and thereby conveys a strong sense of form. (Note that tone is not used to convey information regarding the value of colours.) Carpaccio's structural approach to the rendering of form can be seen clearly in the treatment of the subsidiary group opening the chest; in fact, all the forms are conceived initially as simple, block-like shapes.

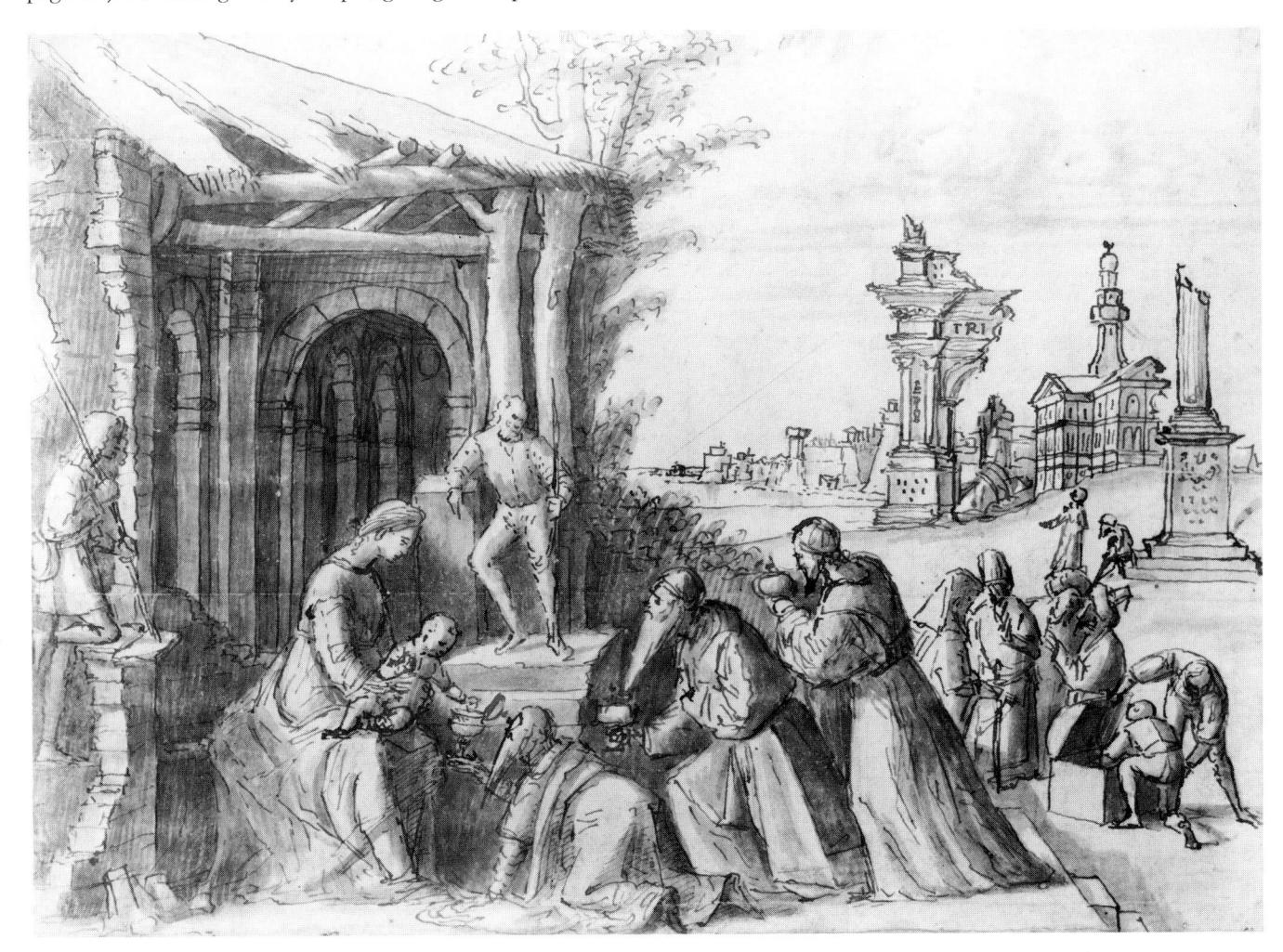

79. Nicolas Poussin Adoration of the Magi

Poussin first went to Rome in 1624 and was enthralled by the Classical antiquities by which he was surrounded; thereafter he spent most of his creative life in Italy. His drawings are simple and direct in technique: he often chooses pen and wash, using the pen line with sure precision to define, and the wash to create atmosphere and form. Here there is little detail or ornamentation, little facial expression (note the anonymity of the Infant Christ), and a bare minimum of architectural setting - a wall parallel to the scene and one broken column. This is an example of a classical composition in which the whole is greater than the sum of the parts. How is it achieved? The answer is simple – or rather, simplicity: simplicity of means plus a perfect sense of balance. Light

shapes are balanced by dark, thrusts of gesture and pose are balanced within the space depicted, and solids are balanced by spaces between them. The 'action', as always in classical composition, takes place as if on a stage, with both stage and figures disposed parallel to the picture plane. We also sense the underlying geometric framework of the composition, which gives it that feeling of logic and formality which is typical of classical work. The drawing is divided horizontally into three equal areas. The top line, along the top of the wall, defines the horizon and links the heads on each side; the bottom line is defined by the outstretched arm which links across to the suppliant Magus.

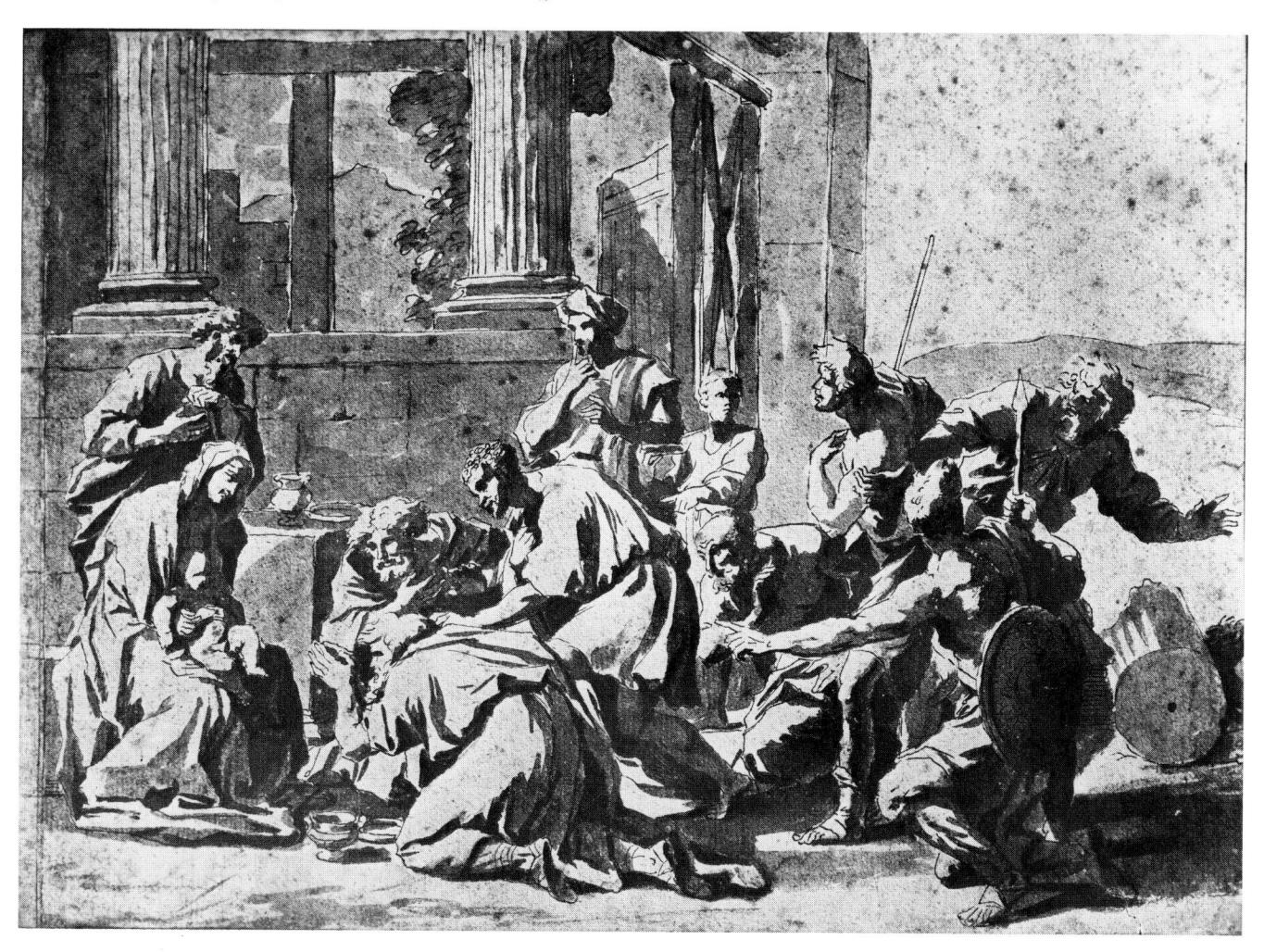

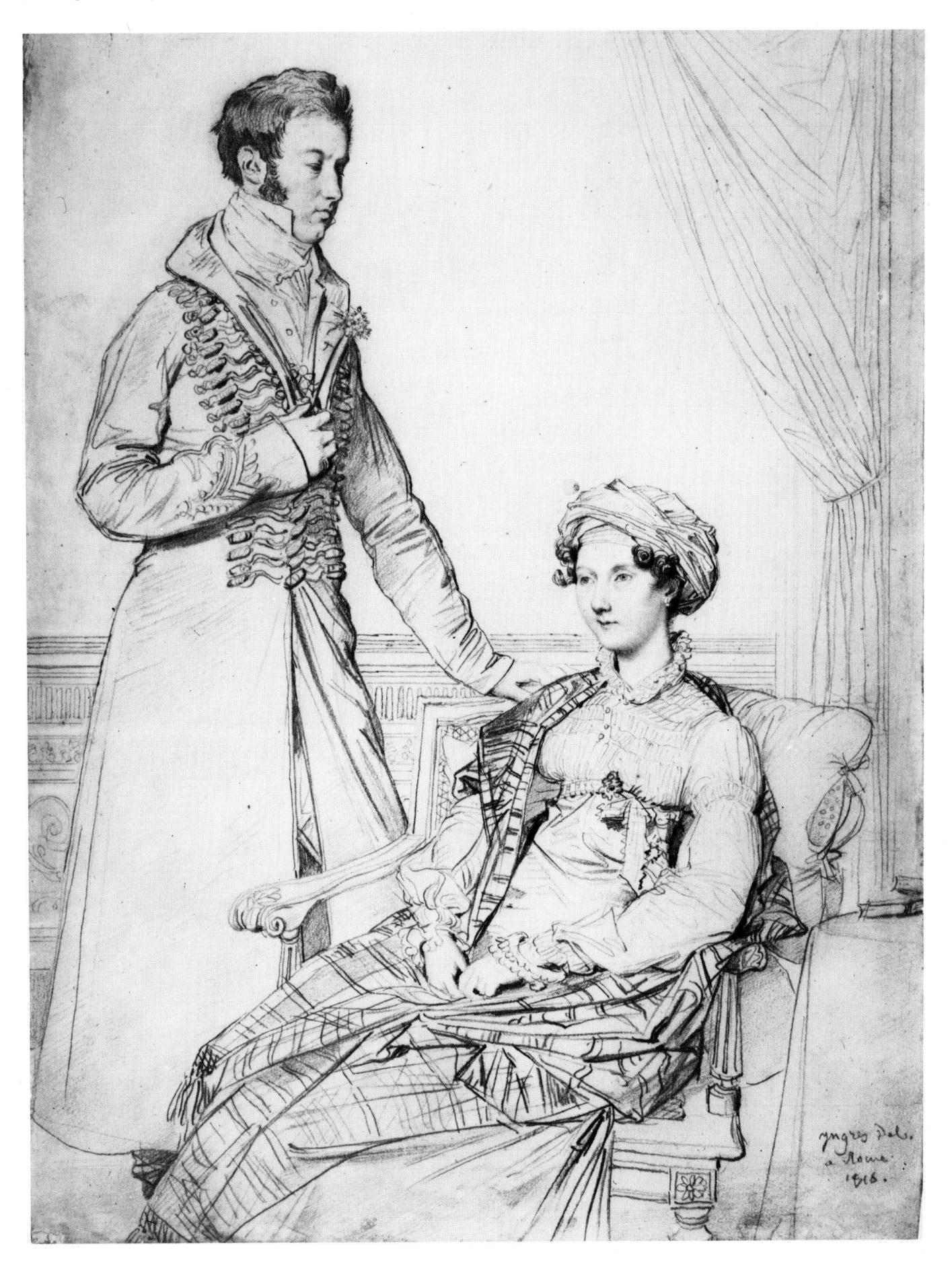

81. Pablo Picasso

Diaghilev and Selinburg

Picasso was a virtuoso draughtsman and displayed his skills to their full extent in his pure line drawings. If one studies the lines of the seated figure in this sketch one finds that by subtle emphasis on straightness and parallelism Picasso has created that sense of perspective which is entirely responsible for the feeling of form, tone being completely absent. The squared brim of the bowler hat describes the form of the head, while the parallel line of the lapels and the centre line of the shirt tell us about the form of the body. The lines of the clasped hands are equally straightened, especially the single line where both hands overlap; this line, common to both hands, is responsible for describing the form of the lower hand. The diagonal composition of seated and standing figures is given compositional unity by linking the figures together with coincidental lines: the hat joins the sleeve and the sleeve joins the lapel.

80. Jean Auguste Ingres Sir John Hay and his Sister, Mary

In Ingres' drawing we see once again the clear yet subtle line of Raphael. This double portrait is an example of sheer observation and accuracy of detail expressed through masterly control of the medium. (The extreme sensitivity of Ingres' technique would not have been possible without the invention by Conté in 1795 of the new form of graphite pencil encased in wood.) Ingres believed that line itself should suggest 'la forme intérieure' with the minimum of modelling; tone is therefore used very sparingly on both the forms and the background, and only lightly indicates on which side of the line it exists. The variation in the strength of pencil line suggests depth: the drapery in the background, for instance, is only lightly delineated, whereas the patterned drapery across the shoulder of the lady is strongly drawn compared to the adjacent hand and chair, while further back still the wood panelled dado is only faintly drawn. As in Picasso's drawing of Diaghilev and Selinburg, the diagonal composition is carefully arranged to give a balanced relationship to the two figures. The arm resting on the back of the chair provides a physical link between the two individuals and the downward glance of Sir John reinforces the effect of bridging the gap.

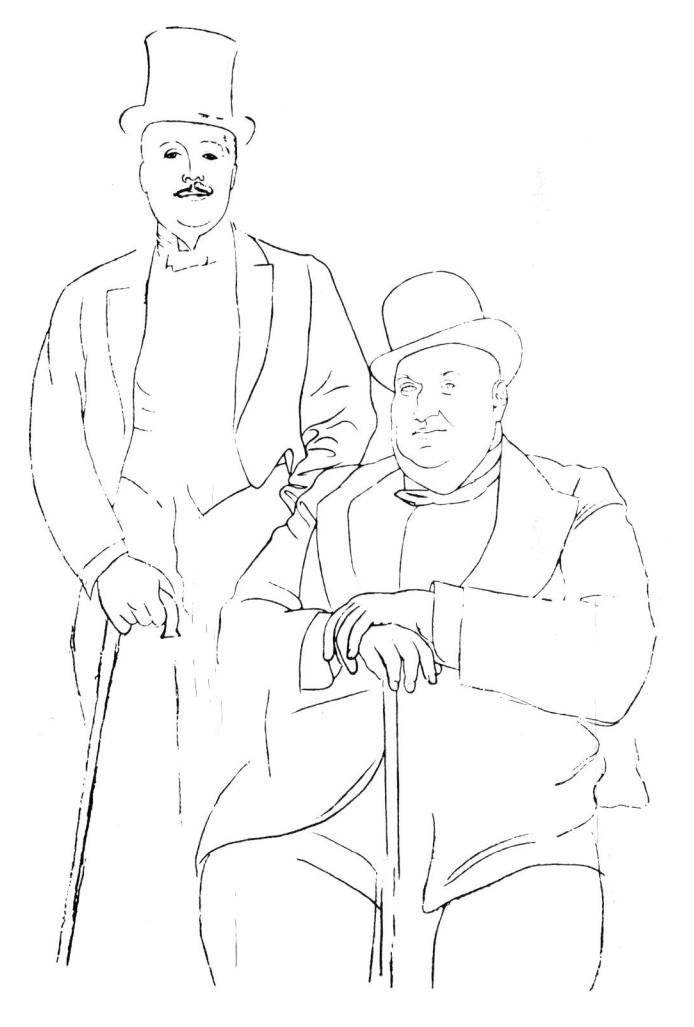

Landscape

The popularity of landscape as a subject for painting has varied considerably throughout the history of Western art. Whereas the Egyptians had sometimes suggested landscape as a symbolic setting for figures, Greek and Roman artists had considered it a subject in its own right; during the Middle Ages landscape declined in importance, eventually re-emerging as the Enchanted Garden (Eden or Paradise) of the manuscript illuminators. But it was the Flemish artists of the fifteenth century who were the first to establish the subject - a fact recognized by Michelangelo (whose own concept of the Garden of Eden consisted of a single tree); he wrote of the Flemish painters, 'Their painting is of stuff, bricks and mortar, the grass of the fields, the shadows of trees and bridges and rivers which they call landscape, and little figures here and there. And all this although it may appear good to some eyes, is in truth done without reason, without symmetry or proportion, without care in selecting or rejecting.' Michelangelo's contempt for landscape as a trivial subject would not, however, have been shared by his great contemporary, Leonardo, whose scientific curiosity extended to the depiction of scenery.

In fact, some of the greatest artists in history have been intrigued by the peculiar and particular problems of land-scape painting. One major problem is the physical difficulty of working out of doors (although this was an approach rarely used or even considered appropriate until Constable and the Impressionists). Then again, there is the sheer scale of the subject. There might be a vast distance to be expressed – a problem not always successfully solved, since it generally involves creating a continuous sense of space from foreground through middle distance to background, without abrupt transitions: a technique which baffled many early masters of the Renaissance. Another great problem is that caused by the ceaseless

movement and constant change of Nature. Constable said that the best lesson in art that he had ever had was 'Remember that light and shadow never stand still.' The changing light and shade and the shifting panorama of clouds are more noticeable in the British Isles (and the Low Countries) than in Mediterranean lands, and it is therefore perhaps not so surprising that a great school of watercolour drawing should have grown up in Britain. Taking an example from Claude and working outdoors, Constable and Turner produced on-the-spot watercolour drawings1 of the most fleeting effects of nature. 'Light dews - breezes - bloom - and freshness yet not one of which has been perfected on the canvas of any painter in the world.' Although this was Constable's view, it seems in fact that these evanescent qualities were well expressed both by himself and by Turner (whose later work was described by conservative academicians as 'paintings of nothing and very like').

Watercolour is the ideal medium for capturing those varied and variable effects, 'the chiaroscuro of nature' that go to make up the weather (as distinct from the climate) of Britain's cloudy islands. The transparent, fluid character of watercolour enables washes to be delicately floated over others, creating effects of light, dews, breezes, and blooms, while retaining a quality of freshness and vitality. Another advantage to the landscape painter is the portability of this medium, as we see from Turner's sketches on his travels through mountains, storms and rains, hail, steam and speed.

¹Watercolours are referred to as drawings since they were originally so called, and often depended on pen or pencil for reinforcement or clarification. In fact the pointed sable brushes used for this work were called 'pencils', and the word is still used by some painters and decorators to describe this kind of brush.

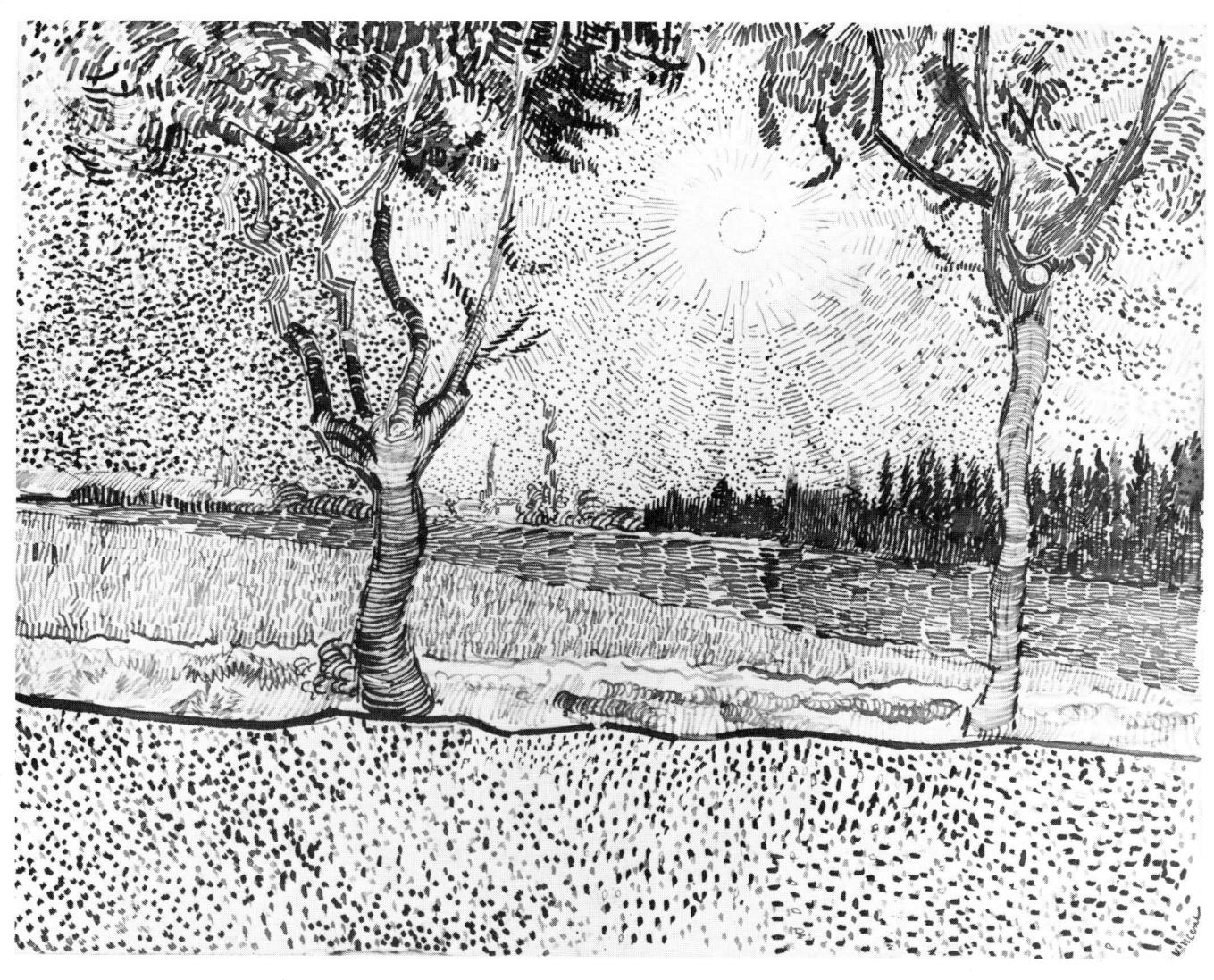

82. Vincent Van Gogh The Road from Tarascon

83. Samuel Palmer Landscape

Van Gogh's pen and ink, as in all his work, is ablaze with light, yet strangely enough there are no cast shadows. He uses a very personal technique involving short, straight pen strokes (curved for the curved forms of tree trunks), defining different surfaces by appropriate treatments. The close pattern of moving points conveys the tone and colour of the sky, while the sun, dazzling in its brilliance, makes it impossible to see anything in its proximity. A different, more open texture of points, still imbued with movement, is used to describe the road, separated from the verge by the only continuous line in the drawing.

From sunlight to moonlight. Samuel Palmer's landscape shows the same absence of shadow as Van Gogh's drawing, but a very different mood. Palmer was inspired in his early work by a meeting with William Blake, whose vision of the world of the imagination was more real to him than the everyday world. In this romantic drawing, Palmer's shapes, though clearly defined, are as difficult to name as in a dream. Shapes (are they trees? Boulders? Buildings?) curiously related by a similarity not only of shape but of texture, overlap, yet without much sensation of depth. Through a crumbling bridge(?) we seem to see another (or an eye?) on the same horizon line. The moon, balancing on edge, echoes the bridge shape and birds wheel in the sky. The landscape is transformed by imagination into a different world.

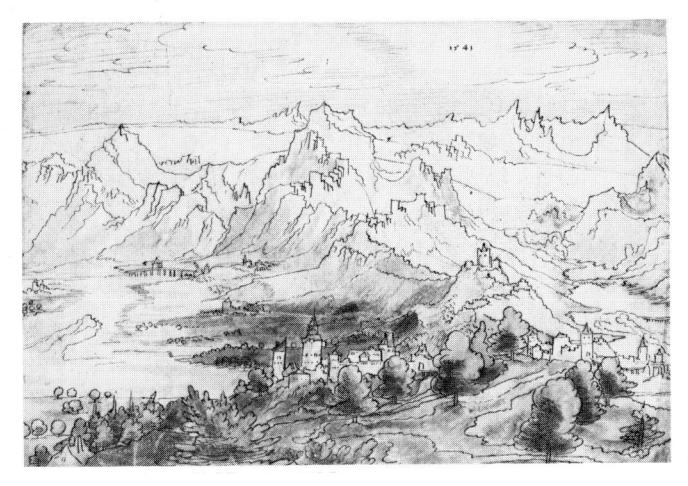

Wolfgang Huber was a German painter and graphic artist noted mainly for his woodcuts; signs of his skill as an etcher are evident in the way he carefully outlines all his forms with pen and ink before applying thin washes of limited colour. This sketch shows the romantic approach to landscapes landscapes of mood, fantasy, and fairy-tale. The mountain peaks, crowned by suggestions of buildings, overlap each other in a continuous sequence. Roelandt Savery presents us with another Alpine landscape, equally romantic; indeed Savery's drawings, although drawn considerably later, have many of the characteristics of Huber: the same preoccupation with edges, and the same brittle forms overlapping each other without much feeling of depth. The fantastic rock formations remind us of those in Patinir's paintings, and in the background to Leonardo's Virgin of the Rocks. Like Huber, Savery was also known for his graphic work and we can see in the essentially linear character of his drawing the same needle sharp, hard, and uncompromising qualities as in his etched line. The shattered pine tree with its spiky branches is reminiscent of the turrets and towers of the period.

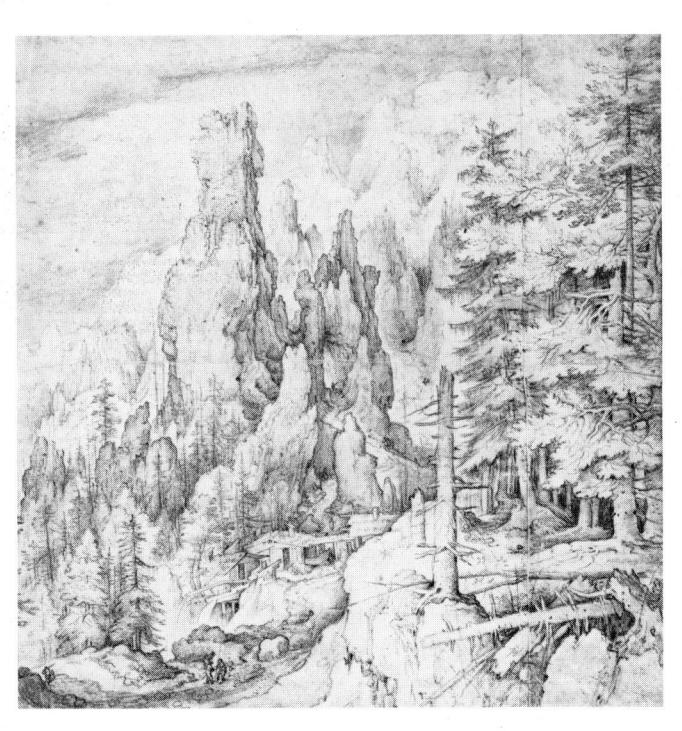

84. Wolfgang Huber
Mountainous Landscape with a Fortified City

OPPOSITE:

86. John Constable

Tillington Church

John Constable is often considered to be the father of modern landscape. Before Constable, 'landskip' painting had been dominated by the notion of the picturesque, producing scenes which were intended to remind the spectator of a picture generally by Claude. Constable worked on his sketches out of doors, mostly in his native Suffolk, and although he states that they describe scenes he saw on the banks of the River Stour, he had also studied carefully the compositional method of Claude. Constable developed his own method of working which was to make first a small oil sketch direct from nature, backing it up with pencil sketches; he would then make a 'full scale sketch' in oils before embarking on the finished work. His preliminary pencil sketches, sometimes (as here) with added transparent washes of colour, have a shimmering vitality which he found difficult to maintain throughout the process of producing his finished works; his large oilpaintings, exhibited at the Royal Academy, were none the less widely acclaimed. Although this is a very small sketch (265 × 230 mm), it has the breadth and sweep of a much larger picture and exemplifies the 'dews, breezes, bloom and freshness' which Constable sought to capture.

87. Thomas Gainsborough
Cart on a Woodland Road

Thomas Gainsborough, too, found inspiration in the Suffolk countryside. Although equally proficient in portraiture and landscape, he once expressed the view that he would like nothing better than to abandon portraiture, take his viola da gamba (he was something of a musician), and paint landscapes. In this wash drawing, using a brush fully loaded with wet colour and limiting his palette to two or three colours at most, he has produced a splendid play of sunlight and an effective massing of light and shade. There is something in the handling – a kind of scribbling, feathery treatment of the foliage – which recalls the technique of Fragonard, and reminds us that this is the eighteenth century, the age of elegant decoration and the Rococo.

85. Roelandt Savery
Alpine Landscape

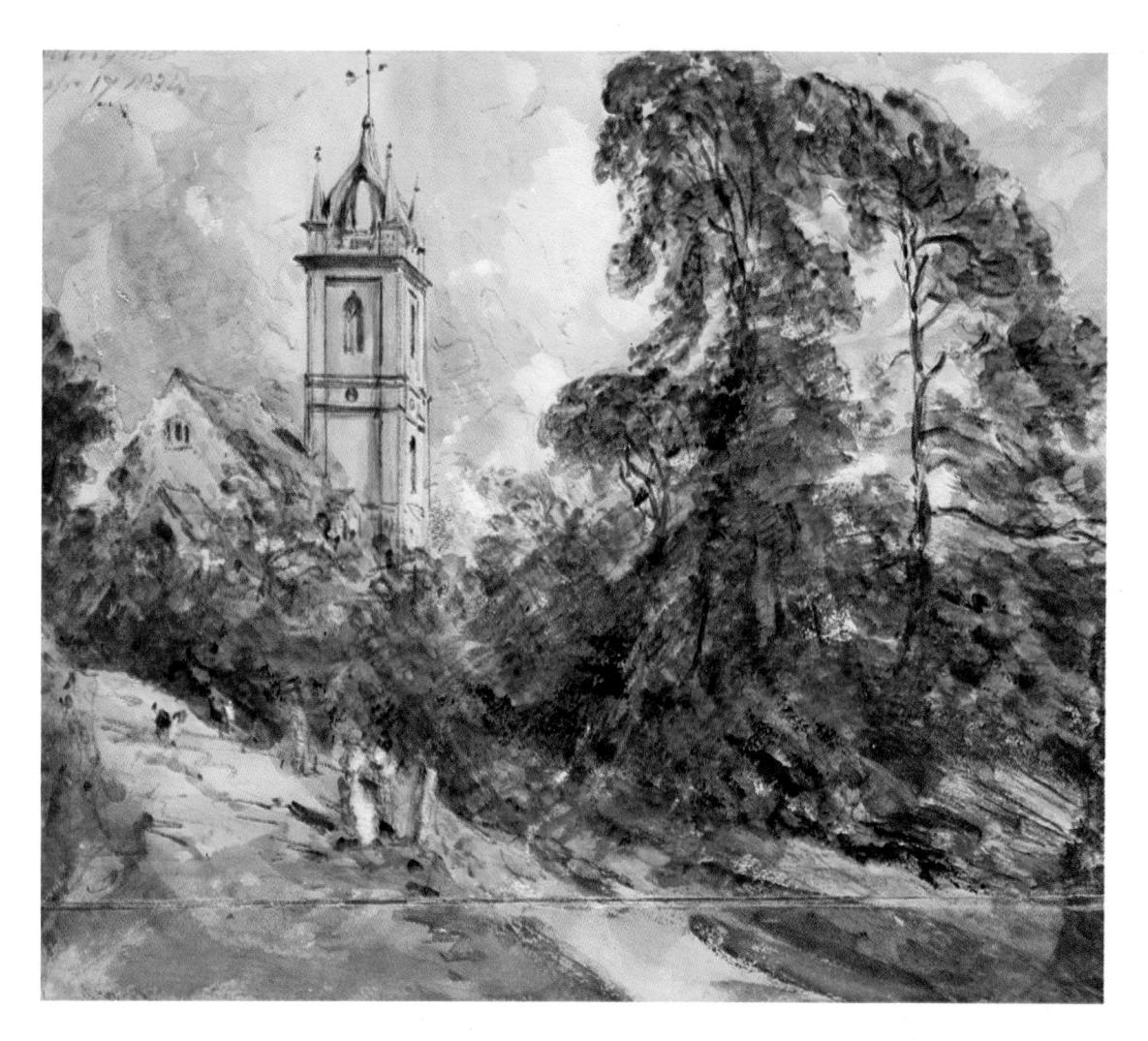

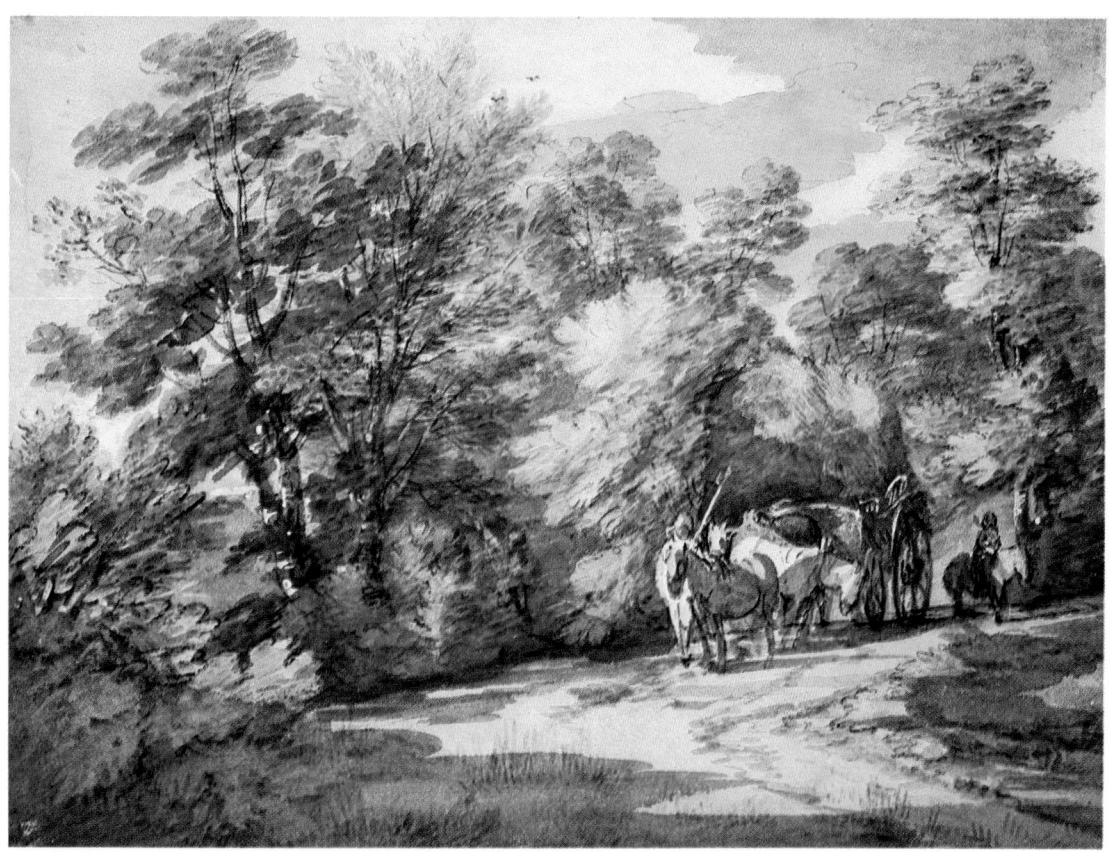

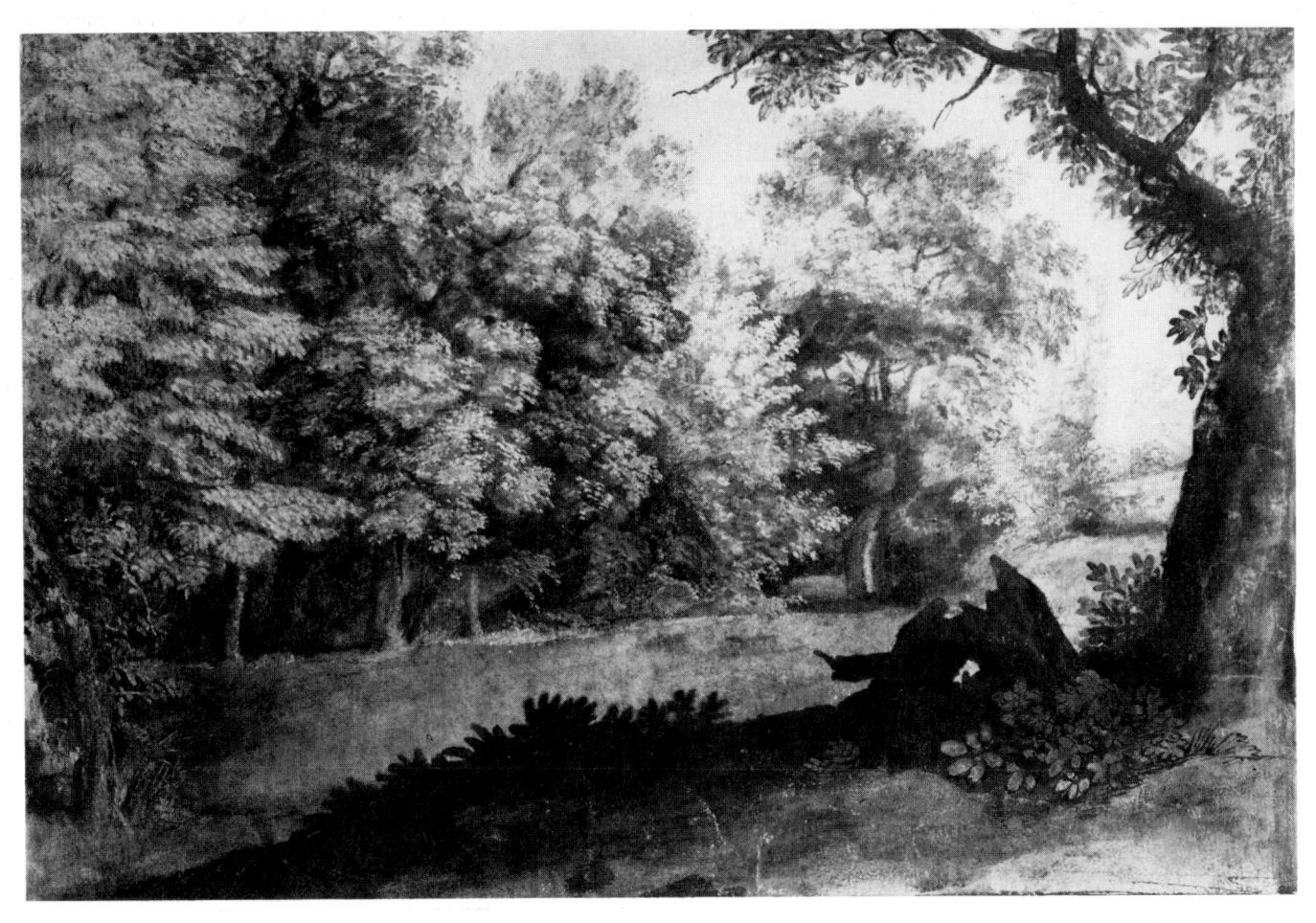

88. Claude Lorrain Clearing in a Wood near Rome

Claude Lorrain, although a French painter, lived and worked in Italy. He had considerable influence on landscape painting (and landscape gardening), and in fact the idea of the 'picturesque' was largely associated with Claude's composition. In this drawing Claude brings the diagonal foreground of his drawing forward by emphasizing the tone of the shadow and by reversing the use of warm colour for this area (the diagonal lead-in to the picture was a favourite

device of Claude's). The near tree and the bank on which it stands are used as a kind of dark frame for the more distant wood. The expression 'one cannot see the wood for the trees', meaning that the whole is overlooked due to preoccupation with detail, is quite inapplicable in this case. The silvery masses of foliage remain resolutely masses and the leafy details suggested are kept subordinate to the forms.

89. Adam Elsheimer River Landscape

Using a very limited palette, virtually only two colours, one warm, one cool, Elsheimer has achieved a very convincing sense of distance and form. He divides the picture to give us more sky than land and rather unusually (as sky is often somewhat arbitrarily dismissed by many landscape artists) he makes them both of equal interest. It seems almost as if the trees (of similar rounded shape to the clouds and lit from the same direction) are reflected in the sky but in reverse: the larger tree opposite the smaller cloud and vice versa. The lightest part of the sky comes against the darkest part of the wood, and, similarly, the distant light on the far bank of the river, as it bends out of view, is emphasized by the contrast with the dark foliage of the trees on the near side of the river, thereby throwing the woods into relief and helping to bring the near bank forward.

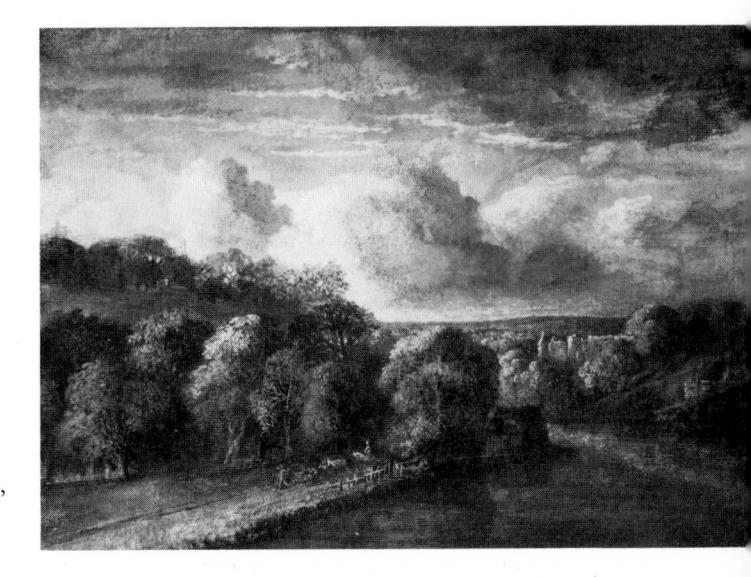

In this drawing Fragonard has made use of basically two colours, a cool blue-grey and a warm sepia. The warmer, stronger tones are reserved for the foreground and cooler, lighter tones for the background, producing a vaporous atmospheric effect and a treatment of space typical of Rococo art. The feathery treatment of the foliage and the graceful curves of the tree trunks are also in the best vein of the Rococo, though the muted colours and general air of decay produce an atmosphere of subdued sadness. The drawing is very skilfully composed and is constructed in such a way that shapes are drawn by a continual counterchange of light against dark tones: the cattle are silhouetted against the light side of the foreground rock, while on the dark side of the rock the figure is silhouetted against a light passage. Follow the contours of the foreground tree and notice how the background always becomes lighter when the tree is darker, and vice versa.

Dufy, who exhibited with the Fauves in 1906 and who was once a successful textile designer, is sometimes dismissed as a mere decorator. The spirit of his work suggests a kind of twentieth-century Rococo, and in fact Dufy once compared himself to Fragonard. In his drawing he developed a kind of deceptively casual, sketchy, and spontaneous style. But this kind of throw-away treatment is not as easy as it looks (as his many imitators, seduced by his nonchalance and charm, have found). Dufy's drawings are a brilliant improvisation, a kind of visual shorthand. Foliage is summed up as one rounded brush stroke, punctuated by the black inverted commas of leaves, deftly flicked in.

90. Jean Honoré Fragonard Landscape with a Bridge through Trees

91. Raoul Dufy Olive Trees by the Golfe Juan

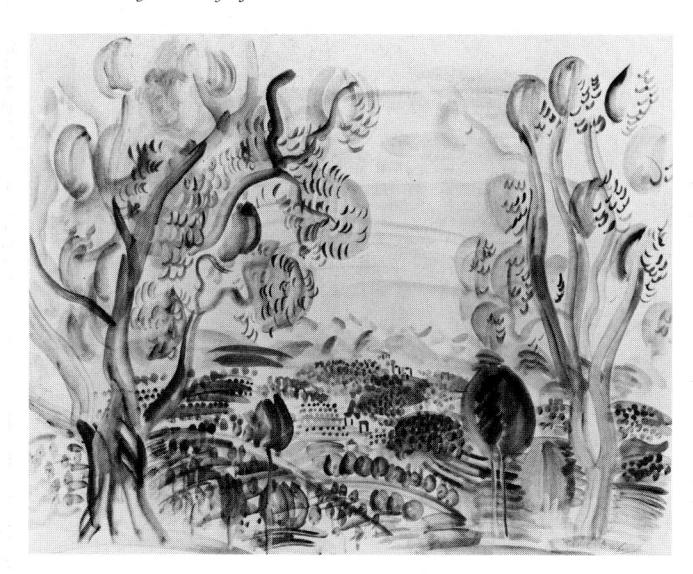

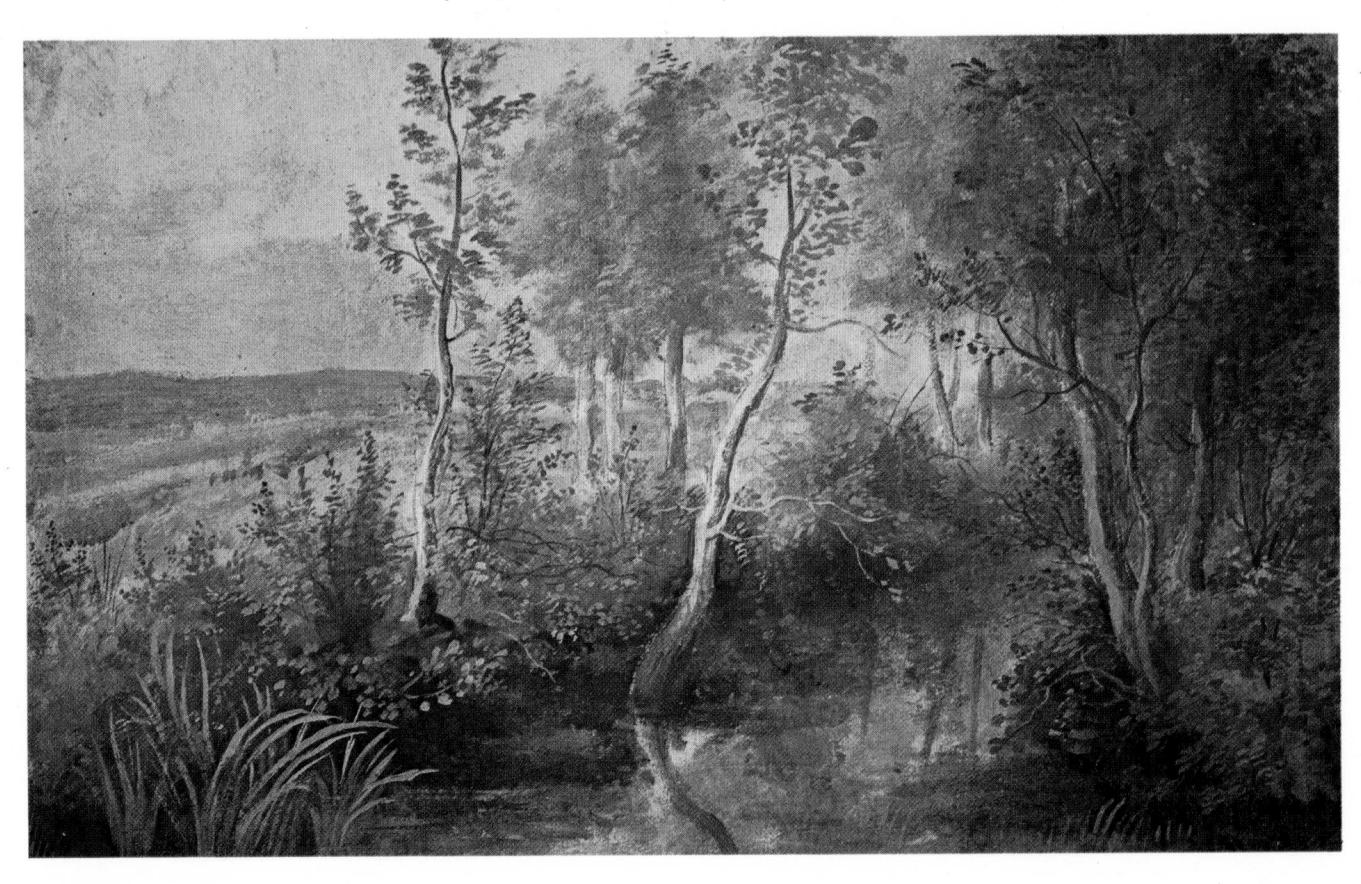

92. Peter Paul Rubens Trees Reflected in Water at Sunset

It is difficult to equate this quiet scene of a small stream overhung by trees with other works by Rubens, the supreme master of the Northern Baroque, who with his brilliant team of assistants expressed the triumph of the Counter-Reformation in vast, spectacular painting. In 1635 Sir Peter Paul Rubens (he had been knighted by Charles I while on a diplomatic mission to London in 1629) bought a country residence, the Castle of Steen, and during the last five years of his life, when not fulfilling commissions, he painted landscapes for his own satisfaction — and, in this intimate study of lush growth on the water's edge, for ours.

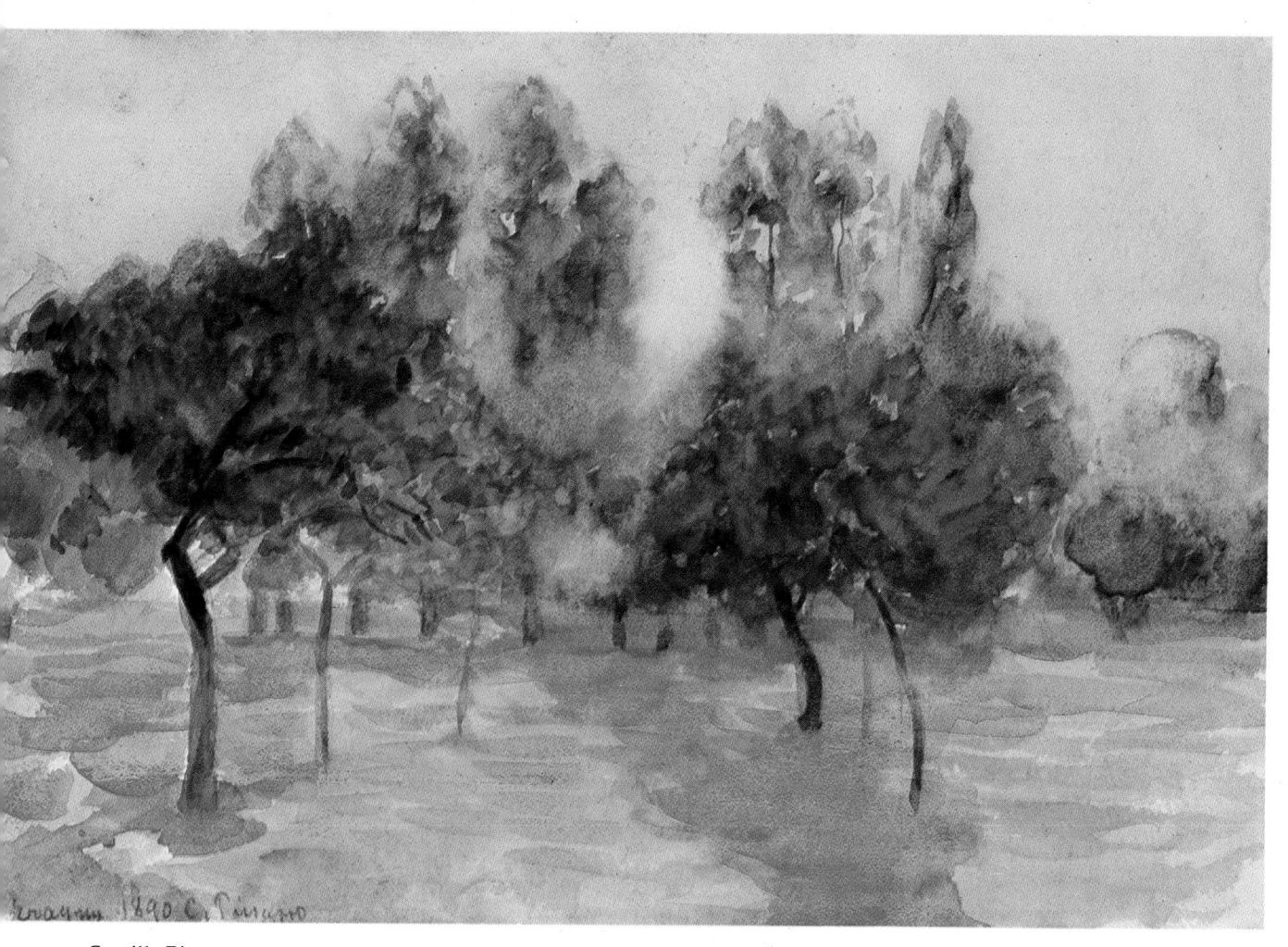

93. Camille Pissarro
An Orchard

The freshness and the complete lack of stylistic overtones make this drawing as 'modern' today as it was when it was painted, and there is little one could say about Pissarro's watercolour study of an orchard at Eragny (where he settled in 1884) that would not be equally applicable to Rubens' sketch; both have a freedom and spontaneity of handling which imbue the pictures with a feeling of light and fresh air.

Cézanne's drawings cannot be appreciated or even understood without some knowledge both of his aims and of his work as a whole. Cézanne was *not* trying to reproduce the appearance of a scene (or anything else) in paint; instead he strove to find visual equivalents to 'realize his sensations'. Unlike the Impressionists, who were concerned to record the effect of light on a particular scene on a particular date at a particular moment, Cézanne concerned himself with what he called 'the

94. Paul Cézanne Pistachio Tree at Château Noir

95. Piet Mondrian Apple Tree

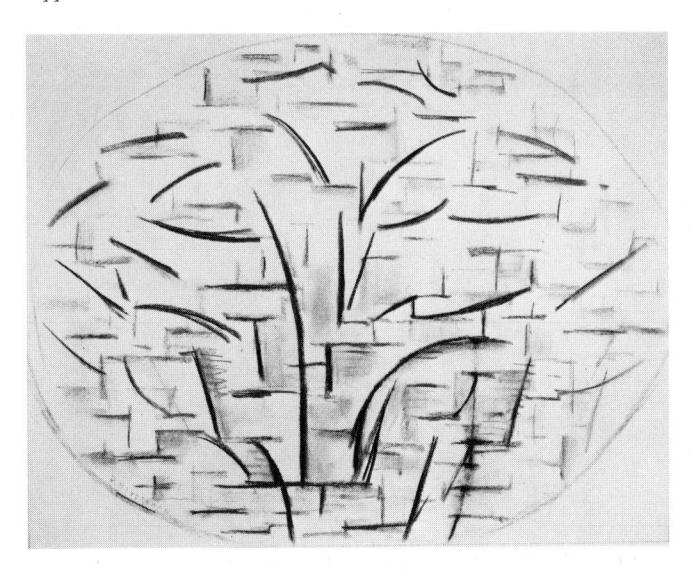

geological substructure' of nature, by which he meant the formal relationship of the composition and its internal rhythms. All Cézanne's drawings show a painstaking analysis of structure expressed in terms of planes; foliage, rocks, and tree trunks are all unified by being seen as structural forms. Cézanne ignores accidental effects of light, atmospheric perspective, fleeting shadows, and textural differences in his determination to concentrate on the solid and durable.

Mondrian takes Cézanne's analysis even further: the colours, textures, leaves, and branches of his apple tree are reduced to basic linear relationships, and the proportions and rhythms found within the tree's structure have themselves become the subject of the drawing. The trunk has been reduced to a central vertical axis, around which the branches are indicated by analogous curves; these are related to a vertical/horizontal system which provides a sense of structure and foreshadows a fundamental element of Neoplasticism – the relationship of the vertical and horizontal. Tone in this drawing has nothing to do with indicating light and shade, or creating the illusion of form or imitating the appearance of the tree in any way. It is used simply to provide a slight sense of depth, of partial relief, while still preserving the essentially two-dimensional nature of the paper on which the drawing has been created.

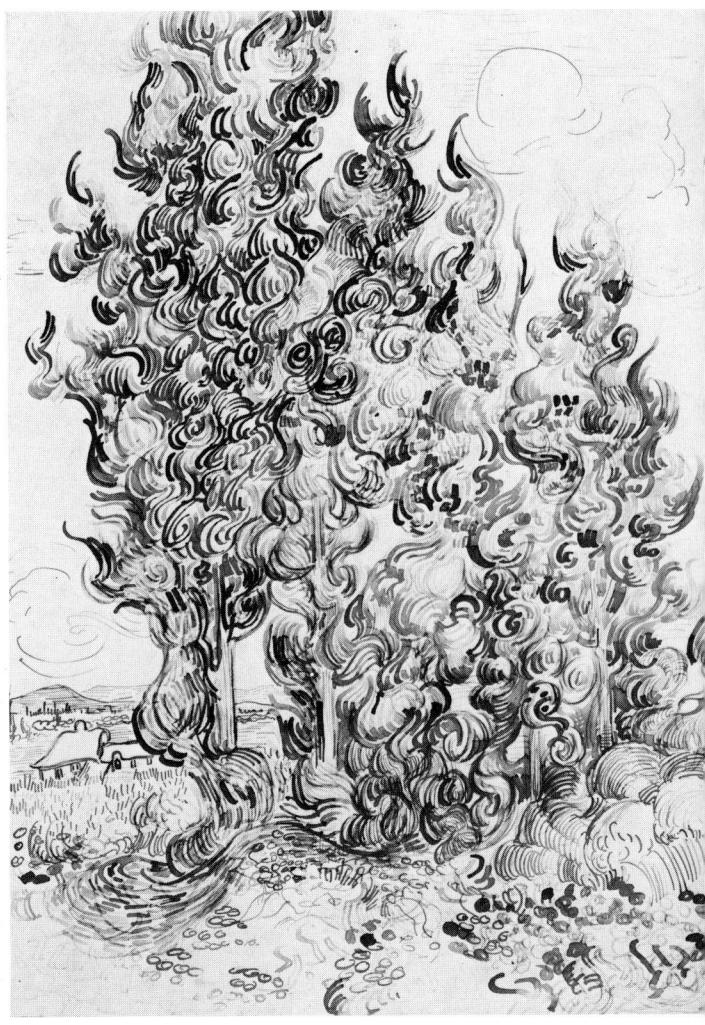

96. Vincent Van Gogh Grove of Cypresses

Van Gogh's cypresses convey the same kind of energy as Leonardo's deluge (although in his case 'frenetic' might be a more appropriate description). All his drawings express movement and disturbance, reflecting the emotional disturbance of the troubled genius. Van Gogh developed a very personal, graphic style of drawing, using a reed pen to produce dots and dashes (almost a kind of musical notation), swirls, and spirals, all in continuous but controlled movement. Everything Van Gogh painted – the sea, the distant rolling hills, even the background of a portrait – whirls and eddies like smoke.

From the asylum at St Rémy on 25 June 1889 Vincent wrote to his brother: 'The cypresses are always occupying my thoughts. I should like to make something of them like the canvasses of the sunflowers, because I am astonished that they have not yet been done as I see them. They are as beautiful in line and proportion as an Egyptian obelisk.'

97. Leonardo da Vinci A Deluge

What has Leonardo, the very epitome of the intellectual, rational approach to art of the Renaissance, and who took so long to complete so few paintings, in common with Van Gogh, pouring out his feelings in paint and producing most of his paintings in only two years? In his relentless pursuit of knowledge, Leonardo made studies of movement in all fields, including the flow, currents, and eddies of water, and the force exerted by its continuous movement. 'The water which you touch in a river' he wrote, 'is the last of that which has passed, the first of that which is to come.' This apocalyptic drawing of the forces inherent in movement is one of a series which shows the power of Nature unloosed; Man and his world overwhelmed in crushing, grinding tumult. This pessimistic vision of human destiny, so out of keeping with the Renaissance view of Man as the measure of all things, reminds us uncomfortably of the terrifying force of Nature contained within the atom. The swirling spiral lines of this drawing are a powerful expression of irresistible force and kinetic energy.

98. Anthony Van Dyck

A Meadow Bordered by Trees

Van Dyck's watercolour drawing is carried out with an elegance and skill which befit Rubens' most brilliant pupil, but in an idiom quite unlike the Grand Manner of the Baroque. The blue-grey colour of the paper, with slight modification, is responsible for the sky, and is in fact used as a moderating influence on all the other colours. The result is a quiet harmony and unity of mood which gives the drawing something of the quality of a tapestry carried out in closely

related colours. The trees are quite simply drawn as a balanced combination of flat, silhouetted shapes and more three-dimensional forms. (Van Dyck is here exploiting the technique whereby forms may be originated as apparently three-dimensional and the continuation of the form may be treated quite flatly, even silhouetted, but by association the flat will appear as an extension and part of the solid.)

99. J. M. W. Turner Benson or Bensington, near Wallingford

Like Van Dyck, Turner often used a blue paper as the support for his sketches, particularly those in body-colour. He has chosen white paper for this watercolour, however, and has taken full advantage of the transparency of the medium which he found so suitable for expressing watery reflections merging into each other, the changing mood of the sky, and the shifting shadows of foliage. Turner was an incomparable master of this difficult medium. He was submitting competent drawings to the Royal Academy at the age of fifteen, and watercolour remained his favourite

medium. The translucent wash effect of his later oil-paintings (described as 'pictures of nothing, and very like') reflects the experience he had gained from the transparent medium of watercolour. Throughout his career Turner became increasingly absorbed with light and colour. The ostensible subject of his work gradually disappeared, dissolved in a blaze of coloured light or lost in a mother-of-pearl mist. The light in this drawing comes from the skilful use of the white ground, which illuminates the sky and provides the sparkle on the surfaces of leaves and water.

100. Vincent Van Gogh

La Crau from Montmajour

Here we compare two pen and ink drawings of extensive prospects, both seen from a raised viewpoint. In Van Gogh's drawing the movement follows a kind of zigzag route along road, rail, and hedge, into the far distance. The surfaces of the fields are all activated by small strokes of the pen, creating myriad moving points. The sense of space and distance in this drawing is chiefly the result of the difference in scale of the pen marks, which become closer together and more compacted, as well as smaller, as they recede. As in all Van Gogh's drawings, the whole seems to be full of light as well as life.

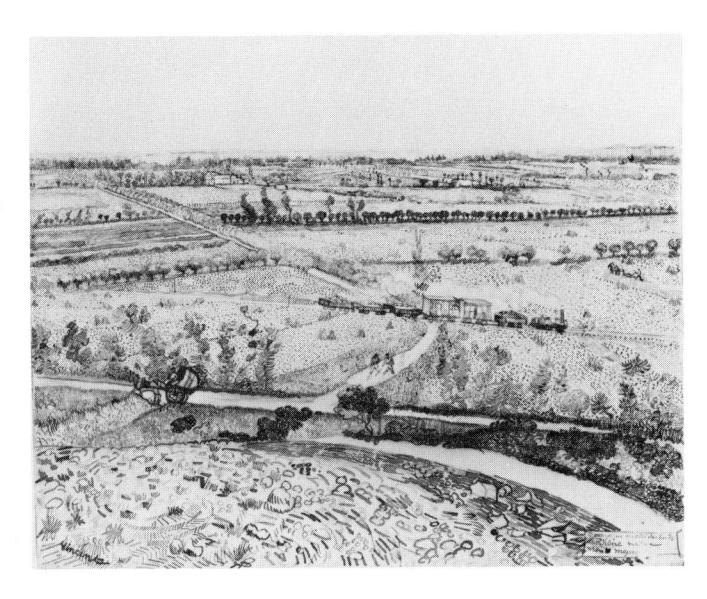

101. Pieter Bruegel Alpine Landscape

Bruegel, too, uses innumeral small-scale marks in his pen drawings of landscapes, varying both the strength and scale of the marks according to the distance. In the foreground of this drawing – part of the high, rocky escarpment from which the scene has been observed – the marks consist of dark, continuous lines expressing a kind of flowing movement, whereas in the distance the marks become fainter and more

broken; but the sense of flowing movement runs through the

flow down hillsides split by ravines. Sometimes barefaced cliffs erupt through the surface foliage. Beneath the movement we feel the underlying rocky structure: Bruegel makes us aware of the organic surface existing on the inorganic skeleton. The sense of movement becomes more sluggish on the plain, where trees are arranged in orderly rows like the tents of an army, emphasizing the feeling of distance as they recede in parallel lines. Little buildings and tiny travellers make us realize the scale of the vast prospect.

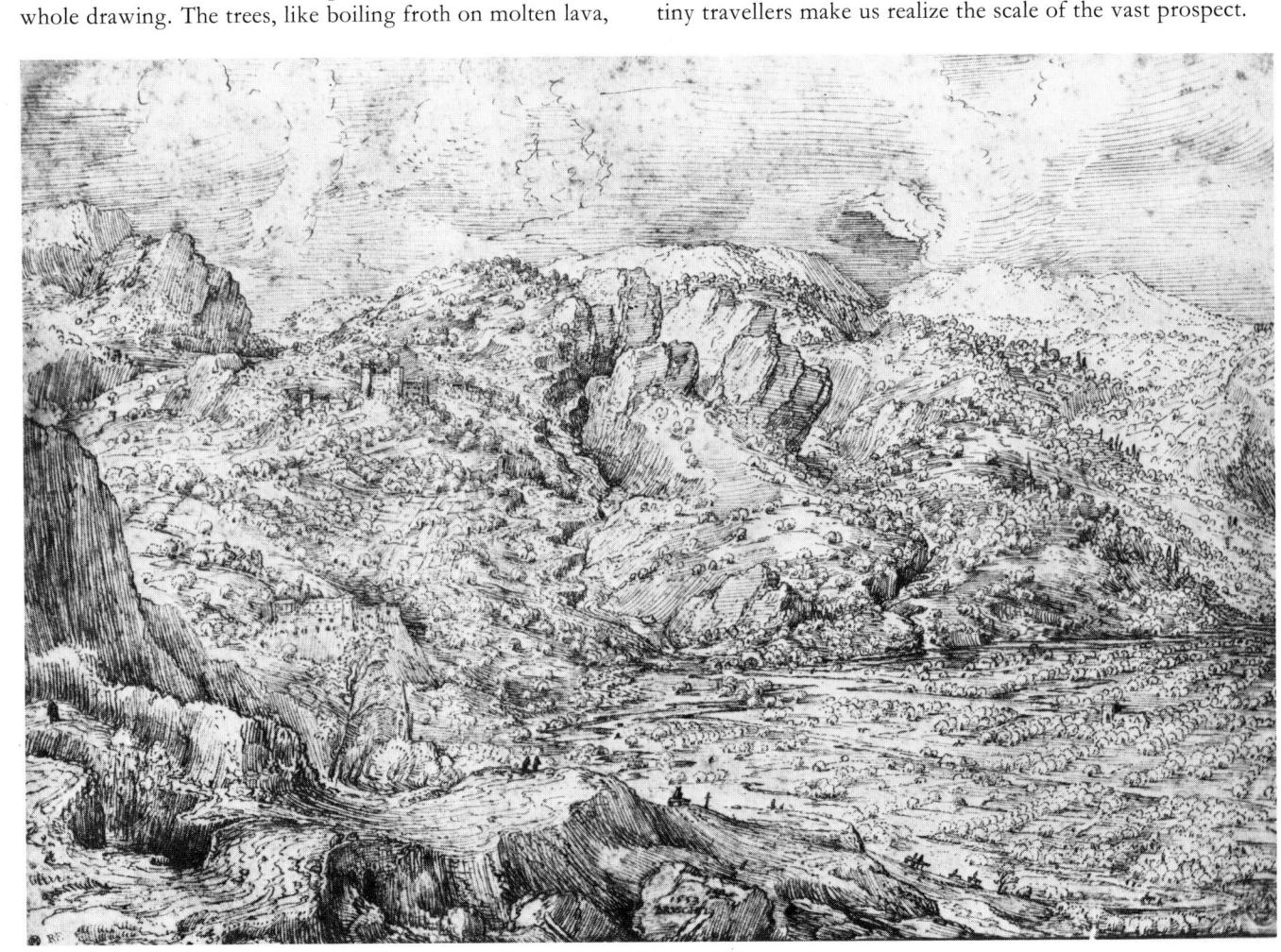

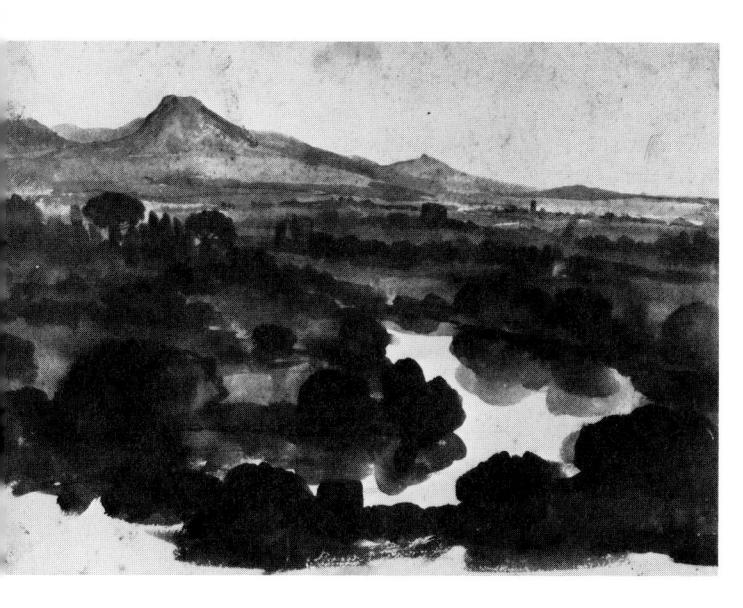

102. Claude Lorrain

The Tiber above Rome: Evening Effect

By the simplest means, a series of beautifully controlled washes, Claude produces a landscape with a true sense of recession – a recession which we experience in terms of precise intervals of tone, enabling us to progress into the distance by a series of orderly steps. As one step is silhouetted against the next the lower edge is softened, creating the impression of an evening mist rising from the low-lying ground. By contrast, against the dark foreground, the light sky reflected in the river is dazzling. All Claude's drawings (however simple) and paintings are imbued with a sense of light (compare Van Gogh's *La Crau from Montmajour*, Ill. 100).

103. Georges Seurat Landscape Study for La Grande-Jatte

Seurat, like Claude, was preoccupied with light. His drawings are always carried out solely in tone, but he preferred the dry medium of conté rather than the wet wash. Though equally skilful as Claude in the control of his chosen medium, Seurat graduates the tones and makes his edges indefinable as they merge into each other thereby producing a sensation of light dissolving the edges of the forms. This is the background on which he will place the figures for his large composition, Sunday Afternoon on the Île de la Grande-Jatte (see also Ill. 71).

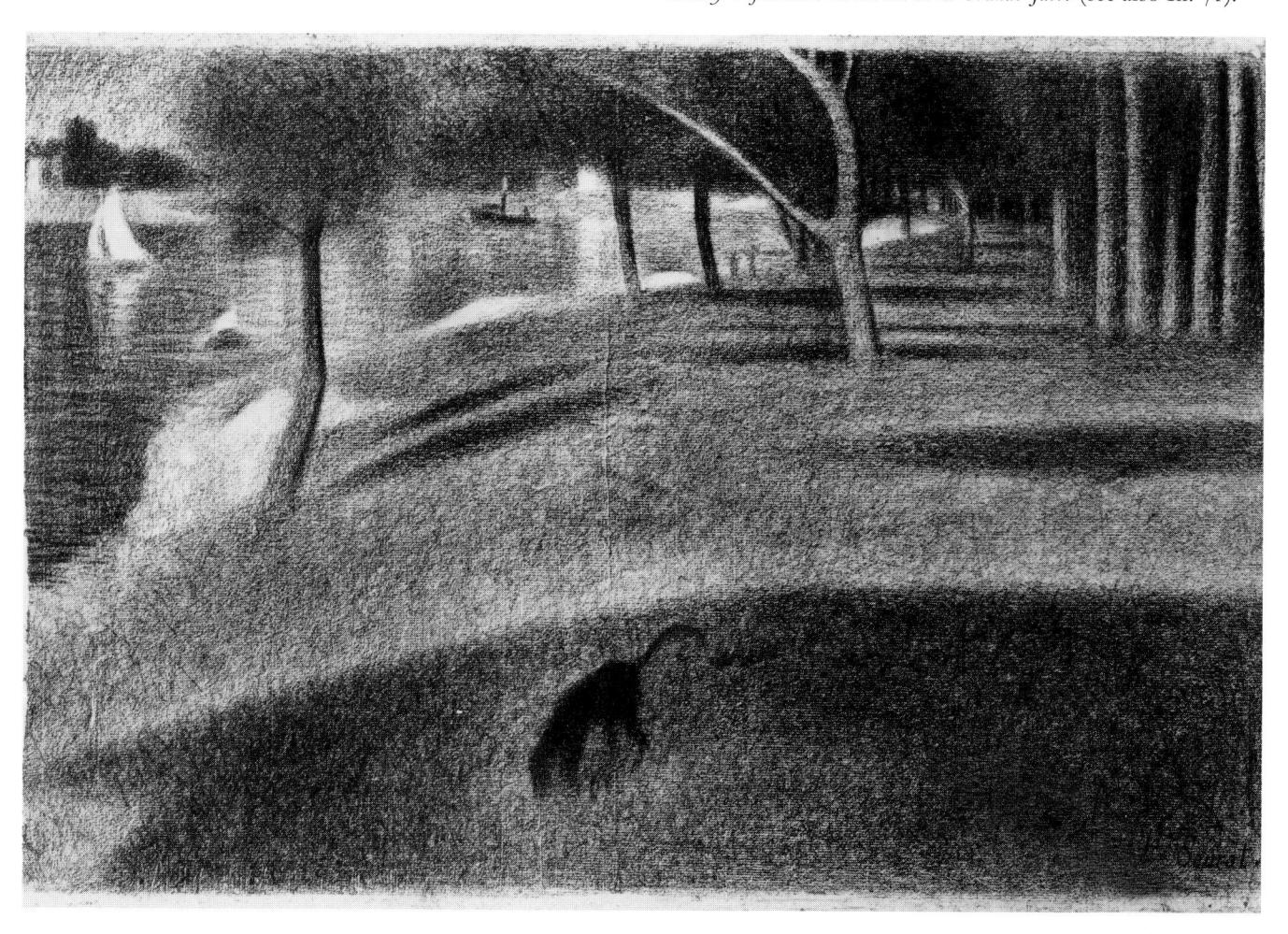

104. J. M. W. Turner

Venice, S. Giorgio from the Dogana

Turner, unlike his great contemporary, Constable, made many sketching tours throughout Europe, finding particular inspiration for his compositions in the Swiss Alps. His first visit to Italy in 1819 had a profound effect on his painting: in Rome, in just three months, he made 1,500 drawings and watercolours, though it was the romantic atmosphere of Venice that made the greatest impression on him. Turner's response to the city's charm is evident from this watercolour

in which the light reflected on the water, the serenity of the muted colours, and the simplicity of tone all combine to produce a mood of quiet introspection. (Surprisingly, many of Turner's works are quite the opposite in mood: like all Romantics he had a predilection for violent thunderstorms, avalanches, fires, tempests, and shipwrecks – preferably all at the same time.)

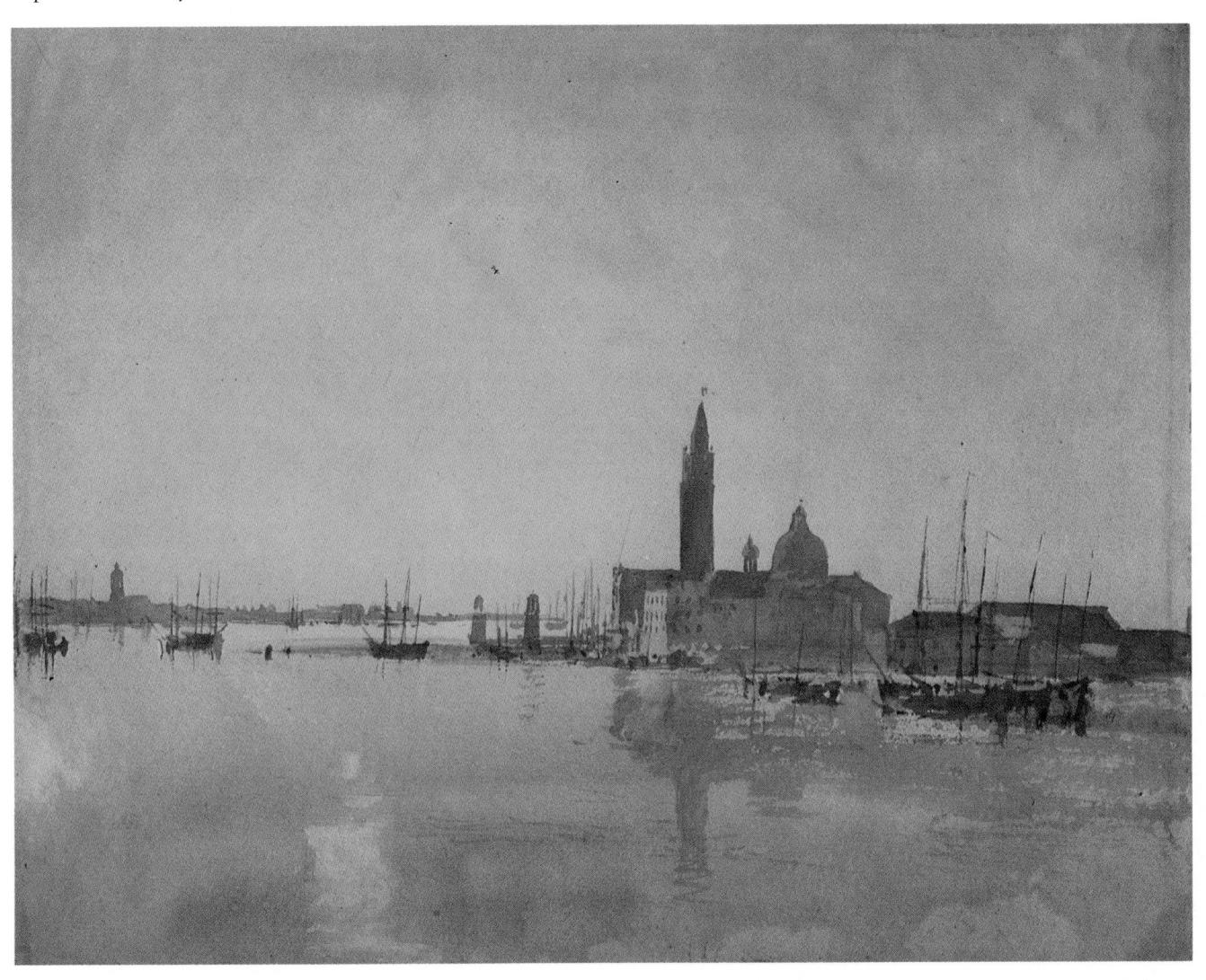

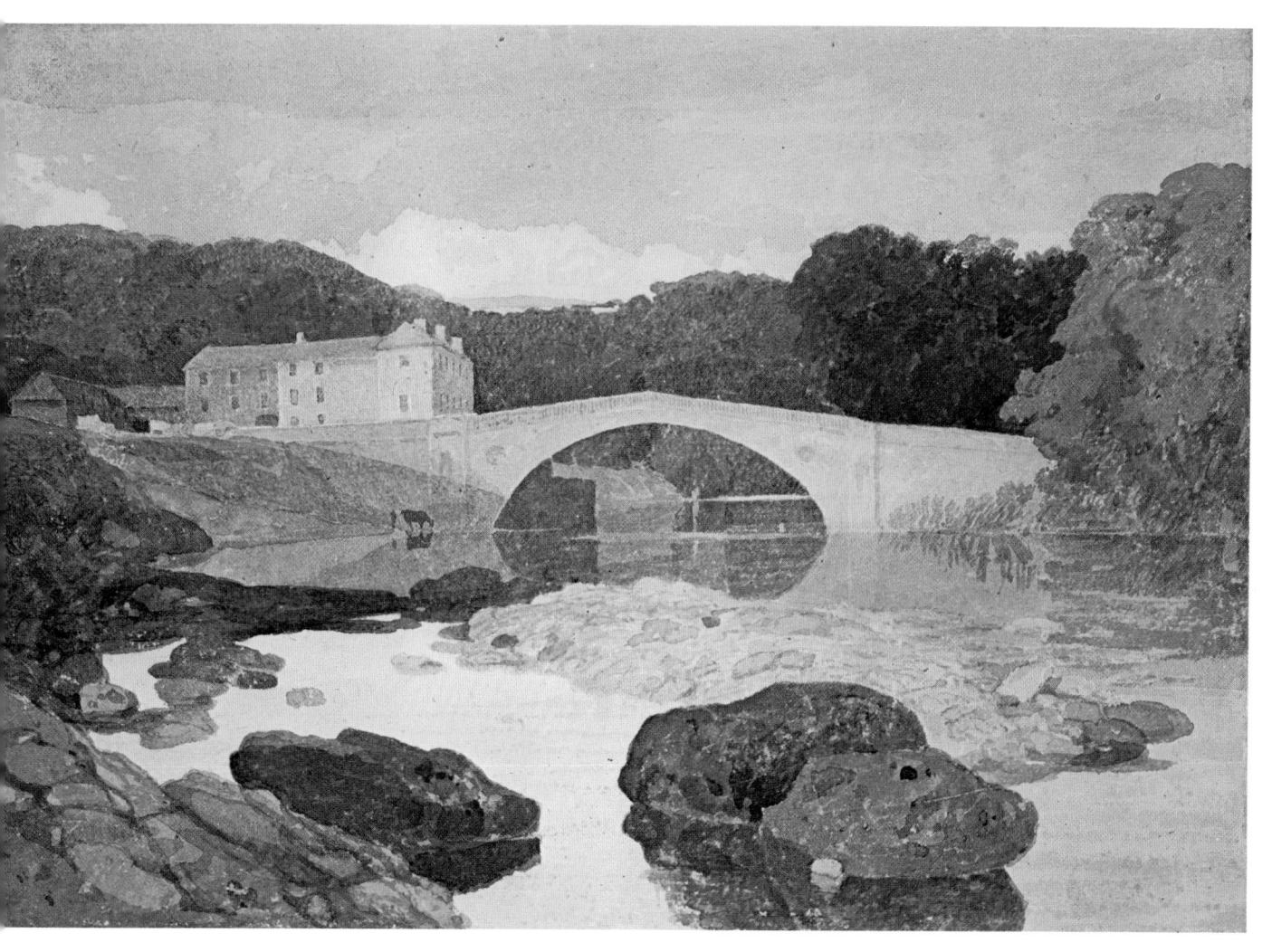

105. John Sell Cotman Greta Bridge

Cotman, a contemporary of Turner, produced many outstanding watercolours and oil-paintings of the English landscape; the quality of his watercolours in particular has never been surpassed (see Ills. 121 and 122). Cotman developed a highly original technique of silhouetting and simplifying the form into large masses, using the tonal values of these broad areas of colour to make a strong pattern of shapes. The masterly suppression of detail, and the power of construction would have been appreciated by Cézanne.

106. Alexander Cozens

A Rocky Landscape

'To sketch is to transfer ideas from the mind to the paper... to blot is to make varied spots... producing accidental forms... from which ideas are presented to the mind... To sketch is to delineate ideas: blotting suggests them...' So Alexander Cozens wrote in his book, A New Method of Assisting the Invention in Drawing Original Compositions of Landscape, published in 1785. He called the method 'blotting', and recommended putting blots on paper and using them as the starting-point of an imaginary landscape. It was Leonardo's

writings that had suggested the idea to Cozens: 'You should look at certain walls stained with damp,' Leonardo advised, 'or at stones of uneven colour. If you have to invent some backgrounds you will be able to see in these the likeness of divine landscapes, adorned with mountain, ruins, rocks, woods, great plains, hills and valleys in great variety . . .' But the blots or stains are only a starting-point, a stimulus to the imagination; whether or not a work of art results from this depends on whose imagination is stimulated.

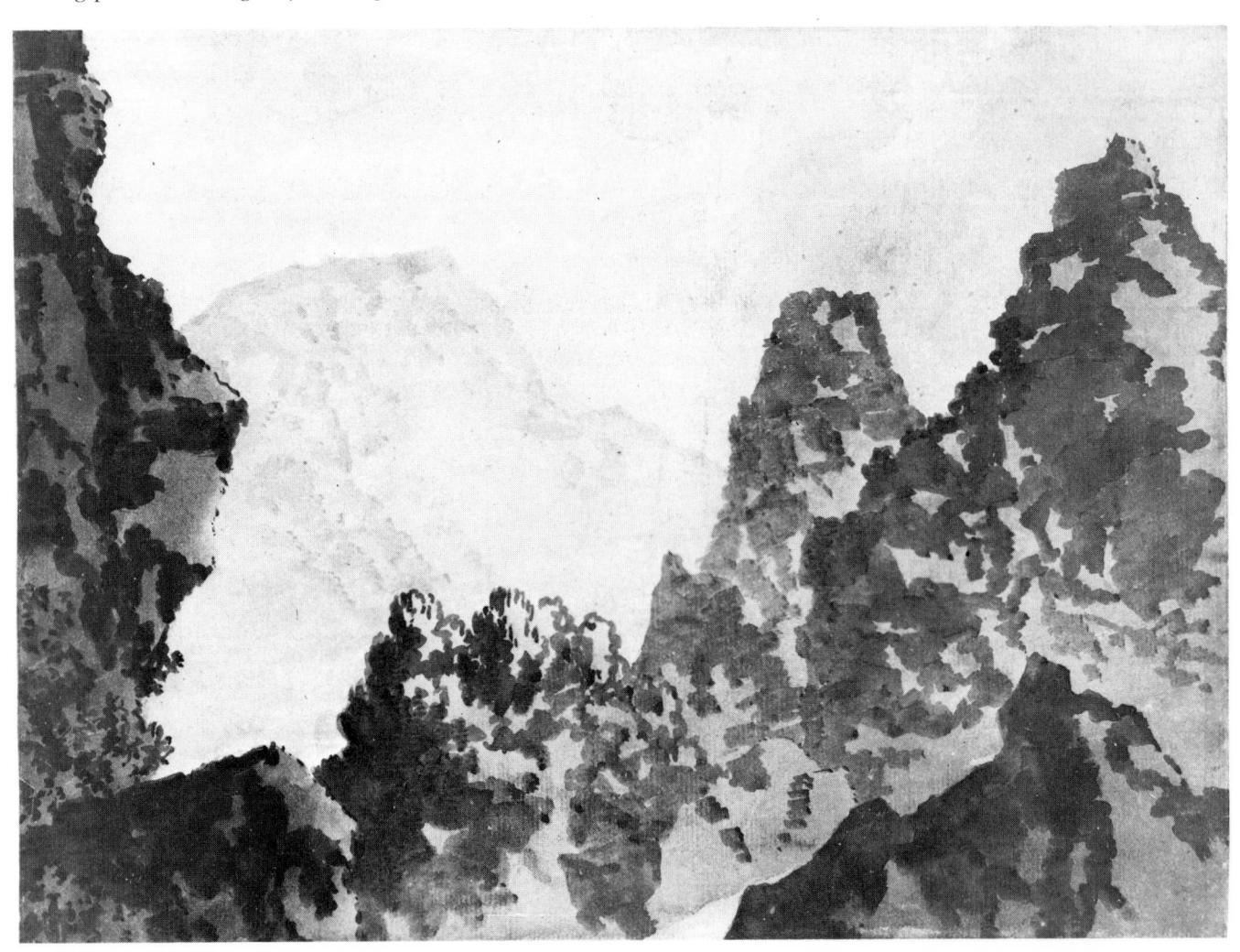

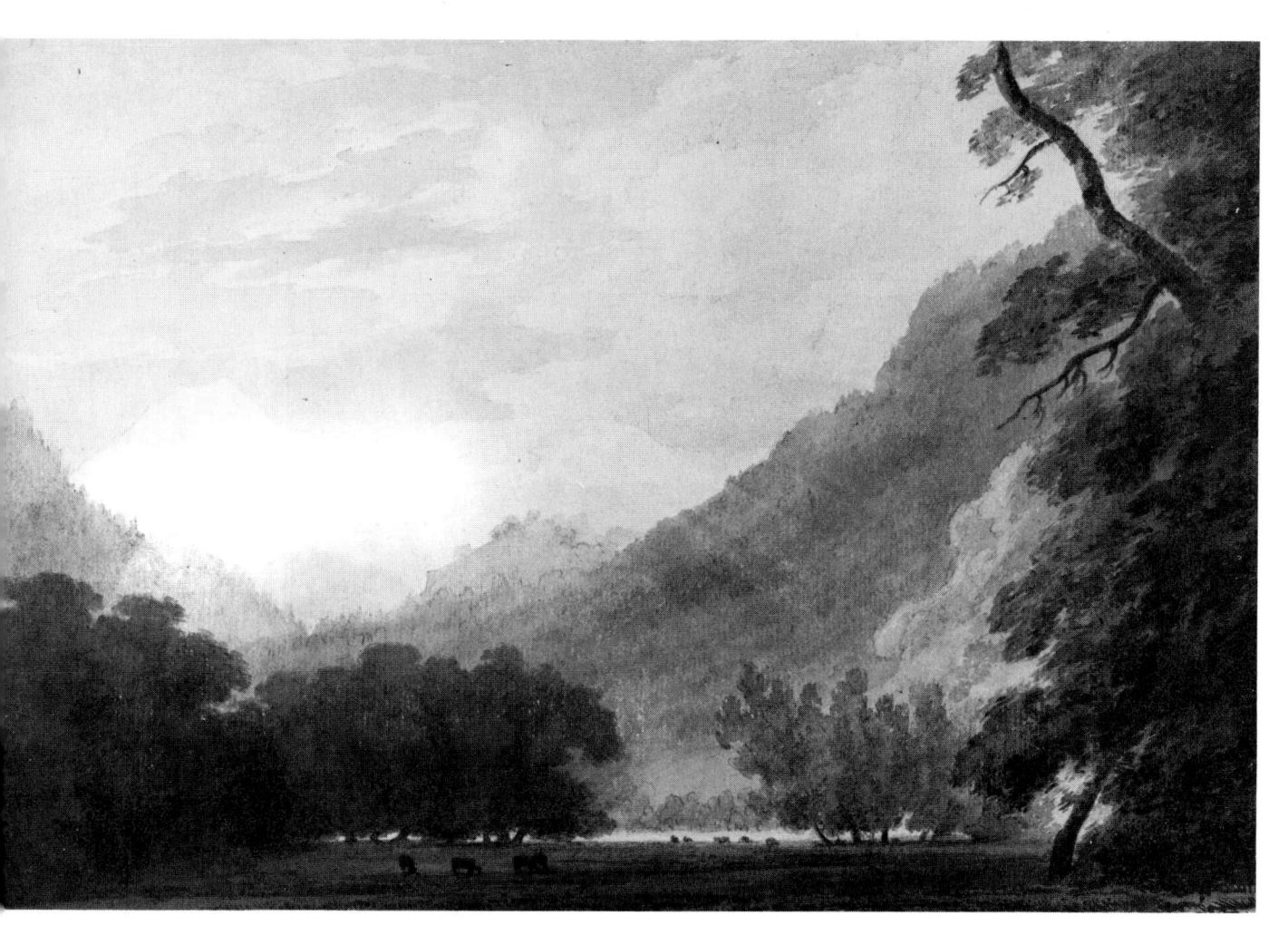

107. John Robert Cozens Interlaken: the Peaks of the Jungfrau Group in the Distance

John Robert Cozens, son and pupil of Alexander, drew and painted Alpine scenery from the Romantic viewpoint rather than the topographical. Like his father, he used a very limited range of tone, but, as we see here, he produced very spacious effects, with a tremendous sense of scale. This imaginary rocky landscape, based on blots, is constructed on three planes of recession: foreground, middle distance, and

distance. The drawing is carried out in a very limited range of tones with the darker values in the foreground, only two or three of the middle tones in the middle distance, and virtually only one middle tone to describe the distance. This gradual narrowing of the scale of tone used is responsible for the sense of distance and atmospheric perspective.

The Built Environment

The titles of the chapters of this book perhaps suggest that the pictures in each section can be fitted into neat categories; this is clearly not the case, and there is inevitably a good deal of overlap and ambiguity. For the purpose of this chapter we may take the title of 'The Built Environment' to include any drawings in which a building or buildings play a fairly prominent part, while recognizing that a good deal of what we call landscape was equally 'built', and that building may very well be seen as part of the landscape, since without land one cannot build.

Throughout history artists have shown a predilection for drawing certain kinds of buildings. The noble Greco-Roman temples and arches provided a subject or setting for the artists of the Renaissance or for those favouring a neoclassical approach, whereas to the Romantics it was the idea of ruins, crumbling or overgrown, which inspired (as it still does today). Churches and cathedrals (including the ruins of the neolithic cathedral of Stonehenge) have also proved a very popular motif. Others have chosen the theatrical setting which gives full range to the artist's

imagination, and allows him to invent his own built environment, expressing his own idea of grandeur, fantasy or Gothic horror. The industrial landscape, on the other hand, has not proved a very popular subject, and the cityscape of housing and streets is also comparatively rare. (The Futurists' love affair with speeding traffic and highrise blocks was very short-lived.) The street scene has usually been a setting for figures, and the same applies to interiors, drawings inside bars, cafés, theatres, or houses, all of which are more often backgrounds for the inhabitants than subjects in their own right.

Perhaps to the amateur draughtsman the particular and peculiar difficulties associated with drawing buildings derive from the problems of perspective. Here, because more straight lines are involved, the effects of linear perspective may be more evident than in a drawing of some other subject. However, a trained artist would be very unlikely to think of this as a particular difficulty, and would probably welcome the opportunity to explore perspective for his own particular ends.

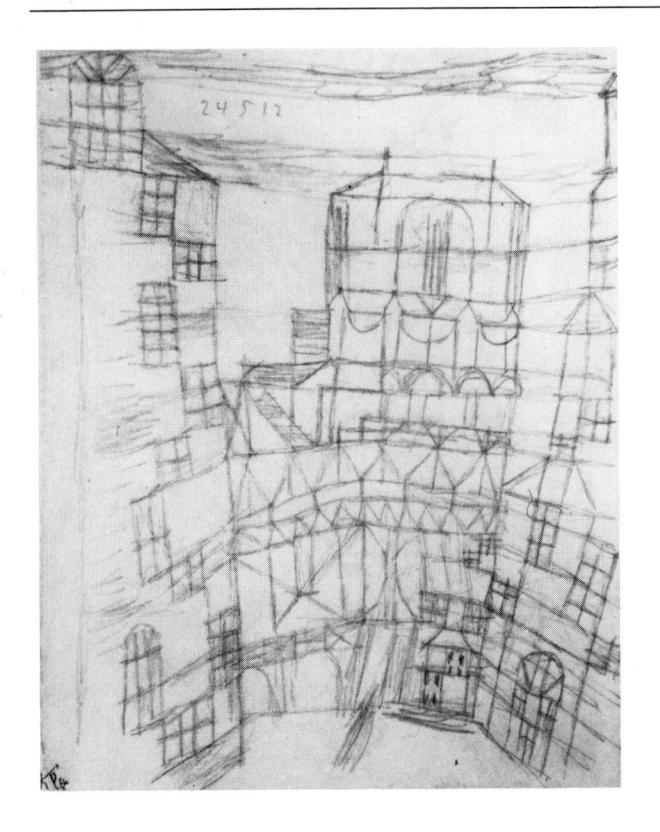

Canaletto's early training was in his father's profession of scenography, and even this drawing of a little loggia has a curiously theatrical air, suggesting a temporary construction in a light-weight material. The effect is largely due to the absence of light and shade, which are normally added to give a feeling of mass. The drawing is made virtually in oblique perspective; that is to say, the orthogonals (parallel lines moving away from the spectator) do not noticeably converge (had they done so the degree of distortion, because of the height of the building, would have made it look very odd). Canaletto was a first-rate topographical draughtsman, and his meticulous studies were sometimes made with the help of the camera obscura, though many were drawn on the spot.

Another theatrical drawing for the same tall, narrow stage, but this time more of a fantasy. Klee's pencil sketch, apparently drawn from a viewpoint half-way up the tall building, is, like all his works, an invention and an exploration of means. In this case, Klee explores the ability of line to express space (the concept of buildings is quite incidental, they are simply a convenient peg to hang the line on). Having created a linear framework to express the idea of space in an enclosed area, Klee subdivides the framework according to a logical system based on the simple geometric division of the rectangles he has created. The result: a world of his own.

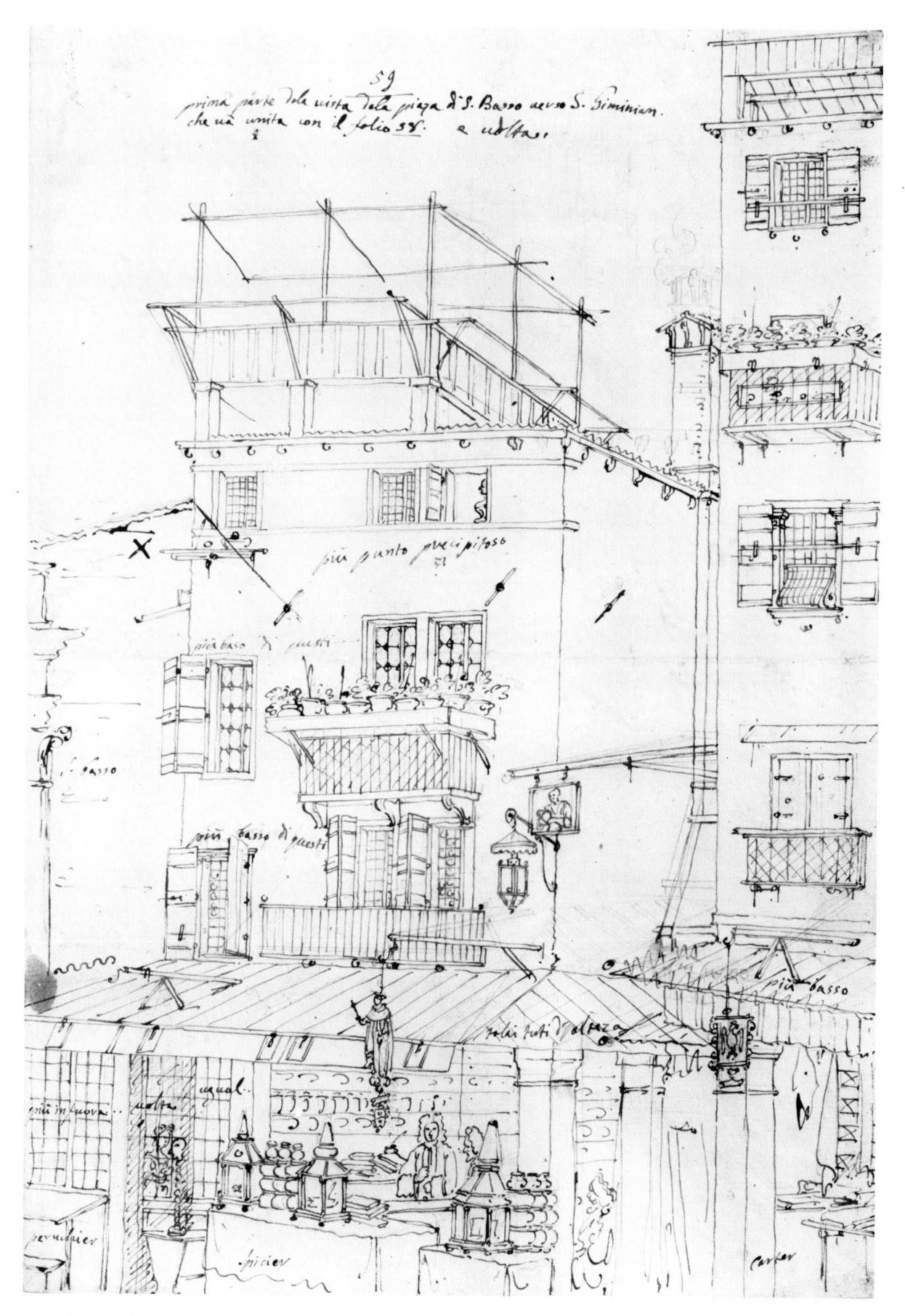

108. Paul Klee From an Old Town

109. Antonio Canaletto Piazza di S. Basso

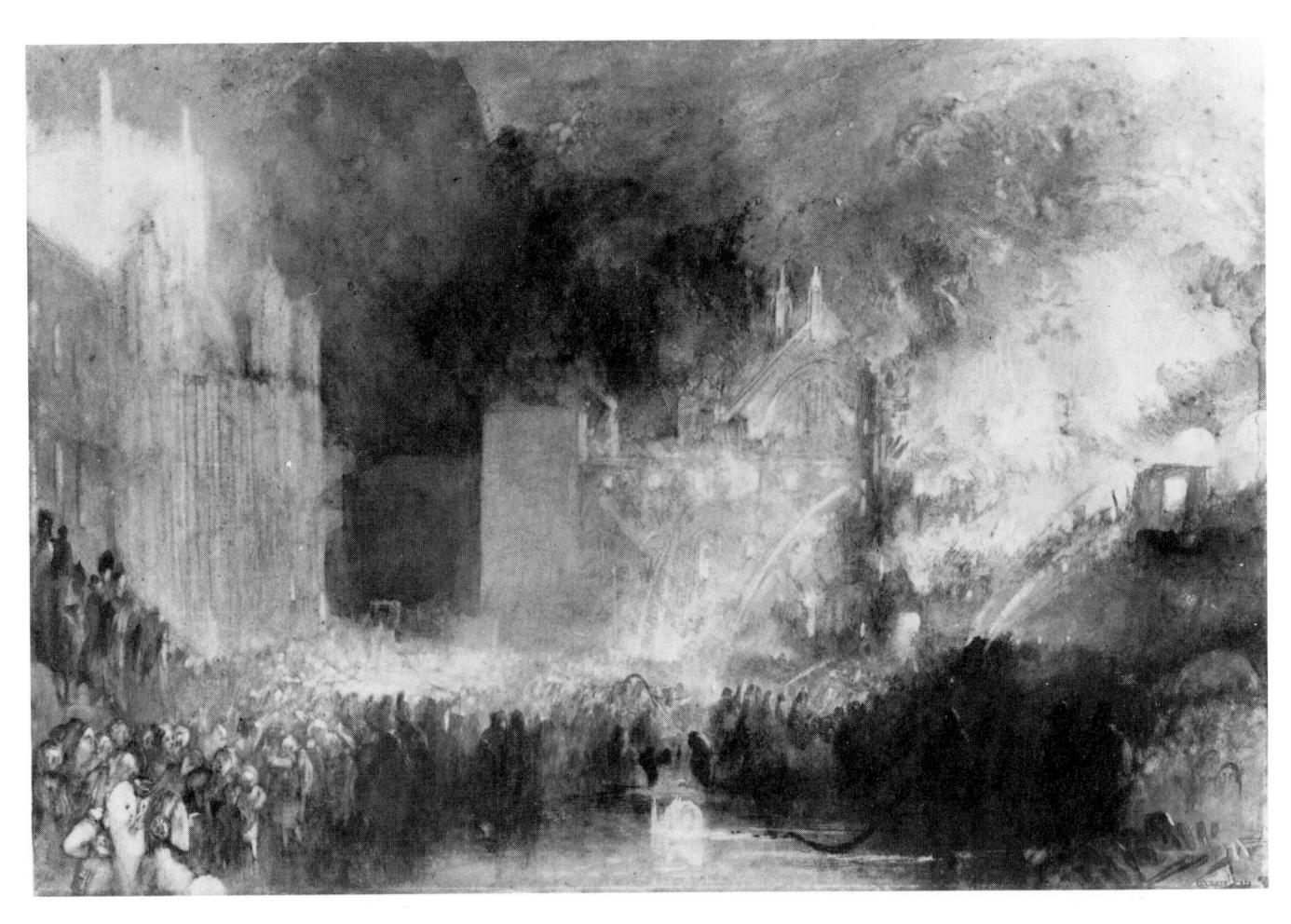

110. J. M. W. Turner The Burning of the Houses of Parliament

We can see from this drawing why some French critics of Turner's day dismissed his work as 'formless exaggeration', and his handling of colour as 'pyrotechnics' or 'confectionery'; today we might tend to judge his imaginative treatment of colour more in the context of Abstract Expressionism. Admitted to the Royal Academy Schools at the age of fourteen, Turner studied to be a topographical draughtsman, since there was a steady demand for views of historic buildings at this time; as his career progressed, however, he became more and more interested in light and colour, both in his oil-paintings and in his watercolours (in

fact making little distinction between the two). A reckless technician, he scraped, scratched, or used any means whatsoever to get the effect he required. Here he seems to have used just a few colours, and, while the paint was still wet, very effectively wiped it out with a rag or sponge. The subject - flames, smoke, and drama - was made for Turner. This was the one occasion on which it is known that he worked directly from the subject in colour, and in his haste to record the apocalyptic event he blotted the pages of his sketch-book against each other.

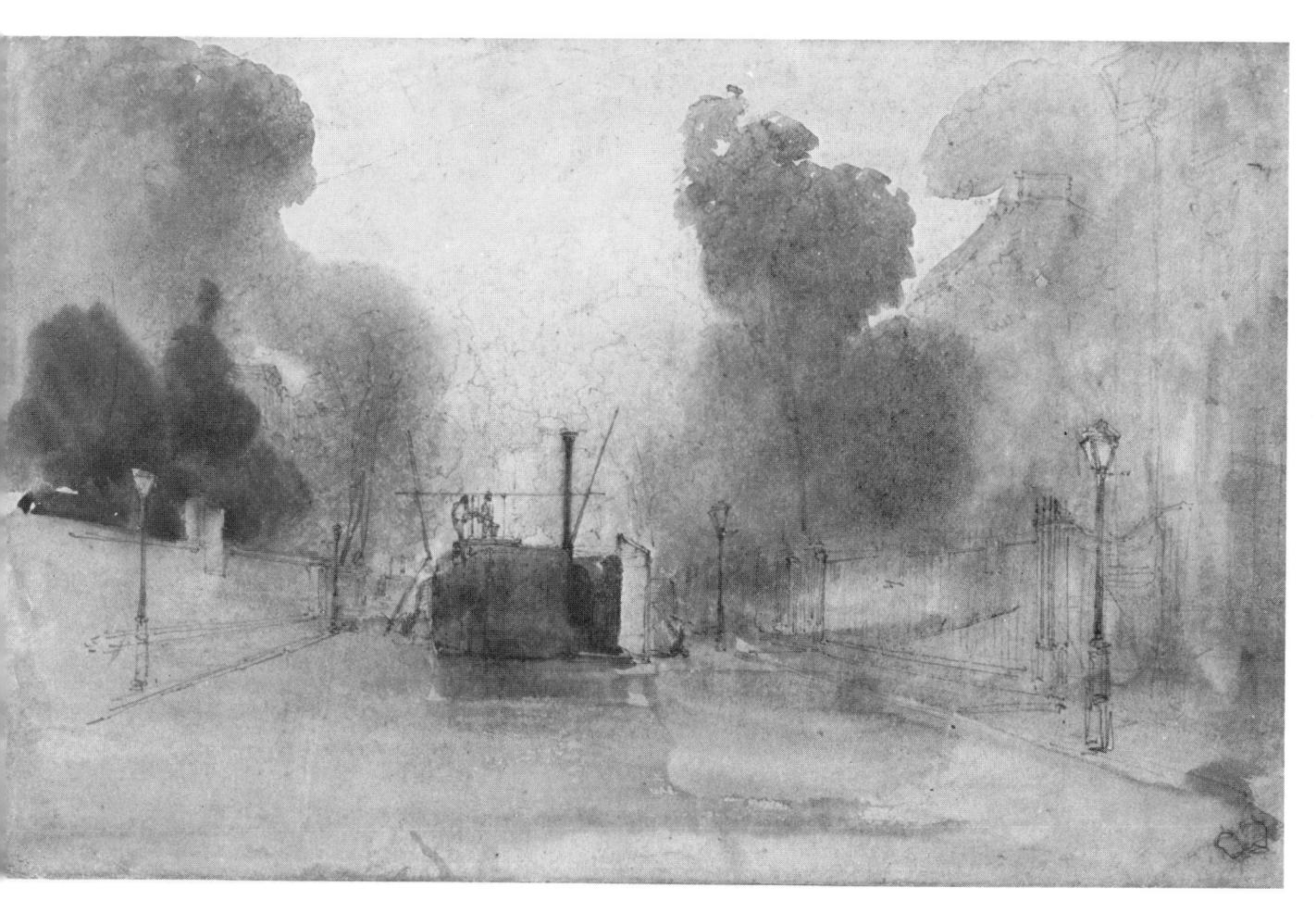

111. James Abbott McNeill Whistler Street Scene, with Tar Engine

Whistler's approach to art, like Turner's, has much in common with that of the abstract artist of today. He spoke of treating the picture as simply 'an arrangement of line, form and colour', and certainly in this drawing little remains of the so-called subject: instead of 'a street scene with tar engine' we see space and movement. This is an Impressionist drawing, reminiscent of Monet's studies of railway engines dissolved

by light and steam. Whistler, like his fellow Impressionists, was a great admirer of the Japanese print. When we look at this drawing with its evocative spontaneity, its exploitation of the wet medium so that shapes flow into each other apparently accidentally, and its feeling of flawless positioning, we can see that the influence of the East was highly beneficial to Whistler's development as an artist.

112. John Constable

The Ruins of Cowdray Castle, Interior

Two Master drawings of castles nostalgically hinting at past glory by the light streaming through the broken windows. The ruins of Cowdray Castle form an unusual composition for Constable, in whose work the sky is often the major item; here the crumbling walls tower above us, but we can still glimpse the sky through the great windows. What is characteristic of Constable's work, though, is the vitality of handling, the brushwork, and the sense of structure underlying even apparently accidental effects. The diagonal walls, paralleled by the diagonal undergrowth in a muted, sad green complementary to the faded pink-greys of the building, are continued by the great diagonal shadow across the far wall, producing a scene of drama and foreboding as powerful as anything in *Macbeth*.

113. Thomas Girtin

Great Hall, Conway Castle

Girtin, born in the same year as Turner, died at the early age of 27. He was one of the team of artists who met at the house of Dr Thomas Monro, a London physician and patron of the arts. Turner and Cotman were also members of his 'academy', and worked at night copying Alexander Cozens and other watercolourists. Girtin quickly developed an original style, using a series of small, broken touches which have the effect of punctuation on the main masses and give the whole a sense of detail and delicacy which is part of the charm of Girtin's work. Like Cozens he tended to draw in tone rather than local colour, using a prevailing key of warm grey (see Ill. 106).

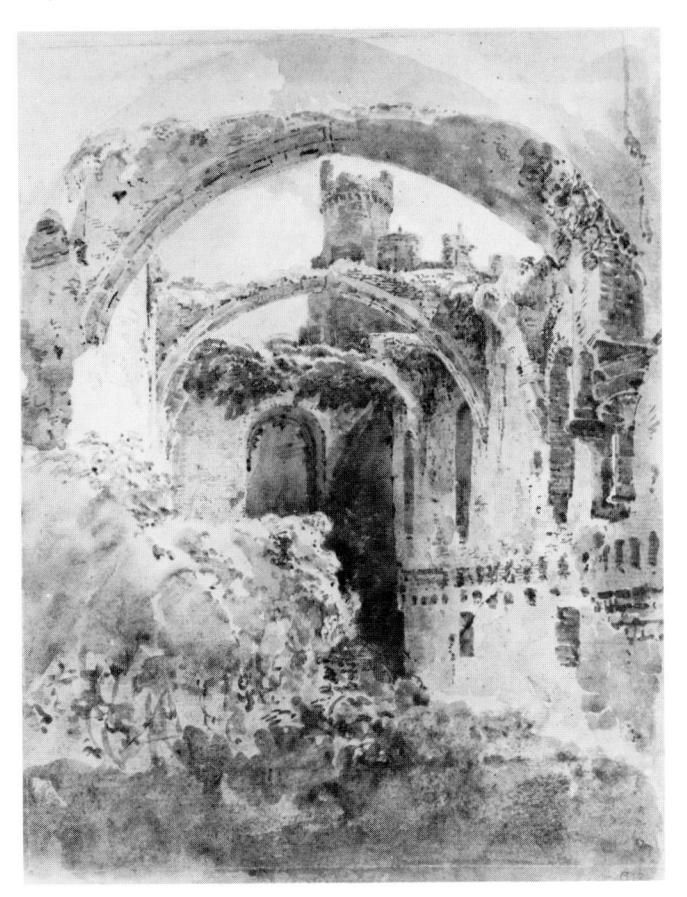

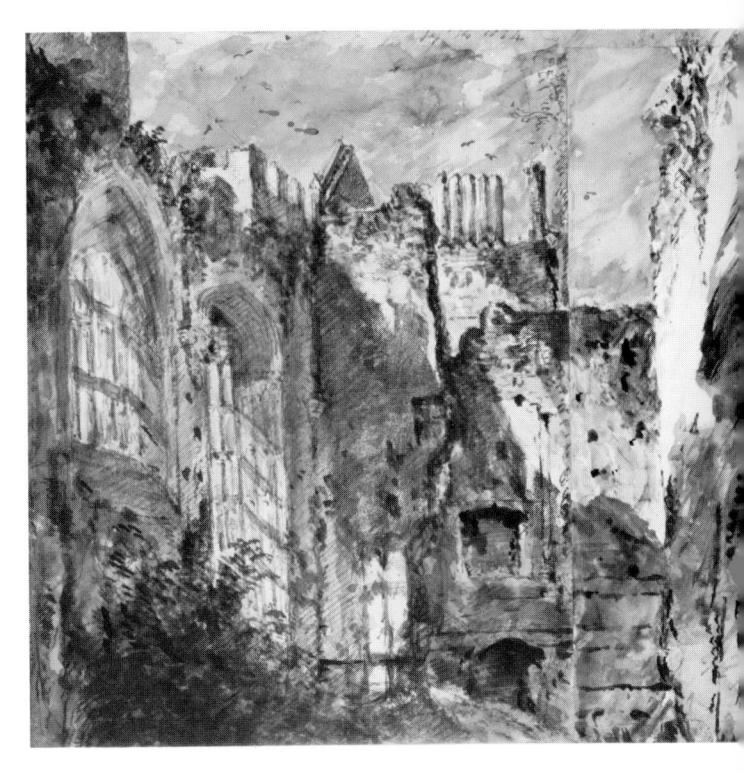

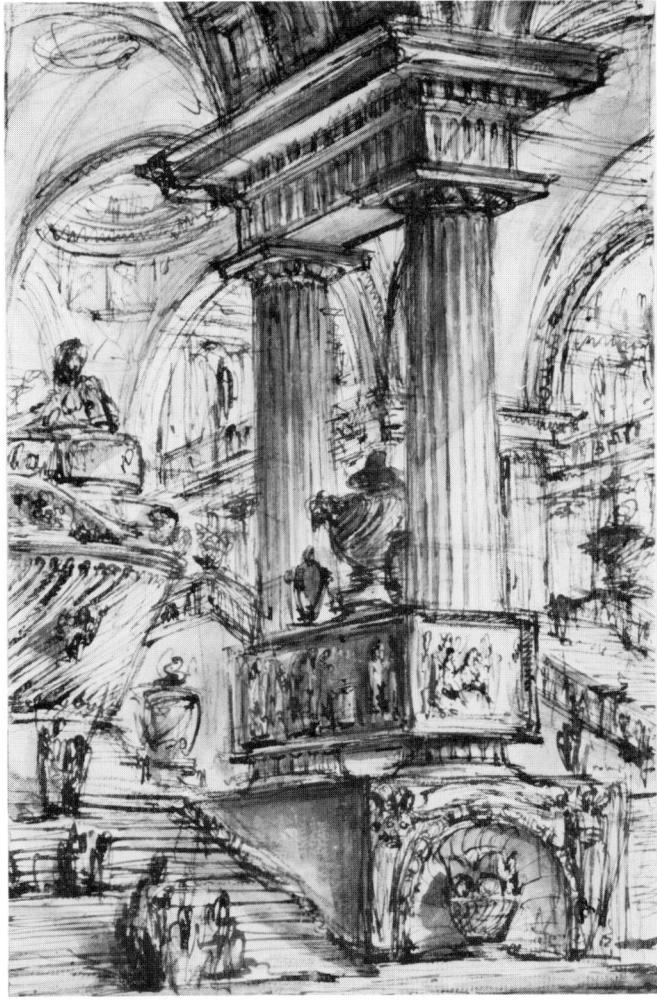

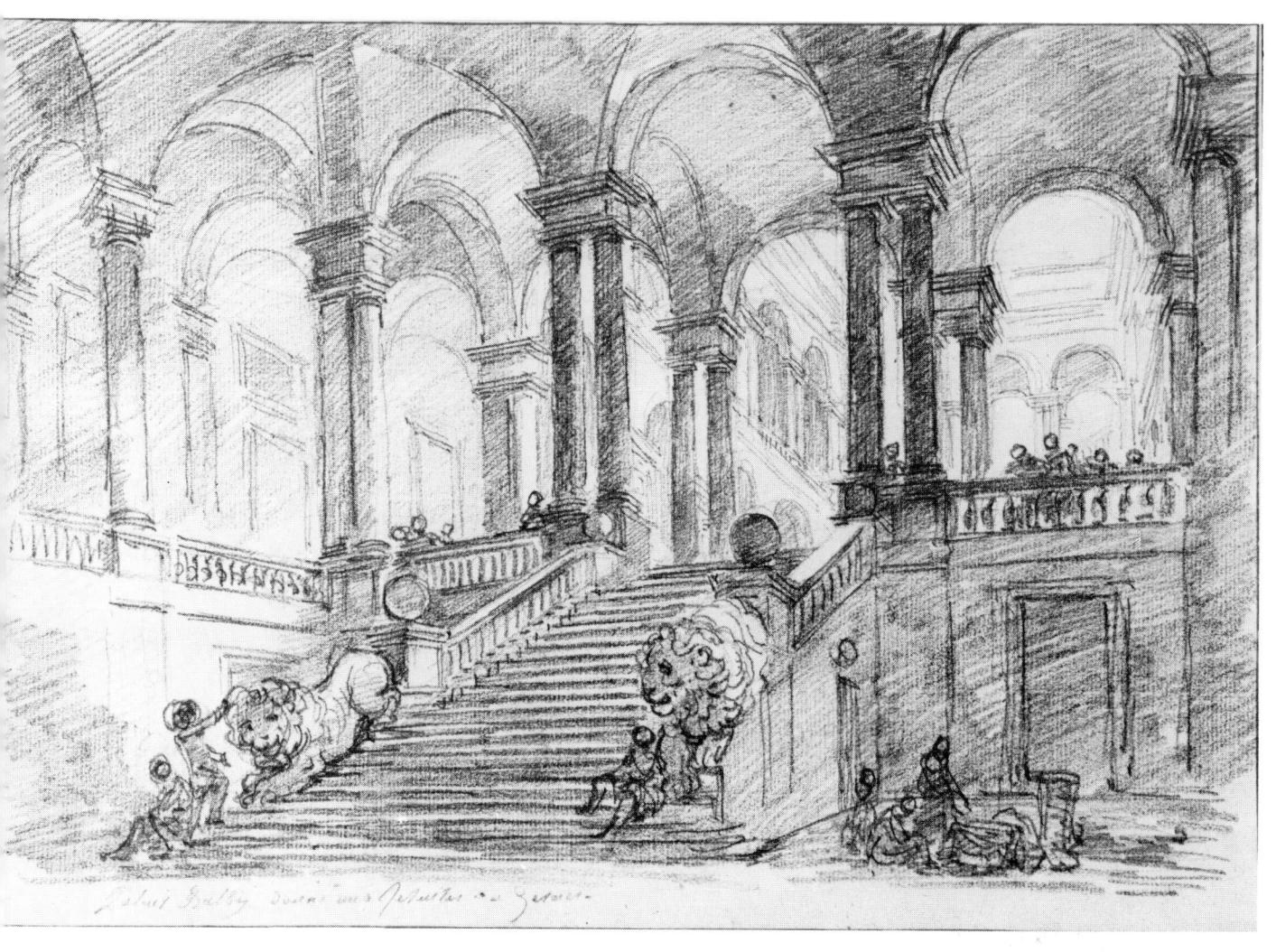

114. Jean Honoré Fragonard Genoa, Staircase of the Palazzo Balbi

Fragonard, the supreme virtuoso of eighteenth-century French art, stayed in Italy from 1756 to 1761, where he was very impressed by the work of Tiepolo. Fragonard's range was astonishing. Besides the frivolous scènes galantes, he could design equally well a composition in the Grand Manner. In this drawing (one of thousands by his hand) he reveals his complete mastery not only of the medium but also of perspective (aerial as well as linear). The coupled columns and arches gradually recede into the distance, the more distant so delicately suggested as to be almost imperceptible. Throughout, the handling of the chalk has a freedom and spontaneity which gives a mood of light-hearted gaiety to the scene. Shadows are lightly scribbled in, and the whole atmosphere is theatrical but fun - so different from the oppressive, authoritative architecture of his contemporary, Piranesi.

OPPOSITE:

115. Giovanni Battista Piranesi

Monumental Staircase leading to a Vaulted Hall

Piranesi, architect, engraver, and etcher, went to Rome to study in 1740. This drawing, with its effect of massive grandeur and its sense of vaulted chambers and staircases extending even further than the eye can see, is typical of his work. Although depending largely on line (a reflection of his etching technique), Piranesi also uses broad washes to create the breadth of shadow. His architectural inventions, especially

his Carceri d'Invenzione, are labyrinthine interiors, in which staircases and archways endlessly interconnect with others, all suggesting a scale which dwarfs the human personality. Piranesi used perspective with skill and panache, apparently enjoying every opportunity of showing off his mastery of the subject. The repeating motif of massive urns creates an atmosphere of barbaric splendour.

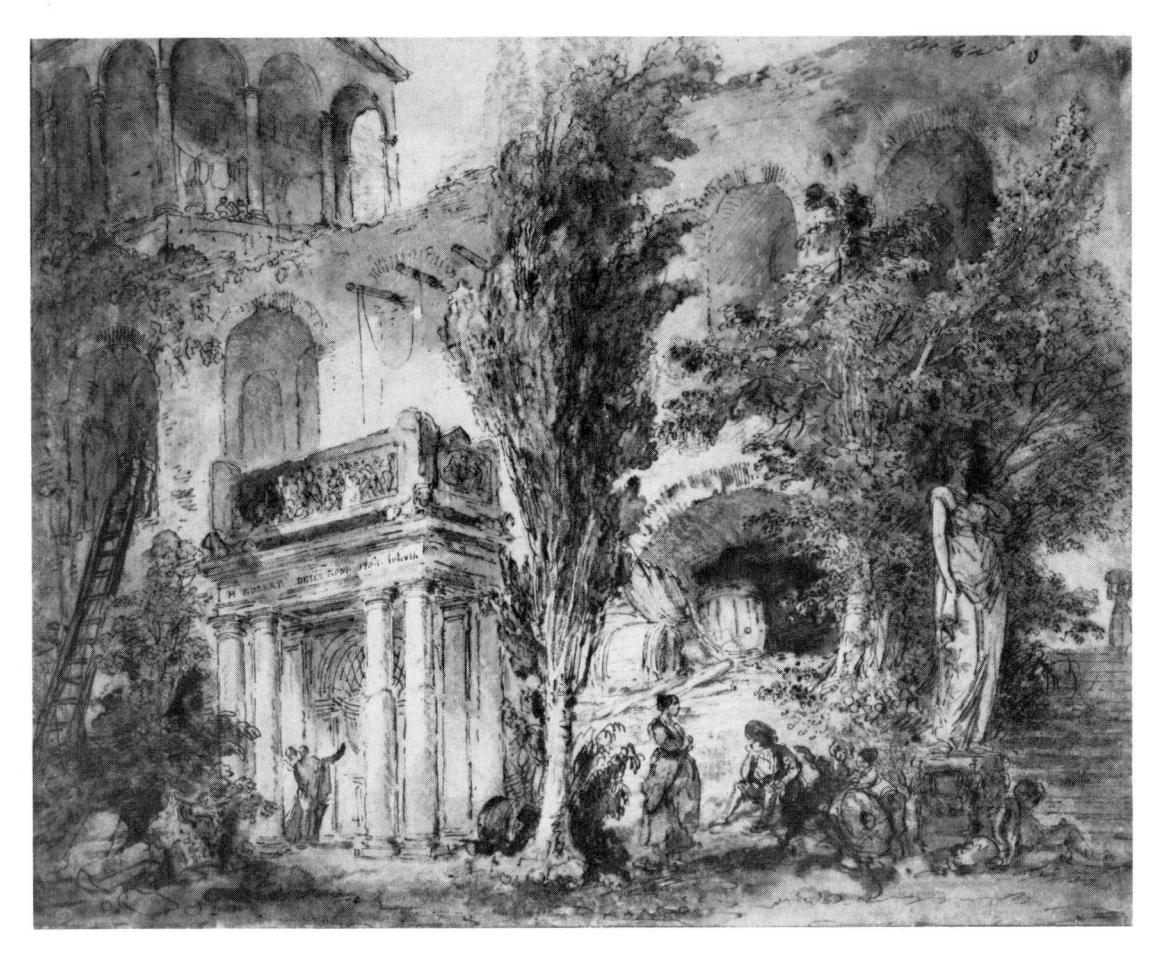

116. Hubert Robert Rome, the Villa Ludovisi

Contemporary with Fragonard and Piranesi, and from the age of 21 also working in Rome, was Hubert Robert, a French painter known as 'Robert des ruines'. Robert, influenced by Piranesi, produced many pictures of classical ruins - some real, some imaginary. While in Rome he became friendly with Fragonard and the two sometimes worked together, each learning from and contributing to the style of the other. This drawing, with its abrupt changes of scale and viewpoint, produces by its inconsistencies a feeling of unreality, suggesting a collection of ideas rather than an actual location. It is a kind of veduta ideata: the scene is realistically conceived, but the elements appear to be imaginary. It would make a good setting for an eighteenth-century comedy in which the lovers exit or enter through such a variety of possibilities that endless confusion is caused. In short, it is a set, a romantic landscape garden with grottoes, ruins, and follies. It is not surprising that after Robert returned to Paris he was made Garden Designer to King Louis XVI.

117. Claude Lorrain

Landscape with Mercury and Argus

This pen and ink drawing is almost a prototype for the countless imitations (of varying degrees of incompetence) made by artists from the seventeenth century to the present day. It is an example of the romantic approach in classical guise. Classical in that the ostensible subject is drawn from Greek mythology and many aspects of the drawing may be said to be consistent with a classical approach: the pyramidal grouping of the figures, for example, and the reference to classical architecture, the emphasis on line and drawing, the underlying suggestion of a vertical/horizontal structure (the placing of figures and animals is on a horizontal line parallel to the picture plane), and the balanced composition (almost a trade mark of Claude) with a vertical mass on each side joined by distant horizontals between. But in spite of all these associations, the classical architecture is romantically ruined. The pastoral mood is much more important than Mercury and Argus, and by his light touch and decorative treatment Claude suggests a kind of nostalgia for the past pleasures of the pagan world.

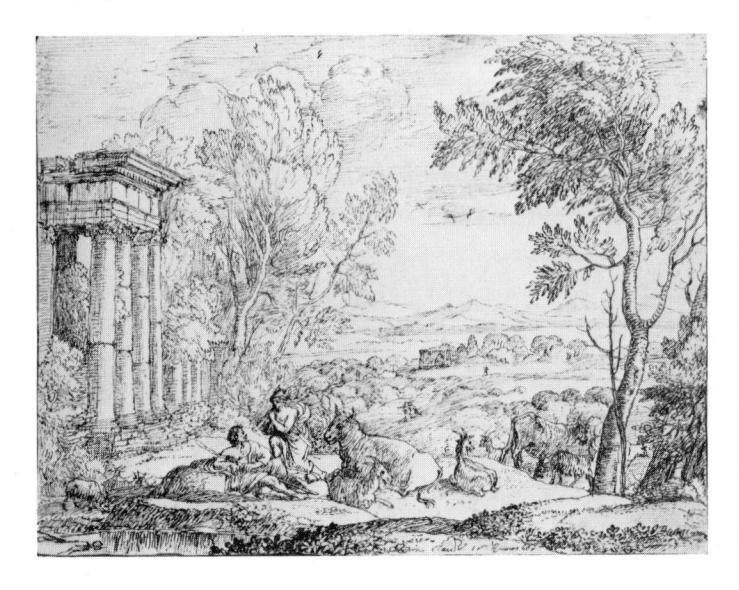

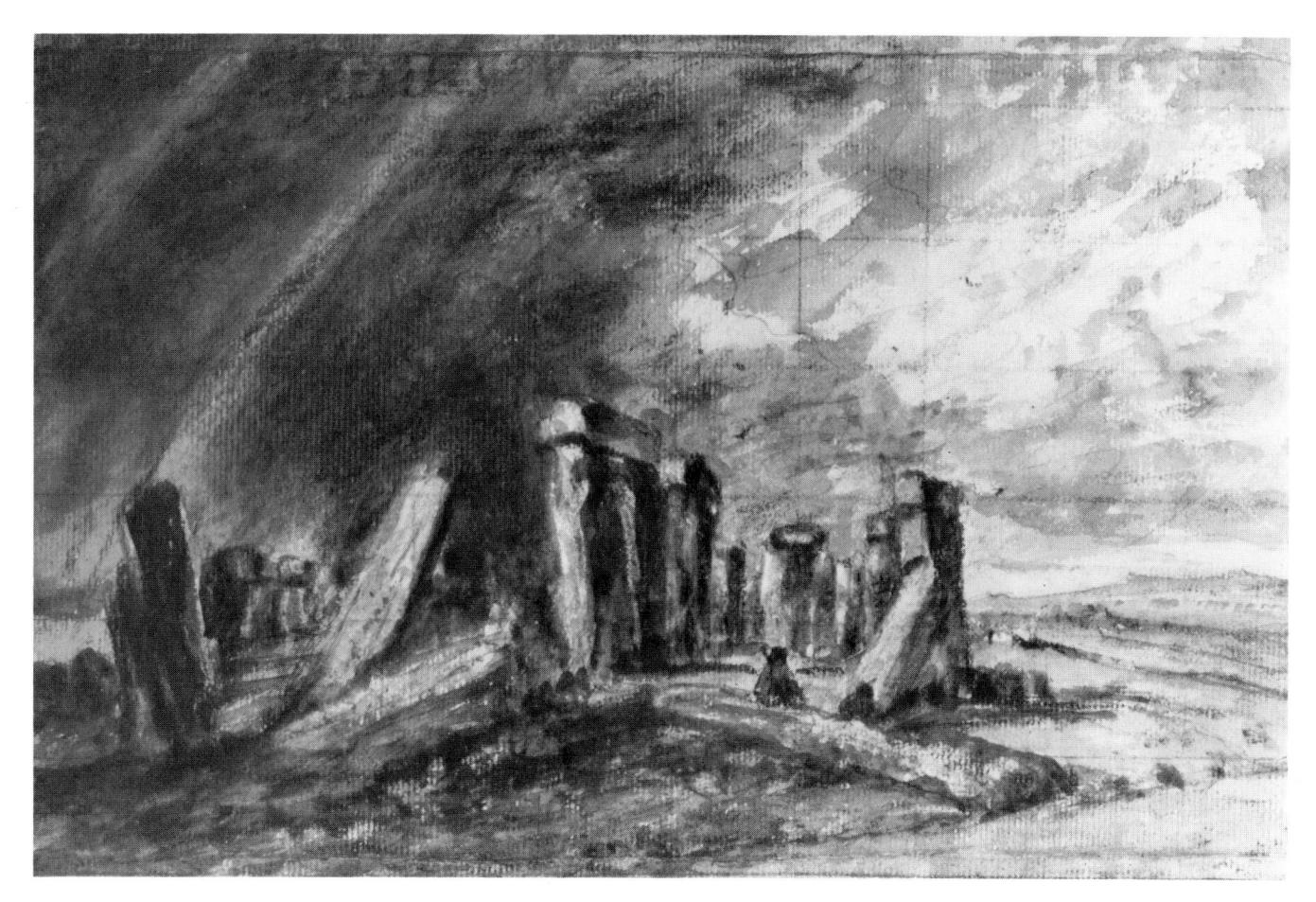

118. John Constable Stonehenge

These two watercolours have much in common: in both, the subject is ostensibly the building, redolent with history and ancient authority. Both drawings are, however, essentially romantic, and stress the mood rather than the subject-matter, recalling Constable's words: 'Painting is for me but another word for feeling.' The drama of Stonehenge, an enigmatic tragedy, is played against a background of indigo sky, and, revealed where the sky is darkest, the hopeful light of the double rainbow appears all the more effective by contrast.

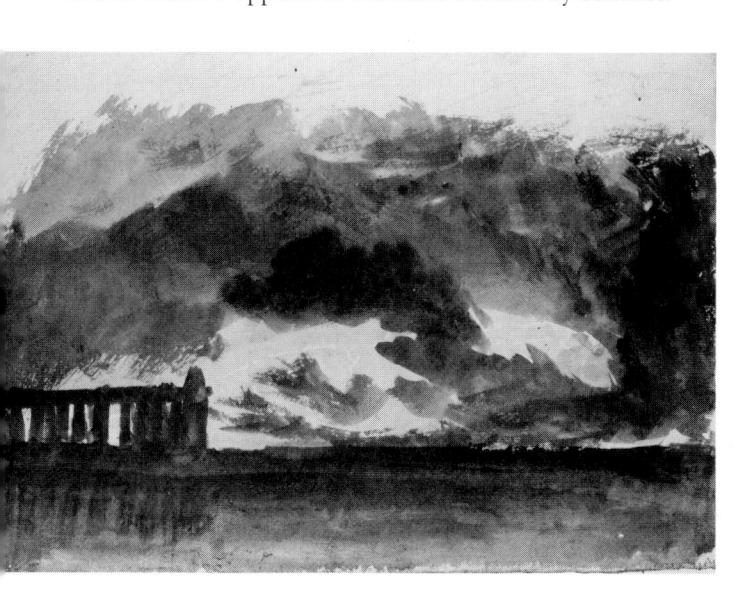

After the death of his wife in 1828 Constable suffered long periods of depression: 'I shall never feel again as I have felt,' he said, 'the face of the world is totally changed for me.' His sombreness was reflected in his work, and the mood of his later landscapes is summed up in his own words: 'Sudden and abrupt appearance of light, thunder clouds wild autumnal evenings, solemn and shadowy twilight . . . with variously tinted clouds, dark cold and grey, or ruddy and bright, with transitory gleams of light, even conflicts of the elements, to heighten if possible, the sentiment which belongs to a subject so awful and impressive.' Constable made a special study of skies, which he described as 'the chief organ of sentiment'. In addition to setting down his own direct observations from Nature, he made copies of the schematic drawings which Alexander Cozens had made for his pupils.

119. J. M. W. Turner Paestum in a Storm

In this drawing of a skeletal building about to be devoured by the great sweep of anthropomorphic cloud turning back on its tracks, Turner, like Constable, makes use of the low eye-level to silhouette the temple against the skyline, heightening the dramatic effect almost to the point of melodrama.

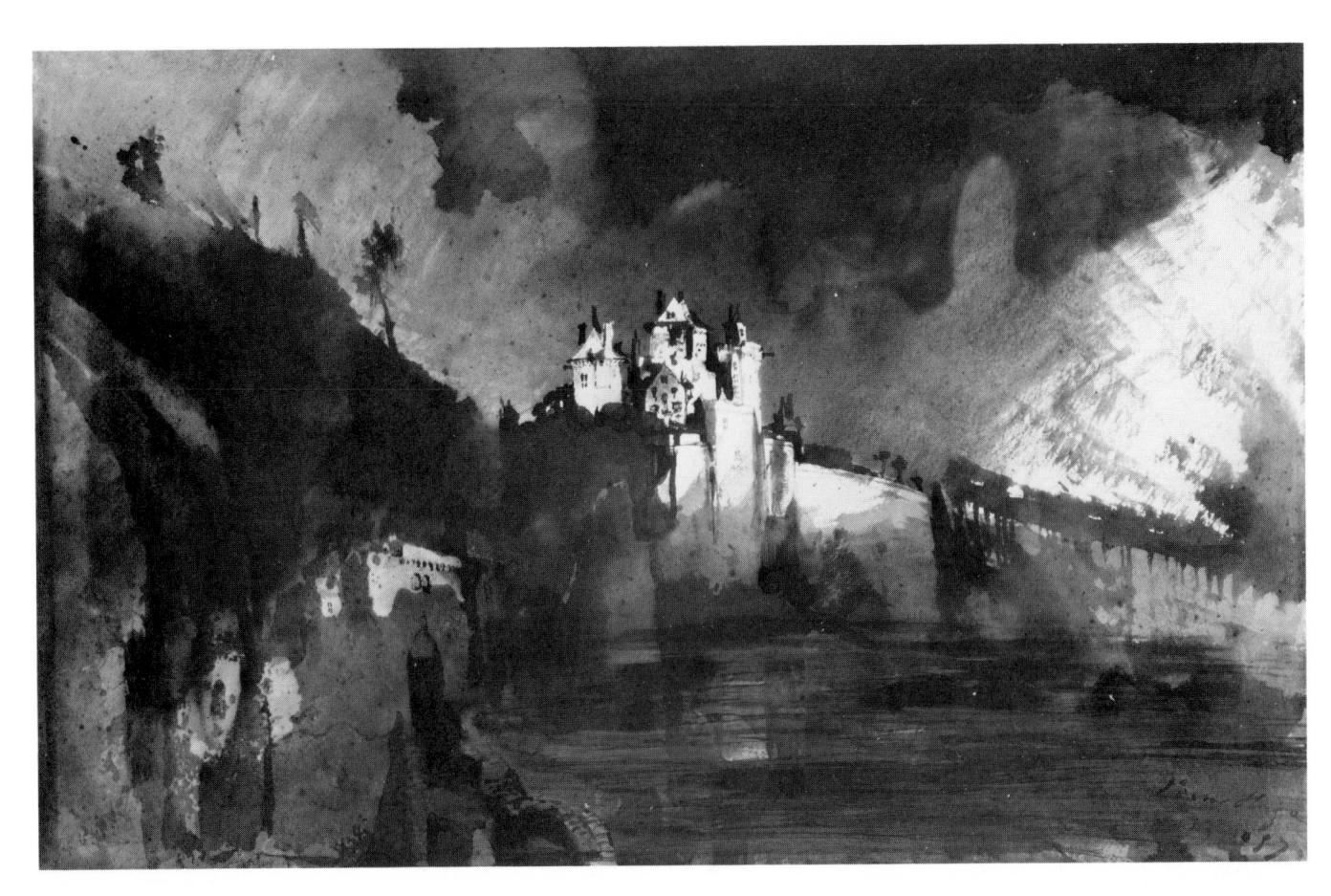

120. Victor Hugo Castle above a Lake

This wash drawing is by Victor Hugo, the French writer, who is perhaps better known for his plays, novels, and poetry; as this drawing reveals, though, he was also an accomplished draughtsman, and exemplifies the best of the Romantic tradition. The castle, its sheer walls towering above the dark water, is suddenly violently illuminated by the dazzling light source on the right, so that with all its drama and fairy-tale associations, the drawing is also an intriguing

counterchange pattern: on the left we have the dark shape of the hill, creating a diagonal movement as it is silhouetted against the light sky, while on the other side we have a blaze of light against a dark sky, throwing the central feature, the castle, into harsh relief. Everything seems to have been painted with a broad square brush and a great deal of confidence.

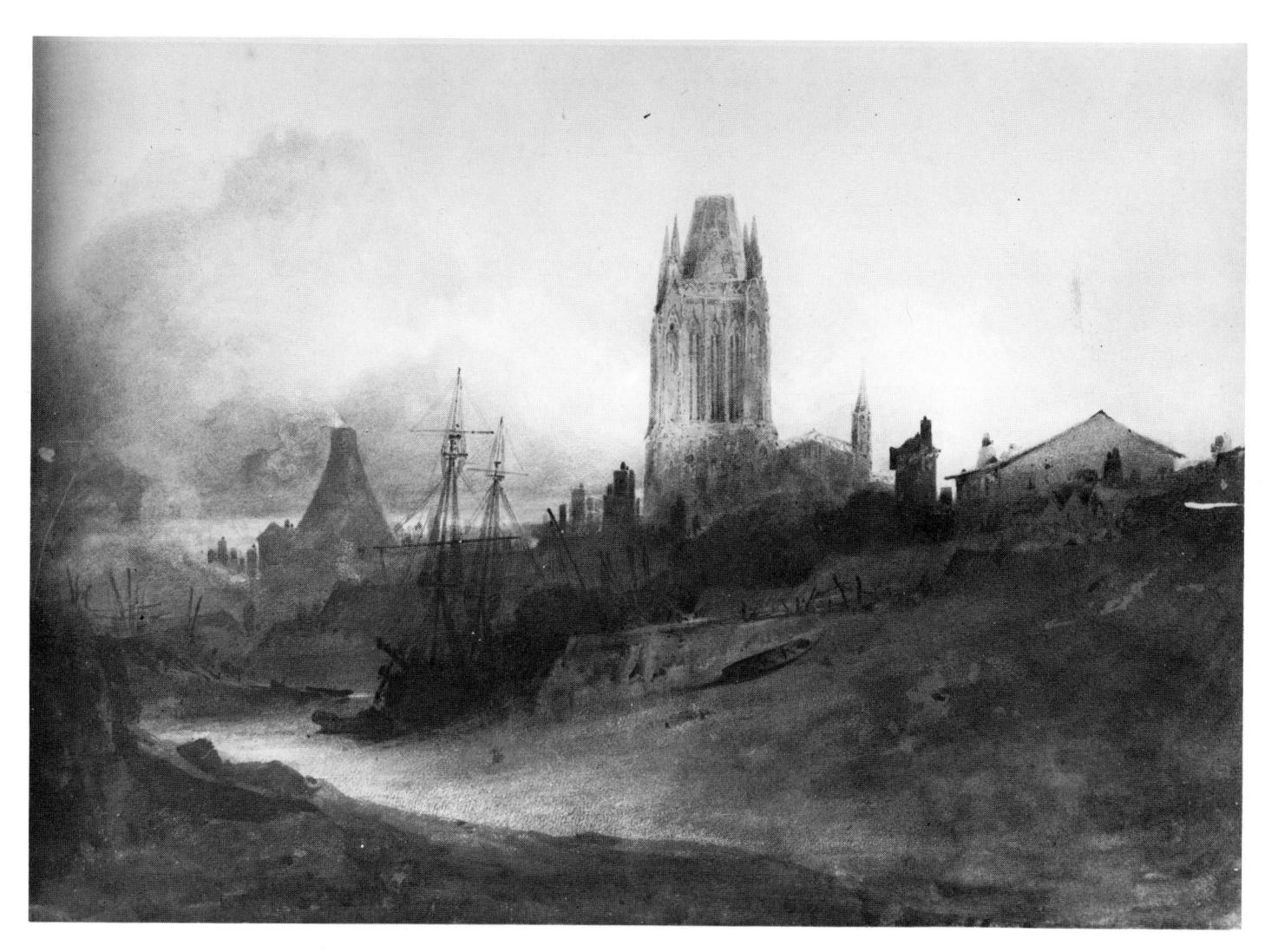

121. John Sell Cotman Bristol, St Mary Redcliffe

Cotman, too, uses the device of silhouetting his shapes as a means of accentuating the dramatic mood so beloved by Romantics everywhere. The more we probe into the shadows the more we seem to be able to see, in spite of the mists which wreathe the scene in mystery. The broad simplicity of the design and the expressively silhouetted shapes are typical of this artist (see Ill. 105).

122. John Sell Cotman

A Sarcophagus in a Pleasure-ground

This watercolour illustrates Cotman's technique perfectly. His use of the silhouetted, simplified shape can be seen in the trees against the skyline and in the changing tones of the dead trunks as they are counterchanged against their background—light against dark and vice versa. Cotman uses very few colours: a cool blue-green contrasts with a warm ochre, and the two are mixed together to give an intermediate warm olive-green. These, plus a unifying grey and a flat blue wash for the sky, against which the clouds are silhouetted, seem to be the only colours used. The result is a strong feeling of pattern and unity of design, and a harmony of colour relationships.

OPPOSITE:

123. Richard Parkes Bonington Paris, The Institut seen from the Quais

Bonington won a Gold Medal at the famous Salon of 1824 where his precocious talent (he was then 22) was admired by Delacroix. Like Cotman, Bonington shows complete control of his tonal and colour schemes. His colours are based on muted complementaries: a greyed-red and a grey leaning towards the opposite of red, green. The tonal scheme is equally controlled, and, again, like Cotman, Bonington treats his shapes as simple masses. The foreground uses a fairly wide range of tone, from the light of the rock to the dark of the cast shadows, and in this foreground area we also find the most positive colour. In the middle distance, which consists of the main building, we find the same colours repeated, but much less assertive; as the colours become more subdued, so the tonal range is narrowed. In the distant scene the tonal intervals are very close together (there is no contrast between light and dark) and the colours are also brought into close relationship with each other, all tending towards a kind of smoky blue. In this work all the elements - tone, colour, and placing - are beautifully and exactly controlled. The reds on the rock and the position of the figure are examples of Bonington's precision of placing, and evidence of his unsurpassed sense of composition. He died aged 26 years.

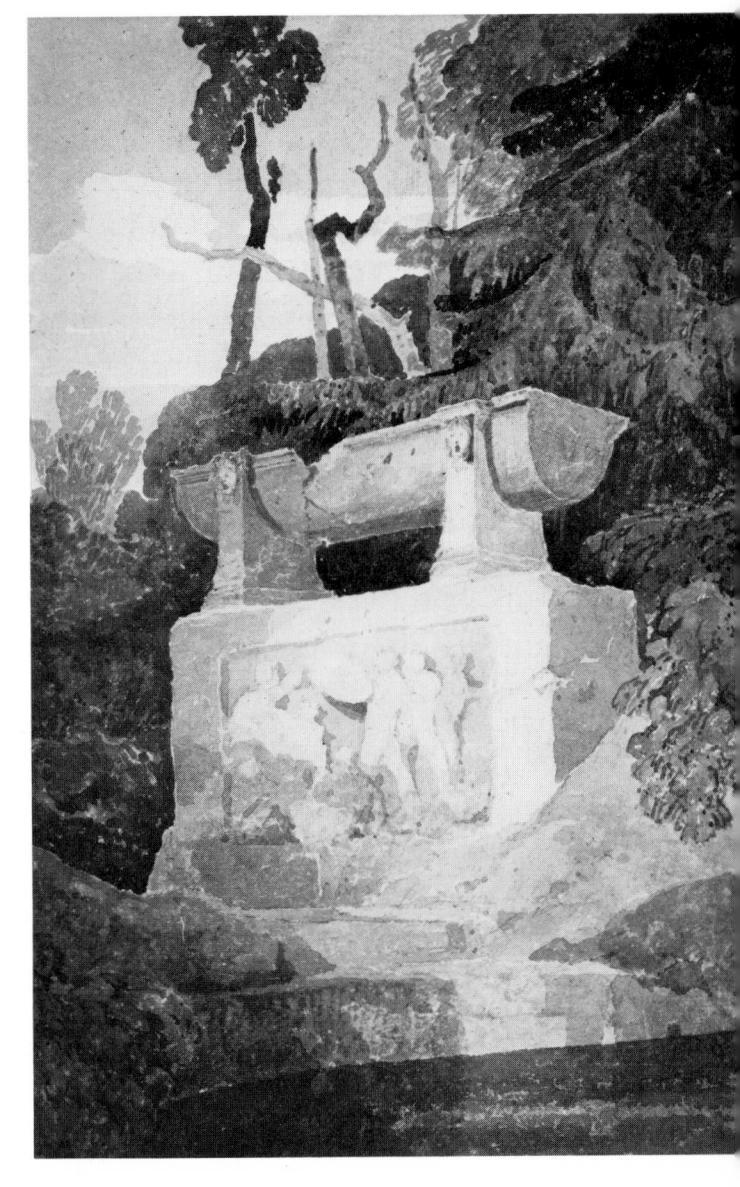
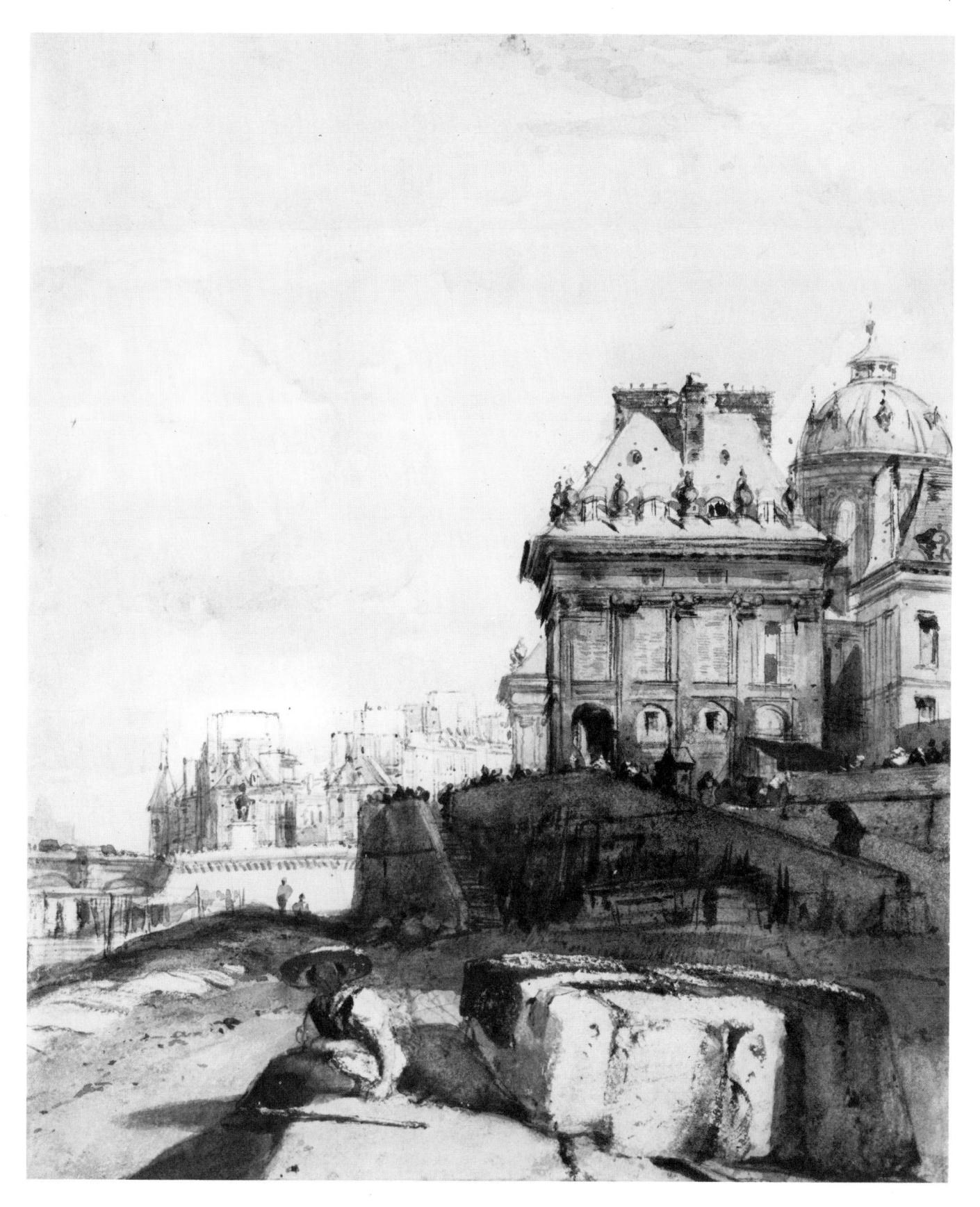

124. Vittore Carpaccio Fortified Harbour with Shipping

Vittore Carpaccio painted a series of narrative pictures for the confraternities of his native city of Venice; the earliest and most influential was his Legend of St Ursula (1490 - 8), now in the Accademia, Venice. This drawing relates to the background of the scene entitled St Ursula and the Prince taking leave of their Parents (1495). If we study it closely we find that the subject has first been sketched lightly in red chalk and then revised and finalized in brown ink. Although light and shade are indicated on some of the buildings in a rather arbitrary way, there is no attempt to describe distance by using aerial perspective, and even the linear perspective is not at all consistent. In spite of all this, Carpaccio has produced a drawing which has both a feeling of space, due to forms overlapping each other, and a sense of scale, due to the amount of detail being kept to the minimum required to convey all that is needed. The combined effect of the restricted depth and the sense of structure (with the predominance of the horizontal and vertical) gives this work a very modern character.

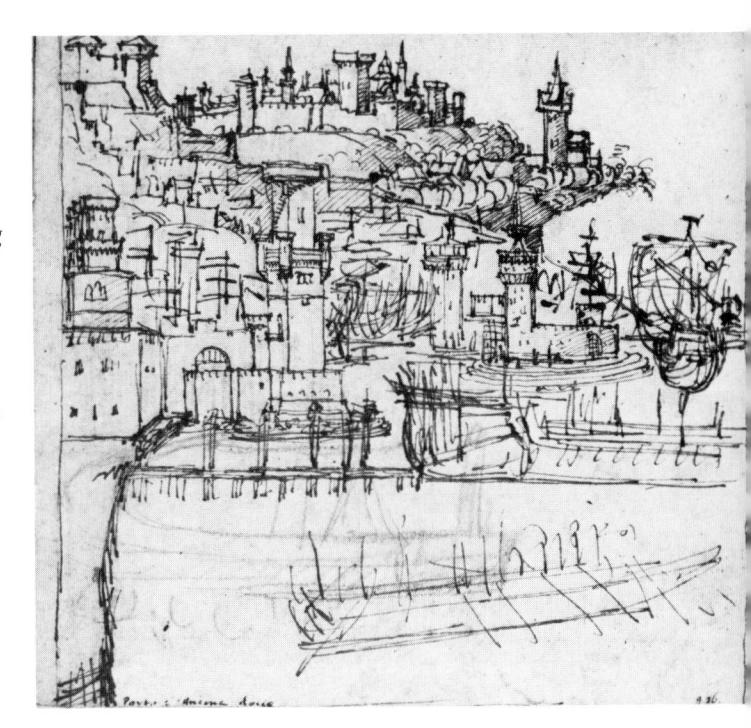

125. Jan van Scorel Alpine Landscape with a Bridge

Contemporary with Vittore Carpaccio was the Dutch painter Jan van Scorel, known for his portraits and religious subjects. He travelled widely, visiting Germany, Italy, and perhaps the Holy Land, and would have had the opportunity to experience precipices and craggy cliffs at first hand. In this pen-and-ink drawing linear perspective is as inconsistent as in Carpaccio's (note, for example, the house on the bridge). But van Scorel does use a light tone of ink for the view through the arch of the bridge – the distant scene, by coincidence, fitting into the archway exactly! The rocky promontaries and the buildings perched upon them are also treated with a degree of aerial perspective, lines becoming progressively fainter as one form consistently, almost inevitably, overlaps the next. The spiky character of this drawing with its turrets and towers belongs more to the medieval world than to the Renaissance (compare Ill. 59).

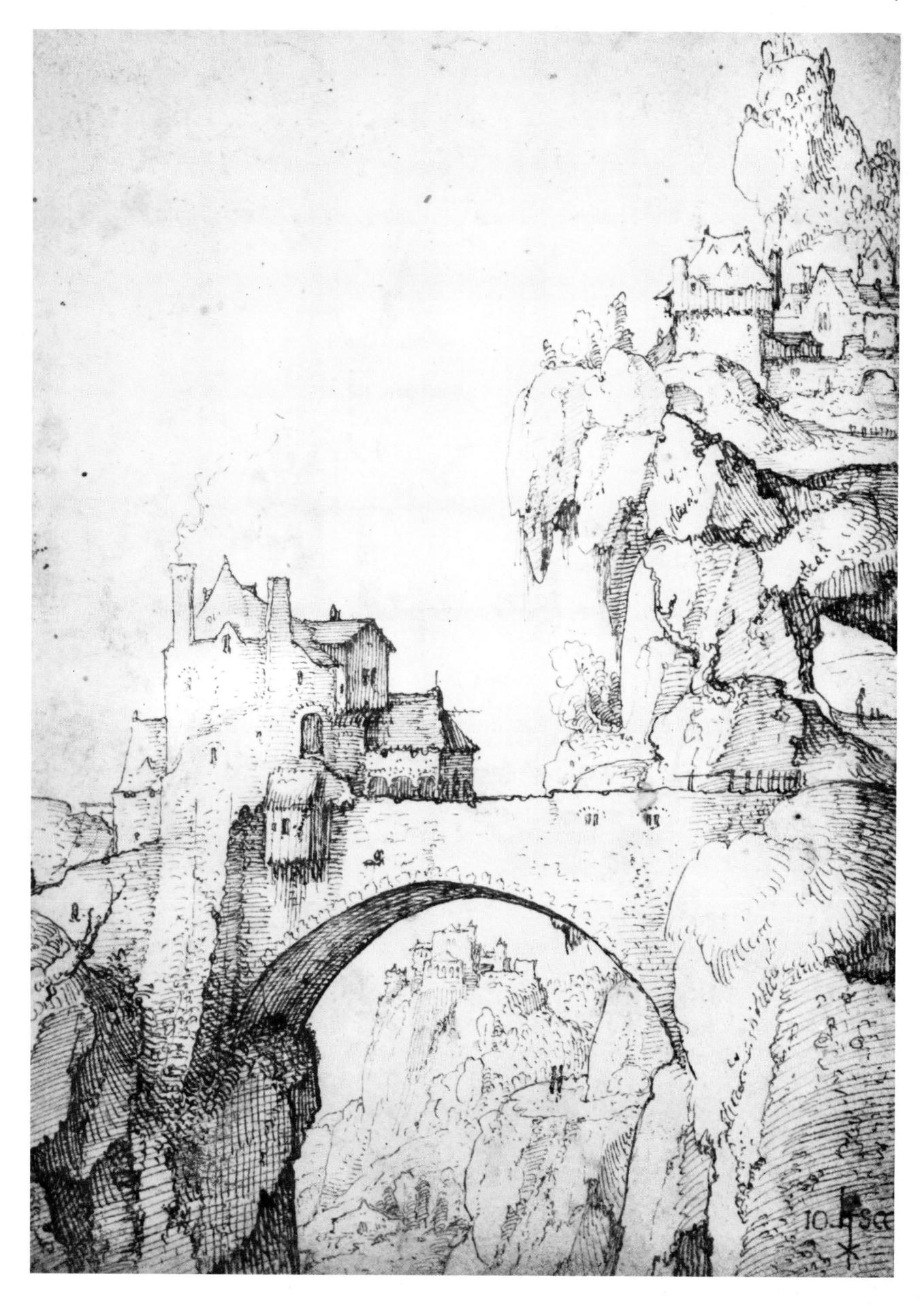

It was said in the Introduction to this section that perspective, being more evident in buildings than in other subjects, might pose some problems, though not for the competent artist. But in this drawing by Cézanne – a more than competent artist – we will find it very difficult to discover the eye-level, or indeed a vanishing point for any of the lines of these buildings. Even where we have a three-quarter view of a building the receding wall is rotated round towards us so that its lines lie parallel with the picture plane rather than disappearing towards the eye-level. Cézanne makes use of all the lines he can find which are parallel to the picture plane: that is to say, all those lines which are

horizontal or vertical or which he can contrive to fit into such a format. The resulting drawing tells us nothing about light and shade, the time of day or direction of light, the tonal value of colours, or the species of trees: it is a drawing solely about structure. Space is not expressed by traditional linear perspective but is *represented* by a series of steps, each of which is parallel to the picture plane. It is a new pictorial concept, dealing in finding visual equivalents for space rather than creating illusions of space by using perspective and aerial perspective. Cézanne's revolutionary ideas were to have widespread repercussions.

126. Paul Cézanne Provençal Landscape with Trees and Houses

127. Piet Mondrian Church at Domburg, 1914

Mondrian's early works (c. 1890 - 1900) show the influence of Dutch naturalism and of Corot; in the early years of this century he became more interested in light and the Impressionists, and a little later experimented with Pointillism, Fauvism, and Expressionism; by 1908 though he was beginning to find his own way. It was in 1908 that Mondrian first went to Domburg, a village to which he returned many times, and began work on his Tree series: an apple tree gradually reduced to a set of vertical and horizontal lines (see Ill. 95). He evolved a method of systematically eliminating all detail from a subject, reducing colour to a minimum, while concentrating on expressing the basic linear structure. In this drawing of the parish church Mondrian has applied the same technique. It is easy to recognize the various parts - the porch and the windows, the cruciform sign - for the sketch is, above all, essentially architectural in its basic rhythms. Mondrian's drawings of this period, with their emphasis on vertical/horizontal relationships, anticipate one of the fundamental elements of Neoplasticism - the ultimate reduction to the vertical and horizontal, to the total exclusion of all other lines.

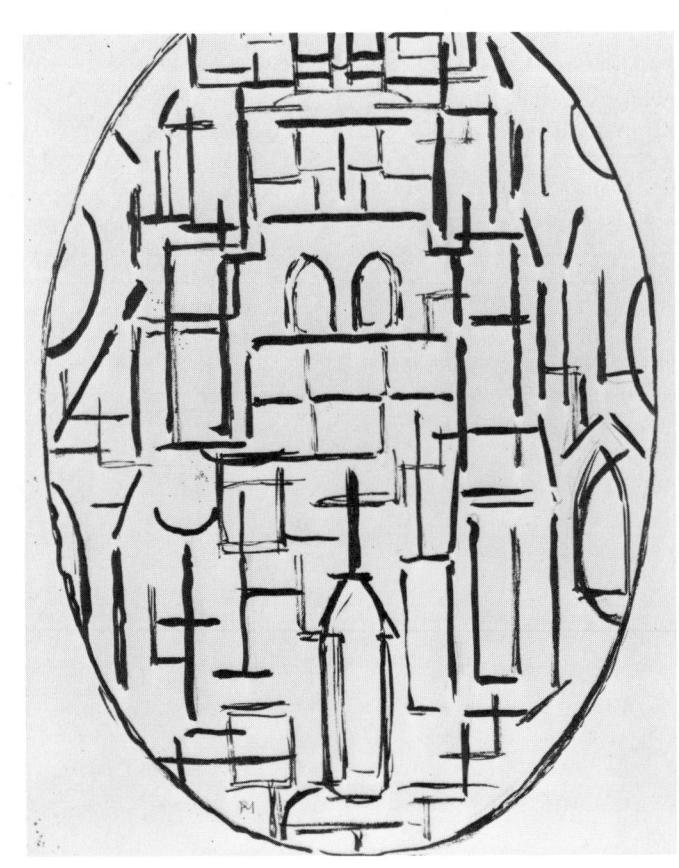

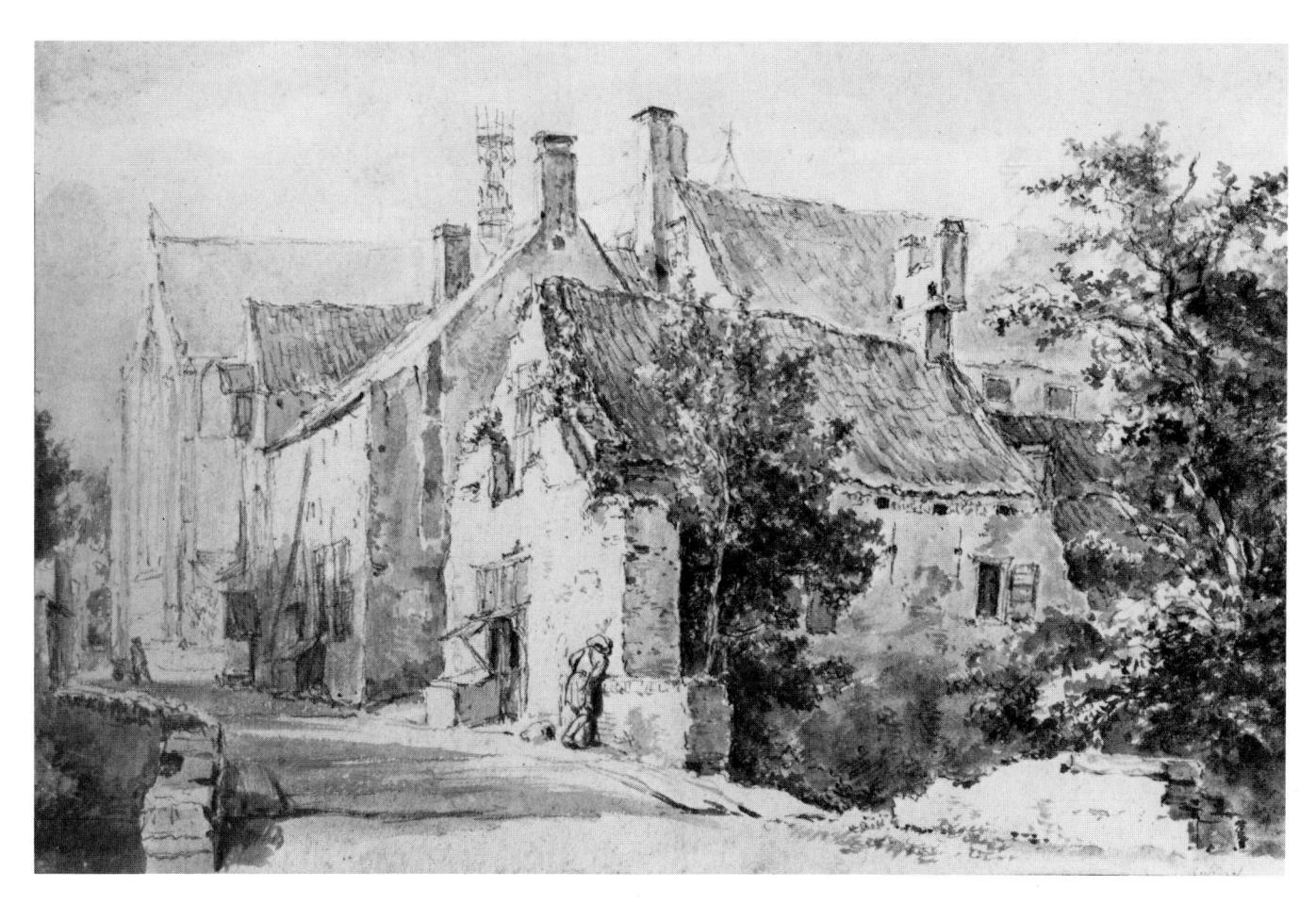

128. Jacob van Ruysdael View in Alkmaar with the Groote Kerk

The two Dutch artists whose work is illustrated here were roughly contemporaries, Ruysdael specializing in landscapes while Saenredam specialized in church interiors. Ruysdael was the more influential (Hobbema was a pupil of his), and Gainsborough, Constable, and the Barbizon owed much to his example. In fact Ruysdael's drawing reminds us of drawings by Constable - the same loving attention is paid to the individual character of crumbling stone and old brickwork, and there is the same mood of quiet acceptance and understanding. A drawing by a native who loves what he sees. The composition Ruysdael has chosen is unusual in that it moves from right to left. Tone is used both to express colour (the dark coloured trees and the roofs of the houses are clearly a darker colour than the walls) and to express shadow, the effect of light and shade. In addition, tone is used with great skill to express aerial perspective.

129. Pieter Jansz Saenredam Interior of the So-called Chapel Church at Alkmaar

The cold austerity of this drawing by Saenredam reminds us of the 'worked up' sketches from an architect's office. The washes are very skilfully handled, the perspective is immaculate, and everything is very neat, clean, and precise.

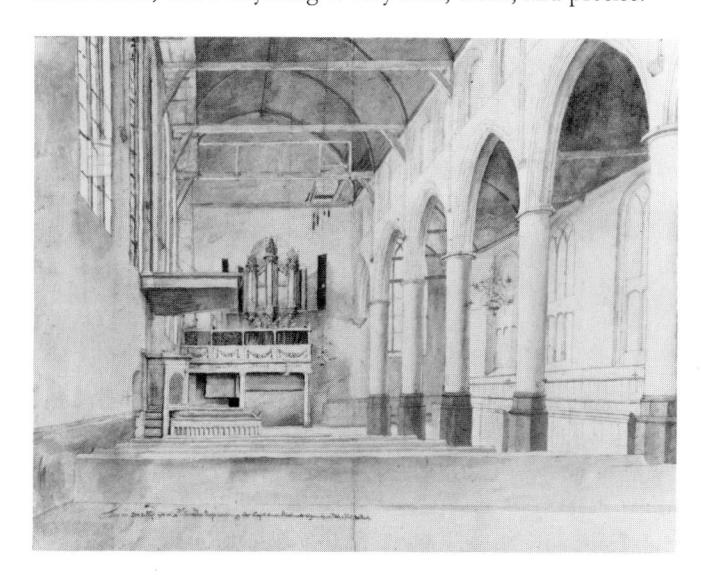

Animals

'Animals are good to know for having no education they are free of prejudice.' DEGAS

Animals have been a popular subject for artists from prehistoric times; this is hardly surprising as they have played a vital rôle in Man's development, feeding and clothing him, befriending him, working at his side, and threatening his life. For the artist they represent a special challenge; to capture their swift movement he must choose a medium which enables him to respond quickly with hand and eye – pen and ink, chalk, or charcoal – while doing justice to their immensely varied characteristics demands close observation and attention to detail; in one case it may be essential to express the coiled muscles, or, in another, the direction of hair growth, speed of reaction, grace of movement or sense of brute force.

Animals have represented something different to each society, the Ancient Egyptians even went so far as to represent their gods in animal form. If we take just one case, that of the horse (perhaps the most rewarding subject for the artist) we can see that changing attitudes to animals are clearly reflected in the way they have been represented in art. The Greeks treated the horse with almost the same reverence as the human figure; to the Romans, the horse was a kind of throne to set off an emperor or general - the equestrian monument captured the proud, powerful nature of both horse and rider. During the ensuing Dark Ages all kinds of curious and unlikely little beasts (some crawling out from the subconscious) entwined themselves round initial letters and decorated the borders of manuscripts; combinations of different animals' parts appear as dragons and gargoyles, assembled as if by alchemy. The armoured war horse, which first appeared in the Middle Ages, represented a new development: trained to use its hooves in a kind of equine karate, it features in the works of the early Renaissance artist, Paolo Uccello (for example The Rout of San Romano). The re-awakening interest in nature during the Renaissance resulted in a realistic study of animals and their anatomy. Leonardo da Vinci, the endless experimenter, made numerous drawings of the horse: as a monument, as a study of comparative anatomy and facial expression, and as part of his exploration of movement. It was during the Baroque period, however, that artists used the sweeping curve of horses' necks, manes, and rounded rumps to convey the robust, powerful mood of the age. In the nineteenth century the horse became a whole series of subjects in itself, particularly in the works of Géricault and Delacroix, who both saw the horse as a powerful symbol of Romanticism, whilst to Toulouse-Lautrec and Degas it was part of everyday life: the horse and rider were drawn as part of the social scene, but we were also taken behind the scenes, literally, to the sweat and sawdust of the circus. Degas was one of the first to make use of the research into animal movement by the pioneer photographer Eadweard Muybridge, whose photography of motion (almost cinephotography) showed artists, for the first time, the position of the horse's legs when in motion.

Given the immense scope of the subject it is perhaps not so surprising that so many of the world's great draughtsmen have found the animal a source of inspiration, and that their interpretations have been so diverse – Rembrandt's lions are leonine, where Rubens' are Rubenesque; Watteau's greyhounds and Fragonard's bull all share the elegance of the eighteenth-century Rococo whereas the animals of Stubbs are anatomically correct. As for today, Picasso has given us a whole repertoire of interchangeable rôles played by the bull, horse, and man, conveying all the inevitability of classical tragedy.

OPPOSITE ABOVE:

Prehistoric Man depended on the large herds of animals for food and clothing, and for tools and weapons, which he made from the bones; hoping to ensure a successful hunt, he drew his prey on the limestone walls of caves, incorporating cracks and using the naturally rounded surfaces where they could be helpful in expressing the form. The technique often consists (as here) of a strong outline in black drawn by brush (a chewed-out stick or stiff bristle brush), filled in with areas of colour, possibly using a pad of fur.

The Paleolithic artists were familiar with the animals depicted and express their characteristics of grace, strength or swiftness with a skill and conviction which, strangely enough, was not seen again until thousands of years later. This example shows an appreciation of the bull bisons' strength and agility as they stand poised ready for instant action, the massive forequarters and emphasis on formidable bulk stressing the latent power and dangerous potentiality of the beasts. The drawing was made by an artist who had felt the earth shake under the pounding hooves of charging creatures like these; it reveals such an intimate knowledge. It also reveals an attention to perspective in the use of the three-quarter view, while the way in which the rumps overlap conveys convincingly a sense of space.

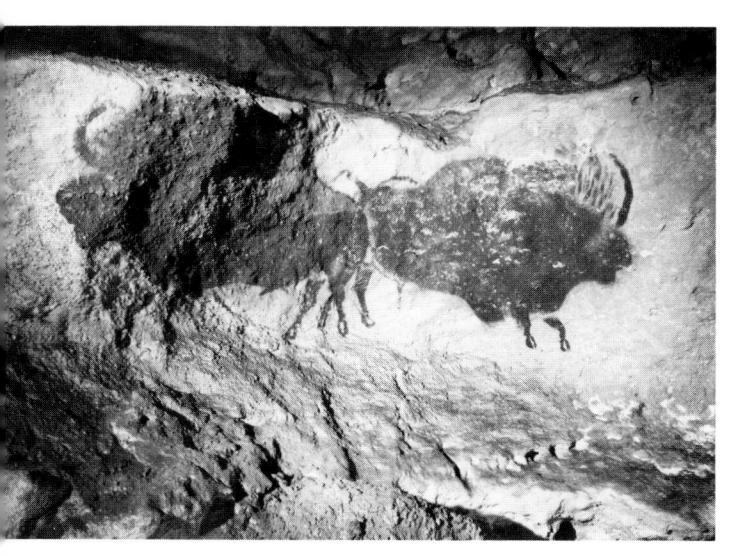

130. Two Bison, back to back (early Magdalenian period)

131. Pablo Picasso Minotaur Attacking an Amazon The minotaur, the archetypal union of man and beast, is seen in Picasso's personal mythology in a whole repertoire of changing rôles: from the seducer to the reveller, from the sacrificial beast in the microcosm of the bullring, facing the moment of truth, to the bull-man – blinded and deprived of brute strength, led by an innocent little girl along the seashore.

In this work the bull/man (man's animal nature) is seen as a powerful representation of animal lust – the ancient Beast and Beauty theme. The drawing is carried out in a combined medium, etching and aquatint; the etched lines are paralleled by the sugar lift aquatint line, a technique which reiterates and reinforces the linear image. All the lines are very closely confined within the available space, a device which emphasizes the power of the animal in contrast to the smallness of the cage; the lines are all drawn with an undulating movement which is again emphasized by the contrast with the minor movement of the lines representing the curly body hairs. The whole lunging rush starts from the position of the foot, pushing against the corner of the frame. Essentially this is a design involving a major diagonal thrust from left to right, opposed by a minor movement represented by the restraining hand of the victim. All the lines in this drawing are interconnected, resulting in a set of complex interweaving lines rather than a depiction of separate protagonists. The bull's head and the female hand are one line, the horn fits the fingers, the fingertips are on the shoulder line, and the plunging hooves (echoes of the bullring) exactly fit into the line of the minotaur's leg.

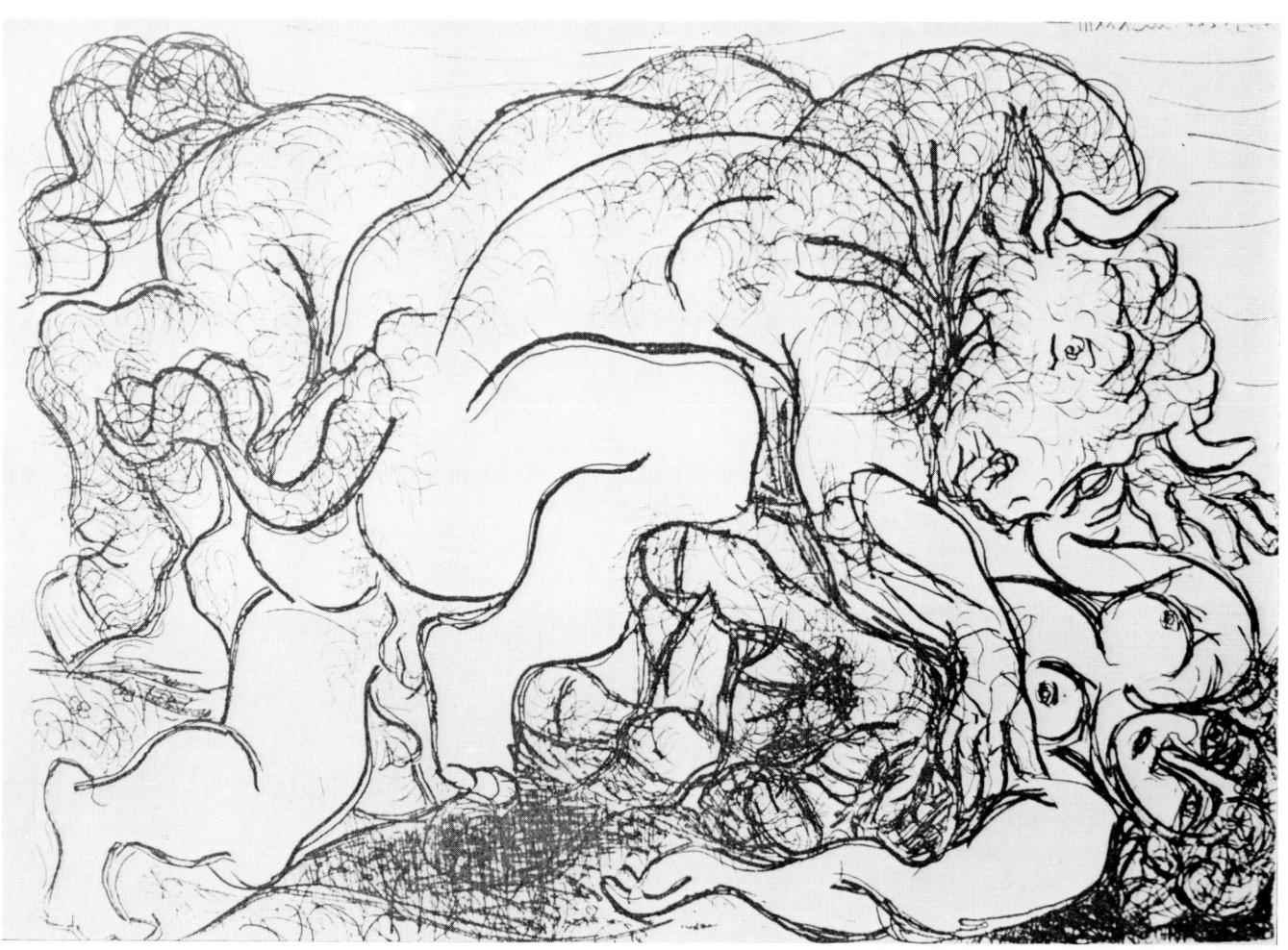

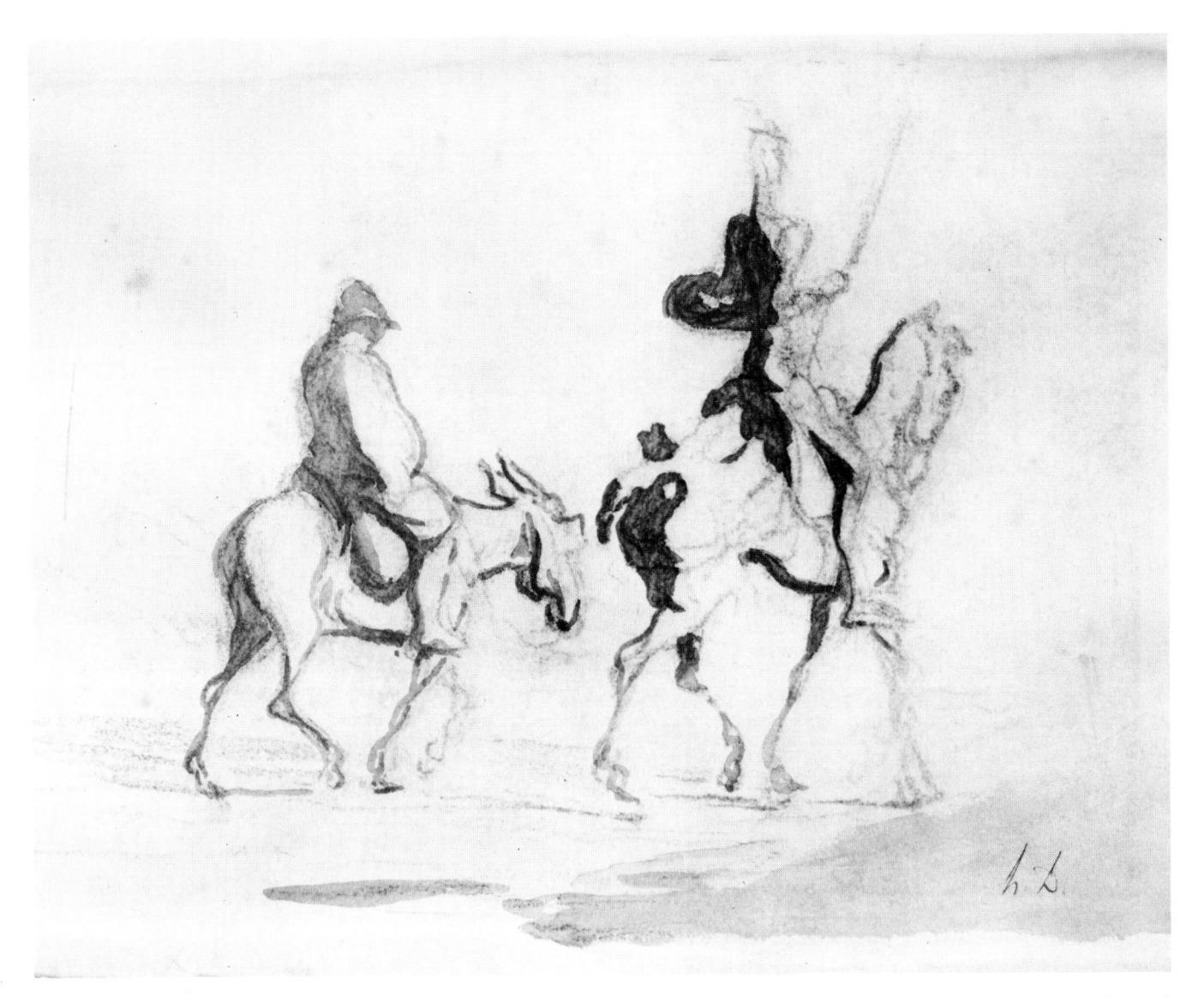

132. Honoré Daumier Don Quixote and Sancho Panza

Daumier was a caricaturist as well as a gifted draughtsman, and specialized in a few subjects. In a great many of his works, however, the real subject is *tone*, and he often reduces the image to very simple tones indeed. In this case he has used charcoal and black ink to produce a drawing in virtually two tones, the charcoal supplying only a slight suggestion of half-tone between the extremes of white and black.

There is an amusing relationship between the portly, bowed figures of Sancho Panza and his donkey, and between the aristocratic, upright Don Quixote and his bony nag: a gentle gibe by Daumier at the heroic pair.

133. Pablo Picasso The Picador

Picasso, using the similar medium of brush and wash expresses no mockery, only harsh reality. Using short bursts of line at opposing angles and with tremendous vigour, he produces an example of calligraphic shorthand: the brush, sometimes fully loaded and sometimes starved before the stroke is complete, produces a broken effect (see Rembrandt's

A Girl Sleeping, Ill. 40). We can feel the way the brush bucked and twisted in Picasso's hand as it was called upon to execute the abrupt twists and volte-face reminiscent of the violent subject. The resulting harsh contrast of black and white suggests the sun and the drama.

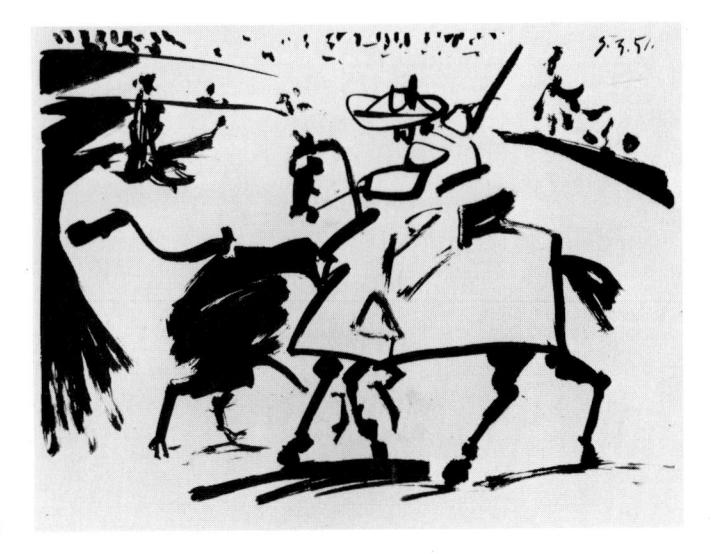

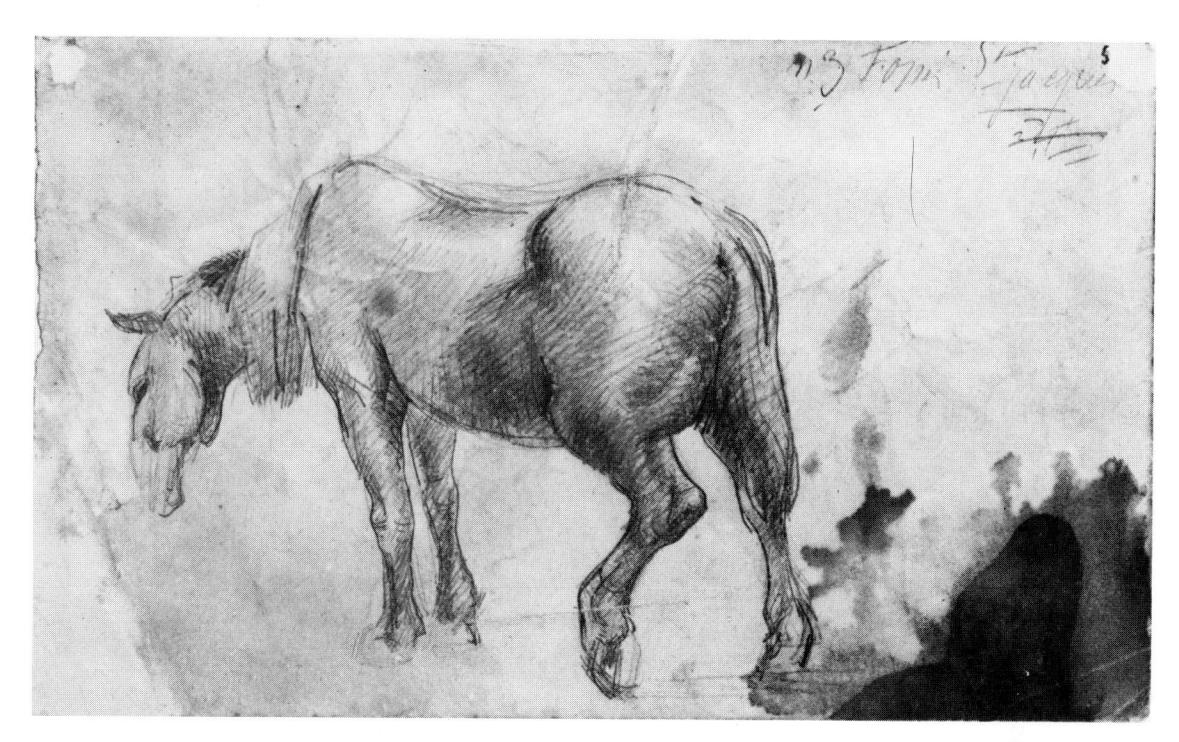

134. Paul Cézanne The Tired Horse

Cézanne treats this animal in much the same way as a still-life of apples. He was not concerned to draw the horse as a symbol of freedom (like Géricault), or as a throne for a general, or as a seat for a jockey, but to find, as in all his work, a means of conveying his idea of *form*. The drawing is carried out in pencil using a directional hatching technique to indicate tone, the chief means Cézanne uses to convey the feeling of form. This hatching is always across the forms, curved lines being used over rounder forms, straight lines on flattened forms; by using a heavier and richer hatching technique on the rump, Cézanne brings the hindquarters

nearer. The contour lines are broken and subtly varied – sometimes overlapping, sometimes revised – but never defining or confirming the forms by their edges. The belly, basically cylindrical, is treated as a series of planes; by changing the direction of strokes and merging the tones with his fingers, Cézanne alters the angles of the planes. Of particular importance in helping to establish the form of the belly is the emphasis placed on those lines which separate belly and legs. The downward line over the head is similarly emphasized by the drooping lines of the mane.

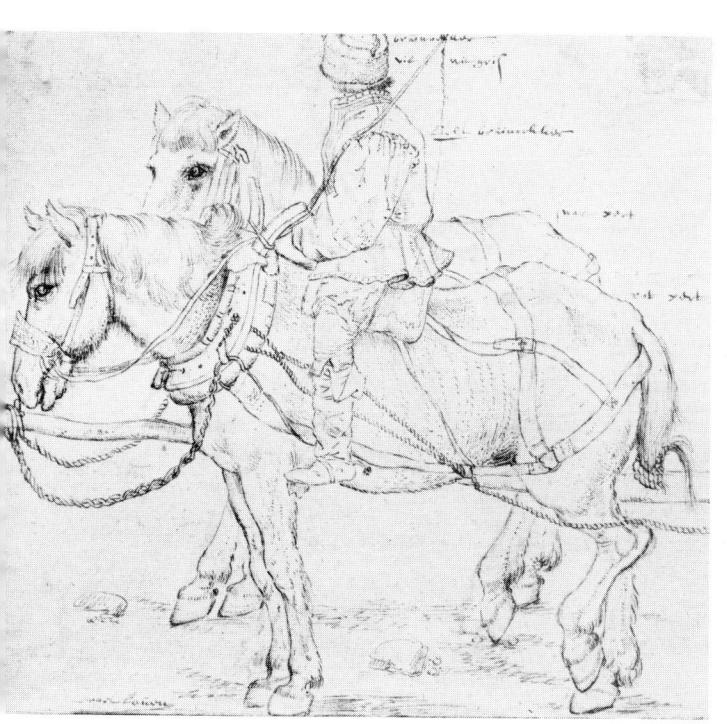

135. Pieter Bruegel the Elder The Team of Horses

In this carefully observed study of horses in their harness, Bruegel conveys by the stance and carriage of the head the enforced patience of the animal. Using the medium of pen and ink over a preliminary chalk drawing, Bruegel uses a wide variety of lines to express the different textures: the hair falling over the eyes is shown as a series of flowing parallels; the curling mane pushed forward by the halter becomes springing curves; the longer hairs on the back of the legs and the shorter hairs on the front are differentiated by linear interpretations. Short broken lines, and lines of dots, are used not only to suggest the all-over body hair, but also to express the underlying anatomical structure in terms of bone and muscle; we see the rib cage, the bony structure of the pelvis, and the main muscle masses clearly modelled by this linear means. Furthermore, by using the carefully observed lines of the harness, as it fits round and over the body, to describe the cross-sections, Bruegel conveys a strong sense of form as well as texture.

136. Leonardo da Vinci

Studies of Horsemen

Both Leonardo and Klee were particularly interested in the study of movement. Leonardo made drawings of currents of water, studying flow patterns under different conditions and comparing their fluid rhythms with those he found in his studies of the directional growth of hair, roots, and foliage. These little sketches of galloping horses, carried out in a kind of shorthand, allow us to look over Leonardo's shoulder as he visually 'thinks aloud' about the possibilities of expressing violent action through the horse-and-rider theme. All these small-scale dramatic events are depicted in the minimum number of lines; Leonardo had of course made many detailed studies of human and animal anatomy and this has enabled him to summarize their appearance from any viewpoint so concisely.

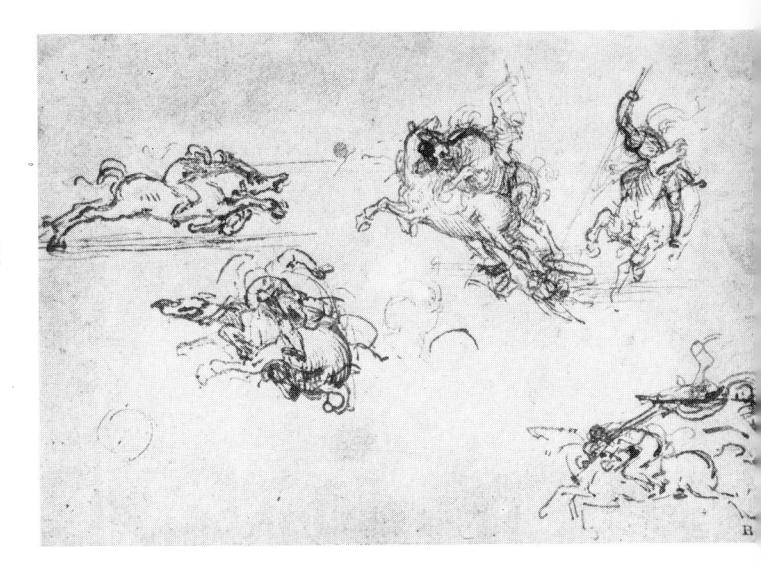

137. Paul Klee Galloping Horses

Klee, too, was interested in all forms of movement, finding linear equivalents (rather than visual descriptions) for all kinds of motion, including the movements of the conductor's baton at concerts – he was passionately interested in music. His approach to this subject is somewhat different from that of Leonardo, since it is the moving line itself which is really the subject of Klee's drawing. In short, this is not really a drawing of a galloping horse seen in three positions (Klee's

titles are often misleading!), but of galloping *lines*. In his teaching and in his own work Klee examined the nature of line, discovering which lines were swift or slow, and which other qualities they could express in themselves. In this drawing continuous lines create an enclosed space within which smaller continuous movements revolve. The combined head/neck feature, with its phallic overtones, breaks out from this continuity, thereby emphasizing it.

138. Albrecht Dürer

Death on Horseback

Dürer, like Leonardo da Vinci, made many detailed studies of horses and mounted knights. Although familiar with equine anatomy, he here freely invents and exaggerates in order to produce this disturbingly convincing image of Death on horseback (which was possibly inspired by an outbreak of plague in Dürer's home town in the same year, 1505). These creatures of skin and bone, joints swollen and distorted, advance with a kind of sinister inevitability – a curiously plodding, staggering gait suggested by the distance between the animal's splayed back legs.

Dürer was a very skilful engraver and in fact used all media with equal facility. Here he shows complete control over the charcoal, varying the strength of the line from faint to dark in order to suggest the modelling. The animal's ribs are gradually strengthened in tone as they pass into shadow under the belly. Similarly, the line used to describe the protruding bones of the animal's pelvis begins very faintly and then swoops into a dark, wide line, creating the bony hollow, as Dürer increases the pressure.

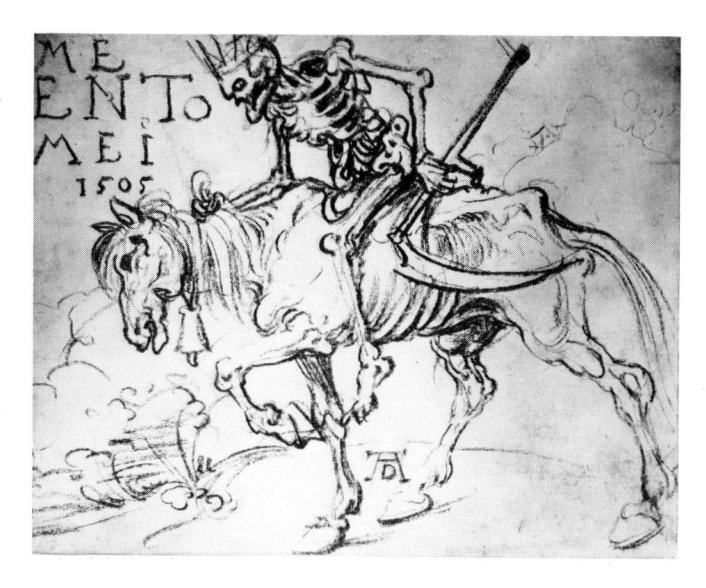

139. Eugène Delacroix Tiger Attacking a Wild Horse

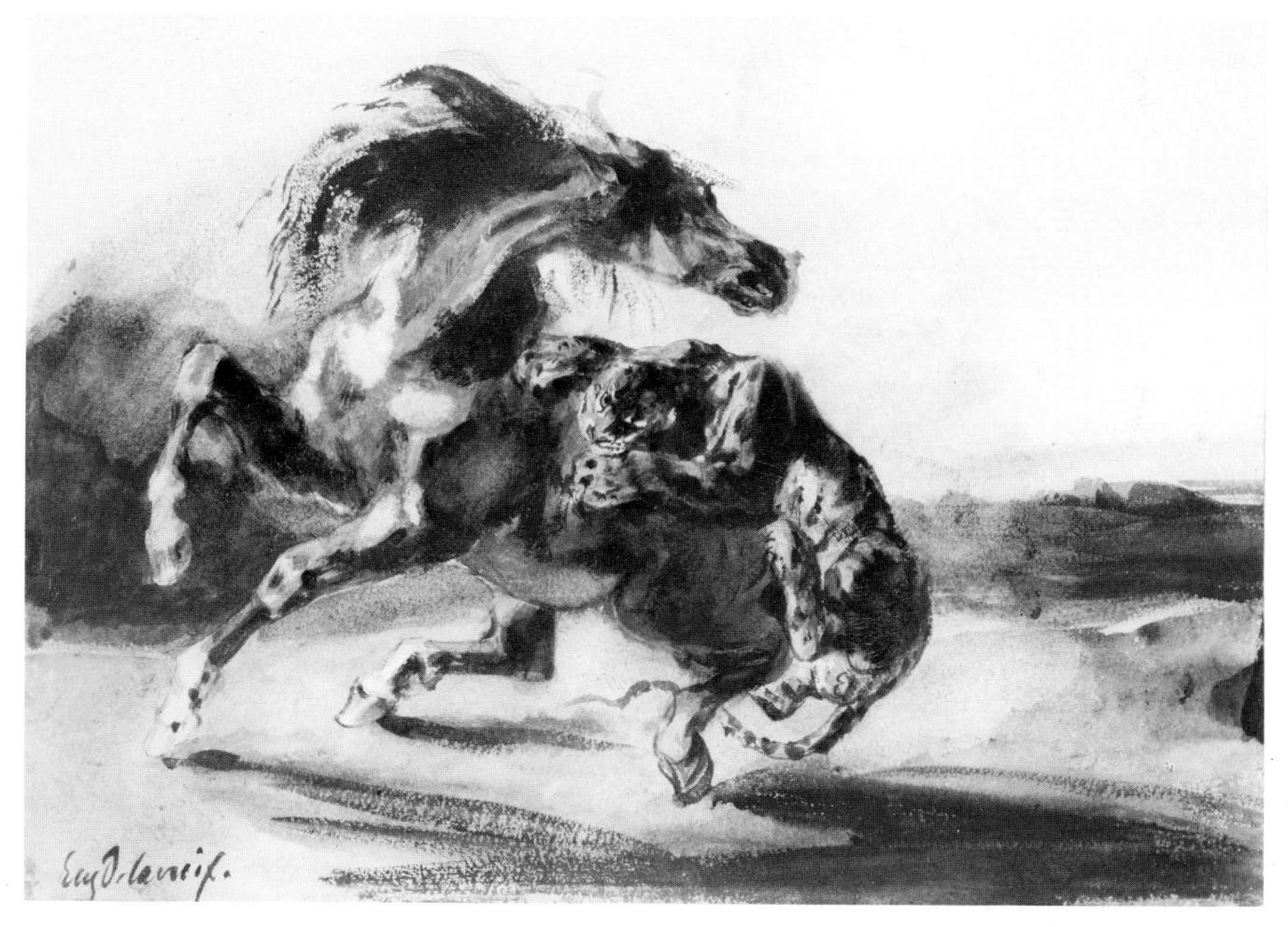

Of the various conflicting art movements which arose during the nineteenth century, Romanticism was the most dramatic. In the forefront of this movement was Delacroix, who, like all Romantic artists, saw the horse as the spirit of untamed freedom: a wild creature roaming where it wills, free as the wind. In the Romantic drama depicted here, a wild, desolate landscape is indicated by a few strokes of colour dragged over an initial wash. The flying mane of the horse is similarly expressed, and emphasizes the tremendously vigorous turn of the horse's head and muscular neck. Delacroix creates the sheen on the coat and rippling muscles of this elegant animal by making the most of reflected lights – for example by wetting and wiping out the wash under the belly and on the forequarters.

140. Theodore Géricault Charging Officer of the Carabineers

Here we have two drawings stressing the idea of movement: one a three-quarter back view, the other a three-quarter front view, both relying on perspective as a means of creating space within which the form can move. Géricault uses black chalk to draw the shape, bringing the hindquarters nearer by strengthening these lines; the drawing is then tinted with watercolour, silhouetting the rider against the sky. The low horizon line and the accent on sweeping curves create a sense of the heroic: the movement is swashbuckling and slightly larger than life. The officer becomes his own equestrian monument, caught in a momentary pause before the charge.

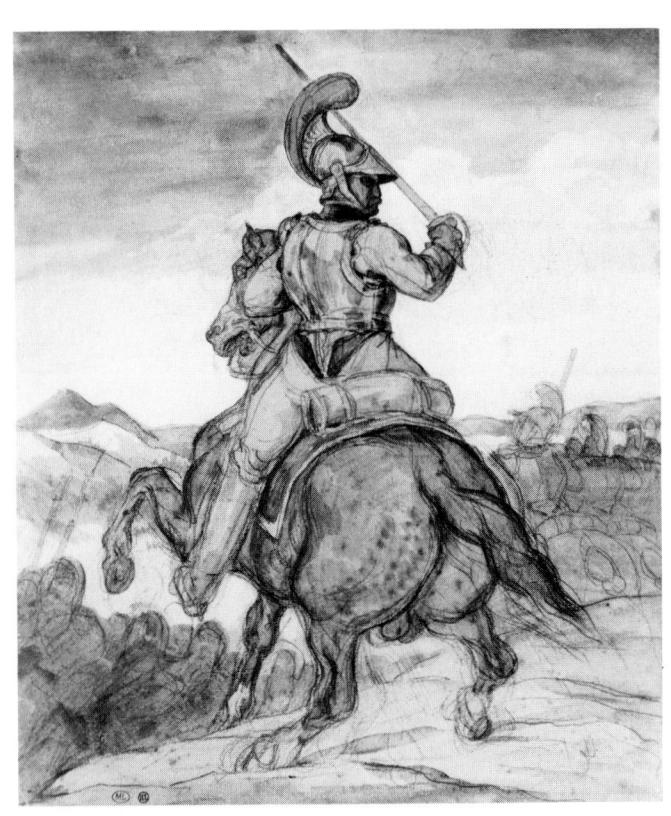

141. Henri de Toulouse-Lautrec Equestrienne

Toulouse-Lautrec presents us with a ringside view of his equestrienne. Again perspective is emphasized, throwing the animal's massive head and the exaggerated curve of its powerful neck into close-up, thereby creating a strong contrast with the petite figure of the equestrienne, who effortlessly controls her mount while gently restraining the rise and fall of her transparent gauze skirts. Toulouse-Lautrec uses the outline of the trappings (in a similar way to Bruegel) to define the forms by cross-section.

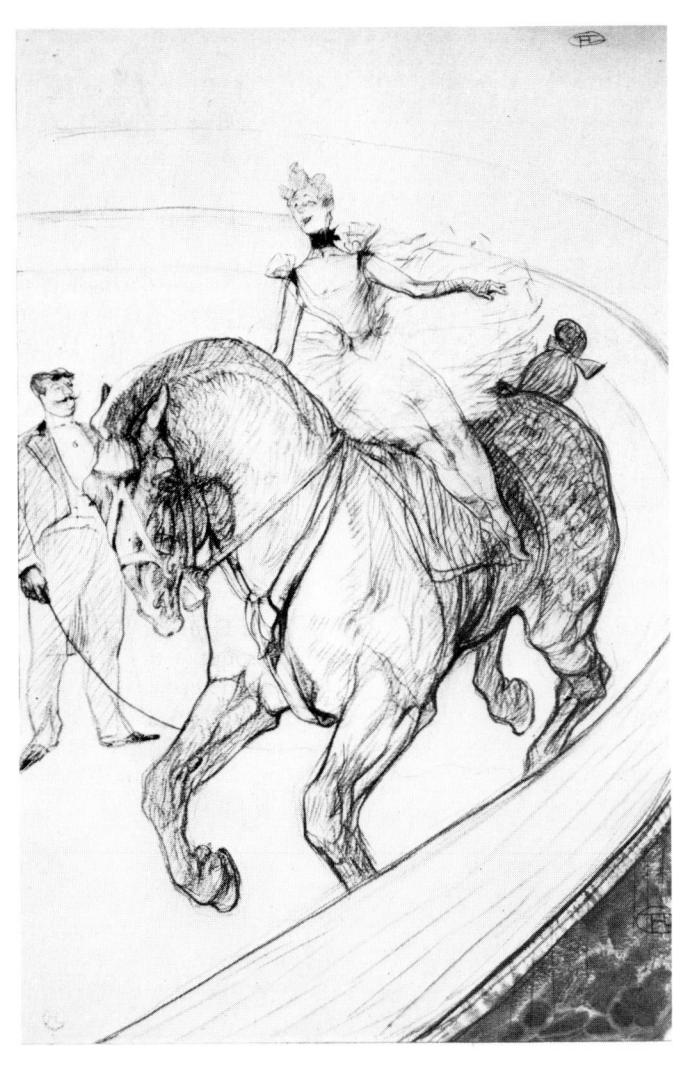

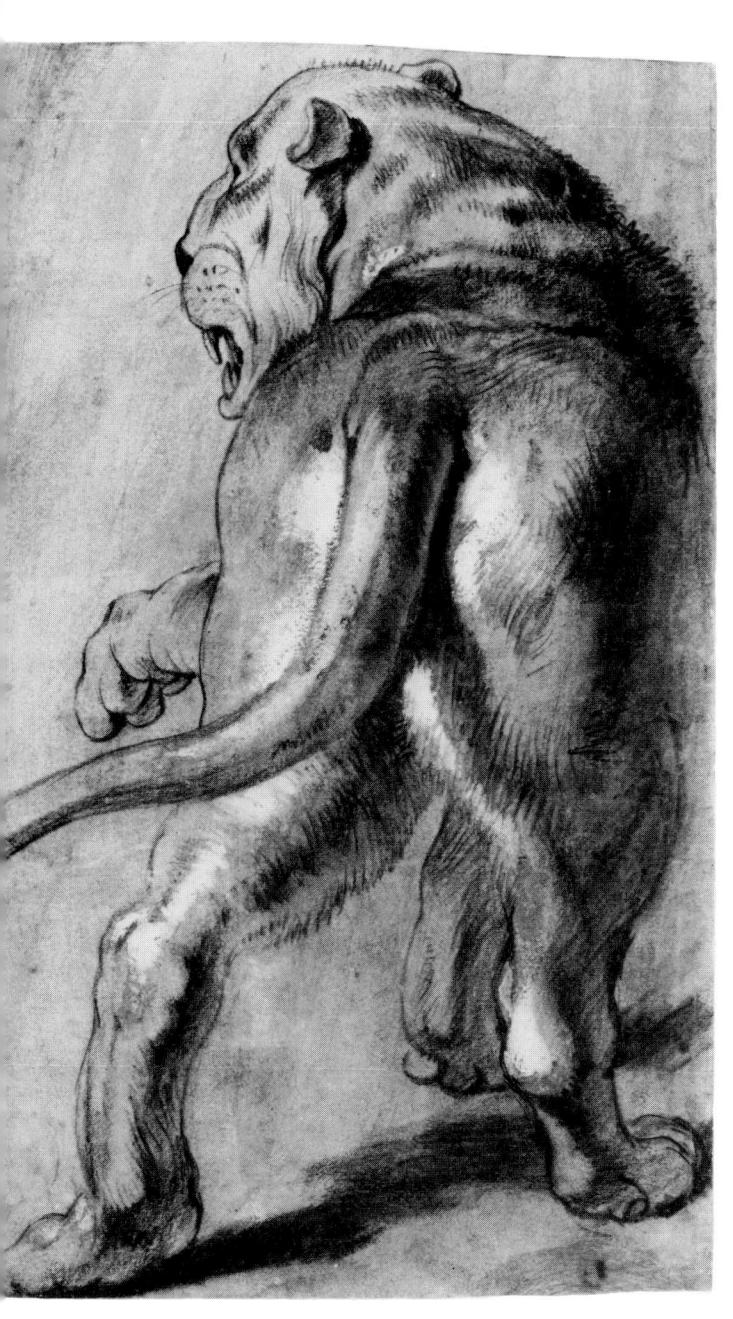

142. Peter Paul Rubens Lioness

Rubens' lioness, a study for a painting of Daniel in the Lions' Den, is typical of Rubens and of the Baroque period. Using the paper as a mid-tone, Rubens skilfully describes the form and direction of hair growth by means of closely hatched lines. The back view – the curves of the bottom accentuated by the white highlights, and the serpentine curves of the swinging tail emphasizing the feeling of movement – is typical of the Baroque. In this drawing the foreshortening is not very convincing, since the animal's head is too large for the position in which it is described. One feels that this is a skilful piece of drawing from memory.

143. Rembrandt
Four Studies of Lions

Like his drawings of elephants, Rembrandt's studies of lions (perhaps done in preparation for his etching of St Jerome) are clearly drawn from life. They walk, recline or doze with heavy head resting on paws, in that deceptively lazy 'pussycat' way so typical of the animal; they are all expressed with Rembrandt's characteristic economy, the minimum means being used to convey maximum expressiveness. There is little or no need to say anything more about this work: the drawing says it all.

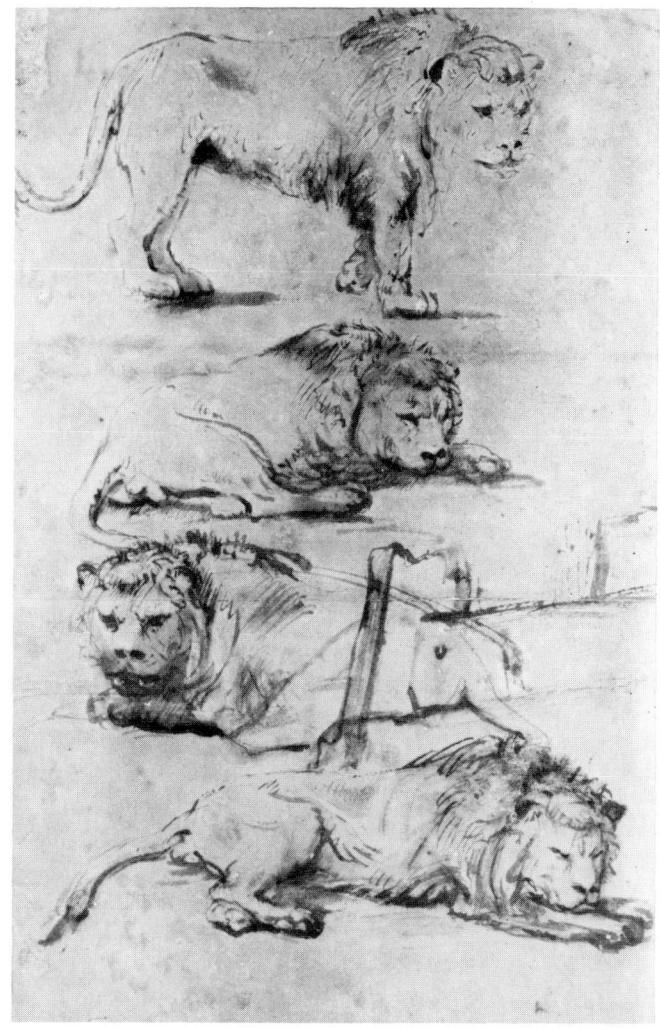

144. Theodore Géricault Studies of a Wild Striped Cat

Since the worship of the cat as a deity in Ancient Egypt, many artists have been fascinated by the creature's lithe grace. These studies of a cat by Géricault, in sharp but soft pencil, are crisp, sure, and full of observed detail – though the detail is kept subordinate to the more general idea of the feline form and character of the animal. Géricault varies the strength of the pencil-work considerably in different parts of these

studies, so as to make his line as expressive as possible; generally the nearer parts are made darker in order to bring them closer. He also uses the pencil to suggest the colour and pattern of the coat. The dark patches are used very much to draw the form as well as to express the marking – notice the detailed attention paid to eye-sockets and the way the pencil suggests the colour of drawn-back lips.

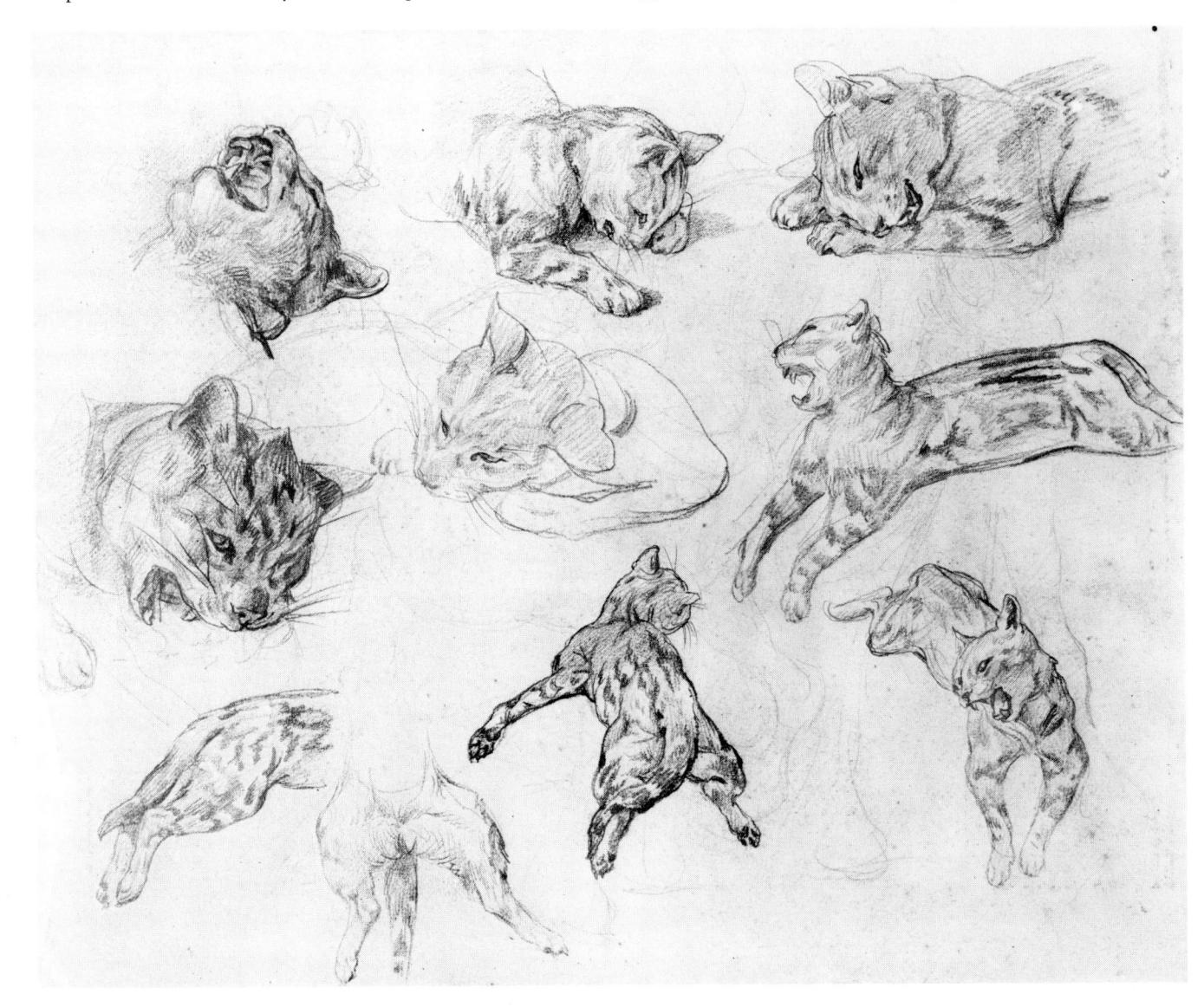

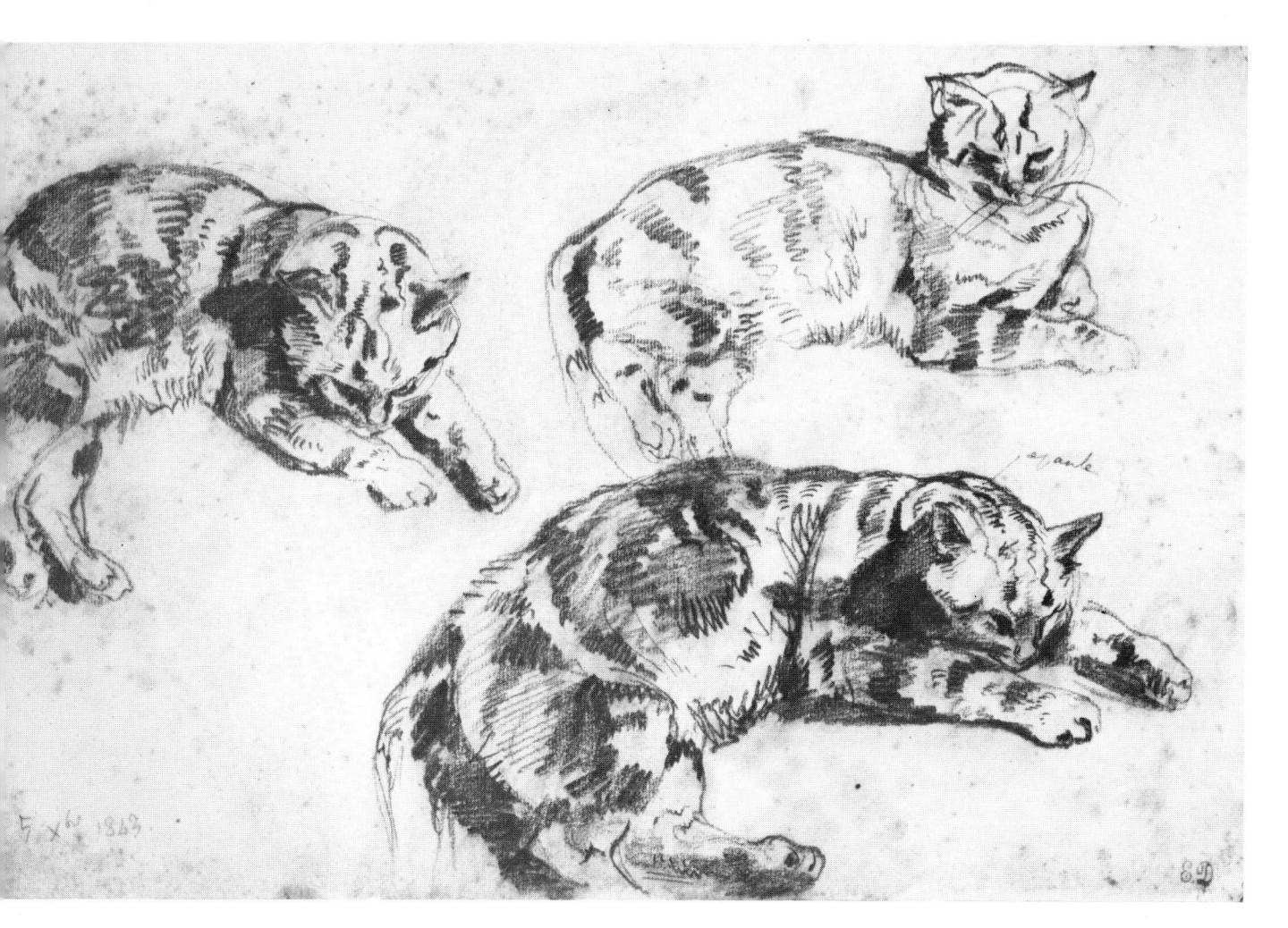

145. Eugène Delacroix *Three Studies of Cats*

Delacroix's three studies are quite different in emphasis and intention. There is very little detail, and much more emphasis on tone than in the drawing by Géricault, who favours a comparatively linear approach. The patches of loosely scribbled crayon create a pattern of light and dark areas which effectively communicate a vision of the lazy domesticated animal with its underlying independence of character.

Two very different approaches to a similar subject: Francis Barlow's approach is that of the engraver, using a clear, precise line (although the artist is not quite so clear about what to do with the rhino's front legs!); for all its clarity, though, it is obvious that Barlow did not make this study of a so-called battle (a ritual without any drama) from life, whereas Rembrandt, with all the imprecision of his outlines, clearly drew his elephant from direct observation, the little group of onlookers in the background supplying a sense of scale. Francis Barlow may have seen the stuffed head of an elephant, since it appears more elephantine than the body, but the rest is based on verbal description. The rhinoceros was presumably described as 'armoured', so the artist has dressed it in suitably adapted fashionable armour of his own time; the tailpiece is particularly inventive, as are the 'Bermuda shorts' for the back legs. Similarly, we are to understand that an elephant is a wrinkled beast with flat feet and five toes. The wrinkles depicted by Barlow do little to describe the form but ripple all over the surface, suggesting a mass of quivering jelly; Rembrandt, on the other hand, uses the chalk to produce a coarse-grained effect which expresses the leathery texture of the animal's skin, and which, by creating an involved network of directional hatching, gives not only a feeling of texture but also a feeling of form: the lines used to indicate the wrinkles of skin are at the same time suggestive both of the sections of form and of the folds of flesh. (The study was possibly a preparation for the elephant in the background of the Adam and Eve etching of 1638.)

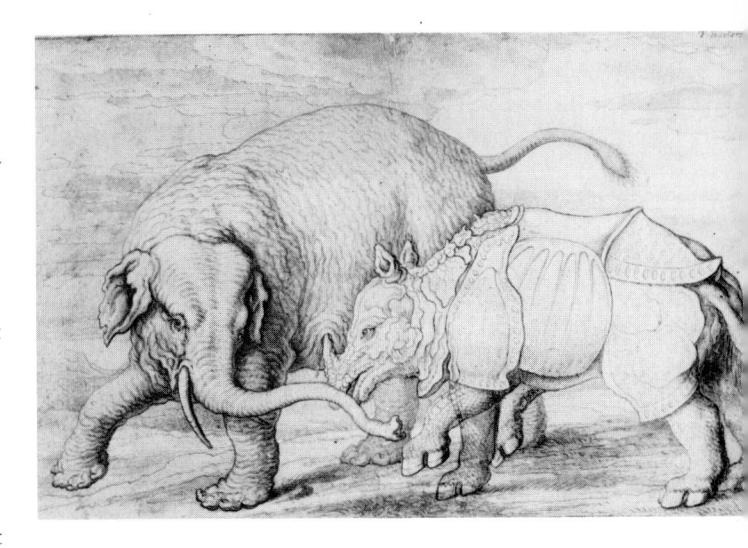

146. Francis Barlow
Fight between an Elephant and Rhinoceros

147. Rembrandt Elephant

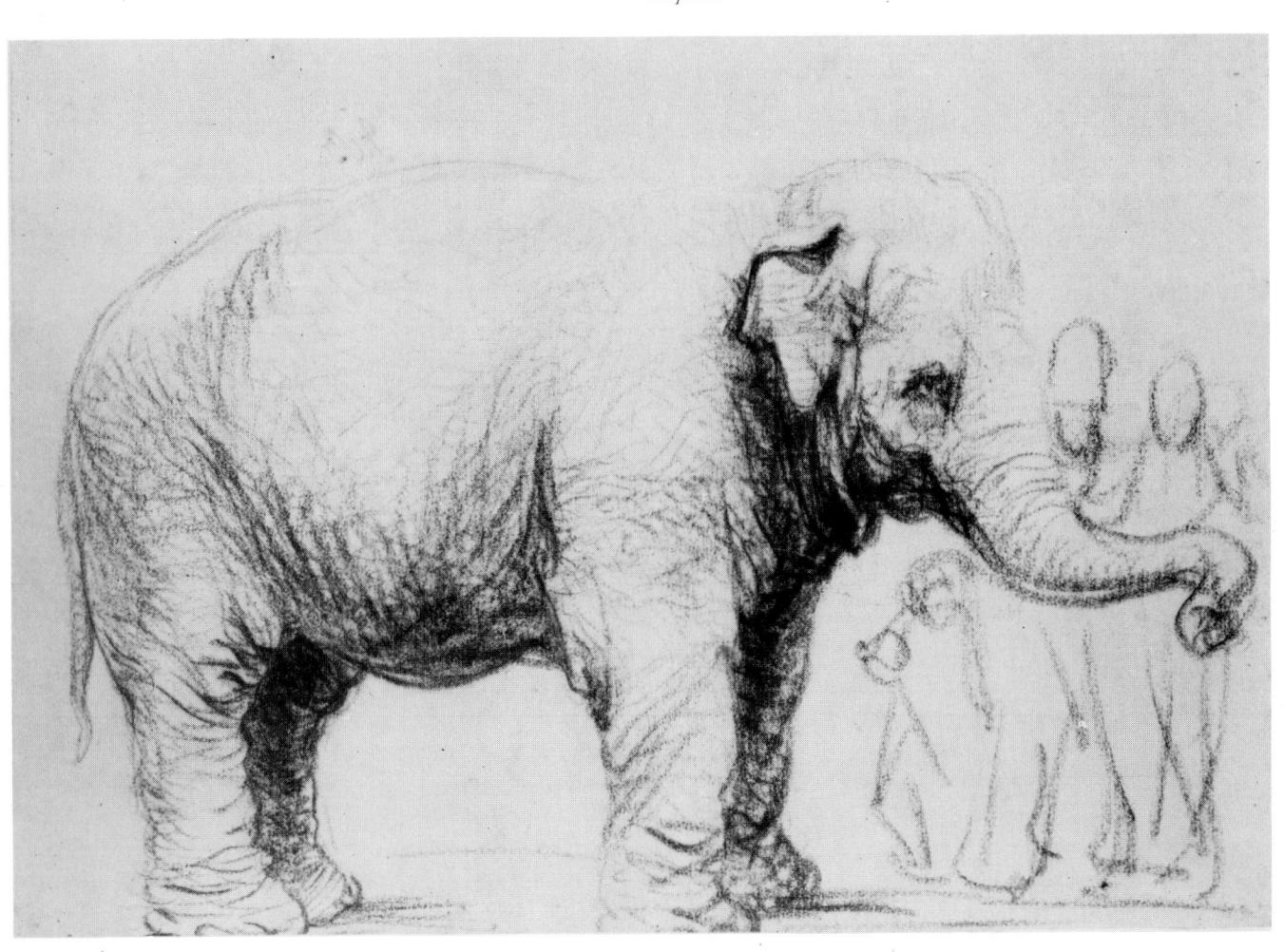

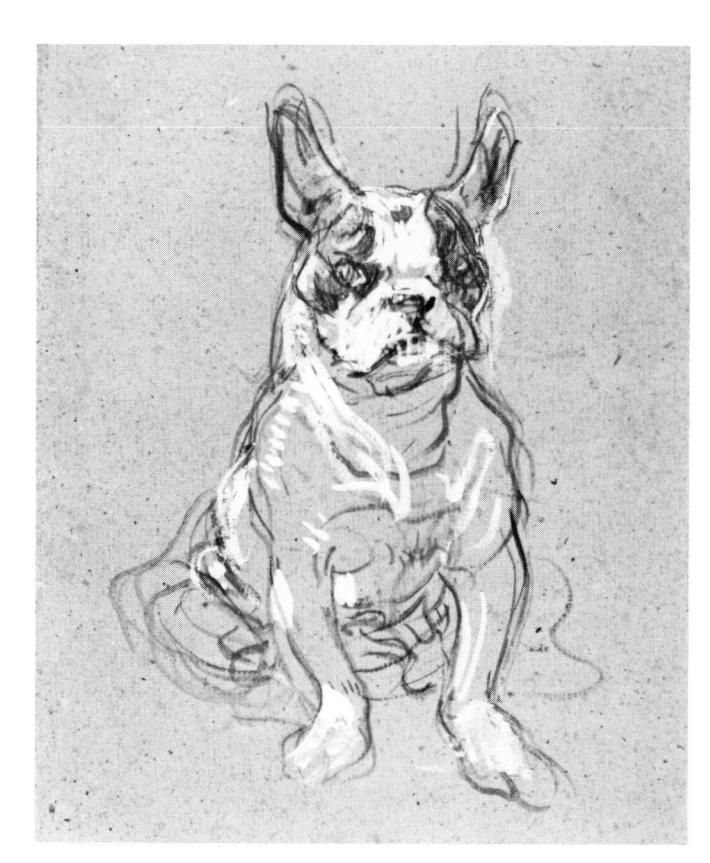

148. Henri de Toulouse-Lautrec Bouboule, Madame Palmyre's Bulldog

Sometimes Toulouse-Lautrec's drawings remind us of those of Daumier (see Ill. 132). Both artists were essentially draughtsmen, both lithographers, and both had a feeling for caricature: the pugnacious pose of the bull-dog, with curved ears echoing the curves of its bandy legs, is an astonishing display of skilful handling of the brush. Toulouse-Lautrec often worked on a toned ground (straw-board or brown paper), using light and dark strokes and leaving the ground as the middle tone. As we study the drawing we begin to notice how much of it consists of the untouched paper! The drawing is made up of a number of swift assessments of the relative positions of selected lines of the pose. These lines are then revised and finalized by drawing other, stronger versions on top.

149. Albrecht Dürer Greyhound

Dürer uses the brush just as skilfully as, but in a different way from, Toulouse-Lautrec in his drawing of a greyhound. We see here the linear approach of the engraver, and feel his complete control of the brush as he creates lines which start almost imperceptibly, gradually swell and strengthen, thicken to express shadows, and fade away again. These curving parallel lines express the modelling of the surface, the direction of hair growth, and the textures of different areas, all at the same time.

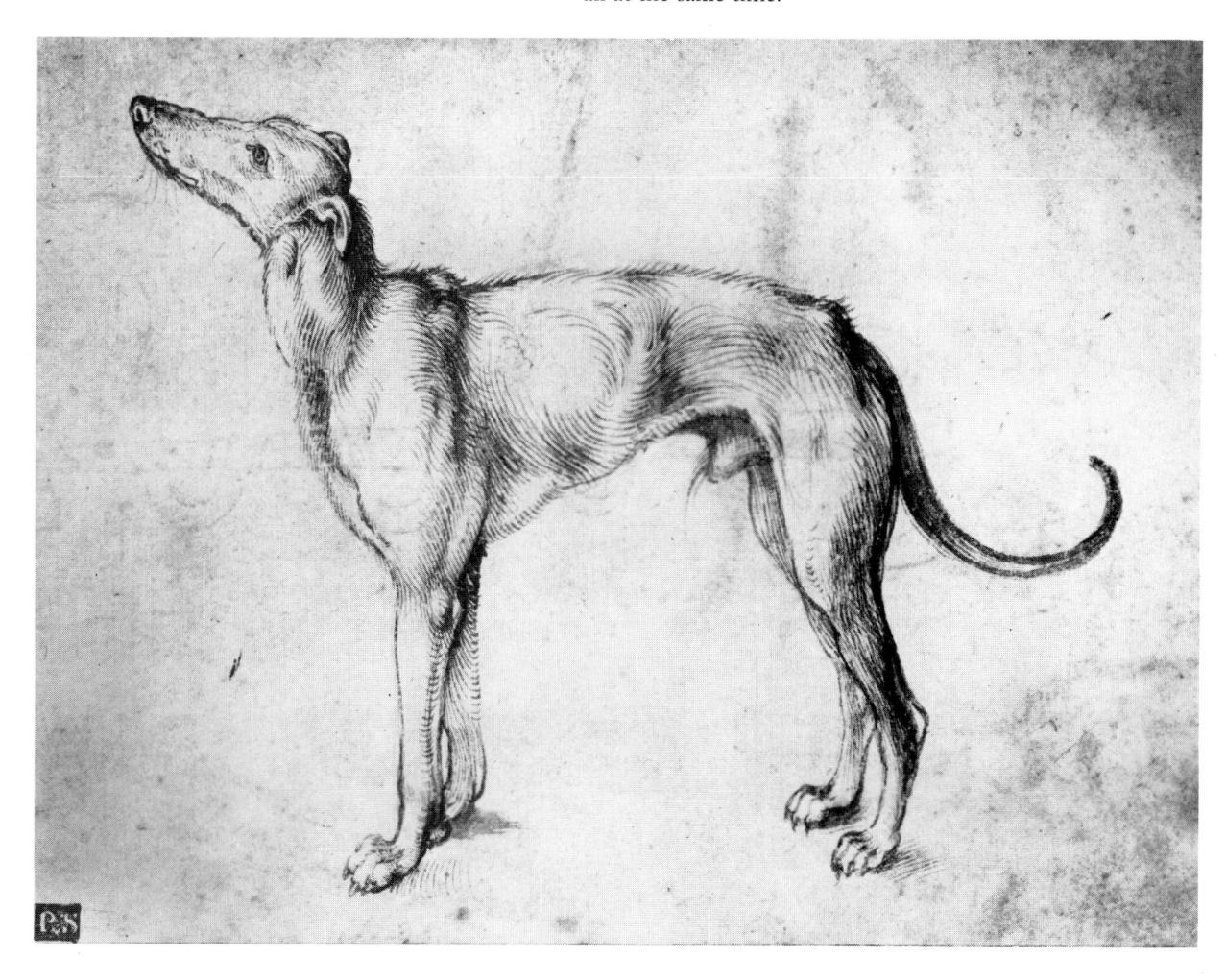

150. François Boucher Study of a Rooster

Boucher's *Study of Rooster* and Fragonard's *Bull in a Stable* may seem at first sight a rather unlikely pair with very little in common, but both these drawings share characteristics of the fashionable Rococo style favoured by the decorative artists of eighteenth-century France. The waving comb of the rooster, the emphatic curves of the bull's hooves, and the double curve of its tail — all contribute to the overall decorative quality of these drawings.

The rooster, its comb and face coloured red, is effectively made up of decoratively sweeping curves, the outstretched wings and ruffled feathers are treated (appropriately enough) with feathery strokes of the chalk – a technique which can also be seen in Watteau's dromedary (see Ill. 153) and in the depiction of trees during this period (see Ill. 90). The bull, although carried out in a different medium, bistre wash, shows much the same kind of feathery handling as the bird; the silhouetted edges of the animal's ears are quite feathered, and the whole drawing, like that of the rooster, is carried out in a series of rippling curves which convey a curious sense of prettiness, somewhat at variance with the animal's massive musculature.

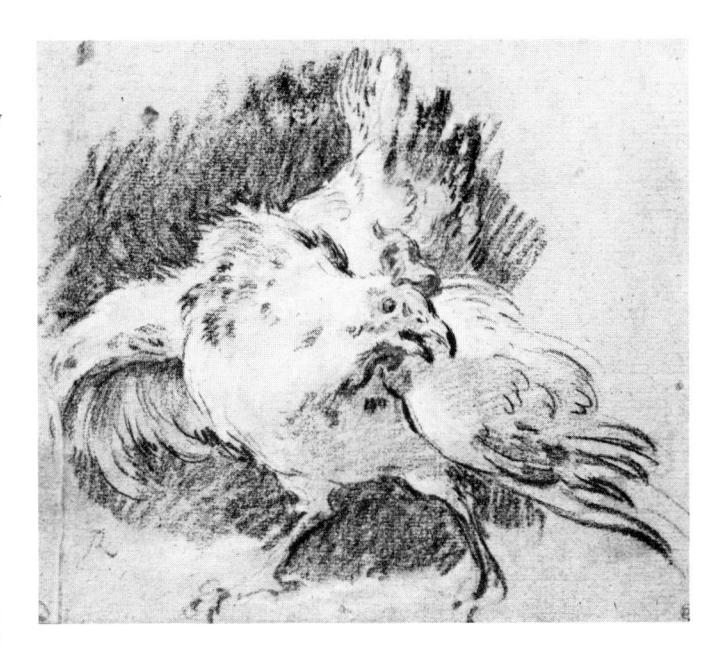

151. Jean Honoré Fragonard Bull in a Stable

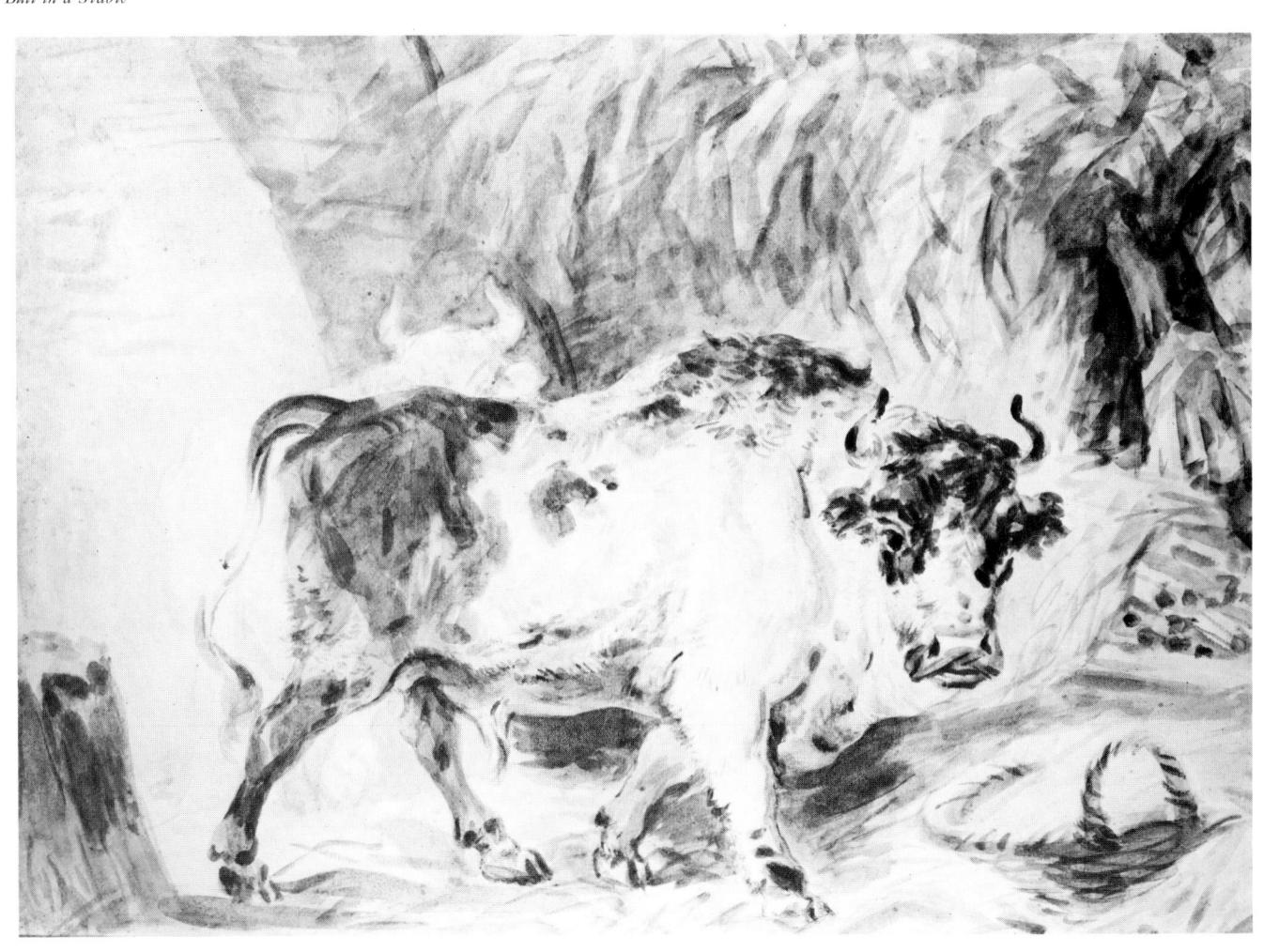

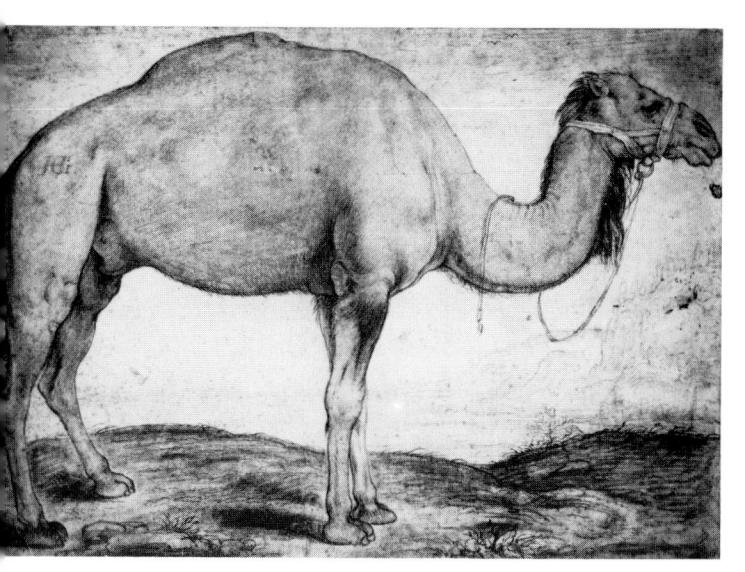

152. Hendrick Goltzius Camel

Goltzius was a Dutch engraver and painter who from about 1600 was much influenced in his paintings by Italian mannerism. As an engraver he is noted for the way in which he exploited all the tonal possibilities of line, while emphasizing surface qualities by thickening or swelling the engraved lines. This camel is essentially linear in treatment: from the looped rein over the beast's neck, the whole form is bounded by a precise and clearly observed outline within which the surface is subtly modelled by graduations of the red and black chalk.

153. Jean Antoine Watteau Five Studies of a Dromedary

Watteau's chalk studies of a dromedary look almost feathery by comparison, the tufts of hair on the shoulders, and elegantly curling beard are typical of the rococo artist's interest in the decorative (see Ills. 56 and 90). The feeling of form is created by the close directional hatching generally travelling across the shorter direction of the form.

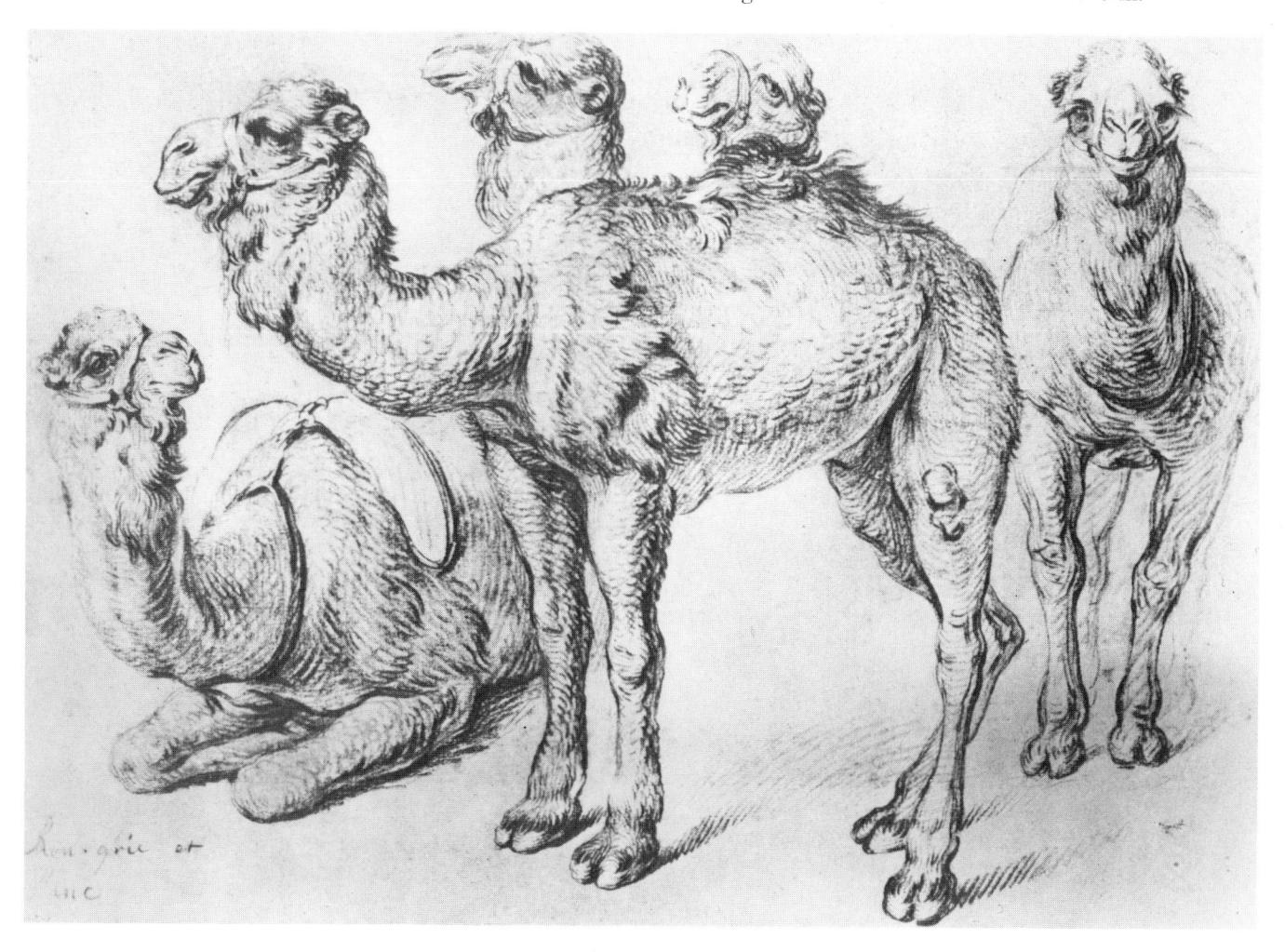

Further Reading

Anthony Bertram, One Thousand Years of Drawing (Studio Vista, 1966)

Jean Cassou and P. H. Jaccottet, French Drawing of the 20th Century (Thames and Hudson, 1955)

Fred Dubery and John Willats, *Drawing Systems* (Studio Vista, 1972)

Colin T. Eisler, German Drawings: From the 15th Century to the Expressionists, 'Great Drawings of the World' series (Studio Vista, 1965)

E. H. Gombrich, Art and Illusion (Phaidon Press, 2nd edition 1977)

Una E. Johnson, 20th Century Drawings: Part 1 1900–1940, 'Great Drawings of the World' series (Weidenfeld and Nicholson, 1964)

Una E. Johnson, 20th Century Drawings: From 1940 to the Present Day, 'Great Drawings of the World' series (Studio Vista, 1965)

Frederick Malins, Understanding Pictures: Elements of Composition (Phaidon Press, 1979)

Master Draughtsman Series (over thirty titles): the drawings of the great artists (Borden Publishing Company, Alhambra, California, 1966)

Philip Rawson, *Drawing*, 'The Appreciation of the Arts' No. 3 (Oxford University Press, 1969)

A. G. Reynolds, Nineteenth Century Drawings (Pleiades Art Books, 1949)

Jakob Rosenberg, Great Draughtsmen from Pisanello to Picasso (Oxford University Press, 1959)

Benjamin Rowland, Jr., Cave to Renaissance, 'Great Drawings of the World' series (Studio Vista, 1965)

Regina Schoolman and Charles E. Slatkin, Six Centuries of French Master Drawings in America (Oxford University Press, 1950)

Jean Vallery-Radot, French Drawings: From the 15th to the Early 19th Century. 'Great Drawings of the World' series (Studio Vista, 1965)

Abstract Expressionism, 98 African art, 18, 20, 55 Barbizon School, 111 Barlow, Francis, 122; Fight between an Elephant and Rhinoceros, 122, 122 Baroque art, 40, 50, 51, 60, 84, 88, 112, 119 Bellini, Gentile, 56; A Turkish Woman, 56, 56 Bernini, Gian Lorenzo, 25, 50; Self-portrait, 25, 25; Self-portrait as an Old Man, 25, 25; Study for a Fountain, 50, 50 Blake, William, 60, 66, 79; The Blasphemer, 66, 66 Bonington, Richard Parkes, 106; Paris, The Institut seen from the Quais, 106, 107 Bosch, Hieronymus, 43, 62; Entombment, 43, 62, 62 Botticelli, Sandro, 49; Abundance, 49, 49 Boucher, François, 41, 61, 124; Study of a Rooster, 124, 124; Three Nymphs, 61, 61 Brancusi, Constantin, 57 Braque, Georges, 24, 33 Bronzino, Angelo, 48 Bruegel, Pieter, the Elder, 90, 115, 118; Alpine Landscape, 90, 90; The Team of Horses, 115, 115 Buonarroti, Michelangelo, see Michelangelo Canaletto, Antonio, 96; Piazza di S. Basso, 96, 97 Carpaccio, Vittore, 74, 108; The Adoration of the Magi, 74, 74; Fortified Harbour with Shipping, 108, 108; Legend of St Ursula (narrative series), 108 Celtic art, 65 Cézanne, Paul, 21, 22, 33, 57, 58, 60, 61, 86, 93, 110, 115; Four Bathers, 61, 61; Pistachio Tree at Château Noir, 86, 86; Provencal Landscape with Trees and Houses, 110, 110; Self-portrait, 22, 22; The Tired Horse, 115, 115 Charles I, King of England, 84 Claude Lorrain, 8, 78, 80, 82, 91, 102; Clearing in a Wood near Rome, 82, 82; Landscape with Mercury and Argus, 102, 102; The Tiber above Rome: Evening Effect, 91, 91 Constable, John, 10, 78, 80, 92, 100, 103, 111; The Ruins of Cowdray Castle, Interior, 100, 100; Stonehenge, 103 103; Tillington Church, 80, 81 Corot, Jean Baptiste Camille, 110 Cotman, John Sell, 93, 100, 105, 106; Bristol, St Mary Redcliffe, 105, 105; Greta Bridge, 93, 93; A Sarcophagus in a Pleasure ground, 106, 106 Cozens, Alexander, 94, 95, 100, 103; A Rocky Landscape, 94, 94 Cozens, John Robert, 95; Interlaken: the Peaks of the Jungfrau Group in the Distance, 95, 95 Cubism, 21, 22, 24, 33, 55 Daumier, Honoré, 114, 123; Don Quixote and Sancho Panza, 114, 114, Degas, Edgar, 30, 40, 54, 112; Dancer Adjusting Slipper, frontispiece, 54, 54; Study for Portrait of Diego Martelli, 30, 31 Delacroix, Eugène, 65, 106, 112, 117, 121; Three Studies of Cats, 121, 121; Tiger Attacking a Wild Horse, 117, 117 Delvaux, André, 63; The Siesta, 63, 63 Dufy, Raoul, 83; Olive Trees by the Golfe Juan, 83, 83

Dürer, Albrecht, 26, 72, 117, 123; Death on Horseback, 117, 117;

Greyhound, 123, 123; Head of an Old Man, 26, 27; The Nailing to the Cross (pen and ink with grey wash), 72, 72; The Nailing to the Cross (pen and brown ink), 72, 72; St Jerome in Meditation, 26 Dyck, Anthony Van, 88, 89; A Meadow bordered by Trees, 88, 88 Egyptian art, 40, 46, 60, 78, 112 Elsheimer, Adam, 82; River Landscape, 82, 82 Expressionism, 37, 43, 110 Fauvism, 21, 83, 110 Flemish art, 78 Fragonard, Jean Honoré, 80, 83, 101, 102, 112, 124; Bull in a Stable, 124, 124; Genoa, Staircase of the Palazzo Balbi, 101, 101; Landscape with a Bridge through Trees, 83, 83 Freud, Sigmund, 43 Fuseli, Henry, 65; Hamlet and Ophelia, 65, 65 Futurism, 96 Gainsborough, Thomas, 69, 70, 80, 111; Cart on a Woodland Road, 80, 81, Diana and Actaeon (oil on canvas), 70, 71; Diana and Actaeon (preliminary sketches), 70, 70; Second Study for the Duke and Duchess of Cumberland, 69, 69 Gauguin, Paul, 46, 56; Woman of Brittany, 56, 56 Géricault, Theodore, 112, 115, 118, 120, 121; Charging Officer of the Carabineers, 118, 118; Studies of a Wild Striped Cat, 120, 120 Giacometti, Alberto, 41; Nude, 41, 41 Girtin, Thomas, 100; Great Hall, Conway Castle, 100, 100 Gogh, Vincent Van, 7, 18, 33, 37, 68, 69, 79, 87, 90, 91; La Crau from Montmajour, 90, 90, 91; Grove of Cypresses, 7, 86, 87; Peasant of the Carmargue, 36, 37; The Road from Tarascon, 79, 79 Goltzius, Hendrick, 125; Camel, 125, 125 Greek art, 40, 60, 78, 96, 112 Gris, Juan, 21; Portrait of Max Jacob, 21, 21 Gromaire, Marcel, 55; Seated Nude, 55, 55 Guercino, II, (Giovanni Francesco Barbieri), 57; Seated Nude with Arms Upraised, 57, 57 Henry VIII, King of England, 28 Hobbema, Meindart, 111 Hogarth, William, 18 Holbein, Hans, the Younger, 28; An English Woman, 28, 28 Huber, Wolfgang, 80; Mountainous Landscape with a Fortified City, 80, Hugo, Victor Marie, 104; A Castle above a Lake, 104, 104 Iberian sculpture, 55 Impressionism, 22, 30, 46, 52, 53, 58, 61, 78, 86, 99, 110 Ingres, Jean Auguste Dominique, 28, 46, 48, 69, 77; Nude Study, 48, 48; Sir John Hay and his Sister, Mary, 76, 77 Islamic art, 59 Japanese prints, 30, 99

Klee, Paul, 18, 20, 96, 116; From an Old Town, 96, 96; Galloping

Horses, title page, 116, 116; Portrait of a Girl Smiling, 20, 20

24, 24

Kokoschka, Oskar, 24; The Artist's Mother Relaxing in an Armchair,

Lautrec, Henri de Toulouse-, see Toulouse-Lautrec, Henri de Leonardo da Vinci, 18, 26, 40, 45, 50, 78, 80, 87, 94, 112, 116, 117; A Deluge, 87, 87; Leda and the Swan, 50, 50; Self-portrait, 26, 26; Studies of Horsemen, 116, 116; Virgin of the Rocks, 80 Lorrain, Claude, see Claude Lorrain

Maillol, Aristide, 46; Reclining Nude, 46, 46 Manet, Edouard, Portrait of Emile Zola, 30

Mannerism, 40, 48, 125

Marcoussis, Louis, 33; Portrait of Edouard Gazanion, 33, 33

Marks, Claude Roger-, see Roger-Marks, Claude

Matisse, Henri, 8, 21, 41, 59, 60; Nude, 59, 59; Nude with Fern, 59, 59; The Plumed Hat, 21, 21

Medieval art, 40, 60, 65, 78, 112

Mexican sculpture, 44

Michelangelo Buonarroti, 26, 40, 41, 45, 51, 64, 66, 78; Moses, 26; Study for the Creation of Adam, 45, 45; Study for a Flying Angel, 51, 51; The Virgin and Child with the Infant St John, 64, 64

Modigliani, Amedeo, 20, 57; Caryatid, 57, 57; Portrait of Mateo Alegria, 20, 20

Mondrian, Piet, 7, 60, 86, 110; Apple Tree, 86, 86; Church at Domburg, (1914), 110, 110

Monet, Claude, 99

Monro, Dr Thomas, 100

Moore, Henry, 41, 44, 73; Reclining Nude, 44, 44; Standing Nude, 41, 41; Two Women Bathing a Child, 73, 73

Muybridge, Eadweard, 112

Neoclassicism, 96 Neoplasticism, 86, 110

Paleolithic art, 60, 112; Two Bison, back to back (early Magdalenian period), 112, 113

Palmer, Samuel, 79; Landscape, 79, 79

Patinir, Joachim, 80

Picasso, Pablo, 18, 19, 21, 24, 33, 41, 55, 60, 63, 77, 112, 113, 114; Les Demoiselles d'Avignon, 55; Diaghilev and Selinburg, 77, 77; Female Nude with Raised Arms, 55, 55; Head of a Young Man, 18, 19; Man with Pipe, 32, 33; Minotaur Attacking an Amazon, 113, 113; The Picador, 114, 114; Two Figures, Hands Clasped, 63, 63

Piranesi, Giovanni Battista, 101, 102; Monumental Staircase leading to a Vaulted Hall, 100, 101

Pissarro, Camille, 85; An Orchard, 85, 85

Pointillism, 110

Poussin, Nicolas, 60, 61, 66, 74, 75; The Adoration of the Magi, 61, 74-5, 75

Pre-Raphaelites, 65

Raphael (Raffaello Sanzio), 18, 28, 33, 46, 48, 62, 64, 66, 77; Composition Study for the Borghese Entombment, 62, 62; Female Saint, half-length, 28, 29; The Virgin and Child: Study for the Madonna di Foligno, 64, 64

Rembrandt van Rijn, 8, 30, 52, 53, 58, 68, 73, 112, 114, 119, 122;

Adam and Eve, 122; Elephant, 122, 122; Four Studies of Lions, 119

119; A Girl Sleeping, 52, 52, 114; Group of Three Women before a

House, 68, 68; Nude Study of a Young Man Standing, 58, 58; St Jerome,

119; Seated Old Man, 30, 30; Study of a Female Nude Reclining on a

Couch, 53, 53; Two Women Teaching a Child to Walk, 73, 73

Renaissance art, 40, 60, 62, 64, 78, 87, 96, 112

Renoir, Pierre Auguste, 41, 46, 54; Nude Woman Seated, 46, 47, 54

Robert, Hubert, 102; Rome, the Villa Ludovisi, 102, 102

Rococo art, 33, 60, 61, 69, 80, 83, 112, 124

Roger-Marks, Claude, 28

Roman art, 60, 78, 96, 112

Romanticism, 65, 80, 92, 95, 96, 104, 105, 112, 117 Rossetti, Dante Gabriel, 65; *Hamlet and Ophelia*, 65, 65

Rubens, Peter Paul, 18, 33, 51, 84, 85, 88, 112, 119; Daniel in the Lion's Den, 119; Lioness, 119, 119; Portrait of Isabella Brant, 18, 33,

34; Study of a Figure for the Descent of the Damned, 51, 51; Trees Reflected in Water at Sunset, 84, 84, 85

Ruysdael, Jacob van, 111; View in Alkmaar with the Groote Kerk, 111,

Saenraedam, Pieter Jansz, 111; Interior of the So-called Chapel Church at Alkmaar, 111, 111

Savery, Roelandt, 80; Alpine Landscape, 80, 80

Schiele, Egon, 37, 43; Self-portrait, 37, 37; Wally with Red Blouse, 43,

Scorel, Jan van, 108; Alpine Landscape with a Bridge, 108, 109 Segonzac, André Dunoyer de, 42, 43; Young Girl by a Red Umbrella, 42, 42

Seurat, Georges, 7, 58, 60, 69, 91; Landscape Study for La Grande-Jatte, 91, 91; Standing Female Model, 58, 58; Study for La Grande-Jatte, 69, 69, 91; Sunday Afternoon on the Île de La Grande-Jatte, 69, 91

Sickert, Walter, 7

Signac, Paul, 69

Spencer, Stanley, 7, 66; Chopping Wood in the Coal Cellar, Elsie, 7, 66, 67 Steinlen, Théophile Alexandre, 57

Stubbs, George, 112

Surrealism, 63

Sutherland, Graham, Portrait of Sir Winston Churchill, 18

Tiepolo, Giovanni Battista, 101

Toulouse-Lautrec, Henri de, 33, 52, 57, 68, 112, 118, 123; At the Opera, 68, 68; Bouboule, Madame Palmyre's Bulldog, 123, 123; Eauestrienne, 118, 118; Woman Asleep, 52, 52

Turner, Joseph Mallord William, 78, 89, 92, 93, 98, 99, 100, 103; Benson or Bensington, near Wallingford, 89, 89; The Burning of the Houses of Parliament, 98, 98; Paestum in a Storm, 103, 103; Venice, S. Giorgio from the Dogana, 92, 92

Uccello, Paolo, 112; Rout at San Romano, 112

Van Dyck, Anthony, see Dyck, Anthony Van Van Gogh, Vincent, see Gogh, Vincent Van Veronese (Paolo Caliari), 19, 37; Head of a Negro, 19, 37, 38 Verrocchio, Andrea del, 18, 19; Head of a Woman with Elaborate Coiffure,

Villon, Jacques, 22, 24; My portrait, 24, 24; Self-portrait, 22, 23 Vitruvius, 40

Watteau, Jean Antoine, 18, 33, 37, 53, 54, 69, 112, 124, 125; Five Studies of a Dromedary, 124, 125, 125; Head of a Negro inclined to right, 33, 37, 39; Portrait of Isabella Brant, 18, 33, 35; Study for 'La Toilette', 53, 53, 54; A Woman Performing her Toilet, 54, 54
Whistler, James Abbott McNeill, 99; Street Scene with Tar Engine, 99, 99

PICTURE ACKNOWLEDGEMENTS

The author and publishers would like to thank the following individuals and institutions for supplying photographs:
Bildarchiv Preussischer Kulturbesitz (Ills. 13, 109), Courtauld Institute of Art (37), Giraudon (79), Robert E. Mates (82), The Museum of Modern Art, New York (18), and The Art Museum, Princeton University (3); illustrations 2, 11a, b, 14, 15, 20, 25, 31, 33, 35, 36, 39, 40, 43, 44, 48, 50, 58, 59, 62–5, 70, 71, 76, 80, 84–90, 92, 93, 98–100, 102–7, 110–25, 128, 129, 136, 138, 142, 143, 147, 152 are reproduced by Courtesy of the Trustees of the British Museum.

Illustrations 24, 51, 140 are Clichés des Musées Nationaux, Paris; 130 is © Arch. Phot. Paris/S.P.A.D.E.M.. Fig. 1 first appeared in Remembering: A Study in Experimental and Social Psychology by F. C. Bartlett (Cambridge University Press, 1932), and is reproduced by permission of the publishers.

				2
			_	